THE WORLD'S GREATEST ART

Publisher and Creative Director: Nick Wells
Project Editor: Catherine Emslie and Claire Walker
Designer: Colin Rudderham
Picture Researchers: Frances Bodiam, Melinda Révész

Special thanks to: Andrea Belloli, Karen Fitzpatrick, Sarah Goulding,
Chris Herbert, Patrick O'Brien, Sara Robson, Polly Willis, Kelly Fenlon

STAR FIRE

Crabtree Hall, Crabtree Lane
Fulham, London, SW6 6TY
United Kingdom

www.star-fire.co.uk

First published 2006

06 08 10 09 07

1 3 5 7 9 10 8 6 4 2

Star Fire is part of the Foundry Creative Media Company Limited

The CIP record for this book is available from the British Library.

ISBN-10 1 84451 683 0
ISBN-13 9781 84451 683 4

Every effort has been made to contact copyright holders. We apologize in advance for any omissions
and would be pleased to insert the appropriate acknowledgement in subsequent editions of this publication.

While every endeavour has been made to ensure the accuracy of the reproduction of the images in this book,
we would be grateful to receive any comments or suggestions for inclusion in future reprints.

Printed in China

THE WORLD'S GREATEST ART

General Editor: Dr Robert Belton • Foreword by Richard Humphreys

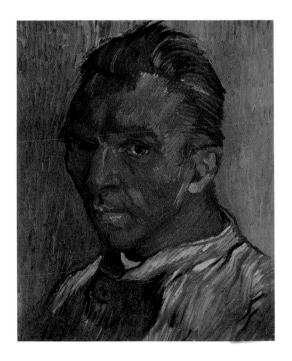

STAR FIRE

Contents

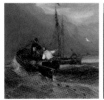 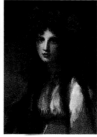

How To Use This Book

The reader is encouraged to use this book in a variety of ways, each of which caters for a range of interests, knowledge and uses.

- The book is organized by era: Gothic and Medieval; Renaissance; Baroque & Rococco; Neoclassicism & Romanticism; Impressionism; Post-Impressionism; and Modern.
- The chronological format allows the reader to explore the progression and development of style within each era.
- The chronological format also enables the reader to discover unusual or unknown art amongst more well-known artists of familiar periods.
- The text provides the reader with a snapshot of an artist's lifetime and allows further exploration of influences that can be discovered elsewhere in the book.
- The Introduction gives an interesting perspective on our notion of what art is, and shows the reader how to gain more insight into a painting than merely appreciating it for its aesthetic appeal.

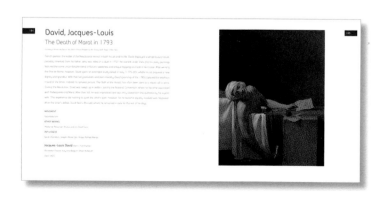

1. Title of painting. Occasionally the origins of a painting are uncertain. We have used a number of terms to describe the artist where the name is not definite: 'studio', 'school of' and 'circle of' reveal that the actual painter had direct contact, or perhaps studied with or under, the name attributed. 'Follower of' is usually used to indicate that the painter worked in the years after the attributed name. 'After' means a copy of a known work by the named artist.

2. Name of artist, by surname then forename

3. Date of painting (if known)

4. Detail's of the artist's life and work

5. Date of artist's birth and place of birth (if known)

6. Geographical region(s) in which artist worked

7. Date of artist's death and place of death (if known)

8. Name of artist by forename, then surname

9. Other artists who influenced the featured painter

10. Other works by the artist

11. Name of the movement to which the painting and artist belongs

12. Picture credit

Foreword

Become A Curator And See The World

Curators know about and look after art and seek to form judgements about it. The best way to get to understand something about art is to look at a lot of it, over a long period of time and without too much concern for where it's from and who says what about it. A trip to your local art school's annual degree show or to a nearby church to see the dusty monuments is as important as an outing to Tate Britain or to the Louvre. You can become as good a curator as anyone else and the more you absorb and get involved with looking, brooding and comparing, the more successful your secret career and the deeper and more convincing your judgement will be. You will at the same time find out about much more than art, while forming a stronger understanding of how many artists work.

You should look at things you think you don't like as well as at your favourites. Once looking becomes a habit like any other, you will quickly have built a store of images which grows and changes as you discover more and think more. Journeys and books, TV programmes and conversations are all opportunities to create this personal art gallery. You will find that all sorts of objects will happily reside alongside one another – Japanese wood-block prints, oil paintings, comic strip imagery, sculptures, photographs, bits of graffiti, maps, old master drawings, African masks, movies and adverts. They are all part of the promiscuous visual world we live in now and all feed off one another and affect our perceptions and feelings.

This personal picture gallery will change its size, layout and atmosphere as some things get brought up from the cellars, some get demoted to distant stores and as you create new rooms for your collection. Your research and education programmes will involve finding out

about biographies, social history, techniques, literature, geography, science, religion, languages and a host of other subjects you may not have thought of before, as art becomes the focus for new and unexpected interests. Each image becomes in itself a store of knowledge and new experience.

This is probably how most artists go about acquiring their knowledge of art and developing their personal vision. They are not art historians in an academic sense but rather live through visual images, with no artificial boundaries of taste and meaning to dampen their enthusiasms.

This is certainly the sort of book which artists will enjoy and which will become heavily used, covered in paint and coffee stains and casually dropped on the studio floor. It is a rich gallery of images from around the world, organised by simple historical period, which are all powerful and memorable visual statements. From The Birth of Sin to that of Venus, from Chop Suey to a basket of onions, an array of sacred and profane works are on offer which all celebrate life and looking and demand further acquaintance. Some artists are so well-known you wonder if they ever really existed, others you, and I, won't have heard of. Whoever they are, look hard, read the words and trust yourself.

Richard Humphreys

Richard Humphreys
Senior Curator, Tate

Introduction

For most people the process of viewing something aesthetically pleasing can be a momentarily life-enriching experience. The same people might also feel that there is a big difference between looking at a painting for its own sake, and accepting the concept of art as a medium conveying a set of intellectual theories and arguments, and many would ask why should we bother with art? The enjoyment provided by the visual is an acceptable motivation in itself. However, it does not tell us very much about anything — after all, sweets can provide enjoyment too. Unlike sweets, though, art has the potential to enrich life in a manner that goes well beyond mere enjoyment, agreeable décor or a more superficial gratification through popular imagery. Moreover, because the art of our own time often simply reaffirms our own values and expectations, being familiar with the art of other times and places is a useful portal into others' aesthetics, ideologies, morals, philosophies, politics and social customs. This familiarity, in turn, may well invite us to question our own ideologies and social customs; in fact, much art was never meant to be enjoyed at all, in the common sense of the word. Art's most fundamental importance is therefore not as décor but as an avenue of intellectual communication. This makes insight into art an invaluable part of an advanced comprehensive education.

For a long time there was little doubt that one of the higher expressions of a culture was its advanced visual art. For the layperson, the word 'Renaissance' remains to this day more likely to conjure up the works of Leonardo da Vinci and Michelangelo than those of, for example, the composers Heinrich Isaac and Josquin des Prez. However, it is difficult to say the same of the visual art of our own time, unless we are speaking specifically of the mass media. With a few notable exceptions, such as Picasso, modern and contemporary art is much less likely than that of the Renaissance to spring to average people's minds as an example of their own culture's higher accomplishments. For the purposes of this book, when we talk about art we are really referring to paintings, since for most 'lay' people paintings act as their first serious introduction into art interpretation, and for many it is the medium that they find most accessible.

WHY IS ART DIFFICULT?

Why is it that much recent art — even that deemed very important by the critical community of visual arts professionals — simply does not engage the imagination of the average person in the same way as traditional art? One conventional explanation is that over the past 150 years art has increasingly moved away from the familiarity and comfort of resemblance, in part because artists felt photography and film freed them from having to stick to straightforward representation. Another is that instead of clarity in the discourse around new and

unfamiliar work, explanations are increasingly, and deliberately, obscure. This implies that what went into the making of the art object is more important than what it says to, or the effect it has on, an observer.

The development of the mass media means that a larger proportion of the population is exposed to visual art on a daily basis, and consequently exposed to the accompanying argument. In other words, art that was once intellectually challenging is now part of mainstream culture, and in order for those artists pursuing art as a pure 'academic' exercise to push the boundaries of learning, the questions they ask have to become more cryptic. Yet another reason that more recent art fails to engage the populace is a general mistrust for the people who create the art, and a perception of them and their work as elitist, only inviting in a narrow section of the population to engage in the discourse.

The average person's apparent alienation from the advanced art of the late twentieth and early twenty-first centuries puzzles the professionals, for it seems to be based on several faulty assumptions. The most basic of these is that what makes art 'art' is how accurately it resembles something. This misapprehension ignores the fact that part of what makes even traditional art 'art' is its symbolism, codes and composition, regardless of the accuracy of its representation. A well-crafted object with nothing to say is impoverished as art, whereas something that shows intelligence, imagination and creativity can sometimes be good art even if its technique is ostensibly poor. Attributing too high a value to the making of art is clearly what lies behind frequently heard objections like 'my five-year-old daughter could do that', but these are not complaints that have been levelled solely at difficult contemporary art. The nineteenth-century sculptor Harriet Hosmer was criticized for her figures of heroines from history and literature because she did not make the final stone versions of her sculptures with her own hands. She defended herself by explaining that art is not the technique but the 'design' – the intellectual component of the work. The average person's resistance to art is based on the presumption that art is not the design but the technique – that what makes art 'art' is its 'craft', glorifying the means over the end.

A related faulty assumption is that because the art of the last century is almost invariably accompanied and explained by words, the meaning of the piece resides in the words rather than the object itself. This position fails to recognize that traditional art was often accompanied by words and that the words themselves are merely a part of the context in which the piece exists. More will be said about this context presently. As for class-based mistrust, yes, there are those who traffic in very expensive art less as expressions of an artist's motives than as trophies of their own status, but this is also true of other signs of material wealth and it has no bearing on the meaning or intrinsic value of the art itself. In other words, this too is merely an expression of a contextual matrix surrounding the art.

WHAT IS ART AND WHAT IS ART FOR?

We must begin by asking several questions about context, the most basic of which are 'What is art?' and 'What is art for?'. The average person might say, 'Art is decoration' or, more awkwardly, 'Art is the technically skilful representation of something absent in such a way as to create an illusion of its presence.' However, these answers ignore a host of important pieces that are not particularly attractive, realistic or well made. The history of art is filled with brilliant examples of disturbing and violent imagery, stylized or inaccurate likenesses, and objects that require constant care in order to prevent deterioration.

All the definitions of art offered over the centuries include some notion of human agency, whether through manual skills (the art of sailing, painting or photography), intellectual manipulation (the art of politics) or public or personal expression (the art of conversation). As such, the word is related to 'artificial' – that is, produced by human beings rather than by nature. But it doesn't stop there: this definition of art is correct in a limited way but it is also essentially flawed because it does not allow one to distinguish the defined term from something else that correctly exemplifies the definition.

'A vacuum cleaner is a household appliance' is insufficient as a definition of a vacuum cleaner because 'vacuum cleaner' can be correctly replaced with 'refrigerator', and a vacuum cleaner is not a refrigerator. Saying 'Art equals artificial equals human-made things' fails to distinguish art from other things produced by human beings. It gives us a start, however, for it makes it clear that infinitely realistic painting would simply replicate the world. In so doing, realistic painting says nothing much about human agency and thereby ceases to be art in all but the most bankrupt way. It would be similarly unsatisfactory to try to understand art while limiting oneself to only one or two of the ends above. 'Art is decoration' fails to distinguish advanced art from simple ornament, and 'Art is the exhibition of technical skill' fails to distinguish art from sports and woodworking.

To fail to remain open to the wide range of art's purposes is to be indifferent to its contextual variations, even before we get to the seemingly infinite variety of means and ends. This cripples one's understanding of and openness to art. For example, those who say that art's goal is accurate representation ignore many cultures (such as African, indigenous Australian and Islamic, not just the modern West) in which realism is subordinate to emotional exuberance, imaginative visions anchored in faith or the expression of an idea. Some would declare that art, by definition, has to be beautiful, arbitrarily excluding innumerable depictions of social injustice, violence and tragedy. Still others might maintain that art's only real identity lies in redefining what constitutes art, but that is surely not what was on the mind of an artist whose work is effectively an anguished outburst.

INTERPRETING ART

So, the answers to the questions 'What is art?' and 'What is art for?' are that art is a particular way of saying something or

producing an effect in an observer, and art is 'for' whatever it says or produces as an effect in an observer. The judges of what art is for must be the observers themselves, who are in some ways interpreters of this art. It does not follow, however, that one interpretation is just as good as the next one. Historians and older academics tend to encourage interpreters to 'perform the art' (the word 'interpret' means 'to perform' in some languages) subject to the constraints provided by the work itself. They do so because they believe that this produces more of a statement about the work itself than about the observer. However, observers have the right to interpret as they feel – like a musician improvising around a theme, i.e., they can pretty much refuse to 'perform the art' subject to its constraints, allowing themselves to be inspired in a way that produces more of a statement about themselves than about the work. Both attitudes, and every position between them, can be seen in current writing about art. This might all seem complicated, but bear in mind that there are in fact only three categories of statements one can make about a work of art: Context, Form and Content. However, there are numerous possibilities for interaction between the elements within each category (for example, Form to Form), exponentially more possibilities for interaction between the categories themselves (e.g, between Form and Content) and virtually infinite possibilities brought to one layer in one of the categories (Context), so let's look at each of these in turn.

CONTEXT

'Context' refers to the circumstances surrounding the production and reception of a work of art rather than anything physically present in the work itself. Whether an artist was a man or a woman, religious or secular, academically trained or self-taught, is not something in the work, but it provides additional information that can certainly affect our understanding of the work. Whether the work was produced for public consumption in a religious establishment or for the cabinet of a private collector also affects our interpretation and understanding of the piece. We would have to interpret a work made during the time of the Spanish Inquisition differently from a hypothetically identical one made, say, during the expansion of the railways in the New World because we would need to keep in mind the very different cultural expectations behind them.

Recognizing a contextual code can help an observer understand a lot more about a piece of art. In the absence of this knowledge, a conventionally representational painting might still give us something to look at, even though we do not really understand it at all. In a work that departs from the conventional – for example, art that uses scratchy, unpolished-looking graffiti marks and codes – we do not even have the comfortable familiarity of the contemporary Zeitgeist on art. If we do not know that a certain mark means 'the people who live here are friendly to the homeless', for example, then we do not understand the piece and we may have no meaningful

experience of it. Without contextual information our interpretation is likely to be insufficient at best and faulty at worst.

Information about the artist is one of the major factors in the Context category. Although some might argue that details about the artist's social world are more significant, society in general did not produce the actual work, however much it may have influenced or affected its creation. Since no work would exist without its maker, primary Context describes the circumstances of the work's production at the individual artist's level. Contextual information is not a description of the production of the piece of art itself; it is the artist's attitudes and beliefs, education and training, gender and sexual preference, likes and dislikes, lifestyle and philosophy, politics and religion, social standing and personal wealth. As with all Context, none of these things has to appear in the work, but they all affect our understanding of it. For example, Artemisia Gentileschi (1593–1653) did not paint her experience of rape by her tutor Agostino Tassi in 1612, but knowing this detail of her life gives us license to interpret her depictions of male decapitations in a certain way.

We can consider secondary Context to be the broader cultural expectations, such as the philosophy, politics and religion of the observers or patrons of the work, which of course the artist might have shared. Again, none of these things appear in the work, but they can change our interpretation of it. For example, it can help us to understand that a swastika – a Greek cross with its arms bent in the same rotary direction – can be interpreted in one way in twentieth-century Europe where it is associated with Nazism, and in a completely different way in ancient China, India and Tibet where it is inextricably linked to Buddhism, Jainism and Hinduism. The information we gain about a piece of art's context must be accurate and relevant (the sexual assault mentioned before is relevant, for example, whereas knowing that that artist was fond of a particular type of cheese would not be). One of the fascinating things about art history, however, is the way that later generations of observers sometimes retrieve and re-use an aspect of Context that an earlier generation found irrelevant. Every observer brings to a work his or her own secondary Context, and in this way the art is a reflection of ourselves. Secondary Context is theoretically infinite, unless we arbitrarily restrict our interpretations to a given range – for example, the lifetime of the artist or the patron. Because we have difficulty deciding where the boundary falls between acceptable and unacceptable circumstantial evidence, the proliferation of secondary Context makes the meanings of art seem inexhaustible.

FORM

Form differs fundamentally from Context. While the latter does not appear in the work, Form is the work and its constituent elements, independent of any meaning they might have. A work's colour, light, medium, shape, size, technique and texture are all aspects of Form. The basic formal elements are primary when they are treated in isolation. For example, to

speak of the character of a single shape in a painting as organic, geometric, static or dynamic is to refer to an aspect of primary Form. When we say something about how that shape relates to another shape, we shift to a secondary level of Form, in which elements relate to each other, as in balance, composition, contrast, distance, perspective, space, and so on. When we recognize shapes as particular things with particular identities – identifying an arrangement of coloured stripes as a flag – we assign them a meaning and move from Form to Content. The mechanism that makes the change in the flag example is Context: we know that certain stripes (Form) indicate a flag (Content) within the horizon of expectations of a particular culture. Moving from Form to Content is so natural to us that we find it difficult to distinguish between the categories. It is, however, a useful exercise, for Form, however interesting on its own, plays an important role in actually creating Content.

CONTENT

Content refers to what a work says and the effects it produces in an observer. Some may actually be 'meanings' (in the sense that the artist meant or intended to convey them), and some may be better described as 'significances' (pseudo-meanings not intended or controlled by the artist but peculiar to an individual observer). Like the other categories, Content has primary and secondary levels. Primary Content corresponds approximately to the literal level of language – attributes, events, facts, objects,

people, places and things, all representing what they appear to represent, as opposed to symbolizing something else. As soon as we point out that one thing symbolizes or stands for something else, we shift to a secondary level of Content. Every competent performer of a language instinctively understands that figurative expressions are not to be taken as literal. 'She was on cloud nine' does not refer to someone floating in the sky; it pushes beyond the primary to a secondary layer of Content, 'happiness'. This is the core flaw in the theory that the value of art lies in its ability to render something accurately: to praise a work solely for its realism is to ignore the codes that may be obvious to an observer who shares its artist's horizon of expectations. In other words, what you see may not be what you (are supposed to) get.

There are several mechanisms by which primary Content becomes secondary Content. Probably the most common of these is symbolism – the comparison of a literal element in the picture to another element, whether present or implied, until a different level of meaning emerges. Devices such as the metaphor work in exactly this way. A child blowing a bubble is just that if we take the scene literally, but if we are prepared to see it as a comparison of the child and the bubble, a metaphor is produced. The understood characteristics of the bubble – its beauty and fragility – imply something less immediately apparent but no less true about the child. A good many of these tropes, as they are known, are conventional and widely understood by the culture or society in which the work has been produced. 'She was on cloud

nine' would not be figuratively meaningful in a culture that had not standardized the expression. Other tropes are invented by the artist rather than borrowed from culture in general. Observers may recognize these spontaneously, or they may have to work at understanding them by filling in the gaps in their knowledge of the artist. That an observer's knowledge of the artist is never complete is another of the many ways in which the meanings of art seem to be inexhaustible.

RELATIONSHIPS BETWEEN CONTEXT, FORM AND CONTENT

That Form consists of elements independent of meaning does not mean that it does not affect the meaning of a piece of art. Just as Context influences Content, pushing it from primary to secondary, Form also affects Content, although it uses a less familiar method of category-shifting that we might call 'paralinguistic'. Though the term strictly applies to the spoken language, the same principles can be applied to the visual image. The term refers to the way changes in individual delivery (or performance) of a statement lead to changes in our understanding of what is meant. If one changes the Form of a literal image (that is, the way in which it is delivered or performed), one can produce a corresponding change of the literal meaning of the image to a metaphorical one. Like tropes, some of these shifts can be conventional, evoking an immediate response that is mediated by secondary Context. For example, in Western culture everyone spontaneously recognizes the difference between the look, sound, and meaning of 'fire' spoken

normally and 'FIRE!' screamed loudly, even though the core meaning is the same. Moreover, everyone can tell the difference between 'fire!' yelled in a crowded theatre and 'fire!' shouted next to a line of aiming soldiers. Someone who fails to understand the difference has overlooked something important about the culture in which the expressions have achieved currency.

Rather than limiting themselves to illustrating paralinguistic shifts that are already part of the popular culture, artists re-invent them for expressive and aesthetic purposes. Let us look at an expressionist work, Van Gogh's Starry Night. Because of the painting's departure from conventional depictions of the night sky (and from Van Gogh's own usual style), it seems to evoke a deeply emotional response, and the scene almost cries out in mystical ecstasy. Trying to unravel the meaning-effects of contextual codes and formal nuances without falling prey to the assumption that good art is realistic, is key to understanding art as art, rather than art as craft.

No matter how complicated, then, all works of art involve the interplay of these three categories. This realization provides a way to create a workable definition of visual art that brings us at least a little closer to sufficiency. That is, visual art is the manipulation and interrelation of visible Form, invisible Context and primary Content to create secondary Content — that is, to say something or to produce an effect in the observer that goes beyond the literal — for the purpose of accomplishing one or more of the various ends listed above.

WHAT IS GOOD ART?

The new definition of art carefully avoids the question 'What is good art?'. This is because definitions of 'good' are always mediated by the values of secondary Context, the circumstances in which the piece is seen rather than in which it is created. One set of secondary cultural expectations sees goodness as 'quality', for example. But in one culture quality is defined as formal orderliness whether or not it is really appropriate for the Content, and in another culture quality is interpreted as whether or not artists have achieved what they set out to achieve. Where some cultures have not seemed to care whether an artist's use of symbolism is purely conventional or original, another culture highly prizes 'innovation' – the deliberate striving of the artist to invent a new and unconventional way of expressing something. Today, innovation is in the ascendant and it is manifest in only about three ways. First, artists can innovate by portraying primary Content with Form that is unexpected and, ideally, previously unused in this connection in such a way that new secondary Content is produced. As raw subject matter, Picasso's famous weeping women are nothing new, but his inventive Form shifts them until they say something new and produce a new effect in the observer. Second, artists innovate by making unusual combinations of secondary Context. Judy Chicago's famous Dinner Party of 1979 (in which place-settings are decorated with flower motifs that pun on female genitalia) retrieves old associations – for example, women's art as flower painting – and reinvents them within the set of cultural assumptions that constitutes feminism. Third, artists innovate by developing and depicting idiosyncratic aspects of primary Context. Because this involves personal motivations that are often difficult to pinpoint, this third way to innovate is another contribution to the impression that art's meanings are inexhaustible.

HOW TO READ THIS BOOK

We invite readers to use this book in any way they see fit. We do, however, ask them to keep in mind that its final purpose is to see art as a way to exercise our hearts, imaginations and minds, not only to expand our knowledge of others' ideologies and social customs but also to question our own. These poles of respect and critique provide the parameters within which this book will achieve its purpose.

You may find that you end up reading this book, or at least sections of it, more than once. Dipping into the entries selectively will allow you to be drawn into the subject of art through the artists, or pieces, that most appeal to you. Finally, don't think of the book's selection of works as the final word on the subject – art history's canonical 'greatest hits', as it were. Think of them instead as exercises to prepare you for the great adventure of art – to explore a world that could never be encapsulated within the covers of one book.

Dr Robert Belton

13th–15th Centuries

The Gothic & Medieval Era

Cimabue, Giovanni

Angels from the Santa Trinita Altarpiece, 1280–90

Courtesy of Galleria Degli Uffizi, Florence, Italy/Bridgeman Art Library

Cimabue was the nickname of Genni di Pepo or Peppi, who was born in Florence around 1240. He began his career by imitating the Byzantine styles then prevalent, but soon developed a style of his own which earned for him the title of 'Father of Italian Painting'. There were certainly distinctive Italian painters before his time, but he was the outstanding artist of his generation and a role model for his successors. His fame rested mainly on the enormous altarpiece in the chapel of the Rucellai in Santa Maria Novella, Florence, although this was later proven to have been painted by Duccio. Works that are definitely attributed to him include the frescoes in the church of St Francis of Assisi and a number of paintings of the Madonna. He was the precursor of Giotto, whom he is supposed to have discovered as a 10-year-old shepherd-boy and recognized his artistic potential.

MOVEMENT

Florentine School

OTHER WORKS

St John (Pisa Cathedral)

INFLUENCES

Byzantine, Romanesque

Cimabue *Born c.* 1240 Florence, Italy

Painted in Florence

Died c. 1302 Florence

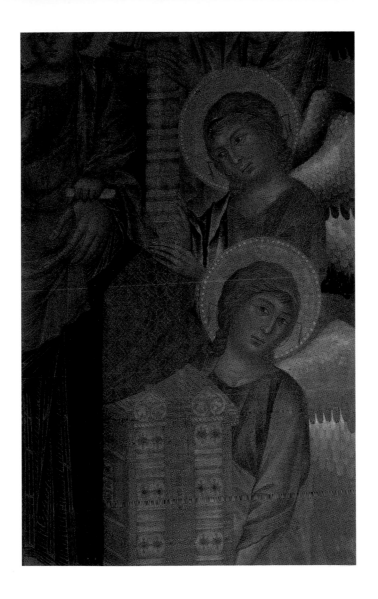

Giotto (Giotto di Bondone)
Lamentation of Christ, c. 1305

Courtesy of Scrovegni (Arena) Chapel, Padua, Italy/Bridgeman Giraudon

One of the founding fathers of the Renaissance, Giotto was revered by early commentators as the greatest artist since antiquity, and it is clear that he was still influencing painters more than a century after his death. His greatest achievement was to rid Italian art of the repetitive stylizations deriving from Byzantine painting. In the process, he became one of the first Western artists to stamp his own personality on his work. In particular, Giotto displayed an unparalleled degree of naturalism, both in his ability to depict solid, three dimensional forms and in his grasp of human psychology. He was also a gifted storyteller, conveying his religious narratives with absolute clarity and simplicity.

The details of Giotto's own life are, however a mystery. There is a tale that his master, Cimabue, first spotted his talent when he saw him as a shepherd-boy, sketching a lamb on a slab of rock. This is probably apocryphal, however, and the identification of Giotto's pictures presents even greater problems. The marvellous frescoes in the Arena Chapel, Padua, are usually cited as his masterpiece, but most other attributions are hotly disputed. Even his three signed altarpieces may only be workshop pieces.

MOVEMENT

Renaissance

OTHER WORKS

Arena Chapel Frescos; Madonna and Child; Ognissanti Madonna

INFLUENCES

Cimabue, Pietro Cavallini

Giotto *Born c. 1267*

Painted in Italy

Died 1337

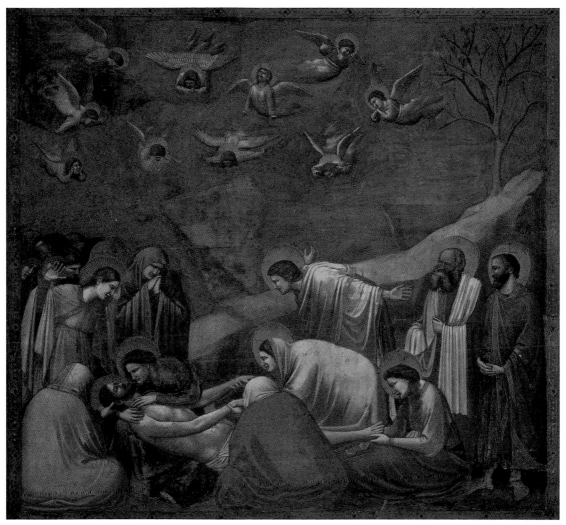

Duccio di Buoninsegna
Madonna and Child, *c.* 1315

Courtesy of National Gallery, London, UK/Bridgeman Art Library

Western art begins with Duccio di Buoninsegna, who learned his craft from studying the illuminated manuscripts created by unknown Byzantine limners. His earliest recorded work, dating about 1278, was to decorate the cases in which the municipal records of Sienna were stored. In 1285 he was commissioned to paint a large Madonna for the church of Santa Maria Novella. This is now known as the Rucellai Madonna, for centuries attributed to Cimabue. Duccio painted the magnificent double altarpiece for the Cathedral of Siena, regarded as his masterpiece and one of the greatest paintings of all time. Many other works documented in the Sienese records have been lost, but sufficient remain to establish Duccio as the last and greatest of the artists working in the Byzantine tradition, as well as the founder of the Sienese School, and thus the progenitor of modern art. In his hands the degenerate painting of the Gothic style was transformed and the principles of expressive portraiture established.

MOVEMENT

Sienese School, Italy

OTHER WORKS

The Crucifixion; Majestas; Madonna with Three Franciscans

INFLUENCES

Byzantine illuminations

Duccio di Buoninsegna *Born c.* 1255 Siena, Italy

Painted in Siena and Florence

Died 1319 Siena

Van Eyck, Jan

Portrait of Giovanni Arnolfini and Wife (Arnolfini Marr), 1434

Courtesy of National Gallery, London, UK/Bridgeman Art Library

Jan van Eyck settled in Bruges in 1431, where he became the leading painter of his generation and founder of the Bruges School. He and his elder brother Hubert are credited with the invention of oil painting. Van Eyck's paintings have a startlingly fresh quality about them, not only in the dazzling use of light and colour but also in their expression and realism, which was something of a quantum leap in portraiture. Van Eyck was very much a pillar of the establishment, being successively court painter to John of Bavaria, Count of Holland, and Philip the Good of Burgundy. He was equally versatile in painting interiors and outdoor scenes, and exhibited a greater attention to detail than in the works of his predecessors. It is not surprising that he should not only sign and date his paintings but add his motto Als ich kan ('As I can').

MOVEMENT

Bruges School of Flemish Painting

OTHER WORKS

A Man in a Turban

INFLUENCES

Hubert van Eyck

Jan van Eyck *Born c.* 1389 Maastricht, Holland

Painted in Maastricht and Bruges

Died 1441 Bruges

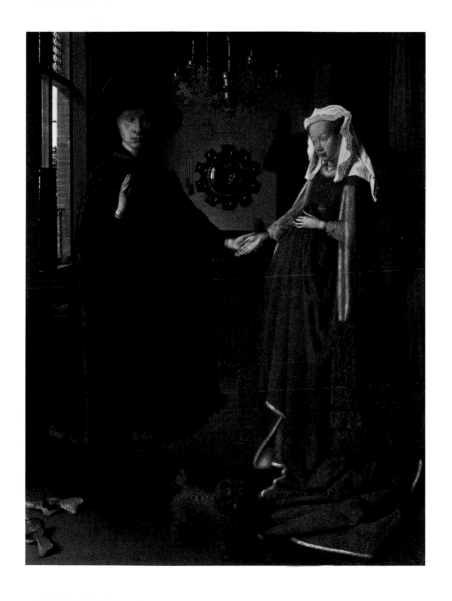

Fouquet, Jean
The Nativity, *c.* 1445

The most representative French painter of the fifteenth century, Jean Fouquet originally came under the influence of Van Eyck, but a period in Italy – where he was commissioned to paint the portrait of Pope Eugenius IV – brought him in contact with the new styles emerging in Tuscany. On his return to France he combined the Flemish and Tuscan elements to create a wholly distinctive French style. Highly influential on the succeeding generation of French artists, Fouquet's supreme importance was not fully realized until 1904, when his surviving works were brought together for an exhibition in Paris. His painting combines the skills and precision acquired during his early career as a limner and miniaturist with a new-found expressiveness that places him in the forefront of the painters who could get behind the eyes of their subjects and reveal the underlying character.

MOVEMENT

French Primitives

OTHER WORKS

Virgin and Child; Saint Margaret and Olibrius; Jouvenal des Ursins

INFLUENCES

Van Eyck, Piero della Francesca

Jean Fouquet *Born c.* 1420 Tours, France

Painted in France and Italy

Died c. 1481 Tours, France

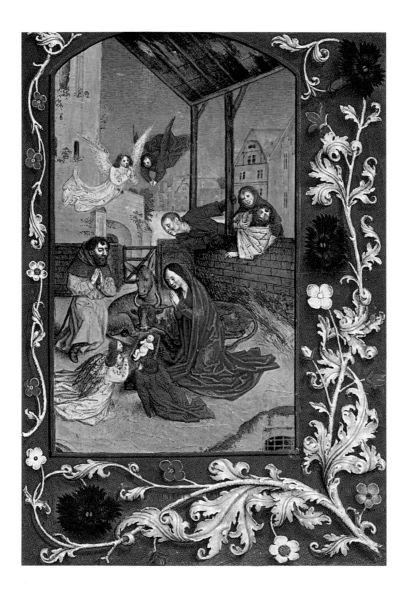

Van der Weyden, Rogier

Crucifixion, 1468

Rogier van der Weyden studied under Robert Campin in his native city of Tournai before going to Brussels, where he made his mark both as an artist and as a prominent citizen. From 1436 he was the official painter to the city as well as the Burgundian Court. Although he visited Rome in 1450 it had no impact on his style. A very accomplished technician, he excelled not only in form and composition but also in his use of colour. But his main contribution to the progress of art was in his highly expressive portraiture, one of the first painters to convey the character and psychological profile of the model or the subject. He combined deep religious feeling with a desire to make the maximum impact on the spectator and in this he succeeded admirably. He wielded enormous influence over his contemporaries and the ensuing generation of Flemish artists.

MOVEMENT

Flemish School

OTHER WORKS

Deposition; The Last Judgment

INFLUENCES

Robert Campin

Rogier van der Weyden *Born* 1399 Belgium

Painted in Tournai and Brussels

Died 1464 Brussels, Belgium

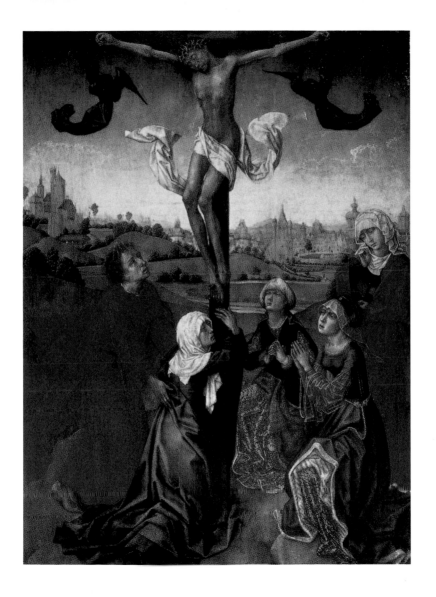

Memling, Hans

Adoration of the Magi (Central panel of triptych), c. 1470

Although born in Germany Memling spent most of his life in Bruges (now in Belgium), where he was probably a pupil of Rogier van der Weyden. This is borne out by the great triptych, whose central panel was painted by Rogier but the wings by 'Master Hans'. Bruges, which had been the commercial centre of the duchy of Burgundy, was then in decline and it has been said that Memling's genius alone brought lustre to the city. He was certainly residing in Bruges by 1463 and four years later enrolled in the painters' guild. In 1468 he painted the triptych showing the Virgin enthroned, flanked by the family of the donor, Sir John Donne, who was in Burgundy for the wedding of Charles the Bold that year. Although best known for his altarpieces and other religious paintings, Memling also produced a number of secular pieces, mostly portraits of his contemporaries. His paintings are characterized by an air of serenity and gentle piety enhanced by the use of vivid colours and sumptuous texture.

MOVEMENT

Flemish School

OTHER WORKS

The Mystic Marriage of St Catherine; The Virgin Enthroned

INFLUENCES

Rogier van der Weyden

Hans Memling *Born c. 1433, Germany*

Painted in Bruges, Belgium

Died 1494 Bruges

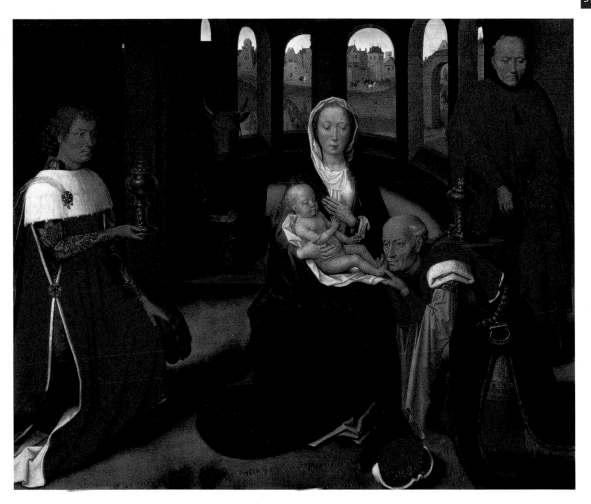

Van der Goes, Hugo
The Fall, after 1479

Courtesy of Kunsthistorisches Museum, Vienna, Austria/Bridgeman Art Library

Hugo van der Goes was the Dean of the painters' guild in that city from 1467 to 1475, before retiring to the monastery of Rouge Cloître near Brussels, where he continued to execute religious paintings. The outstanding Flemish artist of his generation, his reputation rests mainly on a single work: the magnificent altarpiece which was commissioned by Tommaso Portinari for the chapel in the hospital of Santa Maria in Florence. It is a vast triptych, crammed with figures, the great centrepiece representing the Adoration of the Shepherds, while the wings portray Portinari and his sons praying under the protection of Saints Anthony and Matthew and Protinari's wife and daughters on the other, protected by Saints Margaret and Mary Magdalen. A number of easel paintings have been attributed to this artist, while he also designed stained glass windows and frescoes.

MOVEMENT

Flemish School

OTHER WORKS

Fall and Deposition; Adoration of the Magi; Death of the Virgin

INFLUENCES

Rogier van der Weyden

Hugo van der Goes *Born c.* 1440 Ghent, Belgium

Painted in Ghent

Died 1482 Ghent

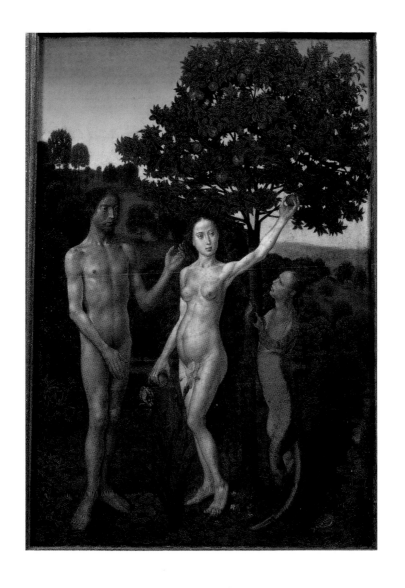

Bosch, Hieronymus
The Garden of Earthly Delights, (detail) *c. 1500*

Courtesy of Prado, Madrid, Spain/Bridgeman Art Library

Born Jerome van Aken but known by the Latin version of his first name and a surname from the shortened form of his birthplace 's Hertogenbosch in North Brabant, where he spent his entire life, he painted great allegorical, mystical and fantastic works that combined the grotesque with the macabre. His oils are crammed with devils and demons, weird monsters, dwarves and hideous creatures, barely recognizable in human form. His quasi-religious and allegorical compositions must have struck terror in the hearts of those who first beheld them, but centuries later he would have a profound influence on the Surrealists. In more recent times there have been attempts to analyse his paintings in Jungian or Freudian terms, the theory being that he tried to put his more lurid nightmares onto his wood panels. This is his best known work, executed on four folding panels, in which he develops the story of the Creation and the expulsion of Adam and Eve. At the core of the work is a vast sexual orgy, symbolizing the sins of the flesh that caused man's downfall.

MOVEMENT

Surrealism

OTHER WORKS

The Temptation of St Anthony; Last Judgment

INFLUENCES

Gothic art

Hieronymus Bosch *Born c. 1450, Hertogenbosch, Holland (now in Belgium)*

Painted in Hertogenbosch, Holland

Died 1516 Hertogenbosch, Holland

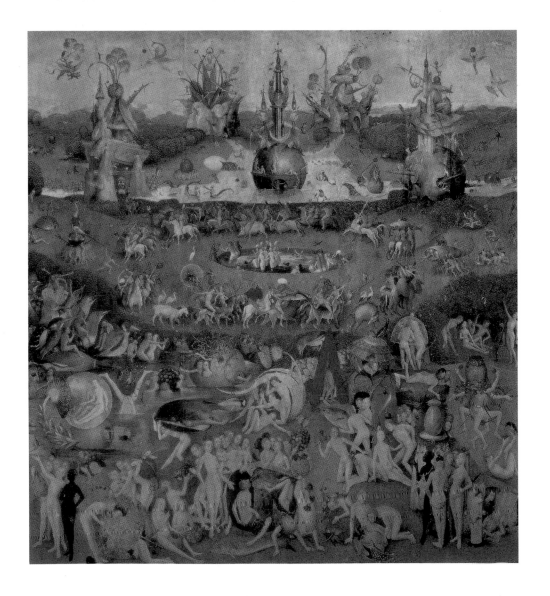

Grünewald, Matthias

Mary Magdalene from the Isenheim Altarpiece, 1510–15

Courtesy of Musee d'Unterlinden, Colmar, France/Bridgeman Giraudon

Born Mathis Gothardt-Neithardt, probably in Würzburg, he flourished at Frankfurt, Mainz, Aschaffenburg and Upper Alsace between 1500 and 1528, where he worked as an architect and engineer. Very little is known of his origins and early life, and he only came to artistic prominence in 1508 when he was appointed court painter at Mainz, taking up a similar post at the court of the Elector of Brandenburg in 1515. It was during the latter period that he undertook the great altarpiece at Isenheim, now preserved in the Colmar Musem. In his heyday he was ranked equal with Dürer and Cranach and is regarded as the last great exponent of German Gothic art, at a time when the ideas of the Italian Renaissance were making inroads into northern Europe.

MOVEMENT

German Gothic

OTHER WORKS

The Crucifixion; The Mocking of Christ

INFLUENCES

Albrecht Dürer

Matthias Grünewald *Born c.* 1470 Bavaria, Germany

Painted in Frankfurt, Aschaffenburg, Mainz, and Colmar

Died 1528 Halle

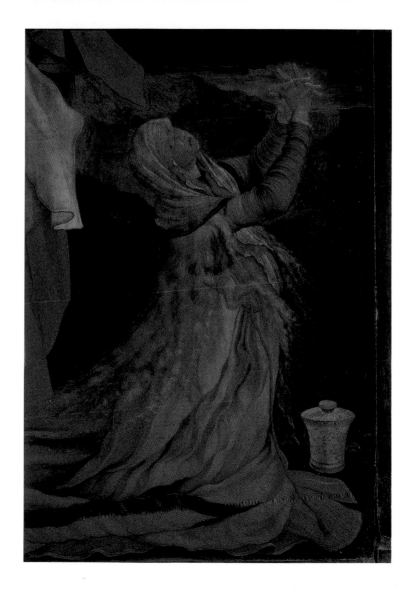

16th Century

The Renaissance Era

Angelico, Fra (Guido di Pietro)
The Annunciation (detail) *c. 1420*

Courtesy of Prado, Madrid, Spain/Bridgeman Art Library/Christie's Images

Fra Angelico was one of a select band of Renaissance artists who combined the monastic life with a career as a professional painter. Little is known about his early years, apart from the fact that he was born at Vicchio, near Florence, and that his real name was Guido di Pietro. He became a Dominican friar *c. 1418–21*, entering the monastery of San Domenico in Fiesole. For the remainder of his life, he placed his art at the service of his faith, earning the nickname 'Angelic', by which he has become known to posterity.

Angelico's earliest surviving works are small-scale and betray an astonishing eye for detail, suggesting that he may have begun his career as a manuscript illuminator. They also display the influence of the International Gothic style, which was starting to fall out of fashion. The painter-monk learned quickly, however, absorbing Tommaso Masaccio's revolutionary ideas about the organization of space and perspective. He also tackled the most prestigious form of religious art: frescoe painting. In this field, Angelico's greatest achievement was a magnificent cycle of frescoes at the newly restored monastery of San Marco in Florence (*c. 1438–45*).

MOVEMENT

Renaissance

OTHER WORKS

Linaivoli Triptych; Coronation of the Virgin

INFLUENCES

Masaccio, Monaco

Fra Angelico *Born c. 1400*

Painted in Italy

Died 1455

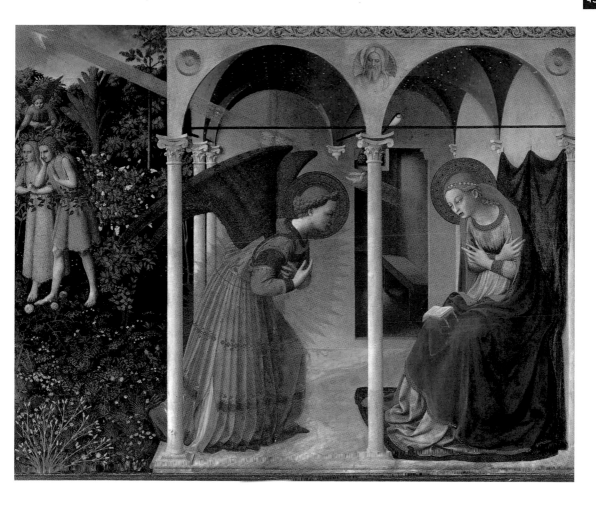

Fabriano, Gentile Da

The Adoration of the Magi, detail of Virgin and Child with Three Kings, 1423

Courtesy of Galleria Degli Uffizi, Florence, Italy/Bridgeman Art Library

Born in the little north Italian town of Fabriano, Gentile worked as a painter mainly in Venice and later Brescia before settling in Rome in about 1419, although subsequently he also worked in Florence and Siena. There he executed a great number of religious paintings although, regrettably, comparatively few of these works appear to have survived. His most important work was probably carried out in Florence where he enjoyed the patronage of Palla Strozzi, the richest magnate of the city in his day. About 1423 Strozzi commissioned him to paint the magnificent altarpiece depicting the Adoration of the Magi for the sacristy-chapel in the church of the Holy Trinity, intended by the patron as a memorial to his father Onofrio Strozzi. This is Gentile's undoubted masterpiece. The very epitome of the Italian Renaissance, it is now preserved in the Uffizi Gallery. It is an extraordinary work, crammed with figures — among whom we may discern the Strozzi family and their friends.

MOVEMENT

Florentine School

OTHER WORKS

Madonna and Child; Madonna with Angels

INFLUENCES

Filippo Brunneleschi

Gentile da Fabriano *Born c.* 1370 Fabriano, Italy

Painted in Venice, Brescia, Rome, Florence and Siena

Died c. 1427 Venice

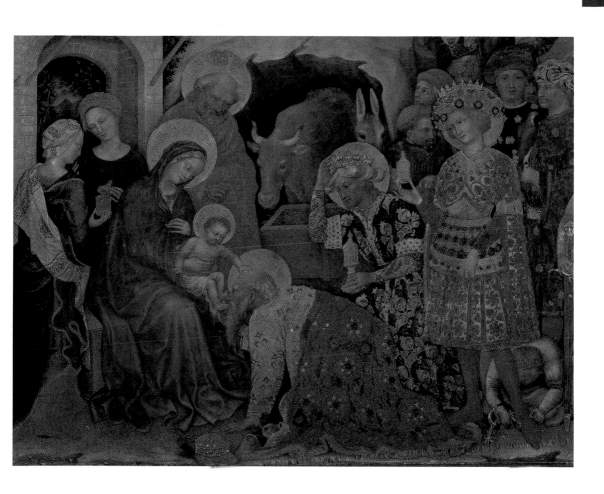

Masaccio, Tommaso
Madonna Casini, after 1426

Courtesy of Galleria Degli Uffizi, Florence, Italy/Bridgeman Art Library

Born Tommaso de Giovanni di Simone Guidi at Castel San Giovanni di Altura in the duchy of Milan, he was nicknamed Masaccio ('massive') to distinguish him from another Tommaso who worked in the same studio. Who taught him is not recorded, but Masaccio was one of the most brilliant innovators of his generation, ranking with Brunelleschi and Donatello in revolutionizing painting in Italy. Biblical figures and scenes became infinitely more realistic in his hands. The human body is more fully rounded than before and Masaccio's handling of perspective is a marked improvement over his predecessors. He wielded enormous influence over his contemporaries and successors, notably Michelangelo. His greatest work consisted of the series of frescoes for the Brancacci Chapel in the Church of Santa Maria del Carmine in Florence (1424–27).

MOVEMENTS

Italian Renaissance, Florentine School

OTHER WORKS

The Virgin and Child; The Trinity with the Virgin and St John

INFLUENCES

Donatello

Tommaso Masaccio *Born* 1401 Castel San Giovanni di Altura, Italy

Painted in Milan and Florence

Died 1428 Rome

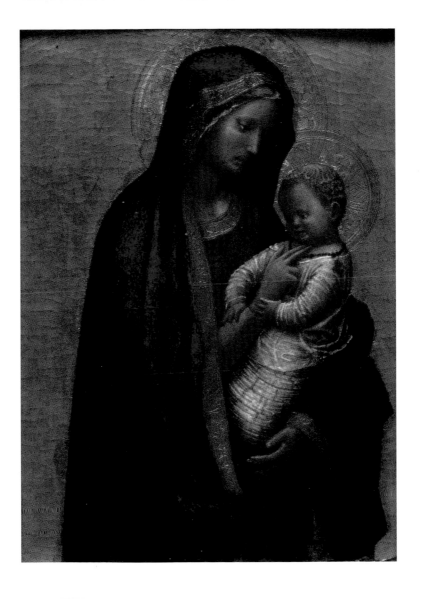

Piero della Francesca

Baptism of Christ, 1450s

Piero della Francesca began his career as a pupil of Veneziano in Florence, although he spent most of his working life in his home town of Borgo San Sepolcro, where he attained some eminence in civic affairs. Although strongly influenced by Donatello, Masaccio and Uccello, he was fascinated with mathematics and problems of perspective. Indeed, from 1470 onwards, he abandoned painting and concentrated on these subjects, writing treatises dealing with geometry and perspective. He was a rather slow, perhaps dilatory, artist who took a long time to complete commissions – one of his greatest masterpieces being the unfinished *Nativity* now in the National Gallery, London. His work was neglected and underrated for many years, but he was rediscovered in the nineteenth century and his stature as one of the major artists of the Renaissance has been re-established.

MOVEMENT

Florentine School

OTHER WORKS

Resurrection; The Legend of the True Cross; Constantine's Dream

INFLUENCES

Veneziano, Donatello, Masaccio, Uccello

Piero della Francesca *Born c. 1420 Italy*

Painted in Florence and Borgo San Sepolcro

Died 1492 Borgo San Sepolcro

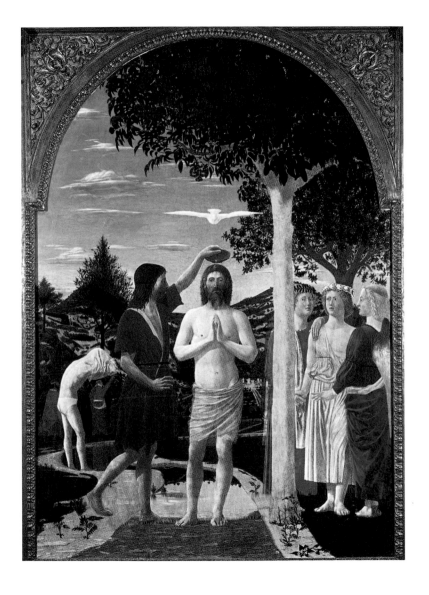

Messina, Antonello da

Portrait of a Man, *c.* 1475

Probably born at Messina, Sicily, whence he derived his surname, Antonello travelled in north-western Europe and spent some time in the Netherlands where he studied the techniques of the pupils of Jan Van Eyck, taking them back to Messina about 1465. Subsequently he worked in Milan and then, in 1472, settled in Venice, where he executed commissions for the Council of Ten. His paintings are remarkable for their blend of Italian simplicity and the Flemish delight in meticulous detail, although some of his earlier works do not always result in a perfect blend of techniques. The majority of his extant authenticated works are religious subjects, mainly painted in oils on wood panels, but he also produced a number of half-length portraits of Venetian dignitaries in the last years of his life. By introducing Flemish characteristics Antonello transformed Italian painting, notably in the use of oil paints, which revolutionized technique.

MOVEMENT

Italian Renaissance

OTHER WORKS

Ecce Homo; Madonna

INFLUENCES

Jan Van Eyck, the Flemish School

Antonello da Messina *Born c. 1430 Italy*

Painted in Messina and Venice

Died 1479 Messina

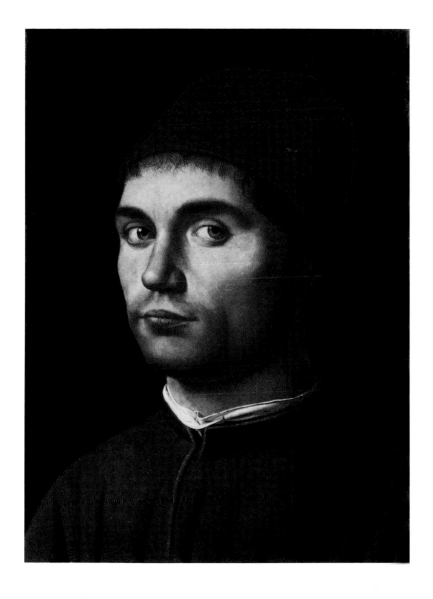

Botticelli, Sandro
The Birth of Venus, c. 1485

Born Alessandro Di Mariano dei Filipepi, he acquired his nickname ('little barrel') from his brother Giovanni, who raised him and who was himself thus named. From 1458 to 1467 he worked in the studio of Fra Lippo Lippi before branching out on his own. By 1480 he was working on the frescoes for the Sistine Chapel and his lesser works consist mainly of religious paintings, although it is for his treatment of allegorical and mythological subjects that he is best remembered. Outstanding in this group are his paintings *Primavera* (1477) and *The Birth of Venus* (1485), both now in the Uffizi. He also excelled as a portraitist and provided the illustrations for Dante's *Divine Comedy*, which he executed in pen and ink and silver-point (1402–5).

MOVEMENT

Florentine School

OTHER WORKS

Venus and Mars

INFLUENCES

Fra Lippo Lippi, Verrocchio

Sandro Botticelli *Born* 1445 Florence, Italy

Painted in Florence and Rome

Died 1510 Florence

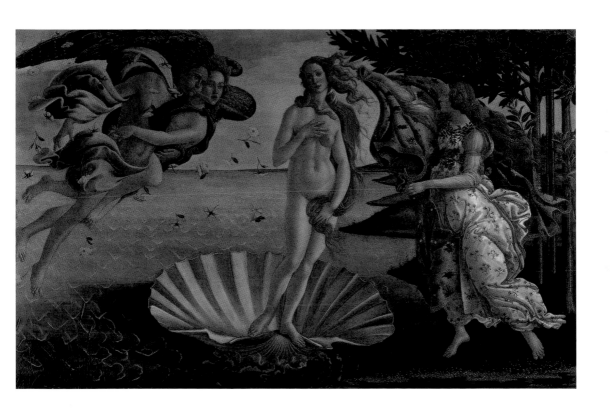

Ghirlandaio, Domenico

Portrait of a Young Man, *c.* 1490

Courtesy of Ashmolean Museum, Oxford, UK/Bridgeman Art Library

Domenico Ghirlandaio was the son of Tommaso Bigordi, under whom he trained as a goldsmith; he later studied painting and the art of mosaic under his uncle Alesso Bigordi. None of his early works have survived, but from 1475 onwards he was renowned as a painter of wood panels and frescoes mainly for church decoration. In 1481 Pope Sixtus VI summoned him to Rome, where he painted a number of frescoes as well as individual religious works in which the subject was placed in a secular setting, often with figures of contemporary personalities as spectators on the sidelines. Ghirlandaio ran a large workshop, employing many pupils including the young Michelangelo. Although these frescoes incorporate numerous portraits, there are relatively few individual works by Ghirlandaio in this genre. The best of these, however, is the touching portrait of an old man with his grandson; the identity of the sitters is unknown.

MOVEMENT

Florentine School

OTHER WORKS

Adoration of the Magi; The Visitation; Virgin and Saints

INFLUENCES

Alesso Bigordi

Domenico Ghirlandaio *Born* 1449 Italy

Painted in Florence and Rome

Died 1494 Florence

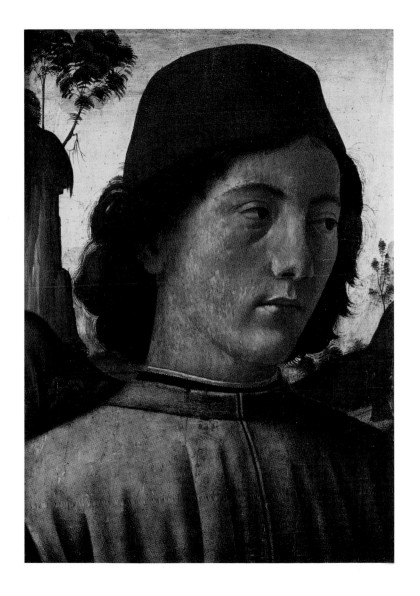

Perugino, Pietro

Madonna and Child with Two Angels, late fifteenth century

Courtesy of Private Collection/Christie's Images

Born Pietro di Cristoforo Vannucci, he is better known by his nickname, from Perugia, the chief city of the district where he grew up and spent much of his working life. Apprenticed to a Perugian painter at the tender age of nine, he showed precocious aptitude. Later he worked under Piero della Francesca in Arrezzo and then was a fellow-pupil of Leonardo under Verrocchio in Florence. From 1480-82 he worked on the frescoes in the Sistine Chapel, Rome, before returning to Perugia, but thereafter worked on various church commissions, occasionally in Rome but mainly in Florence where he had Raphael as one of his pupils for several years. Apart from frescoes and altarpieces he was a prolific painter of individual works, mainly religious subjects but also including a few contemporary portraits.

MOVEMENT

Umbrian School

OTHER WORKS

The Virgin and Child with Saints; Francesco dell' Opera

INFLUENCES

Piero della Francesca, Andrea del Verrocchio

Pietro Perugino *Born c.* 1450 Città delle Pieve, Umbria, Italy

Painted in Parma, Florence and Rome

Died 1523 Fontigano, Italy

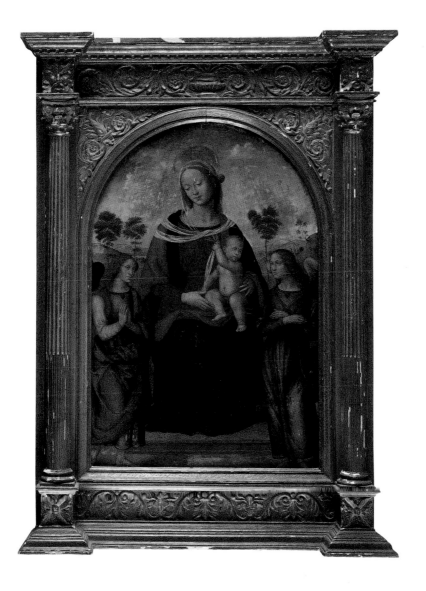

Piero di Cosimo

A Young Man

Courtesy of Dulwich Picture Gallery, London, UK/Bridgeman Art Library

Born Piero di Lorenzo, he was a pupil of Cosimo Rosselli, whose name he adopted. In 1482 he accompanied his master to Rome, where they worked on the frescoes of the Sistine Chapel, and it was during this period that he became imbued with the images of classical mythology which, along with the obligatory religious themes, dominated much of his later work. He also painted a number of portraits and landscapes which are notable for their cheerful accessories. His later style was influenced to some extent by Signorelli and Leonardo da Vinci, although he developed his own highly distinctive approach which his contemporaries regarded as rather eccentric; his interpretation of certain subject matter being at times rather strange. His reclusive character and diet of hard-boiled eggs tended to reinforce this opinion. Nevertheless, his paintings are distinguished by their mastery of light and composition.

MOVEMENT

Florentine School

OTHER WORKS

A Satyr Mourning Over a Nymph; Immaculate Conception

INFLUENCES

Cosimo Rosselli, Luca Signorelli, Leonardo da Vinci

Piero di Cosimo *Born c.* 1462 Florence, Italy

Painted in Florence and Rome

Died c. 1521 Florence

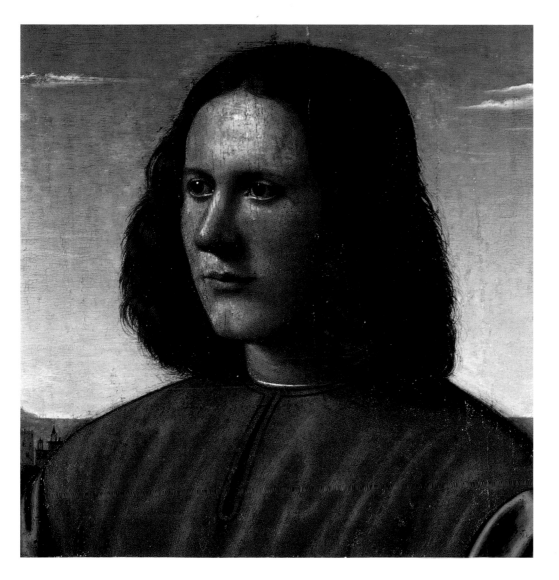

Mantegna, Andrea

Adoration of the Magi, 1495

Courtesy of Private Collection/Christie's Images

Andrea Mantegna was originally apprenticed to Francisco Squarcione, a tailor in Padua who later adopted him. Squarcione was a self-taught painter and it was from him that the young Mantegna learned the rudiments of art. About 1450 he completed an altarpiece for the church of Santa Lucia, which immediately established his reputation. Later he studied the works of Donatello in Florence and Castagno in Venice and mastered the newly developed techniques of perspective. He worked in Verona and elsewhere, executing religious paintings. In 1459 he was recruited by Ludvico Gonzaga, Duke of Mantua, to decorate his palaces and to the subsequent period belong his great masterpieces. Among these is the series of tempera paintings of the Triumph of Caesar executed between 1482 and 1492, later purchased by Charles I and now preserved at Hampton Court.

MOVEMENT

Italian Renaissance

OTHER WORKS

The Dead Christ; The Agony in the Garden

INFLUENCES

Francisco Squarcione, Andrea del Castagno, Donatello

Andrea Mantegna *Born c. 1431 Venice, Italy*

Painted in Italy

Died 1506 Mantua, Italy

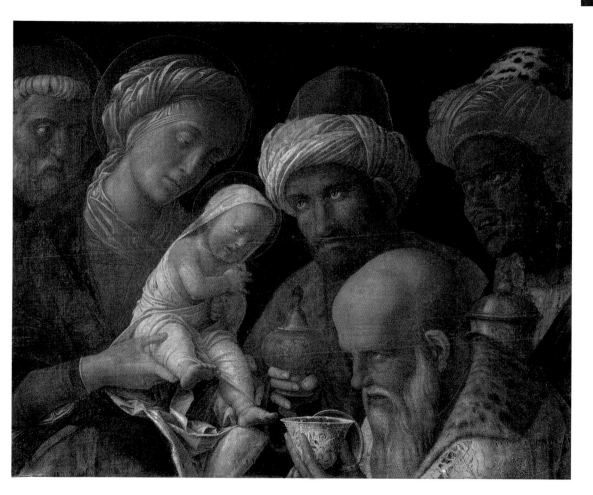

Leonardo da Vinci

Mona Lisa, *c.* 1503–06

Courtesy of Louvre, Paris/Bridgeman Art Library/Christie's Images

Florentine painter, scientist and inventor; the supreme genius of the Renaissance. Leonardo was the illegitimate son of a notary and probably trained under Verrocchio. In 1482 he moved to Milan, where he worked for the Sforzas. His chief work from this period was a majestic version of *The Last Supper*. The composition dazzled contemporaries, but Leonardo's experimental frescoe technique failed and the picture deteriorated rapidly. This was symptomatic of Leonardo's attitude to painting: the intellectual challenge of creation fascinated him, but the execution was a chore and many of his artistic projects were left unfinished. Leonardo returned to Florence in 1500, where he produced some of his most famous pictures, most notably the *Mona Lisa*. These were particularly remarkable for their *sfumato* – a blending of tones so exquisite that the forms seem to have no lines or borders. Leonardo spent a second period in Milan, before ending his days in France. Leonardo's genius lay in the breadth of his interests and his infinite curiosity. In addition to his art, his notebooks display a fascination for aeronautics, engineering, mathematics and the natural world.

MOVEMENT

Renaissance

OTHER WORKS

Mona Lisa; Virgin of the Rocks; The Last Supper

INFLUENCES

Verrocchio

Leonardo da Vinci *Born* 1452 Italy

Painted in Italy and France

Died 1519

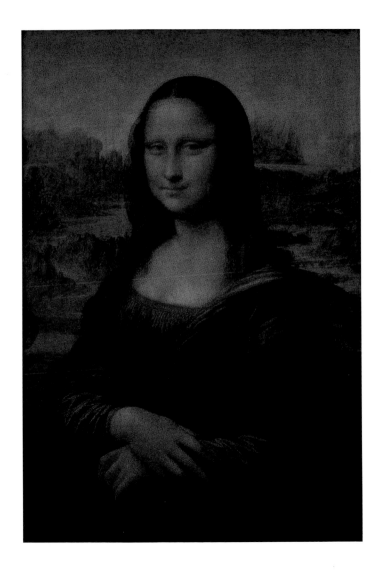

Yin, Tang

The Immortal Ge Changgeng Sitting on his Three-legged Toad, 1506–10

Courtesy of Private Collection/Bridgeman Art Library

An exact contemporary of Wen Zhengming, Tang Yin came from a prosperous middle-class family and had a brilliant academic education. Under the patronage of Wen Lin (Wen Zhengming's father) he seemed destined for the highest ranks in the civil service but he was caught trying to bribe the examiner, imprisoned and later returned to Suzhou in disgrace. His hopes of becoming a mandarin now dashed, Tang Yin took up painting and excelled to such an extent that he came to be regarded as one of the Four Great Masters of the Wu School. Studying under Zhou Chen, he achieved mastery of a very wide range of styles and subjects. Apart from handscrolls and wall hangings, Tang Yin was adept at the difficult art of painting on bamboo. He painted landscapes, scenes from Chinese mythology and portraits of beautiful women with equal skill. Most of his work was executed on paper using pen and ink with restrained use of colour, but combined with poetry and calligraphy in the finest tradition of the scholar-painters.

MOVEMENT

Wu School of China

OTHER WORKS

Moon Goddess Chang-e

INFLUENCES

Zhou Chen, Wen Zhengming

Tang Yin *Born* 1470 Suzhou, China

Painted in Suzhou

Died 1524 Suzhou

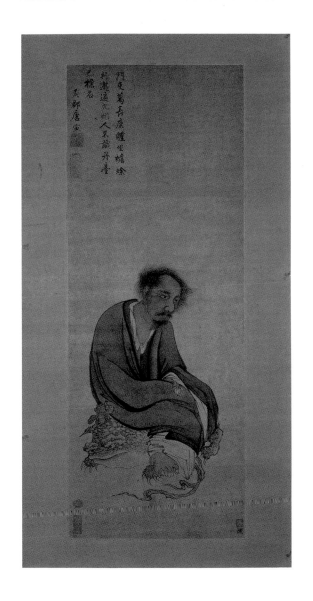

Michelangelo

Creation of Adam, Sistine Chapel detail, 1510

Courtesy of Vatican Museums and Galleries, Rome, Bridgeman Art Library/Christie's Images

Italian painter, sculptor and poet, one of the greatest artists of the Renaissance and a forerunner of Mannerism. Michelangelo was raised in Florence, where he trained briefly under Ghirlandaio. Soon his obvious talent brought him to the notice of important patrons. By 1490, he was producing sculpture for Lorenzo di Medici and, a few years later, he began his long association with the papacy.

Michelangelo's fame proved a double-edged sword. He was often inveigled into accepting huge commissions, which either lasted years or went unfinished. The most notorious of these projects was the Tomb of Julius II, which occupied the artist for over 40 years. Michelangelo always considered himself primarily a sculptor and he was extremely reluctant to take on the decoration of the Sistine Chapel. Fortunately he was persuaded, and the resulting frescoes are among the greatest creations in Western art. The ceiling alone took four years (1508–12), while the Last Judgment (1536–41) was added later on the altar wall. In these, Michelangelo displayed the sculptural forms and the terribilità ('awesome power'), which made him the most revered artist of his time.

MOVEMENTS

Renaissance, Mannerism

OTHER WORKS

David; Pietà

INFLUENCES

Ghirlandaio, Giotto, Masaccio

Michelangelo *Born* 1475 Italy

Painted in Italy

Died 1564 Italy

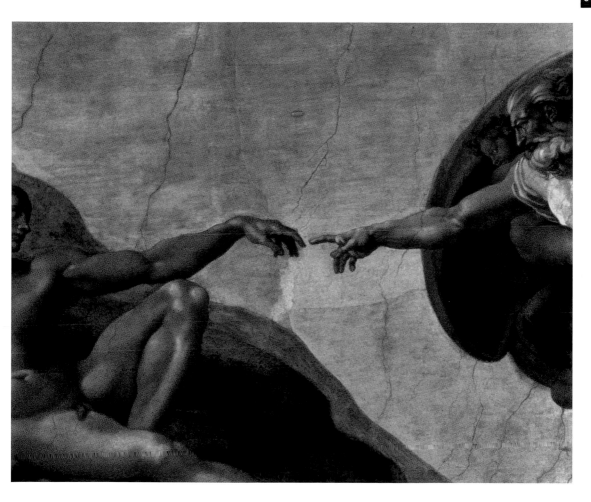

Raphael (Raffaello Sanzio)
School of Athens, 1510–11

Courtesy of Vatican Museums and Galleries, Vatican City, Italy/Bridgeman Art Library

The archetypal artist of the High Renaissance, Raphael received his education in Perugino. In 1504 he moved to Florence, where he received many commissions for portraits and pictures of the Virgin and Child. Soon, his reputation reached the ears of Pope Julius II, who summoned him to Rome in 1508. Deeply influenced by Michelangelo he added a new sense of grandeur to his compositions and greater solidity to his figures. Michelangelo grew jealous of his young rival, accusing him of stealing his ideas, but Raphael's charming manner won him powerful friends and numerous commissions.

The most prestigious of these was the decoration of the Stanze, the papal apartments in the Vatican. This was a huge task, which occupied the artist for the remainder of his life. *The School of Athens* is the most famous of these frescoes. Other commissions included a majestic series of cartoons for a set of tapestries destined for the Sistine Chapel and a cycle of frescoes for the banker, Agostino Chigi. In the midst of this frantic activity, however, Raphael caught a fever and died, at the tragically young age of 37.

MOVEMENT

Renaissance

OTHER WORKS

Galatea; The Sistine Madonna

INFLUENCES

Pietro Perugino, Leonardo da Vinci, Michelangelo

Raphael *Born* 1483 Urbino, Italy

Painted in Italy

Died 1520

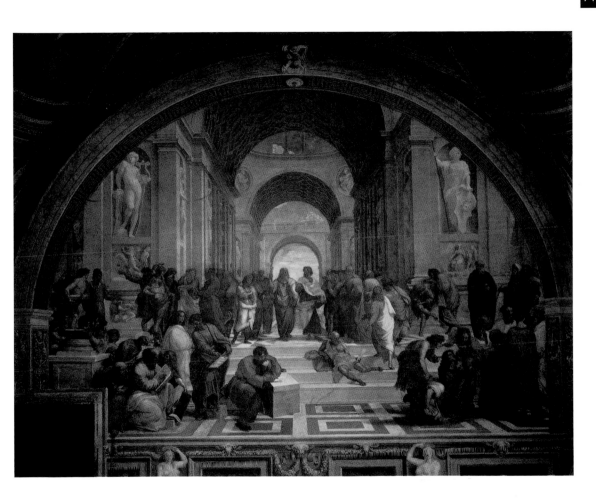

Dürer, Albrecht

Melancholia, 1514

Courtesy of Private Collection/Christie's Images

Albrecht Dürer was the son of a goldsmith who taught him the art of drawing in silver-point. In 1484 he was apprenticed to the leading Nuremberg painter and book illustrator of his time, Michael Wolgemut (1434–1519), from whom he learned the techniques of woodcut engraving. He then travelled extensively in Italy, where the works of Leonardo, Bellini and Mantegna had a profound influence on his later career, both as a practicing artist and as an art theorist who wrote extensively on the subject. Dürer was thus responsible for introducing many of the ideas of the Italian Renaissance to northern Europe. Although now remembered chiefly for his engravings (including the *Triumphal Car*, at nine square metres the world's largest woodcut), he was an accomplished painter whose mastery of detail and acute observation have seldom been surpassed.

MOVEMENT

German School

OTHER WORKS

Wing of a Hooded Crow

INFLUENCES

Leonardo da Vinci, Bellini, Mantegna

Albrecht Dürer *Born* 1471 Nuremberg, Germany

Painted in Nuremberg

Died 1528 Nuremberg

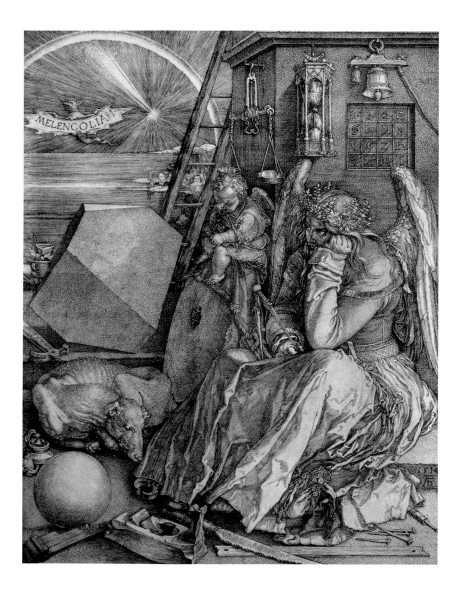

Andrea del Sarto

The Virgin and Child with a Saint and an Angel, *c.*1513

Courtesy of Prado, Madrid, Spain/Bridgeman Art Library

The son of a tailor (*sarto*), hence his nickname, Andrea was originally apprenticed to a goldsmith but his early aptitude for drawing led to him being sent to Piero di Cosimo for training in draughtsmanship and colouring. The measure of how well he learned his lessons is evident, not only in his surviving works but also in the epithet applied to him in his lifetime as 'Andrea the Unerring'. Between 1509 and 1514 he was employed by the Brotherhood of the Servites to paint a series of frescoes illustrating the life of the Servite saint Filippo Benizzi, and this established his reputation for his extraordinary mastery of colour and tone. Widely regarded as the finest fresco painter of his generation, Sarto was later commissioned by François I of France and spent some time in Paris before returning to Florence, where most of his later religious paintings were executed. As well as large wall paintings he excelled in smaller, more intimate portraits and he would undoubtedly have gone on to greater things had he not been struck down by the plague at a relatively young age.

MOVEMENT

Florentine School

OTHER WORKS

Baptism of Christ; Dance of the Daughter of Herodias

INFLUENCES

Leonardo, Michelangelo, Franciabigio

Andrea del Sarto *Born* 1486 Florence, Italy

Painted in Florence and Paris

Died 1530 Florence

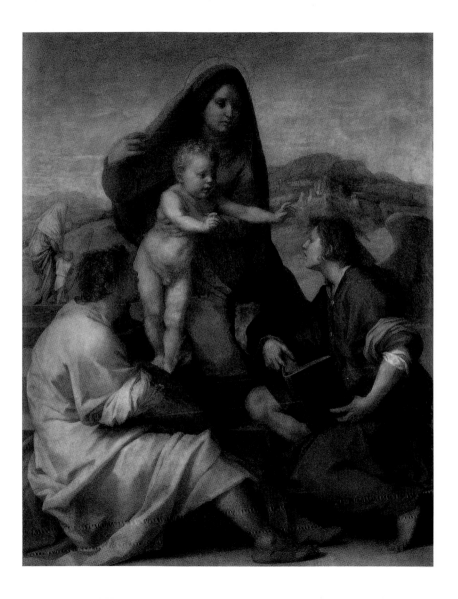

Qiu Ying

Zhao Mengfu Writing the Heart Sutra in Exchange for Tea

Courtesy of Private Collection/Bridgeman Art Library

Regarded as one of the Four Great Masters of the Ming Dynasty (along with Shen Zhou, Wen Zhengming and Tang Yin), Qiu Ying was by far the most versatile of the four. In contrast to his great contemporaries, he was born of humble peasant parents, but his aptitude enabled him to study painting in the Wu School at Suzhou. Unlike the scholar-painters, he relied solely on commissions from wealthy patrons and for that reason he was always more alive to the slightest change in fashion or taste. He painted flowers, gardens, figures, religious subjects and landscapes that revelled in colour and form, very much in line with the sensuousness then prevailing in Ming society. A prolific artist, he frequently copied works of earlier masters or incorporated elements of their work into his own. His technique likewise varied considerably and his palette ranged from the deep, bright colours which give his sensuous and erotic paintings a jewel-like quality, to the paler, more muted shades found in many of his scroll paintings of landscapes, imparting a poetic or contemplative character.

MOVEMENT

Chinese Landscape School

OTHER WORKS

Golden Valley Garden; Landscape after Li Tang

INFLUENCES

Shen Zhou, Zhou Chen

Qiu Ying *Born c.* 1494, Taicang, Jiangsu, China

Painted in Suzhou, China

Died c. 1552, Suzhou

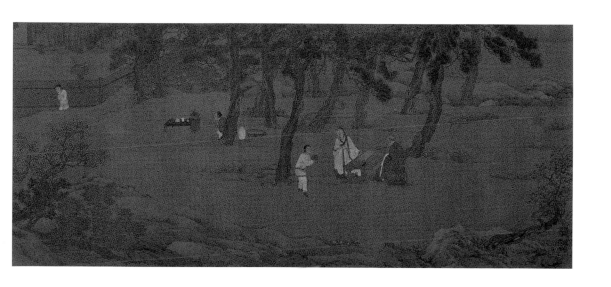

Wen Zhengming (and Qui Ying)

The Student Chang bidding farewell to his lover Ying Ying at the Rest Pavilion

Courtesy of Private Collection/Bridgeman Art Library

Although he pursued his career as a mandarin (senior civil servant), Wen Zhengming retired early to devote the rest of his life to art, which had hitherto merely been a leisure pursuit. He was fortunate to study under Shen Zhou, the great master of the Wu School, and eventually emerged as one of the greatest scholar-painters of the Ming Dynasty. His early work was eclectic, drawing on many different periods, sources and styles for inspiration and, in effect, creating an extraordinary — if subconscious — commentary on the art of his predecessors. His artistic career, however, reflects the transition from the relatively small range of muted colours to a much more colourful style of realism in landscape painting, ultimately employing colour to convey a sense of perspective, a radical departure from traditional techniques in composition. This was a major breakthrough, opening up new aspects of pictorial representation which would be more fully developed by later generations of Chinese painters.

MOVEMENT

Chinese Landscape School

OTHER WORKS

Lofty Leisure Below a Sheer Cliff

INFLUENCES

Shen Zhou, Ni Zan

Wen Zhengming 1470–1559

(**Qui Ying** 1494–1552)

Painted in China

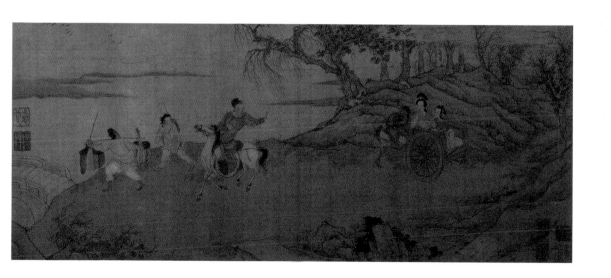

Parmigiano

Self Portrait at the Mirror, c. 1524

Courtesy of Kunsthistorisches Museum, Vienna, Austria/Ali Meyer/Bridgeman Art Library

Girolamo Francesco Maria Mazzola was generally known as Parmigianino ('the little Parmesan') or Parmigiano from his birthplace of Parma. His father and two uncles were painters and from them he learned his craft. Later he followed the style of Correggio, who settled in Parma, and they worked together on a number of frescoes for churches in Parma. Around 1523 he went to Rome, where he worked on the ceiling of the Sala dei Pontifici and painted his earliest individual work, *Vision of St Jerome*. Following the sack of Rome in 1527 he fled to Bologna, where he painted the great Madonna altarpiece for the convent of St Margaret. He returned to Parma in 1531 and was commissioned to paint a series of church frescoes, but defaulting on the job resulted in his imprisonment. On his release he decamped to Cremona, where he died in 1540. His few surviving paintings are distinguished by their grace and serenity.

MOVEMENT

Lombard School

OTHER WORKS

Madonna with St Zacharias; Madonna with the Long Neck

INFLUENCES

Correggio, El Greco

Parmigiano *Born* 1503 Parma, Italy

Painted in Parma, Rome and Bologona

Died 1540 Cremona, Italy

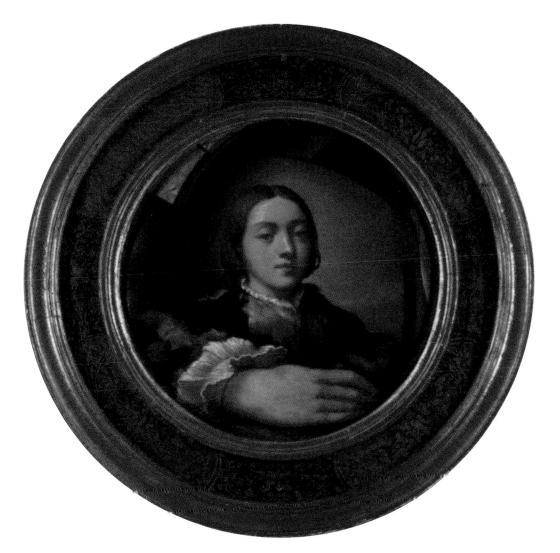

Cranach, Lucas

Venus with Cupid the Honey Thief, 1530

Courtesy of Private Collection/Christie's Images

Born at Kronach in Germany, whence he derived his surname, Cranach learned draughtsmanship from his father. In 1504 his paintings came to the attention of the Elector of Saxony, who appointed him court painter at Wittenberg. Thereafter he designed altarpieces, etched copper, produced woodcuts and engraved the coinage and medal dies for the Saxon mint. In 1509 he visited the Netherlands and painted the portraits of the Emperor Maximilian and his son, the future Charles V. Although Cranach produced many religious paintings, it should be noted that he sided with the reformers and painted the earliest authentic likeness of Martin Luther, while also executing numerous paintings of an allegorical or mythological character. Nevertheless, it is as a painter of very life-like portraits that he is chiefly remembered, especially as a chronicler in oils of the leading personalities of the German Reformation. All three of his sons, including Lucas Cranach the Younger, were painters.

MOVEMENT

German School

OTHER WORKS

Jealousy; The Crucifixion

INFLUENCES

Albrecht Dürer

Lucas Cranach *Born* 1472 Kronach, Germany

Painted in Saxony

Died 1553 Weimar, Germany

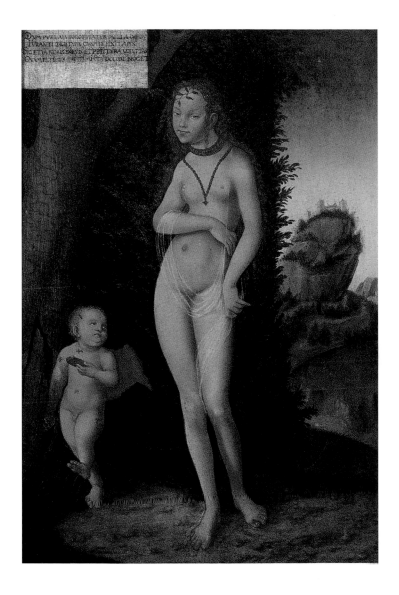

Correggio
Noli Me Tangere, *c.* 1534

Courtesy of Prado, Madrid, Spain/Bridgeman Art Library

Antonio Allegri, known to posterity by his nickname of Correggio, was born in the town of that name in the duchy of Modena. Originally he began training as a physician and surgeon, and studied anatomy under Giovanni Battista Lombardi – believed to be the doctor portrayed in the painting entitled *Correggio's Physician*. In 1518 he embarked on his epic series of frescoes for the Convent of San Paolo in Parma and followed this with the decoration of Parma Cathedral. He was the first Italian artist to paint the interior of a cupola, producing *The Ascension* for the church of San Giovanni in Parma. He also executed numerous religious and biblical paintings, but also occasionally drew on classical mythology for inspiration. His wife Girolama (b 1504) is believed to have been his model for the *Madonna Reposing*, sometimes known as *Zingarella* ('Gipsy Girl').

MOVEMENT

Parma School

OTHER WORKS

Mystic Marriage of Saint Catherine; Ecce Homo

INFLUENCES

Leonardo da Vinci, Andrea Mantegna, Lorenzo Costa

Correggio *Born* 1494 Correggio, Italy

Painted in Correggio and Parma

Died 1534 Correggio

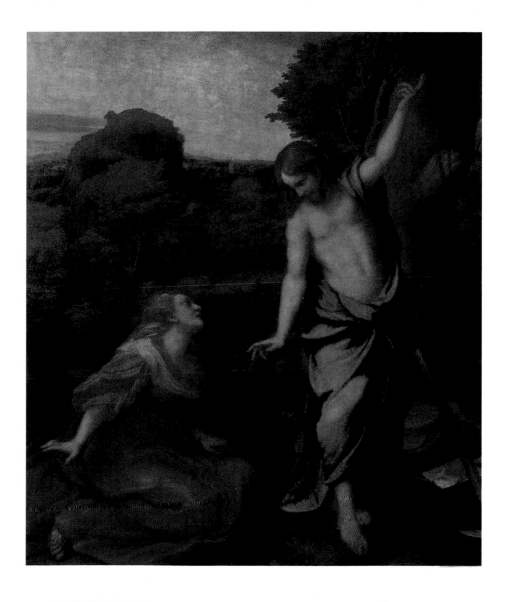

Bronzino, Il

Madonna and Child with Infant Saint John the Baptist

Courtesy of Private Collection/Christie's Images

Born Agnolo di Cosimo di Mariano, he became the leading court painter of the Florentine School in the mid-sixteenth century. He studied under Raffaellino del Garbo and Jacopo da Pontormo (working with the latter on religious frescoes) as well as being strongly influenced by Michelangelo. He spent his entire working life in Florence where he was court painter to Cosmo I, Duke of Tuscany. Second only to Andrea del Sarto among the Florentine portraitists, he also excelled as a painter of religious works. His talents extended to the written word, for he was also a notable poet and a member of the Florentine Academy. From Pontormo he developed a passion for light, resulting in the rich, brilliant colours that dominate his paintings. These are also striking on account of their fascination for the female nude, without precedent or parallel up to that time.

MOVEMENT

Mannerism

OTHER WORKS

Guidobaldo della Rovere; Eleanora Toledo and her Son

INFLUENCES

Raffaeline del Garbo, Jacope da Pontormo, Michelangelo

Il Bronzino *Born* 1503 Monticelli, Florence, Italy

Painted in Florence

Died 1572 Florence

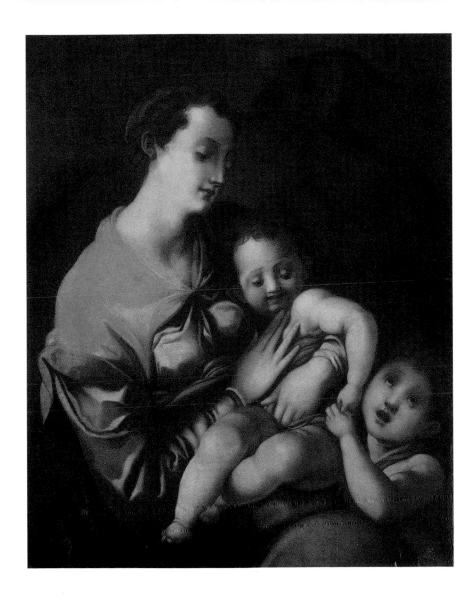

Holbein, Hans
(after) Henry VIII, *c. 1540s*

Courtesy of Private Collection/Christie's Images

Born at Augsburg, Germany, the son of Hans Holbein the Elder, he studied under his father and then went to Basle with his brother Ambrosius as apprentice to Hans Herbst. Subsequently he worked also in Zurich and Lucerne. He returned to Basle in 1519, married and settled there. To his Swiss period belong his mostly religious works. In 1524 he went to France and thence to England in 1526, where he finally took up residence six years later. There being no demand for religious paintings in England at that time, he concentrated on portraiture, producing outstanding portraits of Sir Thomas More and Henry VIII, whose service he entered officially in 1537. From then until his death he produced numerous sensitive and lively studies of the King and his wives, his courtiers and high officials of state. He also designed stained-glass windows and executed woodcuts.

MOVEMENT

German School

OTHER WORKS

Dead Christ; The Triumphs of Wealth and Poverty,

INFLUENCES

Hans Holbein the Elder, Hans Herbst

Hans Holbein *Born* 1497 Augsburg, Germany

Painted in Germany, Switzerland, France and England

Died 1543 London, England

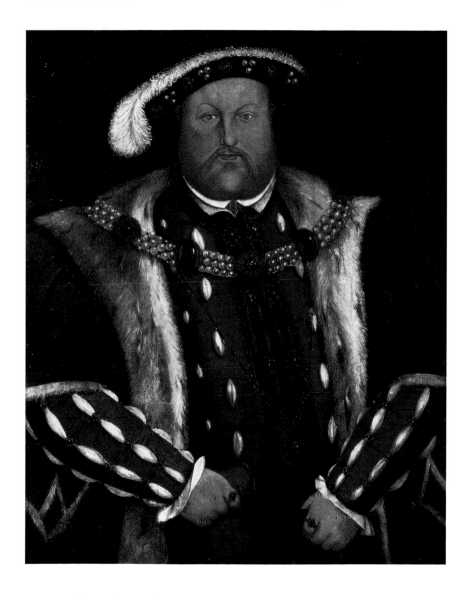

Titian (Tiziano Vecellio)
Venus and Adonis, 1555–60

Courtesy of Private Collection/Christie's Images

The greatest and most versatile artist of the Venetian Renaissance, Titian excelled equally at portraiture, religious pictures and mythological scenes. Born in the Dolomite region, he arrived in Venice as a boy and was apprenticed to a mosaicist. Turning to painting, he entered the studio of Giovanni Bellini, before joining forces with Giorgione. After Giorgione's premature death in 1510, Titian's star rose quickly. In 1511, he gained a major commission for frescoes in Padua, and in 1516 was appointed as the official painter of the Venetian Republic.

This honour enhanced Titian's international reputation and soon, offers of work began to flow in from the princely rulers of Ferrara, Urbino and Mantua. The painter did not always accept these commissions, as he was notoriously reluctant to travel, but some patrons could not be refused. The most distinguished of these was the Emperor Charles V. After their initial meeting in 1529, Titian was appointed Court Painter in 1533 and given the rank of Count Palatine. In 1548, he worked at the Imperial Court at Augsburg and his services were also prized by Charles's successor, Philip II.

MOVEMENT

Renaissance

OTHER WORKS

Bacchus and Ariadne; Man with a Glove; Sacred and Profane Love

INFLUENCES

Bellini, Giorgione

Titian *Born c.* 1485

Painted in Italy and Germany

Died 1576

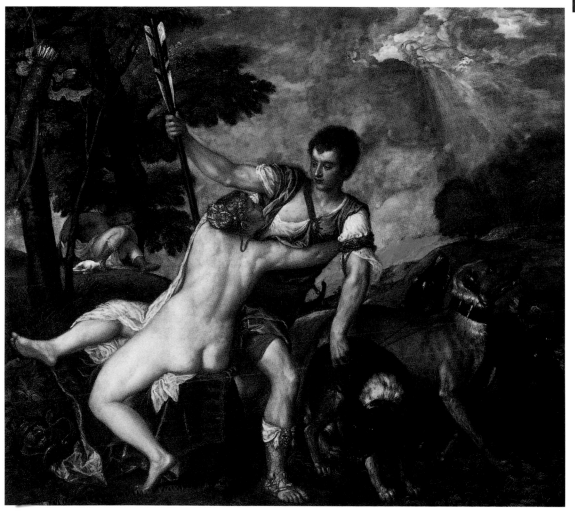

Tintoretto
The Concert of Muses

Born Jacopo Robusti, he derived his nickname, meaning 'little dyer', from his father's trade. He was very briefly a pupil of Titian (who is said to have been jealous of the boy's talents) and though largely self-taught, was influenced by his master as well as Michelangelo and Sansovino. Apart from two trips to Mantua he spent his entire working life in Venice, painting religious subjects and contemporary portraits. His most ambitious project was the series of 50 paintings for the Church and School of San Rocco, but his fame rests on the spectacular *Paradise* (1588), a huge work crammed with figures. He was a master of dark tones illumined by adroit gleams of light. Three of his children became artists, including his daughter Marietta, known as La Tintoretta. His output was phenomenal and he painted with great rapidity and sureness of brushstrokes, earning him a second nickname of 'Il Furioso'.

MOVEMENT

Venetian School

OTHER WORKS

The Annunciation; The Last Supper; The Nine Muses

INFLUENCES

Michelangelo, Titian, Sansovino

Tintoretto *Born* 1518 Venice, Italy

Painted in Venice and Mantua

Died 1594 Venice

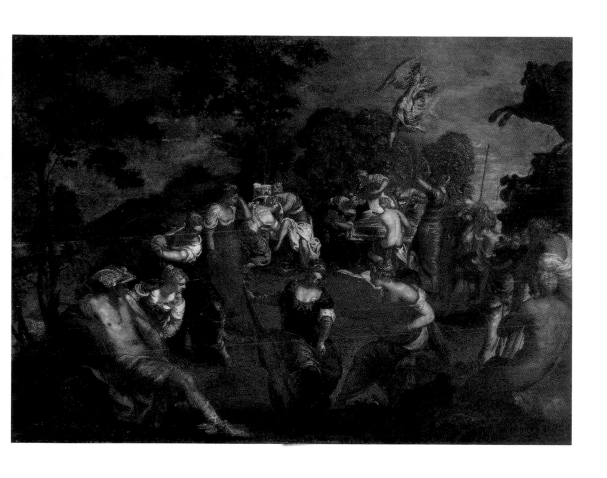

Veronese, Paolo

Christ and the Widow of Nain/Woman Taken in Adultery

Courtesy of Christie's Images

Paolo Caliari or Cagliari is invariably known by his birthplace. He was the son of a stone-cutter and originally trained as a stone-carver, but he showed more of an aptitude for painting and therefore switched to the profession of his uncle, Antonio Badile. According to Vasari he studied under Giovanni Caroto – though this left no mark on his style. He worked in Verona and Mantua before settling in Venice in 1555, where he ranked with Titian and Tintoretto in his range and technical virtuosity, reinforced by a visit to Rome in 1560. He was a skilful master of genre subjects, which he used to imbue his religious works with humanity, but as a result of his painting *The Feast in the House of Levi* (1573), he fell foul of the Inquisition on a charge of trivializing religious subjects. His undoubted masterpiece is the colossal *Marriage at Cana*, which has over 120 portraits, including royalty and celebrities of the period.

MOVEMENT

Venetian School

OTHER WORKS

The Adoration of the Magi; The Holy Family and St John

INFLUENCES

Domenico Brussasorci, Paolo Farinato

Paolo Veronese *Born* 1528 Verona, Italy

Painted in Verona, Mantua and Venice

Died 1588 Venice

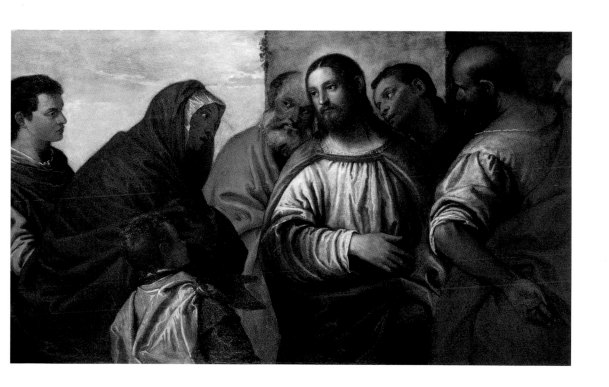

Brueghel, Pieter
Hunters in the Snow, 1565

Courtesy of Kunsthistoriches Museum, Vienna/Bridgeman Art Library/Christie's Images

Also known as Brueghel the Elder to distinguish him from his son Pieter and younger son Jan, Pieter Brueghel was probably born about 1520 in the village of the same name near Breda. He studied under Pieter Coecke van Aelst (1502–50) and was greatly influenced by Hieronymous Bosch, from whom he developed his own peculiar style of late-medieval Gothic fantasy. About 1550 he travelled in France and Italy before returning to Brussels, where his most important paintings were executed. He was nicknamed 'Peasant Brueghel' from his custom of disguising himself in order to mingle with the peasants and beggars who formed the subjects of his rural paintings. Although he was a master of genre subjects his reputation rests mainly on his large and complex works, involving fantastic scenery and elaborate architecture, imbued with atmosphere and a sensitivity seldom achieved earlier.

MOVEMENT

Flemish School

OTHER WORKS

Tower of Babel; Peasant Wedding

INFLUENCES

Pieter Coecke, Hieronymus Bosch

Pieter Brueghel *Born c.* 1520 Brögel, Holland

Painted in Breda and Brussels, Belgium

Died 1569 Brussels

Arcimboldo, Giuseppe
Winter, 1573

Courtesy of Kunsthistoriches Museum, Vienna/Bridgeman Art Library

Giuseppe Arcimboldo began his artistic career by working on the stained-glass windows in the Duomo (Cathedral) in Milan. Later he moved to Prague which, under Charles V, became for a time the centre of the Holy Roman Empire. Here he was employed by the Habsburg rulers as an architect (of the civic waterworks among other public projects), impresario of state occasions, curator of the imperial art collection and interior designer. It was in Prague that he painted the works on which his reputation now rests. In his exploration of human portraits composed of non-human and inanimate objects he was far ahead of his time, anticipating the Surrealists by several centuries. His fantastic heads symbolizing the four seasons were made up of pieces of landscape, flowers, vegetables and animals, even pots and pans and other mundane articles from everyday life, all executed in brilliant colours with an extraordinary attention to detail.

MOVEMENT

Surrealism

OTHER WORKS

Summer

INFLUENCES

Medieval stained glass

Giuseppe Arcimboldo *Born* 1527 Milan, Italy

Painted in Milan and Prague

Died 1593 Milan

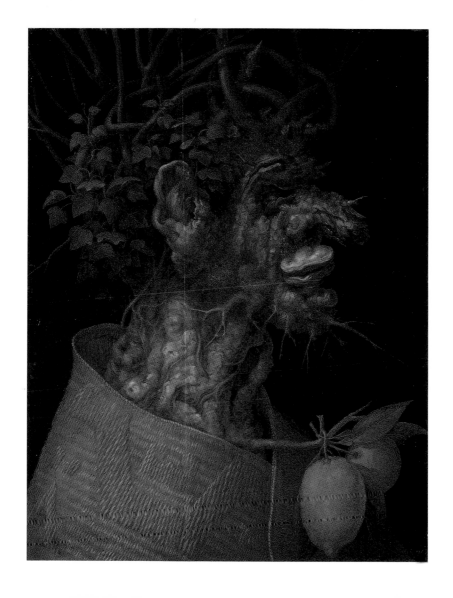

Caravaggio, Michelangelo Merisi da
The Young Bacchus, *c.* 1591–93

Courtesy of Galleria Degli Uffizi, Florence/Bridgeman Art Library/Christie's Images

Born Michelangelo Merisi in the village of Caravaggio, Italy, he studied in Milan and Venice before going to Rome to work under the patronage of Cardinal del Monte on altarpieces and religious paintings. His patron was startled not only by Caravaggio's scandalous behaviour but also by his rejection of the Roman ideals and techniques in painting. Instead, Caravaggio headed the *Naturalisti* (imitators of nature in the raw), developing a mastery of light and shade and concentrating on realism, regardless of theological correctness. As a result, some of his major commissions were rejected and in 1606, after he had killed a man in an argument, he fled from Rome to Naples and thence to Malta. On his return to Italy in 1609 he contracted a fever and died at Porto Ercole, Sicily. The years of exile produced one of his greatest portraits, the full-length *Grand Master of the Knights*.

MOVEMENT

Baroque

OTHER WORKS

Christ at Emmaus; The Card Players

INFLUENCES

Annibale Carracci

Caravaggio *Born c.* 1572 Caravaggio, Italy

Painted in Venice, Rome and Malta

Died 1610 Porto Ercole, Sicily

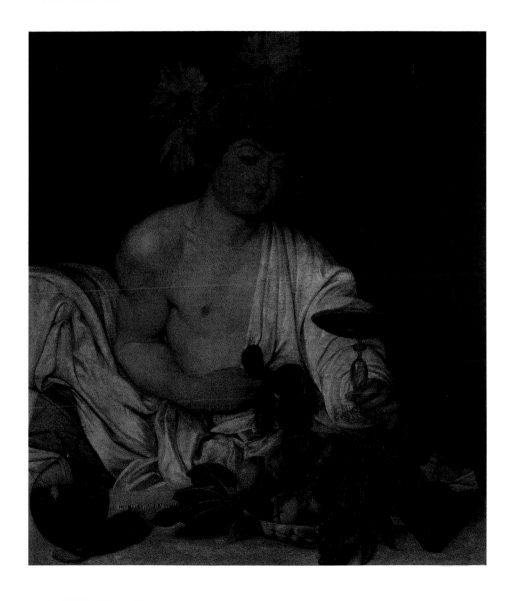

El Greco

Christ on the Cross, *c.* 1600–10

Courtesy of Private Collection/Christie's Images

This nickname, meaning 'the Greek' in Spanish, is the epithet by which Domenikos Theotokopoulos is better known. Born at Candia, Crete, which was then ruled by the Venetians, he worked as a painter of icons in the Byzantine tradition before moving to Italy, where he is believed to have become a pupil of Titian. He then settled at Toledo in Spain. His early portraits show the Venetian influence of his early training, but in Spain he evolved his own highly distinctive, mannered approach to portraiture, characterized by the elongation and distortion of the face and figure, combined with his penchant for sombre colours. These aspects are seen at their most dramatic and solemn in his large religious paintings, but they are also present to a lesser extent in his portraits of his contemporaries. Inevitably, his treatment of his sitters' portraits was considered controversial at the time. Many of his extant works are preserved in the Museo El Greco in Toledo where he spent the last 44 years of his life.

MOVEMENT

Spanish School

OTHER WORKS

Disrobing of Christ; Burial of Count Orgaz

INFLUENCES

Titian, Tintoretto

El Greco *Born* 1541 Candia, Crete

Painted in Toledo, Spain

Died 1614 Toledo

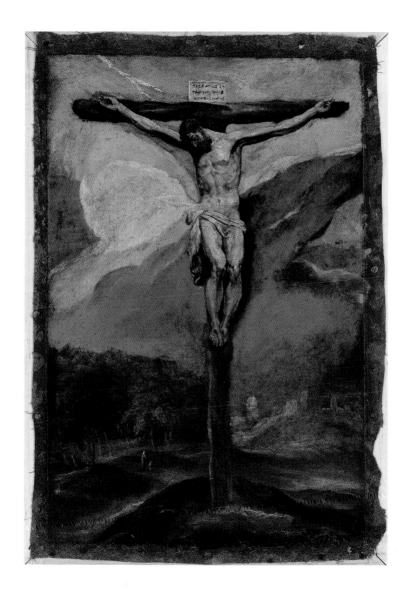

17th Century

The Baroque & Rococo Era

Carracci, Annibale
The Veil of Saint Veronica

Courtesy of Private Collection/Christie's Images

The greatest of a talented family which included his brother Agostino and his cousin Ludovico, Annibale Carracci was self-taught to some extent, although he was influenced by Correggio and Raphael. The three Carraccis founded an academy of painting in Bologna in 1585 and exerted a tremendous influence on Baroque artists of the next generation. In 1595 Annibale went to Rome, where he was employed by Cardinal Farnese in the decoration of his palace with a series of great frescoes whose motifs were mainly derived from classical mythology – an achievement which is surpassed only by Michelangelo's work in the Sistine Chapel. Carracci also produced numerous paintings of religious subjects, often placing the Madonna and saints in somewhat idealized classical landscapes. He thus combined the traditions of classicism with the advances in naturalism in the late sixteenth century.

MOVEMENT

Neoclassical

OTHER WORKS

The Assumption of the Virgin; The Virgin Mourning Christ

INFLUENCES

Correggio, Raphael, Titian

Annibale Carracci *Born* 1560 Bologna, Italy

Painted in Bologna and Rome

Died 1609 Rome

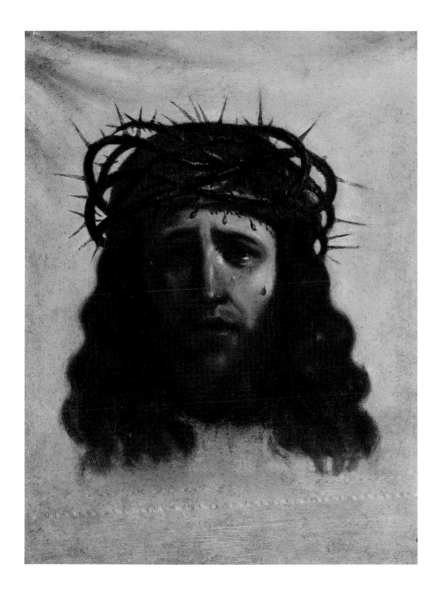

Reni, Guido

Saint John the Baptist

Courtesy of Private Collection/Christie's Images

Guido Reni studied at the Carracci Academy in his native city of Bologna and acquired a mastery of drawing from life. In 1600 he went to Rome, where he studied the works of Raphael, but he was also strongly influenced by the paintings of other masters working on classical and mythological themes. Reni later painted frescoes, of which his *Aurora and the Hours* (1613–14) for the Borghese family is regarded as his masterpiece. After Carracci's death Reni became the most fashionable painter in Bologna and operated a large studio with numerous assistants. The pious sentimentality of his great religious canvasses had an enormous impact on later generations, although he went on to eclipse in the nineteenth century and has been restored to favour in more recent times, his technical mastery of lighting and composition being appreciated once more.

MOVEMENT

Bolognese School

OTHER WORKS

Massacre of the Innocents; Saint Jerome and the Angel; The Nativity

INFLUENCES

Raphael, Annibale Carracci

Guido Reni *Born* 1575 Bologna, Italy

Painted in Bologna

Died 1642 Bologna

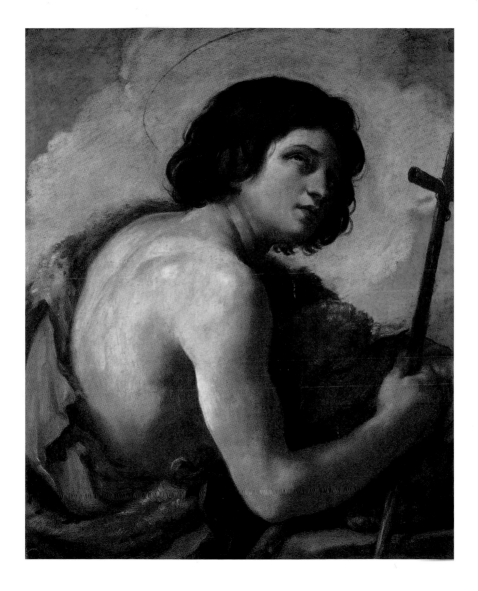

Rubens, Peter Paul
(attributed to) Two Saints

Courtesy of Private Collection/Christie's Images

Born at Siegen, Westphalia, now part of Germany, Peter Paul Rubens was brought up in Antwerp in the Spanish Netherlands. Originally intended for the law, he studied painting under Tobias Verhaecht, Adam Van Noort and Otto Vaenius and was admitted into the Antwerp painters' guild in 1598. From 1600 to 1608 he was court painter to Vincenzo Gonzaga, Duke of Mantua, and travelled all over Italy and Spain, furthering his studies and also executing paintings for various churches. Shortly after his return to Antwerp he was appointed court painter to Archduke Albrecht of the Netherlands. In the last years of his life he combined painting with diplomatic missions which took him to France, Spain and England and resulted in many fine portraits, as well as his larger religious pieces. He was knighted by both Charles I and Philip IV of Spain. In 1630 he retired from the court to Steen and devoted the last years of his life to landscape painting.

MOVEMENT

Flemish School

OTHER WORKS

Samson and Delilah; The Descent from the Cross; Peace and War

INFLUENCES

Tobias Verhaecht, Adam Van Noort

Peter Paul Rubens *Born* 1577 Siegen, Germany

Painted in Antwerp, Rome, Madrid, Paris and London

Died 1640 Antwerp, Belgium

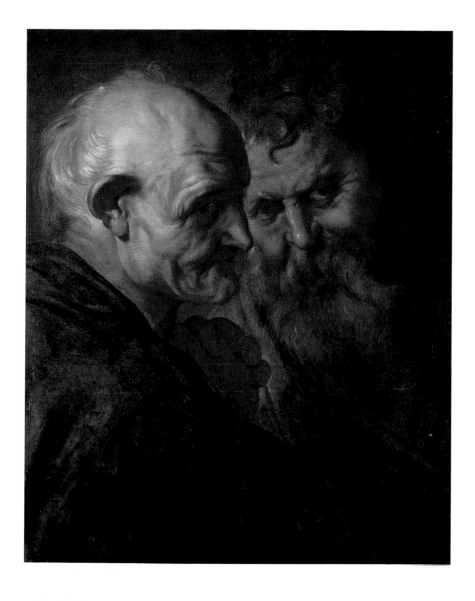

Hasan, Abul

Squirrels on a Plane Tree, c. 1610

Very little is known about the life of Abul Hasan, other than that he was one of the leading Muslim painters at the court of the Mughal emperors and was particularly esteemed by the Emperor Jahangir (1605–27), who conferred on him the special title of Nadir-uz-zaman. He appears to have been born about 1570 and came to prominence in the last years of the Emperor Akbar, but continued to paint in the reign of Shah Jahan (1627–58). He painted portraits of the emperors, courtiers and officials, as well as genre subjects and charming little studies of birds and animals. His technique matured from 1610 onwards and he was undoubtedly responsible for raising the standards of Indo-Persian painting to new levels. The old aggressive colouring was toned down and a general refinement of style and execution was cultivated. In the portraits of men and animals a little shading was introduced by a few delicate strokes, just enough to suggest solidity and roundness, in marked contrast to the flat, two-dimensional profile painting of the previous generation.

MOVEMENT

Indo-Persian School

OTHER WORKS

Elephant in a Palace Courtyard

INFLUENCES

Daswanth, Basawan

Abul Hasan *Born c. 1570 India*

Painted in India

Died c. 1640 Delhi, India

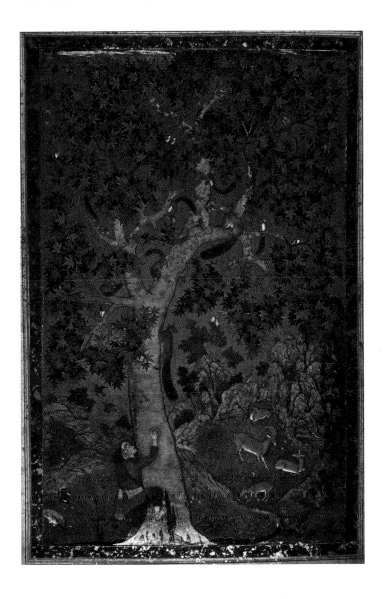

Sotatsu, Tawaraya

Herons and Grasses

Tawaraya Sotatsu operated a print shop in Kyoto that specialized in painted fans, but in 1621 he was commissioned to paint a set of sliding screens depicting pine trees and this appears to have been a major turning point in his career. Later he was closely associated with Ogata Korin in the Rinpa School, but as a result his own contribution to the development of Japanese art in the early seventeenth century was largely overlooked until relatively recently. A pair of two-fold screens depicting the gods of thunder and wind, however, reveals quite a radical departure from the style of the Momoyama painters, much bolder and ascetic, with greater emphasis on asymmetry and overall simplicity, coupled with greater use of colour. Rejecting the styles imported from China, he went back to earlier Japanese traditions both in subject matter and treatment. He also collaborated with Honami Koetsu in founding Takagamine, an artists' colony which reinvigorated Japanese art.

MOVEMENT

Rinpa School, Japan

OTHER WORKS

Deer Scroll; Zen Priest Choka; The Tale of Genji

INFLUENCES

Ogata Korin, Honami Koetsu

Tawaraya Sotatsu *Born* 1576 Kyoto, Japan

Painted in Kyoto

Died 1643 Kyoto

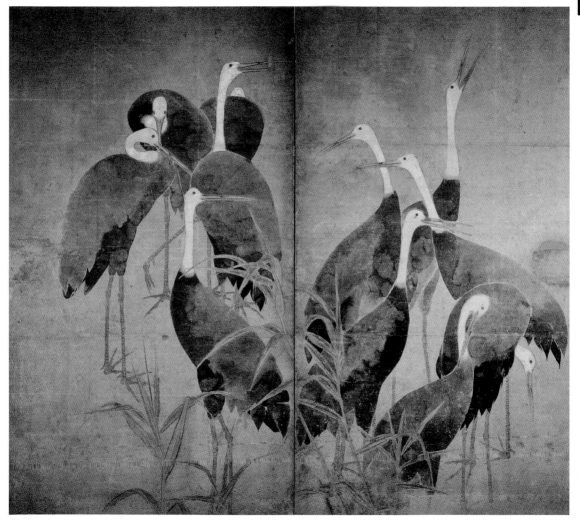

Gentileschi, Artemisia

Judith Slaying Holofernes, c. 1612–21

Courtesy of Galleria Degli Uffizi, Florence, Italy/Bridgeman Art Library

Regarded by many as the finest of all female artists, Artemisia was born in Rome, where she was trained by her father, Orazio. Both artists were heavily influenced by Caravaggio, sharing his fondness for unflinching realism and dramatic lighting effects. During her lifetime, Gentileschi was best known as a portraitist, but she has since become more famous for her powerful religious scenes. In these, she tended to focus on biblical women such as Susanna, Bathsheba and Esther, but her favourite subject was Judith, the Jewish heroine who saved her people by killing an enemy general. Gentileschi produced at least six versions of this story and, although the theme was popular with other female artists of the time, hers are undoubtedly the goriest. This has often been ascribed to a trauma in her own life for, at the age of 19, she claimed that she was raped by an artist from her father's workshop. A five-month trial ensued, during which Gentileschi was tortured with thumbscrews in order to 'verify' her evidence.

During her career, Artemisia worked in Florence, Naples, Venice. and also spent some time in London helping her father complete a commission for Charles I.

MOVEMENTS

Baroque, Caravaggism

OTHER WORKS

Susanna and the Elders; Self-Portrait as the Allegory of Painting

INFLUENCES

Caravaggio, Orazio Gentileschi, the Carracci Academy

Artemisia Gentileschi *Born* 1593 Rome, Italy

Painted in Italy and England

Died c. 1652

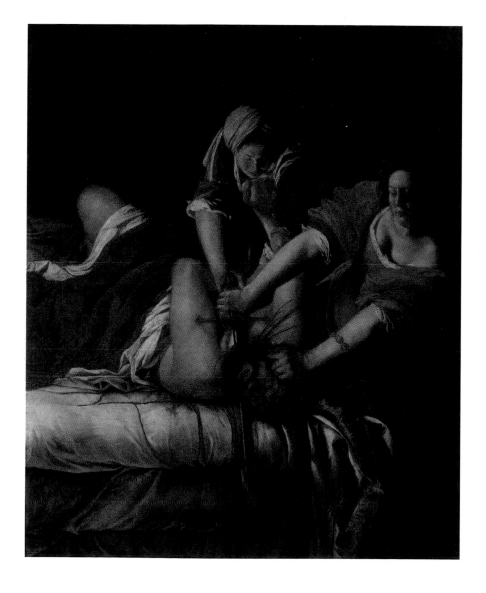

Ribera, Jusepe

Saint Peter in Penitence

Courtesy of Private Collection/Christie's Images

Jusepe Ribera, nicknamed Lo Spagnoletto ('the little Spaniard'), studied under Francisco Ribalta in Valencia and then went to Rome to study the frescoes of Raphael, and to Parma to learn from Correggio's works. He settled at Naples, where his paintings caught the eye of the Spanish viceroy. As a result his career was assured and he became a prolific painter of intensely realistic religious and genre subjects. He delighted in the gory details of the martyrdom of the saints, thus provoking Lord Byron in *Don Juan* to quip that 'Spagnoletto tainted his brush with all the blood of all the sainted'. He was also fascinated with the bizarre or grotesque in contemporary life; but by the 1630s his work assumed a more reflective, tranquil approach. Nevertheless it was the fervent spirituality of his earlier paintings that appealed to his predominantly Spanish clientele.

MOVEMENT

Spanish and Neapolitan Schools

OTHER WORKS

Saint Paul the Hermit; Portrait of a Bearded Woman

INFLUENCES

Raphael, Correggio

Jusepe Ribera *Born* 1591 Jeatiba, Spain

Painted in Naples, Italy

Died 1652 Naples

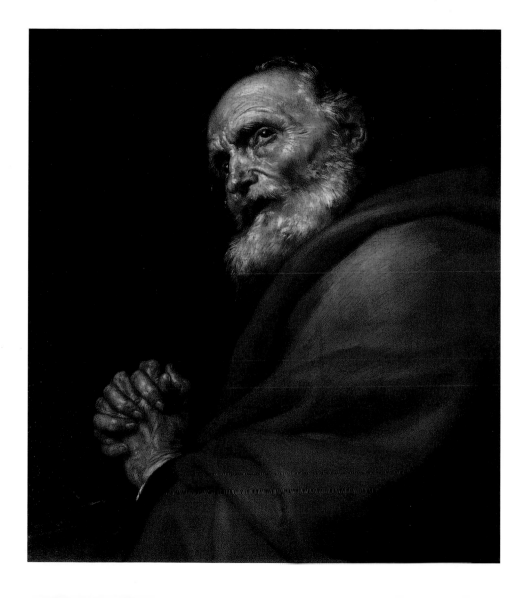

Poussin, Nicolas
The Triumph of David, *c.* 1631–3

Courtesy of Dulwich Picture Gallery, London, UK/Bridgeman Art Library

One of the leading exponents of Baroque painting, Nicolas Poussin settled in Paris in 1612. Ignoring the Mannerist painting then fashionable, he took Raphael as his model and studied the great Classical works of the Italian Renaissance. He left Paris in 1623 and began travelling in Italy, studying the works of the Italian masters at first hand. He settled in Rome the following year. Apart from a brief sojourn in Paris (1640–42) he spent the rest of his life in Rome, executing commissions for Cardinal Barberini. Eschewing the increasingly popular Baroque style, he clung to the Classical style and became its greatest French exponent. He drew upon the rich store of Greek and Roman mythology for his subjects, while utilizing the techniques of colour developed by Titian. His greatest canvasses deal with vast subjects, crowd scenes crammed with action and detail. Later on he tended to concentrate more on landscapes, although still steeped in the Classical tradition.

MOVEMENT

Classicism

OTHER WORKS

The Rape of the Sabines; The Worship of the Golden Calf

INFLUENCES

Raphael, Bernini

Nicolas Poussin *Born* 1594 Les Andelys, France

Painted in Paris and Rome

Died 1665 Rome

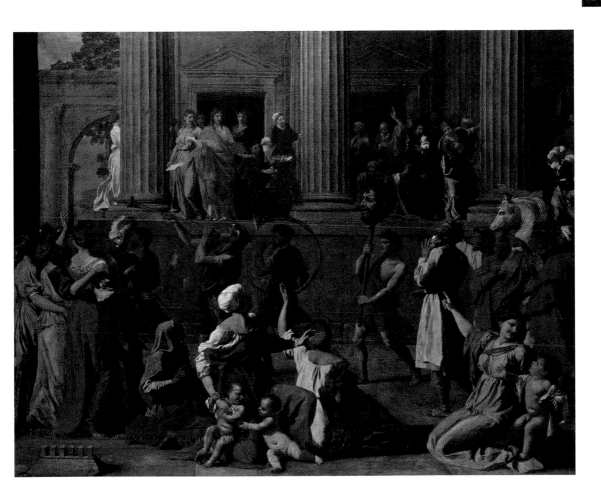

Van Dyck, Sir Anthony

(circle of) Self Portrait with a Sunflower, after 1632

Anthony Van Dyck worked under Rubens and later travelled all over Italy, where he painted portraits and religious subjects. He first visited England in 1620 and was invited back in 1632 by King Charles I, who knighted him and appointed him Painter-in-Ordinary. Apart from a two-year period (1634–35) when he was back in Antwerp, Van Dyck spent the rest of his life in England and on his return to London he embarked on the most prolific phase of his career. He not only painted numerous portraits of King Charles, Queen Henrietta Maria and their children, but also many pictures of courtiers and other notable figures, creating a veritable portrait gallery of the great and good of the period. His immense popularity was due not only to his technical mastery, but also his ability to give his sitters an expressiveness, grace and elegance, which few other artists have ever equalled.

MOVEMENT

Flemish School

OTHER WORKS

Charles I in Hunting Dress; The Three Royal Children

INFLUENCES

Peter Paul Rubens

Sir Anthony Van Dyck *Born* 1599 Belgium

Painted in Antwerp and London

Died 1641 London

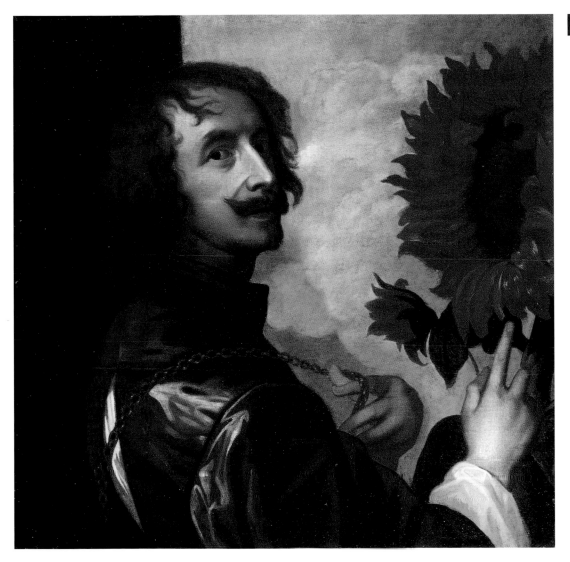

Claesz, Pieter

A Vanitas Still Life, 1645

Courtesy of Johnny van Haeften Gallery, London, UK/Bridgeman Art Library

Born at Haarlem in the Netherlands in 1597 or 1598, Pieter Claesz grew up in a town which was the centre of the Dutch flower trade, so it was not surprising that he developed an early interest in floral painting. He grew up at a time when this style was being introduced to Holland by Flemish refugees, notably Ambrosius Bosschaert the Elder and Balthasar van der Alst. Claesz went on to develop the type of still life known as the breakfast or banquet picture – much less ebullient than the colourful flower paintings with more somber tones suited to the intimate atmosphere of domestic interiors. Claesz in fact took this further than his contemporaries, creating an almost monochrome effect and relying on the precise juxtaposition of each object which then took on a symbolic meaning. He pioneered a style that was emulated by many Dutch artists of the succeeding generation.

MOVEMENT

Dutch School

OTHER WORKS

Still Life with a Candle

INFLUENCES

Ambrosius Bosschaert, Balthasar van der Alst, Caravaggio

Pieter Claesz *Born c.* 1597 Haarlem, Holland

Painted in Haarlem

Died 1660 Haarlem

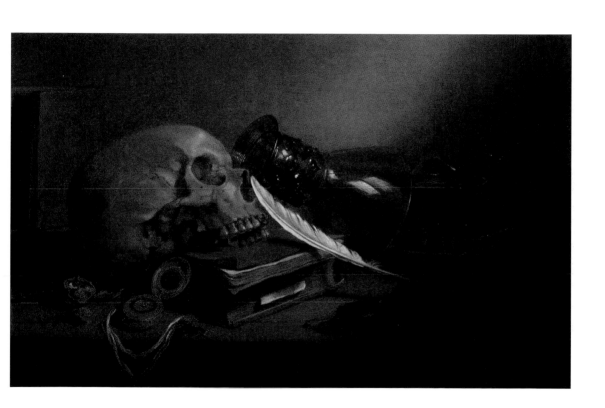

Tour, Georges De La
The Newborn Child, late 1640s

Born at Vic-sur-Seille, France, in 1593, Georges de la Tour established himself at Luneville about 1620, where he received many important commissions from the Duke of Lorraine. He also presented one of his paintings to King Louis XIII, who was so enchanted by it that he decided to remove paintings by all other artists from his private apartments. De la Tour concentrated on religious subjects, many of which were rather sombre with large areas of dark shadows and muted colours subtly illumined by a candle to create dark, dramatic and essentially realistic scenes. In this regard he was heavily influenced by Caravaggio and was, indeed, the leading French exponent of his particular brand of naturalism, although eschewing Caravaggio's penchant for the macabre. De la Tour's paintings exude serenity in keeping with their subject matter. Like his paintings, however, he languished in obscurity for many years and was not rediscovered until 1915.

MOVEMENT

French School

OTHER WORKS

St Peter Denying Christ

INFLUENCES

Caravaggio

Georges de la Tour *Born* 1593 France

Painted in Luneville and Paris

Died 1652 Paris

Hals, Frans
Portrait of a Gentleman, *c.* 1650–52

Courtesy of Private Collection/Christie's Images

Born at Antwerp about 1580, Frans Hals moved with his family to Haarlem at an early age and spent the whole of his life there. It is believed that he received his earliest instruction from Adam Van Noort in Antwerp but continued his studies under Van Mander. None of his earliest works appears to have survived, but from 1618 onwards, when he painted *Two Boys Playing* and *Arquebusiers of St George*, his works show great technical mastery allied to that spirit and passion which made him the equal of Rembrandt in portraiture. His most famous work, *The Laughing Cavalier* is universally recognized, but it is only one of many expressive portraits, distinguished by a liveliness that was far ahead of its time and anticipating the work of the Impressionists. After 1640 his work mellowed and he adopted a darker and more contemplative style.

MOVEMENT

Dutch School

OTHER WORKS

Man with a Cane; Regents of the Company of St Elisabeth

INFLUENCES

Van Noort, Van Mander

Frans Hals *Born c.* 1580 Antwerp, Holland

Painted in Antwerp and Haarlem

Died 1666 Haarlem

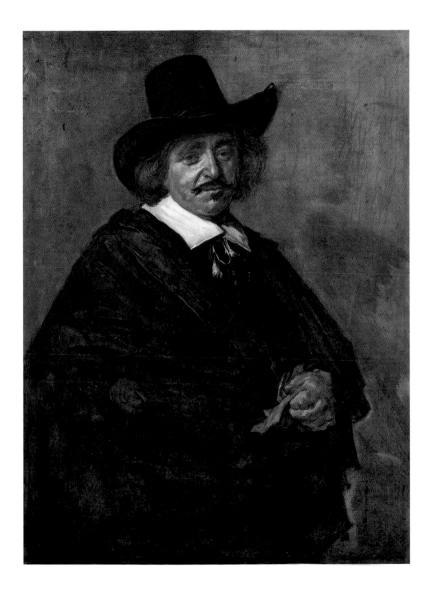

Velázquez, Diego
Portrait of Juan de Pareja, 1650

Courtesy of Christie's Images

Diego Rodriguez de Silva y Velázquez was the son of a prominent lawyer and studied languages and philosophy with the intention of following his father, but his aptitude for drawing induced him to become the pupil of Herera and then Pacheco, whose daughter he married in 1618. His earliest works were domestic genre subjects but after he moved to Madrid in 1623, and especially as a result of a visit to Italy (1629–31), he adopted a much more colourful approach. As the leading court painter of his day he produced numerous portraits of the Spanish royal family and nobility as well as scenes derived from classical mythology. Considering that he is now regarded as one of the greatest painters of all time, it is surprising that his work was little known outside Spain until the early nineteenth century, but his mastery of light and atmosphere had enormous impact on the Impressionists.

MOVEMENT

Spanish School

OTHER WORKS

The Tapestry Weavers; Venus and Cupid

INFLUENCES

Francisco Pacheco

Diego Velázquez *Born* 1599 Seville, Spain

Painted in Seville and Madrid

Died 1660 Madrid

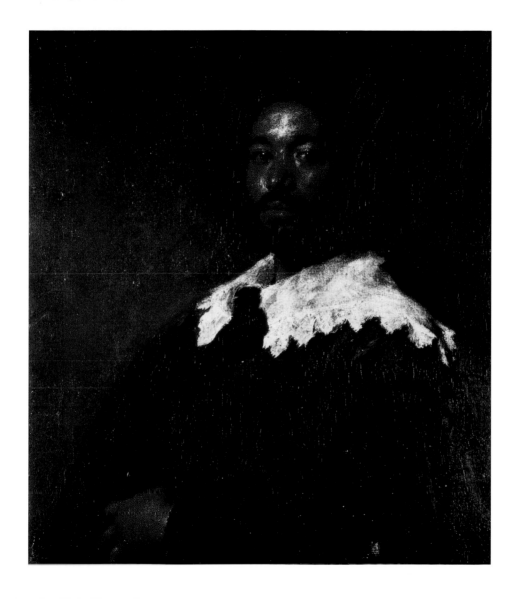

Shouping, Yun
Lotus Flower

A notable poet and calligrapher, Yun Shouping was second only to Wu Li among the Chinese painters who were neither orthodox nor individualist, and therefore he does not fit into any exact category. He has often been dismissed merely as a flower painter, but this does not do justice to his art as a landscape painter. Of course, more than any other artist of his period, he loved to decorate his pictures with masses of flowers, but this does not detract from the fact that his landscapes themselves are among the most serenely beautiful and perfect productions among the later Chinese artists. In his studies of flowers and plants as such, however, he was unsurpassed for the delicacy and clarity of his draughtsmanship and the care he took with his compositions. He preferred a very wet brush so that the ink flowed freely, producing a very sharp, clean-cut line. His landscape paintings are very similar to those of the four Wangs and Wu Li, but it is in his use of floral ornament that he stands out from his contemporaries.

MOVEMENT

Early Ming Period

OTHER WORKS

Bamboo and Old Tree; Peonies; Plum Blossoms

INFLUENCES

Wang Yuanqi, Wang Hui, Wu Li

Yun Shouping *Born* 1633 Wujin, Jiangsu, China

Painted in Changzhou, China

Died 1690 Changzhou

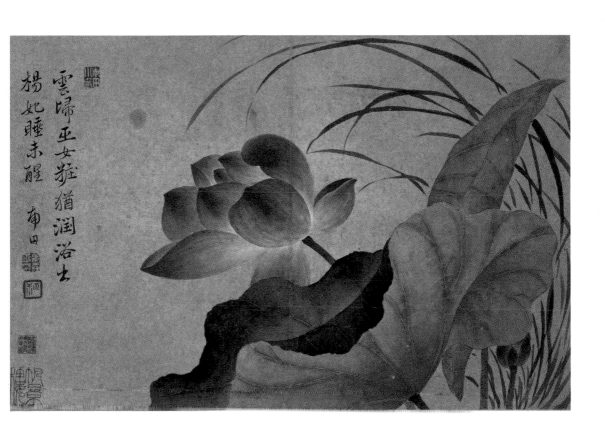

雲歸巫女粧猶潤浴出
楊妃睡未醒
甫田榦

Xian, Gong
Fantastic Mountains, 1655

Courtesy of Private Collection/Christie's Images

Born in China about 1619, Gong Xian is ranked among the greatest of the Individualists working in the Qing period. Although his was the most limited style, it was also the most forceful and dramatic in impact. His paintings have been described as gloomy, funereal and full of foreboding, peopled by ghosts and wraiths; or alternatively as the expression of a monumental genius of somber and passionate temperament. His preferred medium was the hanging scroll, painted in the richest, deepest, most sumptuous shades of black to be found in any Chinese painting, shading subtly in tones of grey, and contrasting with the sunless whites of clouds and mists. He painted empty landscapes; no figures either human or animal disturb the scene. In his experiments with light and shade he went far beyond any of his contemporaries, far less his predecessors and it has been suggested that this reveals the influence of Western artists whose work was beginning to enter China in his lifetime.

MOVEMENTS

Individualist School, Qing Dynasty

OTHER WORKS

A Thousand Peaks and Myriad Ravines

INFLUENCES

Yuan Ji, Zhu Da, Kun-Can

Gong Xian *Born c.* 1619 China

Painted in China

Died 1689 China

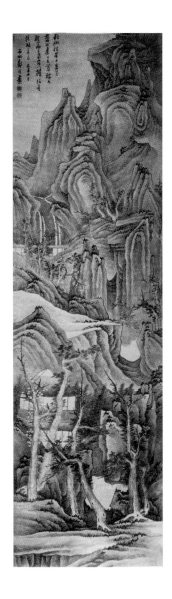

Cuyp, Albert
The Maas at Dordrecht with Fishing Boats

Courtesy of Private Collection/Christie's Images

Albert Cuyp, or Cuijp, was the son of the painter Jacob Gerritsz Cuyp (1594–c. 1652), scion of a well-to-do family. Controversy continues to rage over the extent of his work, many paintings, particularly of still life, being merely signed with the initials AC. On the other hand, those paintings signed 'A Cuyp' are generally landscapes, whose startling lighting effects are very characteristic of his work. As the signed canvasses belong to his later period, it has been argued that the AC paintings are from his earliest years as a painter. He never strayed beyond the Netherlands and his landscapes are bounded by the Maas and the Rhine, but what the flatness of the scenery lacks in variety is more than compensated for by Cuyp's mastery of conveying the different seasons and even different times of day, at their best suffusing the figures of humans and animals with brilliant sunshine.

MOVEMENT

Dutch School

OTHER WORKS

Dordrecht Evening; Cattle with Horseman and Peasants

INFLUENCES

Van Goyen and Jan Both

Albert Cuyp *Born* 1620 Dordrecht, Holland

Painted in Dordrecht

Died 1691 Dordrecht

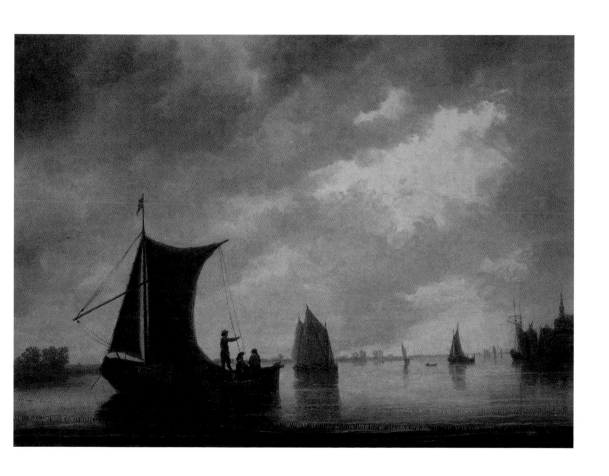

Hooch, Pieter de

The Courtyard of a House in Delft, 1658

Courtesy of Noortman, Maastricht, Netherlands/Bridgeman Art Library

Pieter de Hooch spent his early life in Rotterdam but when he married in 1654 he settled in Delft. Here he came under the influence of Carel Fabritius shortly before the latter's untimely death in the explosion of the Delft Arsenal. De Hooch was subsequently influenced by the late artist's gifted pupil Jan Vermeer. De Hooch himself became one of the leading masters of paintings showing domestic interiors or courtyard scenes, with the emphasis on order, domestic virtue, cleanliness to the point of ascetism and benign tranquillity, shown through the careful arrangement of furniture and figures. His pictures are characterized by a dark foreground, often a doorway or gateway, leading to a bright interior suffused with light and colour. He was an accomplished technician, noted for his complete mastery of perspective which enabled him to create an almost three-dimensional effect.

MOVEMENT

Dutch School

OTHER WORKS

Woman and a Maid with a Pail in a Courtyard

INFLUENCES

Carel Fabritius, Vermeer

Pieter de Hooch *Born* 1629 Rotterdam, Holland

Painted in Rotterdam and Delft, Holland

Died 1684 Amsterdam

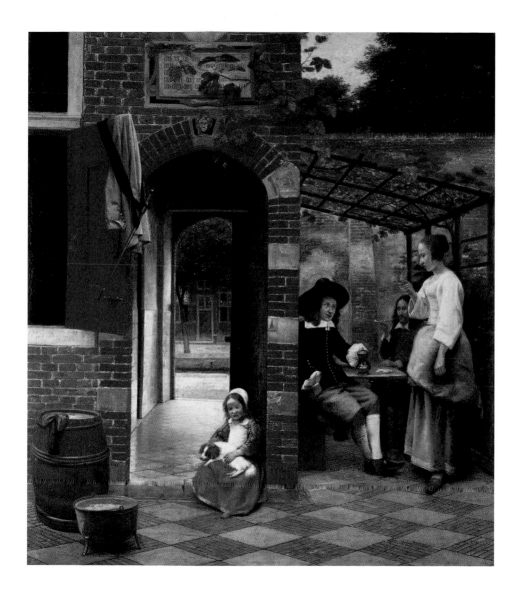

Rembrandt, Harmensz van Rijn

Self Portrait, 1658

One of Holland's greatest and most versatile artists, Rembrandt trained under several painters, the most influential of these being Pieter Lastman. For a time he shared a studio with Jan Lievens, but by the early 1630s he had moved to Amsterdam, where he established a formidable reputation as a portraitist. Rembrandt's approach to group portraiture, in particular, was extremely ambitious. He showed the anatomist, Dr Tulp actually performing a dissection, while his most famous canvas, *The Night Watch*, is a stunningly complex composition portraying a local militia group.

As the 1640s progressed, Rembrandt's art entered a more reflective phase. He painted fewer fashionable portraits, preferring instead to depict the inner life. This can be seen in his magnificent religious paintings, in his intimate, unidealized portrayals of his two wives, Saskia and Hendrickje, and in a penetrating series of self-portraits – perhaps the finest ever produced by any artist. Rembrandt's later work was less commercially successful and, although this led to insolvency, the popular image of him as a reclusive pauper is entirely fictitious.

MOVEMENT

Baroque

OTHER WORKS

The Night Watch; The Anatomy Lesson of Dr. Tulp; The Jewish Bride

INFLUENCES

Pieter Lastman, Jan Lievens, Rubens

Rembrandt *Born* 1606 Leiden, Holland

Painted in Holland

Died 1669

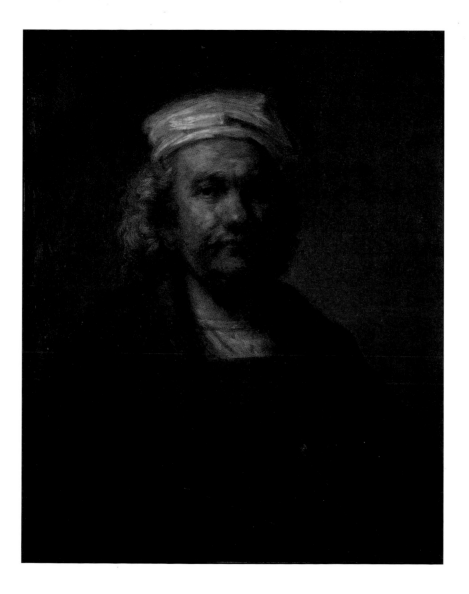

Hobbema, Meindert

A River Landscape with a Ruined Building and Figures, *c.* 1660s

Courtesy of Private Collection/Christie's Images

Originally named Meindert Lubbertszoon, Hobbema studied under Jacob van Ruysdael in his native city. They were close friends and often painted the same subjects; as Hobbema lacked his master's genius in raising the dramatic temperature in his landscapes, Hobbema languished in his shadow. This must also have been the attitude of the picture-buying public at the time, for eventually Hobbema was obliged to forsake painting and work as an excise man, an arduous occupation that left him little time or inclination for art. While it is true that many of his paintings are not particularly distinguished, Hobbema at his best could be sublime and in recent times his painting has been the subject of considerable re-appraisal. It is generally recognized that his greatest achievement was *The Avenue, Middelharnis* – deceptively simple, yet a painting of immense subtlety and complex detail.

MOVEMENT

Dutch School

OTHER WORKS

Stormy Landscape; Road on a Dyke; Watermill with a Red Roof

INFLUENCES

Jacob and Salomon van Ruysdael

Meindert Hobbema *Born* 1638 Amsterdam, Holland

Painted in Amsterdam

Died 1709 Amsterdam

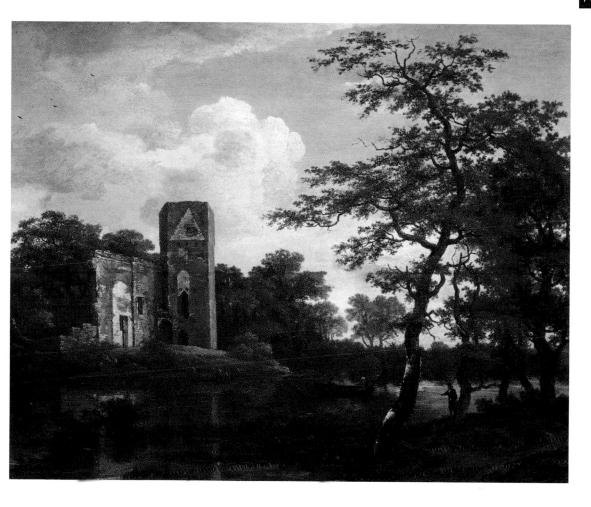

Cooper, Samuel

Miniature of James II as the Duke of York, 1661

Courtesy of Victoria & Albert Museum, London, UK/Bridgeman Art Library

Samuel Cooper is often regarded as the greatest painter of miniatures who ever lived; certainly he was instrumental in raising the status of miniature painting to new heights. He learned his skills from his uncle, John Hoskins. Pepys mentions Cooper frequently in his diaries and noted that he was a fine musician and a good linguist in addition to his artistic talents. He lived through turbulent times and had the distinction of holding official appointments both under the Commonwealth and later the Crown following the Restoration of 1660. He painted several portraits of both Oliver Cromwell and King Charles II, including the effigy of the King used for the coinage. As well as miniatures, painted on ivory or fine parchment, he was also a prolific draughtsman, his collection of chalk drawings being preserved in the University Gallery, Oxford.

MOVEMENT

English Miniaturists

OTHER WORKS

John Aubrey; Mrs Pepys; Self Portrait

INFLUENCES

John Hoskins

Samuel Cooper *Born* 1609 London, England

Painted in London

Died 1672 London

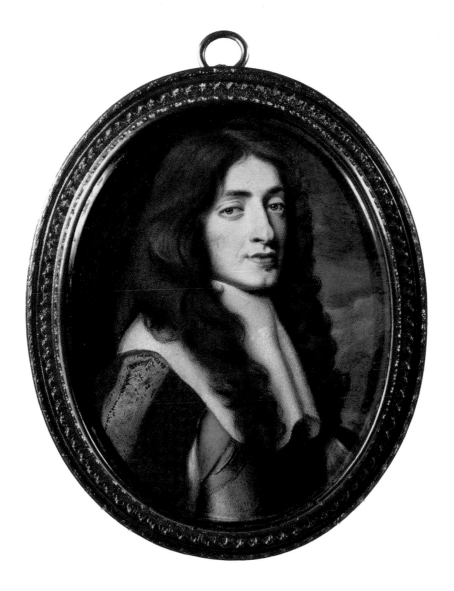

Murillo, Bartolomé Esteban
Immaculate Conception, 1661

Courtesy of Private Collection/Christie's Images

A great master of sentimental religious paintings, Bartolomé Esteban Murillo received his brief artistic training from Juan de Castillo, but when his master moved to Cadiz Murillo scraped a living by painting cheap religious daubs, hawked at public fairs. It was an inauspicious start for the man who would co-found the Seville Academy in 1660 and become its first president. His career took off in 1648 when he went to Madrid and met his fellow townsman Velázquez, who not only helped him but also introduced his work to the royal court. Many of his earlier paintings were portraits of Franciscan saints, executed for the Franciscan monastery in Seville, but he went on to produce numerous works of a more general religious nature. In addition he produced many genre subjects, such as beggars, street urchins, fruit-sellers and other aspects of low life which reflect the hardships of his youth. He died from injuries sustained in a fall from scaffolding while painting an altarpiece at Cadiz in 1682.

MOVEMENT

Spanish School

OTHER WORKS

The Immaculate Conception of the Escorial

INFLUENCES

Juan de Castillo, Velázquez

Bartolomé Esteban Murillo *Born* 1618 Seville, Spain

Painted in Seville

Died 1682 Seville

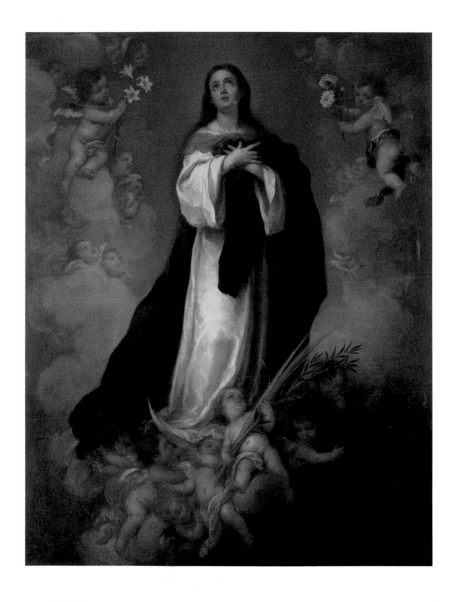

Vermeer, Jan

Girl with a Pearl Earring, *c.* 1665–6

Courtesy of Mauritshuis, The Hague, Netherlands/Bridgeman Art Library

Jan Vermeer studied painting under Carel Fabritius. In 1653 he entered the Guild of St Luke taking the role of head there in 1662 and 1670. Diffident and a poor businessman, he died young, leaving a widow and eight children destitute. He was almost entirely forgotten until 1860, when he was rediscovered and works which had previously been attributed to other artists were properly identified as coming from his brush. He specialized in small paintings of domestic scenes, distinguished by their perspective and clever use of light to create subtle tones, as well as the fact that, unusual for the time, the figures in them are self-absorbed. Only about 40 paintings have definitely been credited to him, but they are sufficient to establish him as one of the more original and innovative painters of his time – second only to Rembrandt.

MOVEMENT

Dutch School

OTHER WORKS

Lady Seated at a Virginal; The Painter in his Studio; View of Delft

INFLUENCES

Carel Fabritius

Jan Vermeer *Born* 1632 Delft, Holland

Painted in Delft

Died 1675 Delft

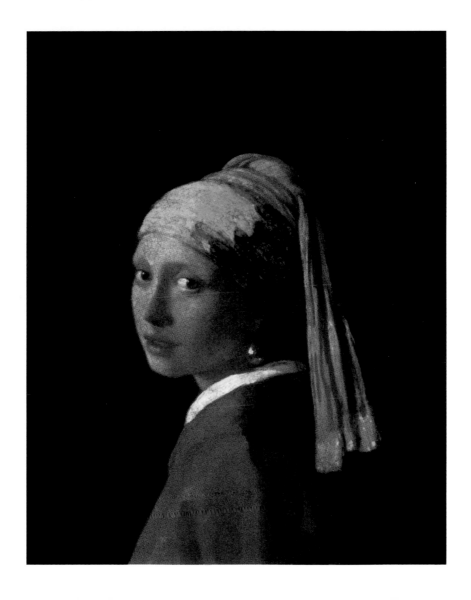

Pozzo, Andrea

The Entry of Saint Ignatius into Paradise, c. 1707

Courtesy of Church of St Ignatius, Rome, Italy/Bridgeman Art Library

One of the most brilliant painters and architects of his generation, Andrea Pozzo was the pupil of an unknown master whom he accompanied to Milan, where he became a Jesuit lay brother. In this connection he was responsible for the decorations of religious festivals and from this graduated to theatrical sets. In 1676 he painted the frescoes for the church of San Francisco Saverio in Modovi, a masterpiece of trompe l'oeil. This was a foretaste of his greatest illusionistic masterpiece, the ceiling of the church of St Ignatius in Rome which, by an ingenious use of perspective, appears to expand the interior by hundreds of feet. In this immense achievement he united his talents as painter, architect and sculptor to great effect. In 1695 he designed the elaborate tomb of Ignatius Loyola, founder of the Society of Jesus. He worked on the decoration of many other churches in Italy and from 1703 onwards was similarly employed in Vienna.

MOVEMENT

Italian Baroque

OTHER WORKS

St Francis Xavier Preaching; Investiture of St Francesco Borgia

INFLUENCES

Andrea Sacchi, Pietro da Cortona, Bernini

Andrea Pozzo *Born* 1642 Trento, Italy

Painted in Mondovi, Rome and Vienna, Austria

Died 1709 Vienna

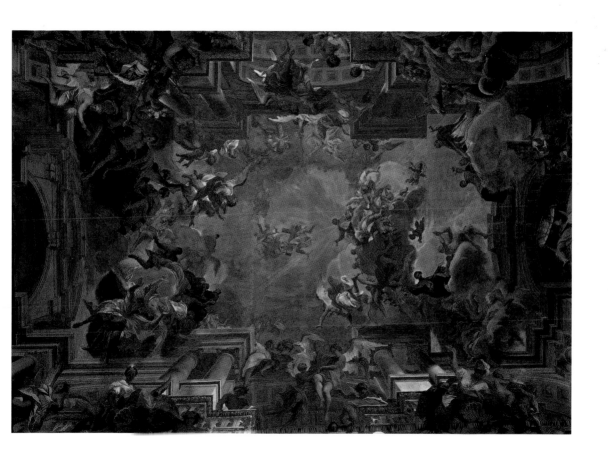

Watteau, Jean-Antoine

Les Plaisirs du Bal, c. 1714

Courtesy of Dulwich Picture Gallery, London, UK/Bridgeman Art Library

Jean-Antoine Watteau studied under Gérin but learned more from the paintings of Ostade and Teniers. On his master's death, Watteau went to Paris, where he worked for the scene-painter Métayer and then in a factory where he turned out cheap religious pictures by the dozen. He was rescued from this drudgery by Claude Gillot and later worked under Claude Audran. The turning point came when he won second prize in a Prix de Rome competition in 1709. He became an associate of the Academy in 1712 and a full member in 1717. He led the revolt against the pompous classicism of the Louis XIV period and broke new ground with his realism and lively imagination. His early works were mainly military subjects, but later he concentrated on rustic idylls which were very fashionable in the early eighteenth century.

MOVEMENT

French School

OTHER WORKS

The Music Party; Embarkation for the Isle of Cythera

INFLUENCES

Claude Audran, David Teniers

Jean-Antoine Watteau *Born* 1684 France

Painted in Valenciennes and Paris

Died 1721 Nogent-sur-Marne, France

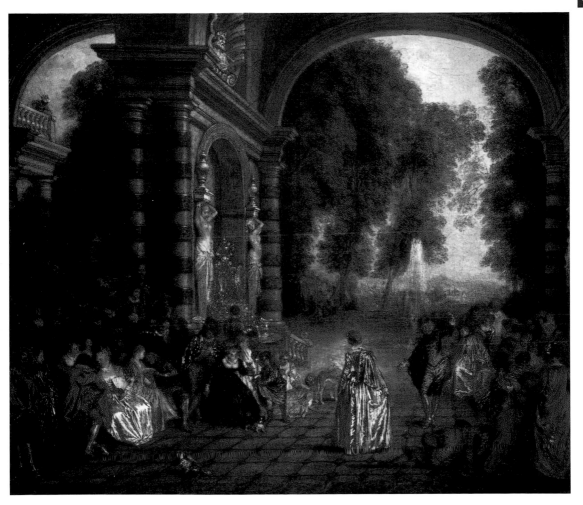

Hogarth, William
Beggars Opera, 1728–31

Courtesy of Private Collection/Christie's Images

William Hogarth became the greatest English satirical artist of his generation. He was apprenticed to a silver-plate engraver, Ellis Gamble, and established his own business in 1720. Seeking to diversify into the more lucrative business of copper-plate engraving, however he took lessons in draughtsmanship under Sir James Thornhill. His early work consisted mainly of ornamental bill-heads and business cards, but by 1724 he was designing plates for booksellers and from this he progressed to individual prints, before turning to portrait painting by 1730. Within a few years he had begun to concentrate on the great satirical works on which his reputation now rests. His canvasses are absolutely crammed with figures and minute detail, sub-plots and side issues to the main theme. Following a visit to Paris in 1743 he produced several prints of low life and moral subjects. He also executed a number of portraits and oils of genre subjects.

MOVEMENT

English School

OTHER WORKS

Marriage à la Mode; Industry and Idleness; Garrick as Richard III

INFLUENCES

Sir James Thornhill

William Hogarth *Born* 1697 London, England

Painted in London

Died 1764 London

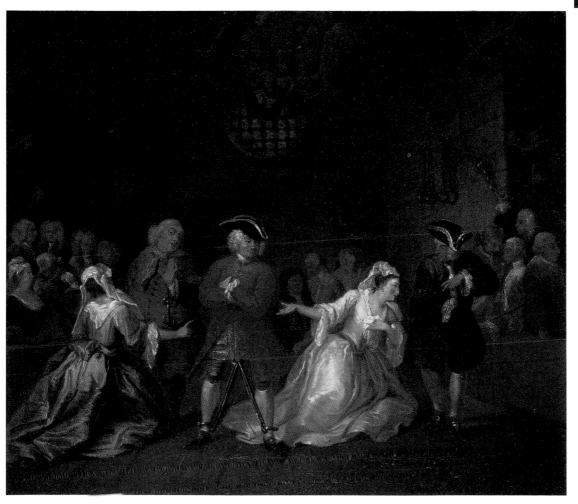

Chardin, Jean-Baptiste-Siméon
Still Life with Ray and Basket of Onions, 1731

Courtesy of Private Collection/Christie's Images

French painter, specializing in still life and genre scenes. Chardin was born in Paris, where he spent most of his life. His father was a carpenter and, initially, he seemed destined to follow this trade, until his aptitude for painting became apparent. As a youth, Chardin trained under two very minor history painters, Pierre Cazes and Noel-Nicolas Coypel, buthis real education came from copying Dutch and Flemish paintings in private art collections. These prompted him to concentrate on still-life pictures – a brave decision, since this type of painting had a low reputation and was very poorly paid.

Despite these drawbacks, Chardin's career flourished. In 1728, *The Skate* won such acclaim at a Paris exhibition that he was invited to become a full member of the Academy, an unprecedented honour for a still life artist. Chardin was delighted and became a stalwart of the institution, holding the post of Treasurer for 20 years. Even so, he found it hard to make a living and, accordingly, extended his repertoire to include simple domestic scenes. These wonderful vignettes of everyday life displayed none of the affectation of the prevailing Rococo style and proved enormously popular with the public.

MOVEMENT

Still life and genre

OTHER WORKS

Saying Grace, The Brioche

INFLUENCES

Nicolaes Maes; Jean-Baptiste Oudry

Jean-Baptiste-Siméon Chardin *Born* 1699 Paris, France

Painted in France

Died 1779 Paris

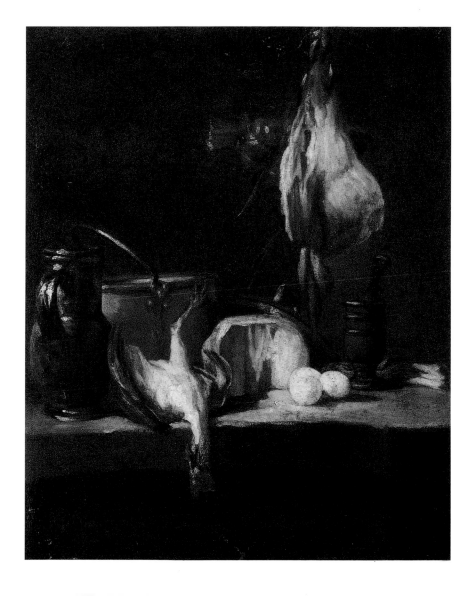

Canaletto

Grand Canal, *c.* 1740

Courtesy of Private Collection/Christie's Images

Originally named Giovanni Antonio Canale, Canaletto was the son of a scene-painter in whose footsteps he at first followed. In 1719 he went to Rome to study architecture and on his return to Venice he began painting those great architectural masterpieces with which he has been associated ever since. Although most of his paintings illustrate the buildings and canals of his native city – executed as souvenirs for wealthy patrons from England making the Grand Tour – he lived mainly in London from 1746 to 1753. This is reflected in his paintings of the Thames and the City, and other views in the Home Counties. He then returned to Venice where he became a member of the Academy in 1763. He established a style of architectural painting that was widely imitated by the next generation of Italian artists, notably Francesco Guardi and his own nephew Bernardo Bellotto, who slavishly imitated him and even signed his works 'Canaletto'.

MOVEMENT

Venetian School

OTHER WORKS

Piazza San Marco; Regatta on the Grand Canal

INFLUENCES

Tiepolo

Canaletto *Born* 1697 Venice, Italy

Painted in Venice and London

Died 1768 Venice

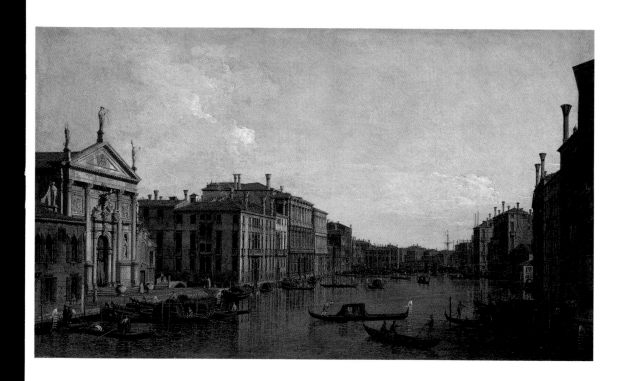

Boucher, François
(attr. to) La Cible D'Amour (The Target of Love), 1758

Courtesy of Private Collection/Christie's Images

French painter and designer, one of the greatest masters of the Rococo style. Born in Paris, Boucher was the son of a versatile, not particularly successful, artist and craftsman. As a result, he learned a wide variety of artistic techniques in his father's workshop before training more formally under François Lemoyne. Boucher's first significant job was to produce a set of engravings after Watteau's drawings, but he also found time to paint, winning the Prix de Rome in 1723. After making the traditional study-tour of Italy (1727–31), he began to gain official plaudits for his work. In 1735 he was granted his first royal commission and this secured his position as a court artist. This role governed the nature of Boucher's art. There were no grand, intellectual themes or moral dramas in his pictures. Instead, he painted light-hearted mythologies and pastoral idylls, which could serve equally well as paintings, tapestry designs or porcelain decoration. This is also evident in Boucher's work for his most distinguished patron, Madame de Pompadour. He immortalized her in a series of dazzling portraits, but also decorated her palace and designed sets for her private theatre.

MOVEMENT

Rococo

OTHER WORKS

The Triumph of Venus; Mademoiselle O'Murphy

INFLUENCES

Watteau, Abraham Bloemaert, François Lemoyne

François Boucher *Born* 1703, Paris

Painted in France and Italy

Died 1770

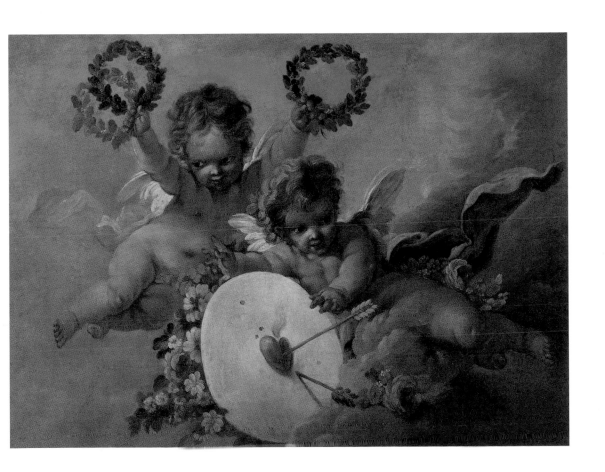

Wright, Joseph

Experiment with an Air Pump, 1768

Courtesy of National Gallery, London, UK/Bridgeman Art Library

Known as Wright of Derby because he spent his entire life in that town, Joseph Wright was the first English painter of any significance to work in the provinces, although even he had to go to London for his formal art education. He established his own studio, where he flourished as a portraitist, and it was probably as a result of his contact with the rising industrialists of the 1760s and 1770s, such as Richard Arkwright and Josiah Wedgwood (whose portraits he painted), that his career eventually changed direction quite dramatically. Wright, in fact, was the artist of the Industrial Revolution, the right man in the right place at the right time, and it is for his spectacular canvasses depicting the wonders of modern science and technology in their infancy that he is chiefly remembered. His attention to the details of machinery was matched by his uncanny mastery of artificial lighting, which he used to good effect.

MOVEMENT

British School

OTHER WORKS

The Air Pump; A Philosopher Giving a Lecture on the Orrery

INFLUENCES

Gerrit van Honthorst

Joseph Wright *Born* 1734 Derby, England

Painted in Derby

Died 1797 Derby

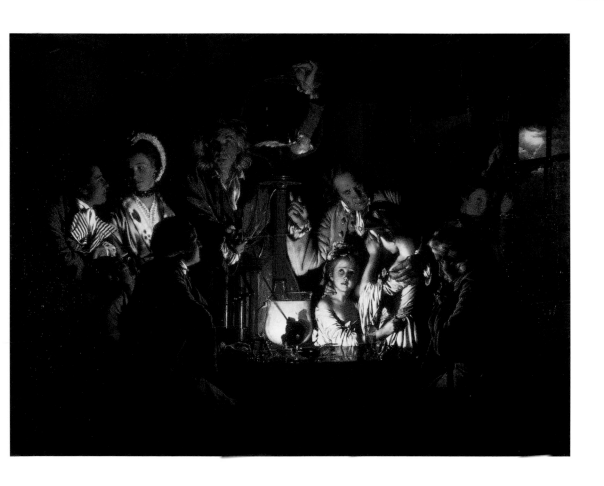

Gainsborough, Thomas
Portrait of David Garrick, exhibited 1770

Courtesy of Private Collection/Christie's Images

Born in Sudbury, Suffolk Gainsborough displayed precocious artistic skills. According to family legend, he helped catch a pear thief in a neighbour's orchard by accurately sketching the culprit. Recognizing his obvious talent, his family sent him to London at the age of 13, where he was trained by the French Rococo artist Hubert Gravelot. In 1745, Gainsborough set up in business hoping to make a living selling landscapes, but the venture failed and he returned to Suffolk. Gainsborough preferred landscapes to 'face-painting', but found that portraiture was far more profitable. With this in mind, he eventually moved from Suffolk to the fashionable resort of Bath, where he was employed by a rich and illustrious clientele. Here, Gainsborough honed his skills to perfection, often painting by candlelight, in order to give his brushwork its distinctive, flickering appearance. By 1768, he was so famous that he was invited to become one of the founder members of the Royal Academy. Gainsborough accepted, and spent the final years of his career in London vying with Reynolds for supremacy in the field of portraiture.

MOVEMENT

Rococo

OTHER WORKS

The Morning Walk; The Painter's Daughters Chasing a Butterfly

INFLUENCES

Hubert Gravelot, Van Dyck, Francis Hayman

Thomas Gainsborough *Born* 1727 England

Painted in England

Died 1788

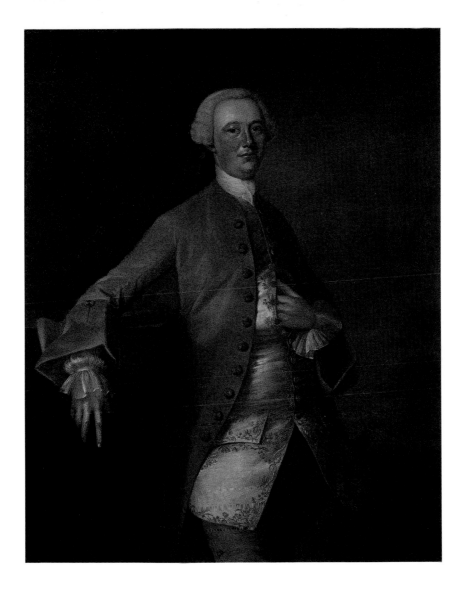

Fragonard, Jean-Honoré

Portrait of Mademoiselle Guimard as Terpsichore, 1773-75

A leading exponent of the light-hearted Rococo style, Fragonard trained under Boucher (Madame de Pompadour's favourite artist) and won the Prix de Rome, both of which seemed to mark him out for a conventional career as a history painter. But he was too ill-disciplined to enjoy the business of copying old masters and his studies in Rome (1756–60) did not progress well. Instead, the Italian countryside awakened Fragonard's interest in landscape painting while, on his return to France, the success of *The Swing* led his art in a different direction.

The Swing demonstrated Fragonard's undoubted gift for playful eroticism, and it brought him a series of commissions for similar 'boudoir' pictures. Patrons were attracted by his dazzling, vivacious style and by his innate sense of taste, which strayed close to the margins of decency, but never crossed them. In this sense, Fragonard became the archetypal painter of the Ancien Régime and ultimately shared its fate. By the 1780s, Neoclassicism had all but supplanted the Rococo style and, although he received help from David after the Revolution in 1789, Fragonard's later years were marred by poverty and neglect.

MOVEMENT
Rococo
OTHER WORKS
The Progress of Love; The Bolt; The Love Letter
INFLUENCES
François Boucher, Hubert Robert, Tiepolo

Jean-Honoré Fragonard *Born* 1732 France

Painted in France and Italy

Died 1806

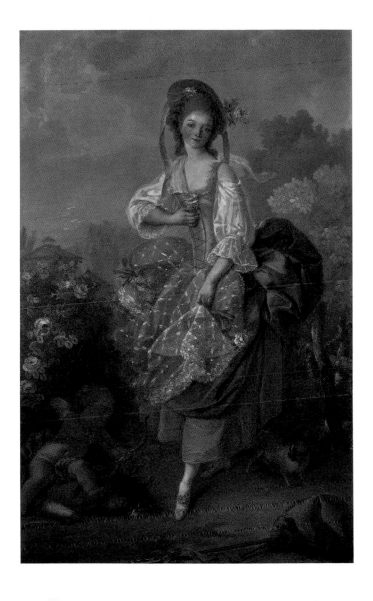

THE W

18th Century

GREAT

The Era of Neoclassicism & Romanticism

Reynolds, Sir Joshua

George Townshend

Courtesy of Private Collection/Christie's Images

Born in Plympton, Devon, Joshua Reynolds was apprenticed in London to Thomas Hudson, a second-rate portrait painter, from whom he learned the rudiments of his craft. In 1743 Reynolds settled in Plymouth, but in 1744 he returned to London where his portrait of Captain John Hamilton, brought him recognition. Reynolds spent two years in Rome perfecting his technique, then visited other Italian art centres, before returning to England in 1752. By 1760 he was the most fashionable portrait painter in London, becoming the first President of the Royal Academy in 1768 and knighted a year later. A prolific artist, he produced over 2,000 portraits, many of which were subsequently published as engravings that further enhanced his reputation.

MOVEMENT

English School

OTHER WORKS

Nelly O'Brien; Samuel Johnson

INFLUENCES

Thomas Hudson, Sir Peter Lely

Sir Joshua Reynolds *Born* 1723 England

Painted in London, England

Died 1792 London

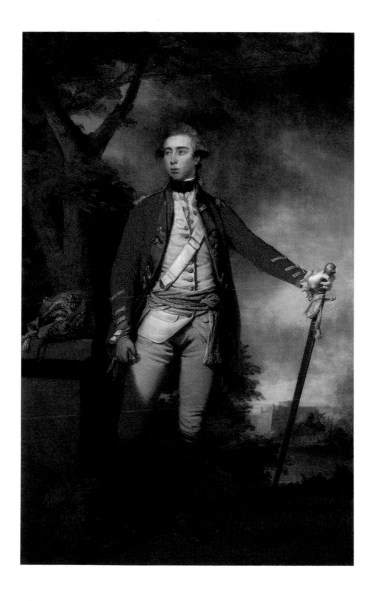

Fuseli, Henry (Johann Heinrich Füssli)
The Birth of Sin

Swiss painter and graphic artist; a key figure in the English Romantic movement. Born in Zurich, the son of a town clerk and amateur painter, Fuseli trained as a minister in the Swiss Reformed Church. He was ordained in 1761, but turned to art in 1768, after receiving encouragement from Sir Joshua Reynolds. Pursuing this ambition, he spent several years in Italy (1770–78), where he was impressed, above all, by Michelangelo's vision of the Sublime – a mood which he tried to capture in many of his own paintings.

In 1778, Fuseli moved to London, making this his principal artistic base. He cemented his reputation with *The Nightmare*, which was exhibited at the Royal Academy in 1782. Fuseli made several versions of this haunting image, which is undoubtedly his most famous work. Although the picture may have had a purely personal meaning for him – the expression of his unrequited passion for a Swiss girl – it has become one of the landmarks of Romanticism. In it, as in his other works, the artist focused on the darker side of the imagination, weaving together elements of horror, fantasy and eroticism.

MOVEMENT

Romanticism

OTHER WORKS

Titania's Awakening; The Ladies of Hastings

INFLUENCES

Michelangelo, William Blake, Sir Joshua Reynolds

Henry Fuseli *Born* 1741 Switzerland

Painted in England, Italy, Switzerland and Germany

Died 1825

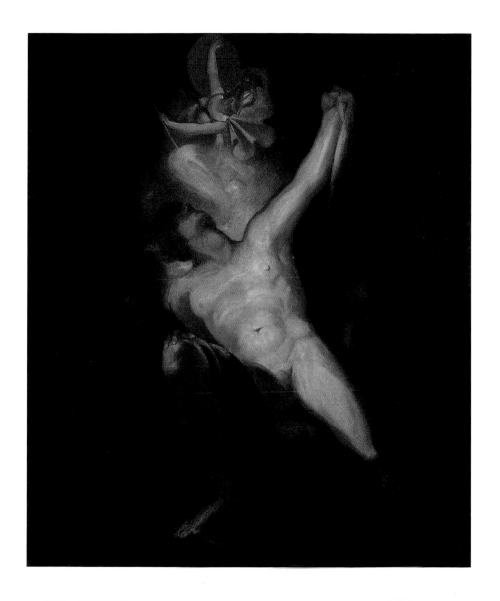

Utamaro, Kitagawa

Act IX of Chusugiwa (detail)

Courtesy of Private Collection/Christie's Images

Kitagawa Nebsuyoshi received a conventional art training but raised it to an entirely new level, earning for him the epithet of *Ukiyo-ye Chuko-no-so* ('great master of the popular school'). A versatile artist who painted flowers, birds, fish and insects in meticulous detail as well as great sweeping landscapes, he specialized in portraits and genre scenes involving the ladies of the court. No one ever surpassed him in the precise delineation of faces, figures and flowing robes that capture the gracefulness and elegance of the courtesans and professional beauties of the Shogunate at the height of its prestige. Though he painted in oils, his fame rests mainly on the colour prints, which had immense appeal not only for the Japanese but also for the Dutch community at Nagasaki. This led to his work being brought to Europe, and it had a tremendous influence on many artists of the nineteenth century.

MOVEMENT

Ukiyo-e

OTHER WORKS

Lovers; Girl Playing Glass Flute; Women Working in the Kitchen

INFLUENCES

Hishikawa Moronobu, Ando Hiroshige

Kitagawa Utamaro *Born* 1753 Kawayoye near Edo (now Tokyo), Japan

Painted in Edo

Died 1806 Edo

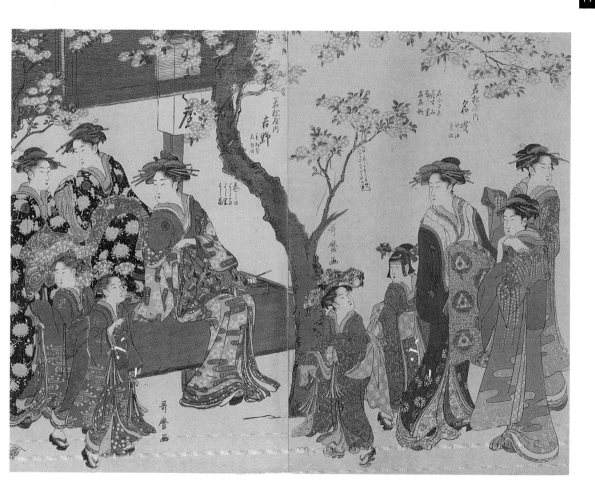

Raeburn, Sir Henry

The Reverend Robert Walker Skating on Duddington Loch, 1784

Courtesy of National Gallery of Scotland, Edinburgh, Scotland/Bridgeman Art Library

Henry Raeburn was originally apprenticed to a goldsmith but began painting portrait miniatures and soon expanded to full-scale oil paintings, though entirely self-taught. After marrying one of his sitters, a wealthy widow, he was enabled to travel to Italy to study for two years, mainly under Pompeo Batoni. He returned to Edinburgh in 1787 and established himself as the most fashionable portraitist of his generation. Unlike Ramsay, he spent most of his life in Edinburgh and seldom visited London. He became a full member of the Royal Academy in 1815. In 1823 he was appointed His Majesty's Limner for Scotland and was knighted the same year. Although his contemporaries judged him less successful in his female subjects, his portraits of both men and women are full of vigour and liveliness and had a profound influence on the development of Scottish art in the nineteenth century.

MOVEMENT

British School of Portraiture

OTHER WORKS

Self Portrait; Sir Walter Scott; Mrs Robert Bell

INFLUENCES

Allan Ramsay, Pompeo Batoni, Sir Joshua Reynolds

Sir Henry Raeburn *Born* 1756 Scotland

Painted in Edinburgh and Rome

Died 1823 Edinburgh

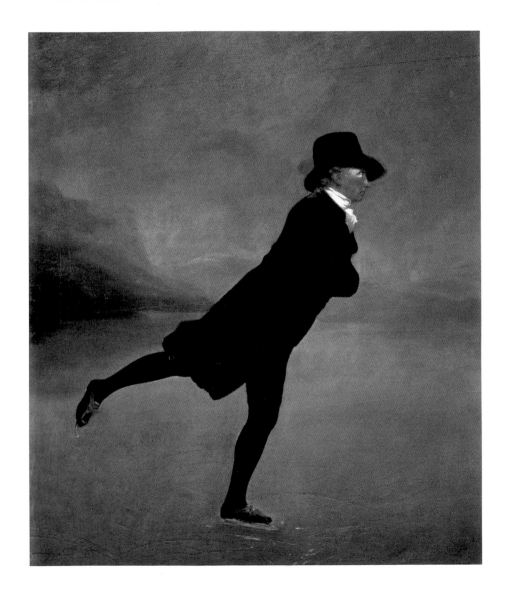

Romney, George

Portrait of Emma, Lady Hamilton, 1786

Courtesy of Philip Mould, Historical Portraits Ltd, London, UK/Bridgeman Art Library

An English painter specializing in portraits, Romney was born in Lancashire, the son of a cabinet maker, and trained under an itinerant portraitist named Christopher Steele. For a time, he picked up commissions by travelling from town to town, before making his base in Kendal. Moving to London in 1762, he established a reputation as a fashionable portrait painter, although his style did not really mature until after his tour of Italy (1773–75). There, his study of Classical and Renaissance art paid huge dividends and most of his best paintings were produced in the decade after his return to England.

Romney, like Gainsborough, was deeply dissatisfied with portraiture. His ambition of becoming a history painter was never fulfilled, perhaps partly because of his nervous, introspective character and partly because of his reluctance to exhibit. His later career was marred by his obsession with Emma Hart, later to become Lady Hamilton and Nelson's mistress. Romney met her in 1781, and in the years that followed produced dozens of pictures of her, usually masquerading as a character from mythology. As his reputation began to wane, the artist returned to Kendal, where he suffered a serious mental decline.

MOVEMENTS

Neoclassicism, Romanticism

OTHER WORKS

The Parson's Daughter; The Beaumont Family; Lady Rodbard

INFLUENCES

Sir Joshua Reynolds, Henry Fuseli, Joseph Highmore

George Romney *Born* 1734 England

Painted in England and Italy

Died 1802

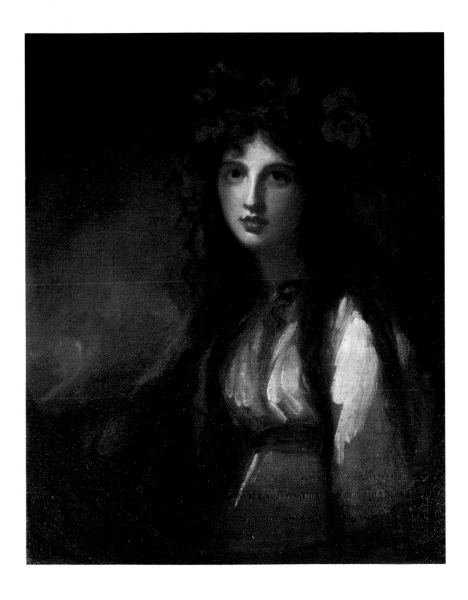

Vigée-Lebrun, (Marie Louise) Elisabeth

Marie Antoinette and her Four Children, 1787

Courtesy of Chateau de Versailles, France/Bridgeman Art Library

Marie Louise Elisabeth Vigée-Lebrun was the daughter of an artist from whom she received her early training, but later benefited from the help of several fellow-painters. By the age of 20 she had already made her mark with portraits of Count Orloff and the Duchess of Orleans. In 1783 she was admitted to the Academy on the strength of her allegorical masterpiece *Peace Bringing Back Abundance*. Following the outbreak of the Revolution she fled to Italy and worked in Rome and Naples, later visiting Vienna, Berlin and St Petersburg. She returned briefly to Paris in 1802 but went to London the same year, where she painted the Prince of Wales and Lord Byron. She was a prolific portraitist and a score of her paintings portray Marie Antoinette alone.

MOVEMENT

French School

OTHER WORKS

Portrait of the Artist and her Daughter

INFLUENCES

Joseph Vernet, Jean Baptiste Grueze, Charles Lebrun

Elisabeth Vigée-Lebrun *Born* 1755 France

Painted in France, England and Europe

Died 1842 Paris

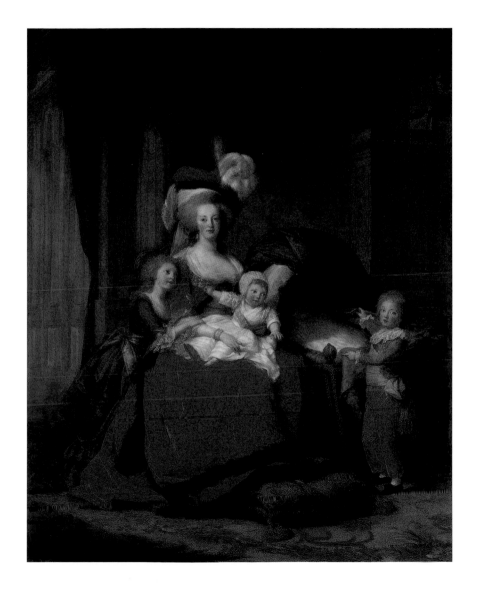

Blake, William

Ancient of Days, Frontispiece of 'Europe, A Prospesy' 1821

Visionary poet and painter, Blake was one of the most individual talents to emerge from the Romantic movement. Living in London for most of his life, Blake trained as a commercial engraver and briefly attended the Royal Academy Schools, although he soon felt stifled by the life classes; for him, the imagination was always far more important than the imitation of nature. Stylistically, Blake's art bore some of the hallmarks of Neoclassicism – particularly in its linear approach and its dramatic intent – but a classical sense of restraint was notably absent. His figures, meanwhile, owed much to the example of Michelangelo. Blake's technique was highly inventive. He devised a system of 'illuminated printing' which enabled him to produce lavish editions of his books of poetry, and pioneered a form of tempera painting in place of oils. His subject matter was largely drawn from the complex, personal mythology outlined in his verses. This baffled many of his contemporaries, who regarded him as an eccentric. Blake did have his admirers, however, which included the group of young artists known as the Ancients.

MOVEMENT

Romanticism, Neoclassicism

OTHER WORKS

Glad Day; God Judging Adam; God Creating the Universe

INFLUENCES

Michelangelo, Henry Fuseli, John Flaxman

William Blake *Born* 1757 London

Painted in England

Died 1827

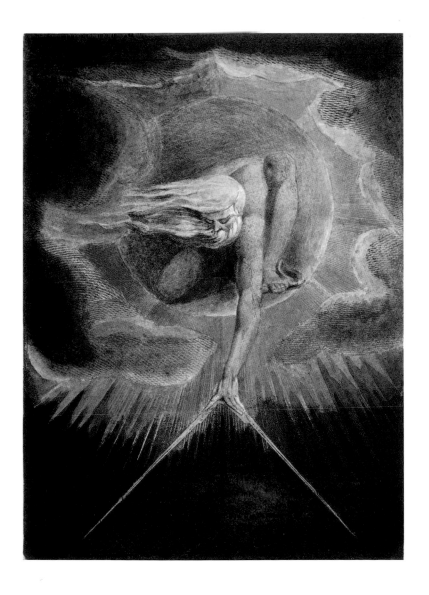

David, Jacques-Louis
The Death of Marat in 1793

French painter, the leader of the Neoclassical revival. In both his art and his life, David displayed a tempestuous nature, possibly inherited from his father, who was killed in a duel in 1757. He trained under Vien and his early paintings featured the same uncomfortable blend of Rococo sweetness and antique trappings as those of his master. After winning the Prix de Rome, however, David spent an extended study period in Italy (1775–80), where his art acquired a new dignity and grandeur. With their fiery patriotism and stern morality, David's paintings of the 1780s captured the rebellious mood of the times. Indeed, his greatest picture, *The Oath of the Horatii*, has often been seen as a visual call to arms. During the Revolution, David was swept up in politics, joining the National Convention, where he became associated with Robespierre and Marat. After their fall, he was imprisoned and was only saved from the guillotine by his royalist wife. This experience did nothing to quell the artist's spirit, however, for he became equally involved with Napoleon. After the latter's defeat, David fled to Brussels where he remained in exile for the rest of his days.

MOVEMENT

Neoclassicism

OTHER WORKS

Madame Récamier; Brutus and his Dead Sons

INFLUENCES

Gavin Hamilton, Joseph-Marie Vien, Anton Raffael Mengs

Jacques-Louis David *Born* 1748 France

Painted in France, Italy and Belgium (then Holland)

Died 1825

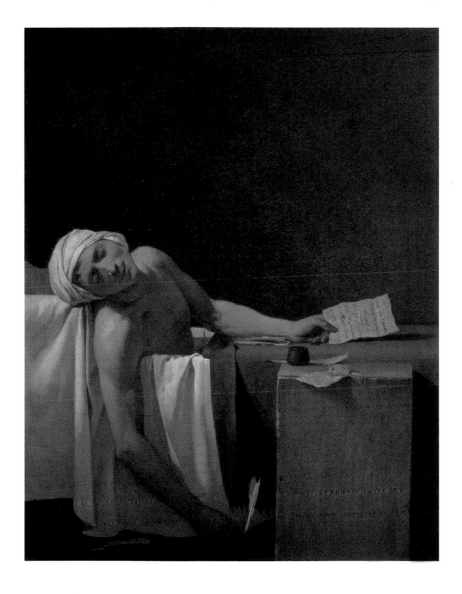

Girtin, Thomas

Dunstanborough Castle, *c.* 1797

Thomas Girtin served his apprenticeship in London as a mezzotint engraver under Edward Dayes, through whom he made the acquaintance of J. M. W. Turner who, being shown Girtin's architectural and topographical sketches, encouraged him to develop his talents as a landscape painter. His early death in 1802 from tuberculosis brought a very promising career to an untimely end, but even by then he had established a high reputation as an etcher. Hitherto, watercolours had been used almost entirely for tinting engravings, but to Girtin goes the credit for establishing watercolour painting as a major art form in its own right. From 1794 onwards he exhibited his great watercolour landscapes at the annual Royal Academy exhibitions and this helped to develop the fashion for this medium from the beginning of the nineteenth century. Girtin collaborated with Turner in making a series of copies of architectural paintings for Dr Monro, notably works by Canaletto.

MOVEMENT

English School

OTHER WORKS

A Winding Estuary; Porte St Denis

INFLUENCES

Turner

Thomas Girtin *Born* 1775 London, England

Painted in London

Died 1802 London

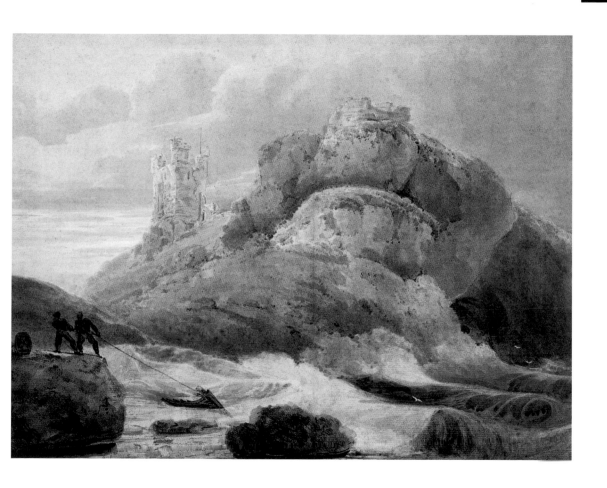

Benoist, Marie-Guillemine

Portrait of a Negress, 1799—1800

Courtesy of Louvre, Paris/Bridgeman Art Library

Marie-Guillemine Benoist was the daughter of a government official who recognized her talent and enrolled her as a pupil of Vigée-Lebrun in 1791; the latter's influence is very evident in Benoist's early works, mainly portraits done in pastels. Later she studied under Jacques-Louis David and as a result she began producing more ambitious works in oils. She made her debut at the Salon with two historical scenes and thereafter painted both portraits and historical subjects. She achieved a high reputation and received a gold medal and an annual government grant. Napoleon commissioned portraits of himself and his family from her. In the early 1800s she switched to painting genre subjects and sentimental domestic scenes which were immensely popular. Her best-known painting, a remarkable portrait of a young black woman painted in 1800, is believed to have been inspired by the decree of 1794 abolishing slavery.

MOVEMENT

French Romantic School

OTHER WORKS

Napoleon Bonaparte; The Imperial Family

INFLUENCES

Vigée-Lebrun, David

Marie-Guillemine Benoist *Born* 1768 Paris

Painted in Paris

Died 1826 Paris

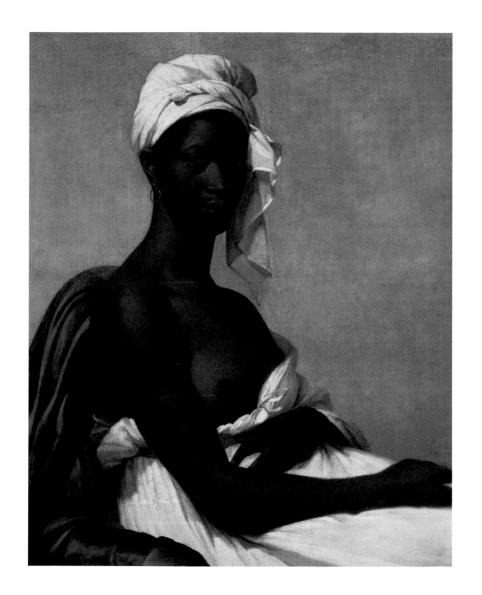

Gros, Antoine-Jean

Napoleon Bonaparte Visiting the Plague Stricken of Jaffa, 1799

Courtesy of Louvre, Paris, France/Bridgeman Art Library

The son of a miniature painter, Antoine-Jean Gros studied under Jacques-Louis David. Following the death of his father in 1791 he went to Italy and it was there that he met Josephine Beauharnais, who introduced him to Napoleon, whom he accompanied on his Italian campaign. He was an eye-witness of the dramatic scene when Bonaparte planted the Tricolour on the bridge at Arcole in November 1796 and the dramatic painting that recorded this incident gave Gros a sense of purpose. Thereafter, as a war artist, he chronicled on canvas the exploits of the Napoleonic army down to the campaign of 1811, and it is on these heroic paintings that his reputation is largely based, earning him the Napoleonic title of Baron in the process. The downfall of Napoleon robbed Gros of his true vocation. In the aftermath of Waterloo he returned to his classicist roots and concentrated on such works as *Hercules and Diomedes*, but by now he was fighting a losing battle against the rising tide of Romanticism.

MOVEMENT

French Classicism

OTHER WORKS

The Departure of Louis XVIII

INFLUENCES

David

Antoine-Jean Gros *Born* 1771 Paris, France

Painted in France and Italy

Died 1835 Bas-Meudon, France

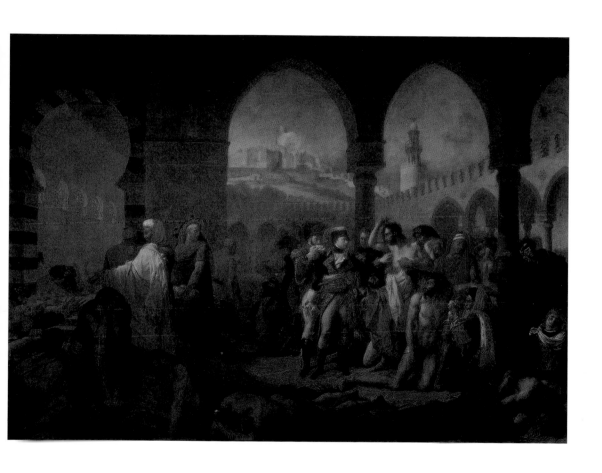

Goya, Francisco
The Clothed Maja, *c.* 1800–05

Francisco José de Goya y Lucientes was raised in the small town of Fuendetodos near Saragossa, Spain. Frequently involved in parochial gang fights, he fled to Madrid in 1765 after a brawl in which three youths were killed. As a result of continued sparring he left Madrid precipitately, joining a troupe of itinerant bull-fighters and eventually reaching Rome, where he resumed his studies in art. In 1798 he returned to Spain as a designer for the royal tapestry factory and executed a number of frescoes drawn from contemporary life, as well as a series of satirical etchings. In 1799 he was appointed court painter to Charles IV, which resulted in some of his most notable portraits. After the French invasion in 1808 he sided at first with the invaders, but secretly sketched their atrocities, which resulted in both full-scale canvasses and numerous etchings. In 1824 he moved to Bordeaux where, in old age, he produced some of his finest genre paintings.

MOVEMENT

Spanish School

OTHER WORKS

Execution of the Defenders of Madrid; The Naked Maja

INFLUENCES

Anton Raphael Mengs, Tiepolo

Francisco Goya *Born* 1746 Fuendetodos, Spain

Painted in Madrid and Bordeaux

Died 1828 Bordeaux

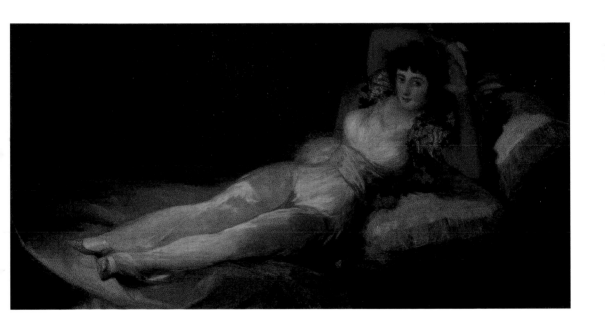

Constable, John

Lock on the Stour

Courtesy of Private Collection/Christie's Images

A pioneering British artist who, together with Turner, raised the status of landscape painting in England. Constable enjoyed a happy childhood in his native Suffolk and this region became the focus for most of his paintings. In Constable's day, however, landscape painting was a poorly paid profession and both his family and that of his lover, Maria Bicknell, were appalled by his choice of career. For many years, the couple were forced to meet in secret, until they eventually married in 1816. Constable's struggle for success was as difficult as his father had feared and, for a time, he was obliged to paint portraits for a living. In part, this was because he did not seek out romantic or picturesque views, but preferred to paint his local area, even though many regarded it as dull, agricultural land. He also paid unprecedented attention to atmospheric conditions, making copious sketches of individual clouds. These were so realistic that one critic joked that Constable's paintings always made him want to reach for his umbrella. Eventually, he found success with his 'six-footers' (i.e. six feet wide), gaining membership of the Royal Academy and winning a gold medal at the Paris Salon.

MOVEMENT

Romanticism

OTHER WORKS

The Hay Wain; Flatford Mill; Salisbury Cathedral

INFLUENCES

Thomas Gainsborough, Jacob van Ruisdael, Claude Lorrain

John Constable *Born* 1776, Suffolk, England

Painted in England

Died 1837

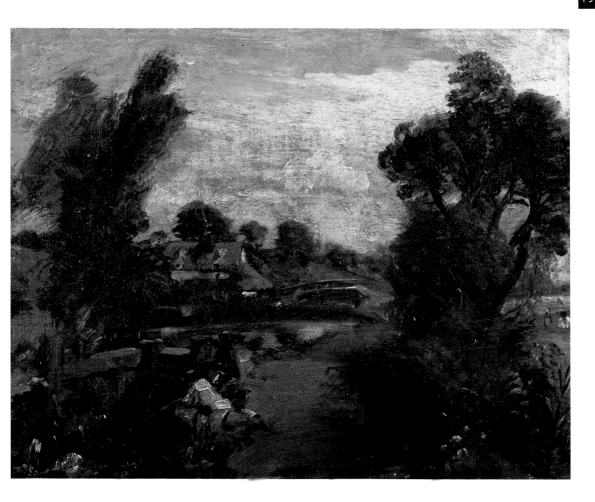

Ingres, Jean-Auguste-Dominique
Jupiter and Thetis, 1811

Courtesy of Private Collection/Christie's Images

French painter and draughtsman, a champion of academic art. Ingres' father was a minor painter and sculptor and, with parental encouragement, he displayed a talent for both drawing and music at a very early age. Opting for the former, he moved to Paris in 1797 and entered David's studio. There, inspired by his teacher and by Flaxman's engravings of antique vases, Ingres developed a meticulous Neo-classical style, notable for impeccable draughtsmanship and a smooth, enamel-like finish. This helped him to win the Prix de Rome in 1801 and brought him a succession of lucrative portrait commissions.

Ingres worked extensively in Italy after 1806, although he continued to exhibit at the Salon and rapidly became the epitome of the academic establishment. This was most obvious in the 1820s, when his pictures were contrasted with those of Delacroix, in the 'battle' between Classicism and Romanticism. While his style was a model of classical correctness, however, Ingres' subject matter was often distinctly Romantic. This is particularly evident in the exotic eroticism of Oriental scenes, such as *La Grande Odalisque* and *The Turkish Bath*.

MOVEMENT

Neoclassicism, Romanticism

OTHER WORKS

Madame Moitessier; The Apotheosis of Homer

INFLUENCES

David, Raphael, John Flaxman

Jean-Auguste-Dominique Ingres *Born* 1780

Painted in France and Italy

Died 1867

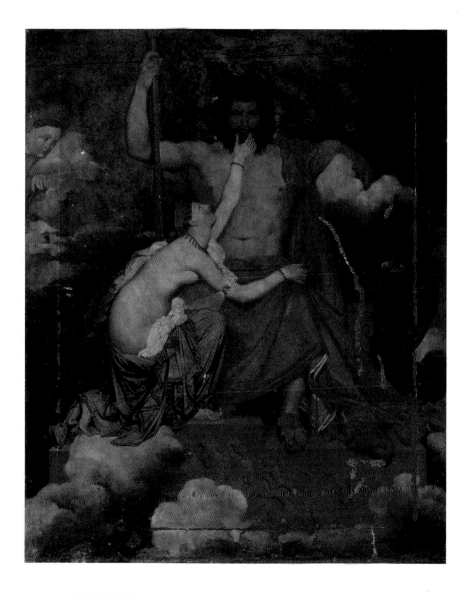

Cotman, John Sell
Fishing Boats off Yarmouth

Courtesy of Christie's Images/Bridgeman Art Library

John Sell Cotman received his art training in London before returning to his native Norwich in 1806, where he became the foremost watercolourist among the group of East Anglian artists who came to be known as the Norwich School. In the early years of the nineteenth century he travelled extensively in England and Wales and his best work belongs to this period. Although chiefly remembered for his work in this medium he also executed a number of fine oil paintings during the time he resided at Great Yarmouth from 1811–23. Failing in business, however, he was forced to sell all his paintings and etchings and return to London, where he obtained a position as drawing master at King's College. There is an uncompromisingly austere character to his landscapes, very much ahead of his time and not at all in step with the fashions prevailing in Regency England, but his handling of light and shade was to have a profound influence on his followers.

MOVEMENT

English Landscape School

OTHER WORKS

Greta Bridge; Chirk Aqueduct; Duncombe Park

INFLUENCES

Thomas Girtin, Turner

John Sell Cotman *Born* 1782, Norfolk, England

Painted in Norwich and London

Died 1842 London

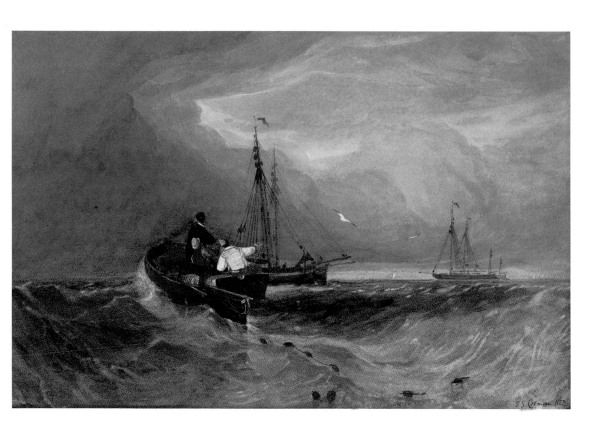

Turner, J. M. W.

The *Fighting Temeraire* Tugged to her Last Berth to be Broken up, before 1839

© National Gallery, London, UK/www.bridgeman.co.uk

Joseph Mallord William Turner entered the Royal Academy School in 1789 and began exhibiting the following year. He travelled all over England, filling sketch-books with drawings of scenery and landmarks which would later provide the raw material for his oils and watercolours. He collaborated with Girtin on a three-year watercolour project but later turned to oils. After his first trip to Italy in 1819 his paintings showed a marked Classical influence, and following his second trip in 1829 his art entered its greatest phase with paintings such as *Rain* and *Steam and Speed* (1844), which were the precursors of Impressionism. A solitary, rather reclusive man who never married, Turner bequeathed over 300 oils and some 20,000 watercolours and drawings to the nation. A prolific artist, he ranks with Constable as one of the greatest British landscape painters of all time and his career marks a turning-point in the development of modern British art.

MOVEMENT

English School

OTHER WORKS

Norham Castle; Sunrise with Sea Monsters

INFLUENCES

Claude Lorraine

J. M. W. Turner *Born* 1775 London, England

Painted in England

Died 1851 London

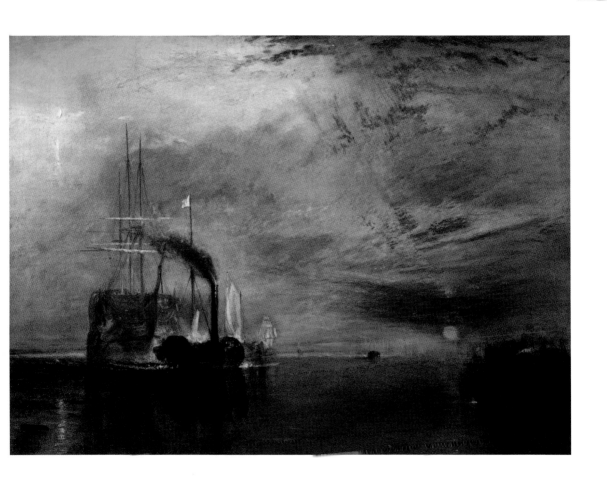

Friedrich, Caspar David

The Wanderer above the Sea of Clouds, 1818

Courtesy of Hamburg Kunsthalle, Hamburg, Germany/Bridgeman Art Library

Caspar David Friedrich studied drawing under J. G. Quistorp in Greifswald before going to the Copenhagen Academy between 1794–98. On his return to Germany he settled in Dresden, where he spent the rest of his life. His drawings in pen and ink were admired by Goethe and won him a Weimar Art Society prize in 1805. His first major commission came two years later in the form of an altarpiece for Count Thun's castle in Teschen, Silesia, entitled *Crucifixion in Mountain Scenery*. This set the tone of many later works, in which dramatic landscapes expressed moods, emotions and atmosphere. Appointed a professor of the Dresden Academy in 1824, he influenced many of the young German and Scandinavian artists of the mid-nineteenth century and as a result he ranks high among the formative figures of the Romantic movement. For many years his works were neglected, but in the early 1900s they were rediscovered and revived.

MOVEMENT

Romanticism

OTHER WORKS

The Wreck of the Hope; The Stages of Life; Graveyard in Snow

INFLUENCES

Albrecht Altdorfer, Turner

Caspar David Friedrich *Born* 1774 Germany

Painted in Dresden, Germany

Died 1840 Dresden

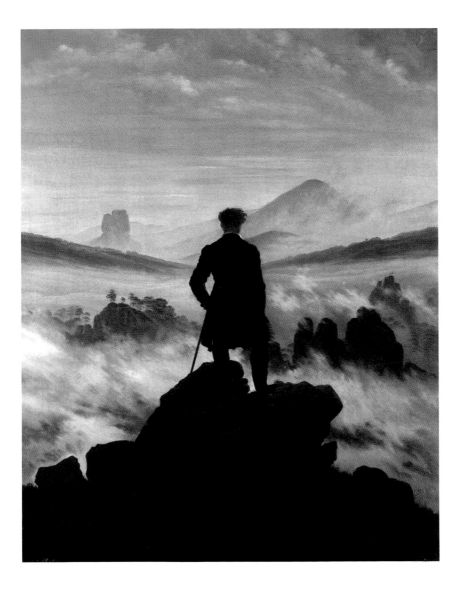

Géricault, Théodore

Homme Nu a Mi-Corps (Man Naked to the Waist)

Courtesy of Private Collection/Christie's Images

Jean Louis André Théodore Géricault studied under Carle Vernet and Pierre Narcisse Guérin, although he was frequently at odds with the latter because of his passion for Rubens and his unconventional approach in interpreting nature. He made his debut at the Salon of 1812 with his spirited portrait of a cavalry officer on horseback, and followed this with the *Wounded Cuirassier* in 1814, subjects which were immensely popular at the height of the Napoleonic Empire. During the Hundred Days, he served as a volunteer in a Royalist regiment, witnessing soldiers and horses at close quarters. He travelled and studied in Italy from 1816–19, and on his return to Paris embarked on the large-scale works which established his reputation as one of the leading French Romantics. For an artist renowned for his equestrian subjects it is ironic that he died as the result of a fall from his horse.

MOVEMENT

Romanticism

OTHER WORKS

Officer of the Hussars; Coirse des Chevaux Libres

INFLUENCES

Carle Vernet, Pierre Narcisse Guérin

Théodore Géricault *Born* 1791 Rouen, France

Painted in Paris

Died 1824 Rouen

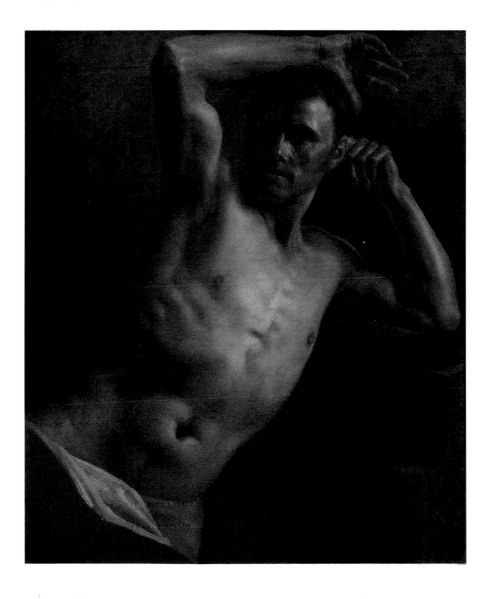

Hokusai, Katsushika

In the Well of the Great Wave, 1823-29

Courtesy of Private Collection/Christie's Images

Born at Edo (now Tokyo), the son of a mirror maker, Hokusai learned the craft of wood-engraving before entering the studio of the painter Katsugawa Shunsho. Disagreement with his master over artistic techniques and principles resulted in his dismissal in 1785. Thereafter he worked on his own as a book illustrator and print maker, using the Japanese techniques of block printing. His illustrations of everyday life executed for the encyclopaedic Mangwa established his reputation as the leading exponent of ukiyo-e ('pictures of the passing world') whose charm is exceeded only by their technical accomplishment. Of his prolific series of colour prints, the best known are *Thirty-six Views of Mount Fuji* (1823–29) and *Hundred Views of Mount Fuji* (1834–35), but he also produced several shorter sets and individual works. His prints had a tremendous impact on the Western world. Quite by chance, some of his prints were used as packing material for some china sent to Felix Bracquemond in 1856, triggering off the enthusiasm for Japanese art which strongly influenced the Impressionists.

MOVEMENT

Ukiyo-e

OTHER WORKS

The Dream of the Fisherman's Wife

INFLUENCES

Hishikawa Moronobu, Ando Hiroshige

Katsushika Hokusai *Born* 1760 Edo (now Tokyo), Japan

Painted in Edo

Died 1849 Edo

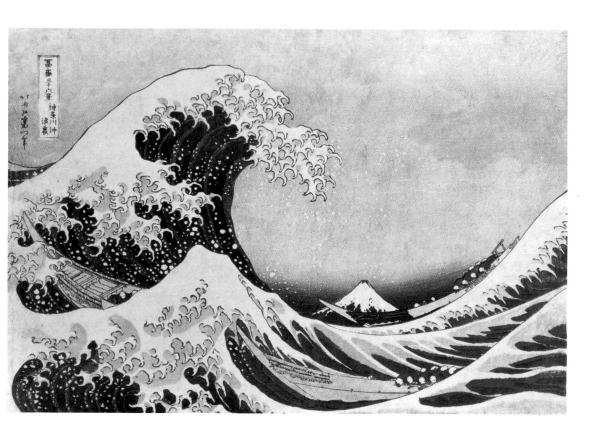

Cole, Thomas
Mountain Sunrise, 1826

Courtesy of Private Collection/Christie's Images

Born in Lancashire, England, Thomas Cole served his apprenticeship as an engraver of textile designs for calico printing. He emigrated with his family in 1818 and worked briefly as an engraver in Philadelphia before settling in Steubenville, Ohio, where he took lessons from an unknown travelling artist. In 1823 he returned to Philadelphia and enrolled at the Pennsylvania Academy of Fine Arts, then moved to New York in 1825. He began sketching along the Hudson River and through the Catskill Mountains, and his paintings of the American wilderness brought him fame and fortune. In 1829–32 he travelled all over Europe painting landscapes and classical ruins. On his return to New York he embarked on a colossal project – a series of large paintings that would chronicle the rise and fall of civilization. He took immense pride in his allegories and deprecated the landscapes which made his fortune and on which his reputation still rests.

MOVEMENT

Hudson River School

OTHER WORKS

Expulsion from the Garden of Eden; The Course of Empire

INFLUENCES

Washington Alliston

Thomas Cole *Born* 1801, Lancashire, England

Painted in North America and Europe

Died 1848 Catskill, New York, USA

Hiroshige, Ando

Nagakubo, c. 1830s

Courtesy of Private Collection/Christie's Images

Hiroshige's family name was Ando Tokitaro, but according to the custom of the time, his professional name was derived from the fact that he was a pupil of Toyohiro. He was a child prodigy, whose sketch of a procession, drawn at the age of 10, was regarded as one of the marvels of the Japanese capital in the early nineteenth century. On the death of his master in 1828, Hiroshige established his own studio but, discouraged by the lack of custom, he moved to Kyoto where he produced a series of landscapes. Returning to Edo (now Tokyo) he became immensely popular and widely imitated. His landscapes in the style of Hokusai (whom he greatly admired) were executed as prints with clearly incised lines and solid blocks of colour which featured every aspect of the scenery along the Tokaido road linking Edo to Kyoto, as well as landmarks in and around the cities where he worked.

MOVEMENT

Ukiyo-e

OTHER WORKS

Moonlight at Nagakubo; Fifty-Three Stages of the Tokaido

INFLUENCES

Hokusai

Ando Hiroshige *Born* 1797 Edo (Tokyo), Japan

Painted in Edo and Kyoto, Japan

Died 1858

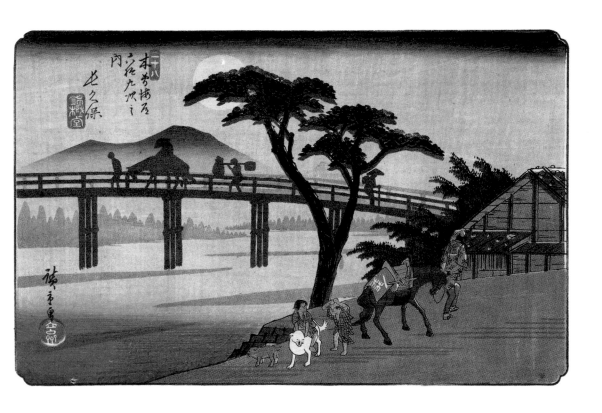

Delacroix, Eugène
Le Puits de la Casbah Tanger

Courtesy of Private Collection/Christie's Images

A champion of the Romantic cause, Delacroix was legally the son of a politician but in reality he was probably the illegitimate child of Talleyrand, a celebrated diplomat. He trained under Guérin, a respected Neoclassical painter, but the dominant influence on his style came from Géricault, a fellow pupil. Delacroix watched the latter creating *The Raft of the Medusa*, one of the seminal works of the Romantic movement, and was overwhelmed by its raw, emotional power. He swiftly began to emulate this in his own canvasses, achieving his breakthrough with *The Massacre of Chios*.

Critics attacked Delacroix for his apparent fixation with violence and his lack of finish. They accused him of wallowing in scenes of brutality, rather than acts of heroism. In addition, they denounced his pictures as 'sketches', because he abandoned the smooth, linear finish of the Neoclassical style, preferring to build up his compositions with small dabs of colour. Like most Romantics, Delacroix was fascinated with the exotic but, unusually, he actually visited the Arab world. As a result, his Orientalist paintings were more sober and realistic than most European fantasies.

MOVEMENT

Romanticism

OTHER WORKS

The Massacre at Chios; Women of Algiers; The Death of Sardanapalus

INFLUENCES

Rubens, Géricault, Constable

Eugène Delacroix *Born* 1798

Painted in France, England, Morocco, Spain, Algeria

Died 1863

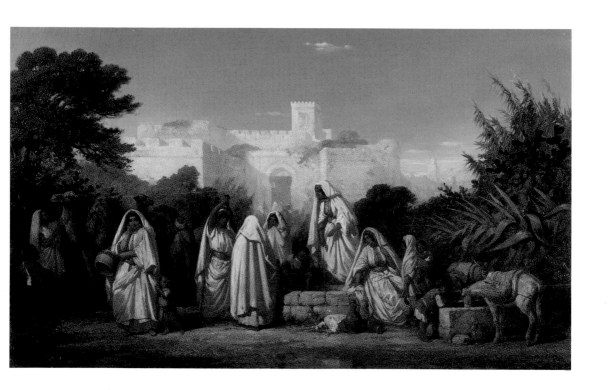

Landseer, Sir Edwin
Saint Bernard Dogs

Courtesy of Private Collection, Christie's Images

Edwin Henry Landseer was taught by his father to sketch animals from life. From the age of 13 he exhibited at the Royal Academy and became one of the most fashionable painters of the mid-Victorian period, specializing in pictures of dogs with humanoid expressions and deer, usually set in misty, romantic Highland glens or moorland made popular by the novels of Sir Walter Scott and Queen Victoria's passion for Balmoral. Landseer's paintings attained even wider prominence as a result of the fine engravings of them produced by his brother Thomas. One of the Queen's favourite artists, he was knighted in 1850. He modelled the four lions, cast in bronze, which sit at the foot of Nelson's Column in Trafalgar Square, London, unveiled in 1867. Landseer's posthumous reputation was dented by accusations of sentimentalizing animals and, in more recent years, of political incorrectness in glorifying blood sports, but he wielded enormous influence on a later generation of British artists.

MOVEMENT

English School

OTHER WORKS

Monarch of the Glen; The Old Shepherd's Chief Mourner

INFLUENCES

George Stubbs

Sir Edwin Landseer *Born* 1802 London

Painted in London

Died 1873 London

Rousseau, Théodore

A Wooded Landscape at Sunset with a Faggot Gatherer

Courtesy of Christie's Images

A French landscape painter, Rousseau is hailed as the leader of the Barbizon School. The son of a clothier, Rousseau developed a deep love of the countryside at an early age. After working briefly in a sawmill, he decided to take up landscape painting and trained with Joseph Rémond. The latter produced classical landscapes, however, and Rousseau's naturalistic tendencies were better served by the study of foreign artists, such as Ruisdael and Constable. He adapted the practice of making sketches outdoor – a foretaste of Impressionism – although he still preferred to finish his paintings in the studio.

Rousseau's favourite location was the Barbizon region, at the edge of the Forest of Fontainebleau. By the late 1840s, this area had become the focus for a group of like-minded artists known as the Barbizon School. Headed by Rousseau, this circle included Corot, Daubigny, Diaz and Millet. In the 1850s, Rousseau's work achieved widespread recognition, fetching high prices, but he preferred to remain in Barbizon, campaigning to preserve the character of the forest. He died in his cottage, in the arms of fellow landscapist Jean-François Millet.

MOVEMENT

Barbizon School

OTHER WORKS

Edge of a Forest – Sunset; Farm in the Landes

INFLUENCES

Jacob van Ruisdael, Constable

Théodore Rousseau *Born* 1812 Paris, France

Painted in France

Died 1867 Paris

19th Century

The Era of Impressionism

Courbet, Gustave

Bonjour Monsieur Courbet, 1854

Courtesy of Musée Fabre, Montpelier, France/Bridgeman Art Library

A French painter, Courbet was the leader of the Realist movement. Born at Ornans in the Jura region, Courbet remained fiercely loyal to this area throughout his life, featuring it prominently in his paintings. Although he later claimed to be self-taught, he actually studied under a succession of minor artists, but learned more from copying old masters in the Louvre. Initially, Courbet aimed for conventional success by exhibiting at the Salon, even winning a gold medal for his 1849 entry. After he showed *The Burial at Ornans*, however, official approval evaporated. Instead, this landmark realist picture was savagely criticized for being too large, too ugly and too meaningless. Worse still, in the light of the recent 1848 Revolution, the artist was suspected of having a political agenda.

Courbet revelled in the furore. In the following years, he gained greater recognition abroad, but remained antagonistic towards the French Establishment. He refused to exhibit at the 1855 World Fair, turned down the offer of a Legion of Honour and served as a Councillor in the Paris Commune. The latter proved his undoing and he was forced to spend his final years exiled in Switzerland.

MOVEMENT

Realism

OTHER WORKS

The Painter's Studio; The Bathers

INFLUENCES

The Le Nain brothers, Velázquez, Millet

Gustave Courbet *Born* 1819 France

Painted in France, Switzerland and Germany

Died 1877

Corot, Jean-Baptiste-Camille
Etretat Un Moulin à Vent, 1855

Courtesy of Private Collection/Christie's Images

Corot, a French painter, specialized in landscapes in the classical tradition. Born in Paris, Corot was the son of a cloth merchant and initially followed his father's trade. For a time, he worked at The Caliph of Bagdad, a luxury fabric shop. Turning to art, he trained under Michallon and Bertin, both of whom were renowned for their classical landscapes. Indeed, Michallon was the first winner of the Historical Landscape category in the Prix de Rome, when it was introduced in 1817. This genre, which Corot was to make his own, consisted of idealized views, set in the ancient, classical world, and was inspired by the 17th century paintings of Poussin and Claude Lorrain.

Corot's distinctive style stemmed from his unique blend of modern and traditional techniques. Each summer, he made lengthy sketching trips around Europe, working these studies up into paintings in the winter, in his Paris studio. He combined this traditional practice with a fascination for the latest developments in photography. The shimmering appearance of his foliage, for example, was inspired by the *halation* or blurring effects, which could be found in contemporary photographs.

MOVEMENT

Romanticism, Barbizon School

OTHER WORKS

The Bridge at Narni; Gust of Wind; Recollection of Mortefontaine

INFLUENCES

Achille-Etna Michallon, Claude Lorrain, Constable

Jean-Baptiste-Camille Corot *Born* 1796

Painted in France, Italy, Switzerland, England and the Low Countries

Died 1875

Millet, Jean-François

La Cardeuse, c. 1858

Courtesy of Private Collection/Christie's Images

Millet was born near the city of Cherbourg, which granted him a scholarship to train in Paris, under Delaroche. His early paintings were mainly portraits or pastoral idylls, but by the 1840s he was producing more naturalistic scenes of the countryside. These drew on his own experience, since he came from peasant stock, but the pictures disturbed some critics, because of their unglamorous view of rustic life.

In the 1850s Millet's work attracted genuine hostility. In part, this was due to fears that his paintings were political. Memories of the 1848 Revolution were still very fresh, and the authorities were nervous about any images with socialist overtones. Millet declined to express his political views, but *The Gleaners*, for example, was a compelling portrait of rural poverty. Some critics also linked his work with the Realist movement, launched by Courbet, which was widely seen as an attack on the academic establishment.

After 1849, Millet was mainly based at Barbizon, where he befriended Rousseau and other members of the Barbizon School. Under their influence, he devoted the latter part of his career to landscape painting.

MOVEMENTS

Naturalism, Barbizon School

OTHER WORKS

The Winnower; Man with a Hoe

INFLUENCES

Rousseau, the Le Nain brothers, Gustave Courbert

Jean-François Millet *Born* 1814 France

Painted in France

Died 1875 France

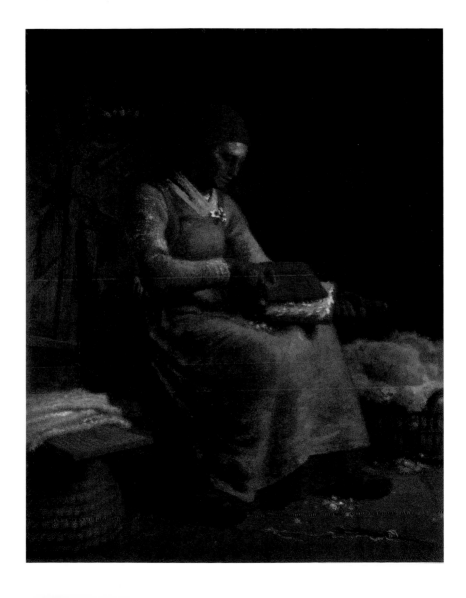

Palmer, Samuel

Illustrations to Milton's Lycidas, *c.* 1864

Courtesy of Private Collection/Christie's Images

Born in London, the son of an eccentric bookseller, Palmer revealed his artistic talent at a very early stage. In 1819, aged just 14, he exhibited at the Royal Academy and the British Institution, selling a painting at the latter. Three years later he met the painter John Linnell, who gave him some instruction. More importantly, perhaps, Linnell also introduced Palmer to William Blake – a meeting which only served to intensify the youngster's mystical outlook.

In 1824, the same year as his encounter with Blake, Palmer started painting at Shoreham in Kent. In this rural retreat, he began to produce the strange, pastoral idylls, which made his name. Using nothing more than ink and a sepia wash, he conjured up a worldly paradise, stocked with dozing shepherds, carefree animals and luxuriant foliage. In 1826, Palmer settled in Shoreham, where he was soon joined by a group of like-minded artists, who came to be known as the Ancients. Sadly, Palmer's period of poetic inspiration was short-lived. By the mid-1830s, his paintings had become disappointingly conventional, although his etchings retained some of his earlier, lyrical power.

MOVEMENTS

Romanticism, the Ancients

OTHER WORKS

The Sleeping Shepherd; Coming from Evening Church

INFLUENCES

William Blake, John Linnell, Edward Calvert

Samuel Palmer *Born* 1805 London, England

Painted in England and Italy

Died 1881

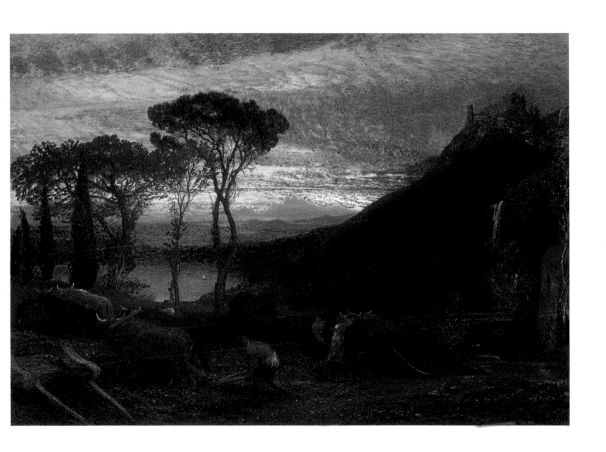

Rossetti, Dante Gabriel

Reverie, 1868

Courtesy of Christie's Images

Rossetti came from a hugely talented family. His father was a noted scholar while his sister Christina became a celebrated poet. For years Dante wavered between a career in art or literature, before devoting himself to painting. While still only 20, he helped to found the Pre-Raphaelite Brotherhood, the radical group that shook the Victorian art world with their controversial exhibits at the Royal Academy in 1848. The Pre-Raphaelites were appalled by the dominant influence of sterile, academic art, which they linked with the teachings of Raphael – then regarded as the greatest Western painter. In its place, they called for a return to the purity and simplicity of medieval and early Renaissance art.

Although championed by the critic Ruskin the Pre-Raphaelites' efforts were greeted with derision and this discouraged Rossetti from exhibiting again. During the 1850s, he concentrated largely on watercolours, but in the following decade he began producing sensuous oils of women. These were given exotic and mysterious titles, such as *Monna Vanna* and were effectively the precursors of the *femmes fatales*, which were so admired by the Symbolists.

MOVEMENT

Pre-Raphaelite Brotherhood

OTHER WORKS

Beata Beatrix; Proserpine

INFLUENCES

Ford Madox Brown, William Bell Scott

Dante Gabriel Rossetti *Born* 1828

Painted in England

Died 1882

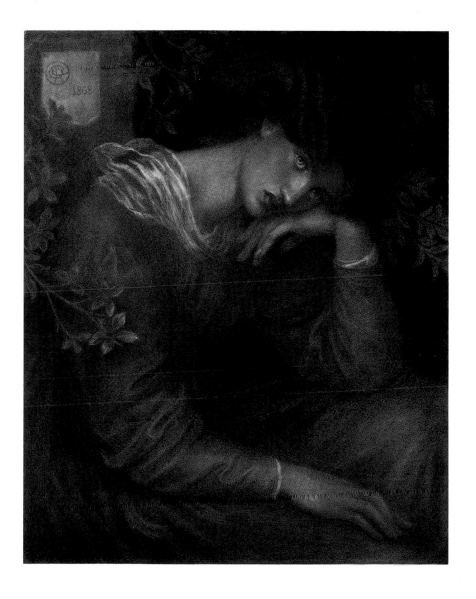

Burne-Jones, Sir Edward
The Prince Enters the Briar Wood, 1869

Courtesy of Private Collection/Christie's Images

Edward Coley Burne-Jones studied at Oxford where he met William Morris and Dante Gabriel Rossetti, who persuaded him to give up his original intention of entering holy orders and concentrate on painting instead. He was also heavily influenced by the art critic John Ruskin, who introduced him to the paintings of the Pre-Raphaelites and with whom he travelled to Italy in 1862. On his return to England he embarked on a series of canvasses that echoed the styles of Botticelli and Mantegna, adapted to his own brand of dreamy mysticism in subjects derived from Greek mythology, Arthurian legend and medieval romance. Burne-Jones, made a baronet in 1894, was closely associated with the Arts and Crafts movement, designing tapestries and stained glass for William Morris, as well as being a prolific book illustrator.

MOVEMENT

Romanticism and Mannerism

OTHER WORKS

King Cophetua and the Beggar Maid; The Beguiling of Merlin

INFLUENCES

Botticelli, Mantegna, Pre-Raphaelites

Sir Edward Burne-Jones *Born* 1833 Birmingham, England

Painted in England

Died 1898 London, England

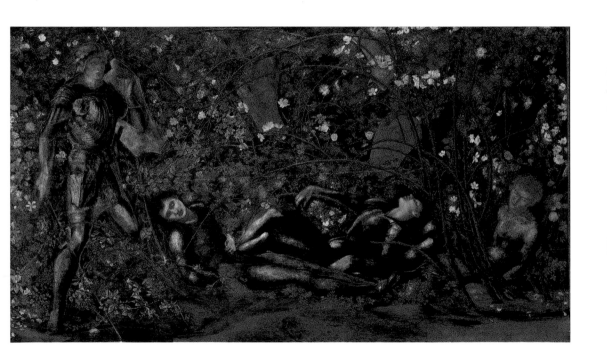

Whistler, James

Arrangement in Flesh Colour and Grey

Courtesy of Christie's Images

James Abbott McNeill Whistler was originally intended for a career in the army and studied at West Point from 1851 to 1854, then worked for a year as a Navy map-maker before going to Paris to take up art instead. He met Courbet and Fantin-Latour, and joined their group of Realist painters. He copied paintings in the Louvre and fell in love with Japanese art, which was then a novelty. In 1859 he settled in London, where he began painting in a style which combined these influences rather than following the English narrative convention. He strove to present a harmonious composition of tone and colour, doing in paint what a composer might do in music. This analogy was evident in the titles of these paintings, which Whistler called *Nocturnes*. Not surprisingly, his work got a very mixed reception, John Ruskin being his most vociferous critic and accusing him of "flinging a pot of paint in the public's face". Nevertheless his views gradually gained ground and influenced the next generation of British artists.

MOVEMENT

Realism

OTHER WORKS

Nocturne in Blue and Gold; Old Battersea Bridge

INFLUENCES

Gustave Courbet, Henri Fantin-Latour

James Whistler *Born* 1834 Massachusetts, USA

Painted in Paris and London

Died 1903 London

Homer, Winslow

Picking Flowers

Courtesy of Private Collection/Christie's Images

Born at Boston, Massachusetts, Winslow Homer served his apprenticeship there as a lithographer, but following the outbreak of the American Civil War he accompanied the Union forces and contributed sketches from the battlefront to *Harper's Weekly* as well as executing his earliest full-scale paintings, *Home Sweet Home* and *Prisoners from the Front*. He spent two years (1881–83) in England, mainly at Tynemouth, painting nautical subjects. Following his return to the USA he continued to paint the sea – apart from occasional genre subjects such as *The Fox Hunt*. During the last two decades of his life he lived at Prout's Neck on the coast of Maine, where he concentrated on watercolours of fishermen in the eternal struggle against the elements. Occasional forays to Florida, the Bahamas and Bermuda provided more exotic material but invariably with a maritime theme.

MOVEMENT

American School

OTHER WORKS

The Gulf Stream; Fishing Boats at Key West; Bearing Up

INFLUENCES

John Frederick Kensett, Fitz Hugh Lane

Winslow Homer *Born* 1836 Boston, USA

Painted in USA and England

Died 1910 Maine, USA

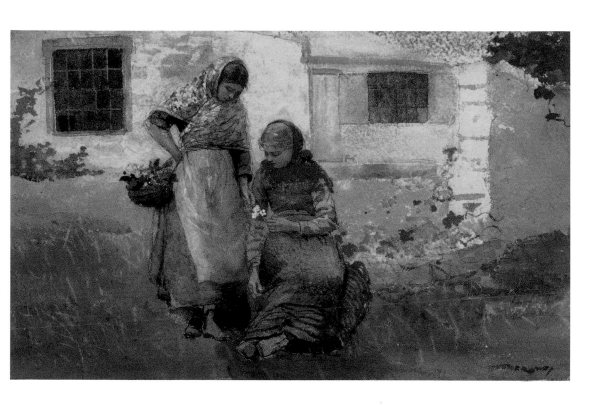

Morisot, Berthe
Enfant dans les Roses Trémières

Courtesy of Private Collection/Christie's Images

One of the leading female Impressionists. The daughter of a high-ranking civil servant, Morisot received art lessons from Corot. Then in 1859, she met Fantin-Latour, who would later introduce her to future members of the Impressionist circle. Before this, she had already made her mark at the Salon, winning favourable reviews for two landscapes shown at the 1864 exhibition. Conventional success beckoned, but a meeting with Manet in 1868 altered the course of Morisot's career. She was strongly influenced by his radical style, and appeared as a model in several of his paintings. For her part, she also had an impact on Manet's art, by persuading him to experiment with *plein-air* painting. The close links between the two artists were further reinforced when Morisot married Manet's brother in 1874.

Morisot proved to be one of the most committed members of the Impressionist group, exhibiting in all but one of their shows. She concentrated principally on quiet, domestic scenes, typified by *The Cradle*, which depicts her sister Edma with her newborn child. These canvasses displayed Morisot's gift for spontaneous brushwork and her feeling for the different nuances of light.

MOVEMENT
Impressionism

OTHER WORKS
Summer's Day; The Lake in the Bois de Boulogne

INFLUENCES
Manet, Renoir, Corot

Berthe Morisot *Born* 1841
Painted in France and England

Died 1895

Eakins, Thomas
The Gross Clinic, 1875

Courtesy of Jefferson College, Philadelphia, PA, USA/Bridgeman Art Library

Thomas Eakins studied at the Pennsylvania Academy of Fine Arts and took anatomy at Jefferson Medical College before going to Paris to study under J. L. Gérôme and Léon Bonnat at the École des Beaux-Arts. On his return to Philadelphia in 1870 he established his studio, later working as Professor of Anatomy at the Pennsylvania Academy of Fine Arts. In addition to figures, he painted numerous genre scenes, such as *Chess Players*, which was critically acclaimed when exhibited at the Centennial Exposition of 1876. His greatest masterpiece, illustrated here, shows his mastery of portraiture and anatomy as the eminent surgeon Professor Gross demonstrates an operation to a group of medical students. Eakins also excelled as a sculptor and many of his paintings have a sculptural quality. He painted athletes and sportsmen, African Americans and rural subjects.

MOVEMENT

American School

OTHER WORKS

The Swimming Hole; Max Schmitt in a Single Scull

INFLUENCES

Jean Léon Gérôme, Léon Bonnat

Thomas Eakins *Born* 1844, Philadelphia, USA

Painted in Philadelphia and France

Died 1916

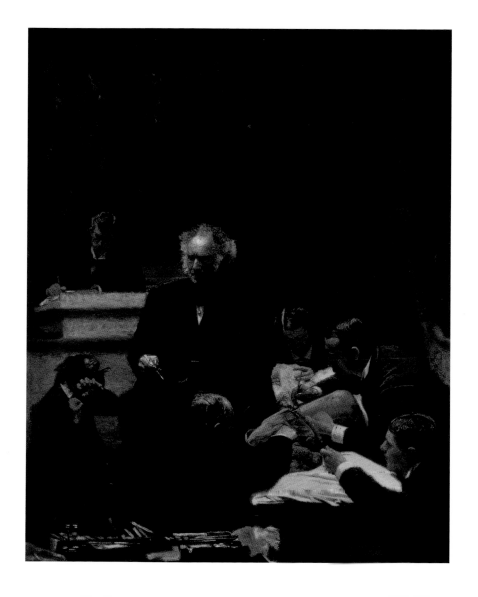

Rousseau, Henri

Vue de L'isle Saint-Louis, Prise du Port Saint-Nicolas Le Soir

Courtesy of Private Collection/Christie's Images

French painter, perhaps the most famous of all Naïve artists. Rousseau came from a poor background and he went through a succession of menial jobs, before turning to art late in life. Among other things he was a clerk, a soldier and a toll-collector. While working as the latter, he began painting as a hobby and, in 1893, he took early retirement, in order to pursue his artistic ambitions. Rousseau was entirely self-taught, although he did take advice from academic artists such as Clément and Gérôme. He copied many of the individual elements in his pictures from book illustrations, using a mechanical device called a pantograph. But it was his dreamlike combination of images and his intuitive sense of colour which gave his art its unique appeal. Rousseau began exhibiting his paintings from the mid-1880s, using avant-garde bodies such as the Salon des Indépendants, for the simple reason that they had no selection committee. He never achieved great success, but his guileless personality won him many friends in the art world, among them Picasso, Apollinaire and Delaunay. Posthumously, his work was an important influence on the Surrealists.

MOVEMENT

Naïve Art

OTHER WORKS

Surprised! (Tropical Storm with a Tiger); The Sleeping Gypsy

INFLUENCES

Jean-Léon Gérôme, Félix Clément

Henri Rousseau *Born* 1844 France

Painted in France

Died 1910 Paris, France .

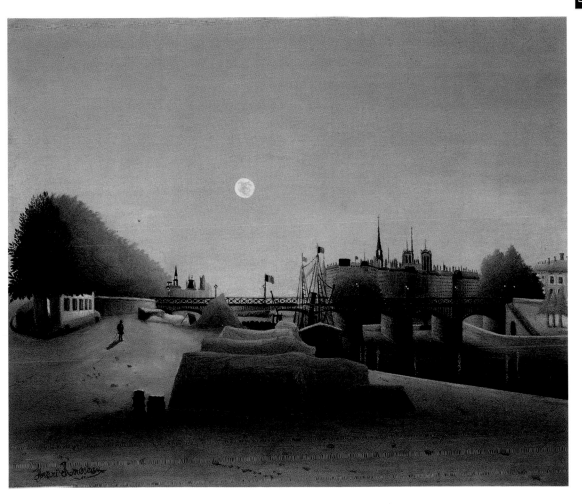

Degas, Edgar
Danseuses Vertes, 1878

Courtesy of Private Collection/Christie's Images

French painter and graphic artist, one of the leading members of the Impressionist circle. Originally destined for the law, Degas' early artistic inspiration came from the Neoclassical painter Ingres – who taught him the value of sound draughtsmanship – and from his study of the old masters. However, he changed direction dramatically after a chance meeting with Manet in 1861. Manet introduced him to the Impressionist circle and, in spite of his somewhat aloof manner, Degas was welcomed into the group, participating in most of their shows.

Degas was not a typical Impressionist, having little enthusiasm for either landscape or *plein-air* painting but he was, nevertheless, extremely interested in capturing the spontaneity of a momentary image. Where most artists sought to present a well-constructed composition, Degas wanted his pictures to look like an uncomposed snapshot; he often showed figures from behind or bisected by the picture frame. Similarly, when using models, he tried to avoid aesthetic, classical poses, preferring to show them yawning, stretching or carrying out mundane tasks. These techniques are seen to best effect in Degas' two favourite subjects: scenes from the ballet and horse-racing.

MOVEMENT

Impressionism

OTHER WORKS

The Dancing Class; Carriage at the Races; Absinthe

INFLUENCES

Jean-Auguste-Dominique Ingres, Edouard Manet

Edgar Degas *Born* 1834 France

Painted in France, USA and Italy

Died 1917

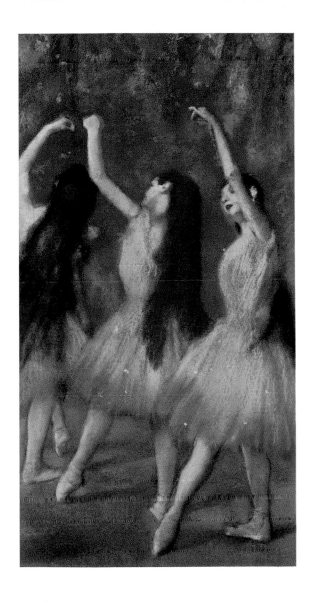

Manet, Edouard

La Rue Mosnier aux Drapeaux, 1878

Courtesy of Getty Museum/Christie's Images

Influential French painter, regarded by many as the inspirational force behind the Impressionist movement. Coming from a wealthy family, Manet trained under the history painter Couture, but was chiefly influenced by his study of the Old Masters, particularly Velázquez. His aim was to achieve conventional success through the Salon, but ironically two controversial pictures cast him in the role of artistic rebel. *Le Déjeuner sur l'Herbe* and *Olympia* were both updated versions of Renaissance masterpieces, but the combination of classical nudes and a modern context scandalized Parisian critics. This very modernity, however, appealed strongly to a group of younger artists, who were determined to paint scenes of modern life, rather than subjects from the past. This circle of friends who gathered around Manet at the Café Guerbois were to become the Impressionists.

Manet was equivocal about the new movement. He enjoyed the attention of his protégés, but still hoped for official success and, as a result, did not participate in the Impressionist exhibitions. Even so, he was eventually persuaded to try open-air painting, and his later pictures display a lighter palette and a freer touch.

MOVEMENTS

Realism, Impressionism

OTHER WORKS

A Bar at the Folies-Bergère

INFLUENCES

Velázquez, Gustave Courbet

Edouard Manet *Born* 1832 France

Painted in France

Died 1883 France

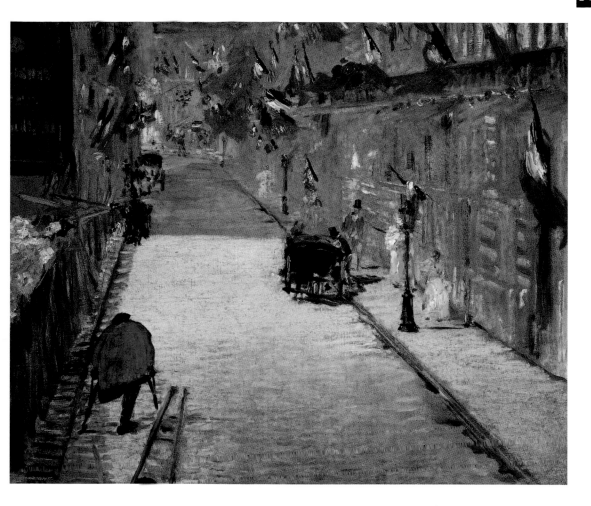

Renoir, Pierre-Auguste
Les Baigneuses

Courtesy of Private Collection/Christie's Images

French Impressionist. Born in Limoges, Renoir trained as a porcelain-painter before entering the studio of Gleyre in 1862. He learnt little from this master, but did meet future members of the Impressionist circle who were fellow-pupils. Together they attended the meetings at the Café Guerbois, where Manet held court. Initially, Renoir was particularly close to Monet and the pair often painted side by side on the River Seine. Although both were desperately poor, these early, apparently carefree pictures are often cited as the purest distillation of Impressionist principles.

Renoir participated at four of the Impressionist shows, but gradually distanced himself from the movement. This was partly because of his growing success as a portraitist, and partly because he had never lost his affection for Old Masters such as Rubens and Boucher. In the early 1880s, he reached a watershed in his career. He married Aline Charigot, one of his models, and travelled widely in Europe and North Africa, reaffirming his taste for the art of the past. In his subsequent work, he moved away from traditional Impressionist themes, concentrating instead on sumptuous nudes.

MOVEMENT

Impressionism

OTHER WORKS

The Luncheon of the Boating Party; The Bathers; The Umbrellas,

INFLUENCES

Monet, François Boucher, Rubens

Pierre-Auguste Renoir *Born* 1841 France

Painted in France

Died 1919

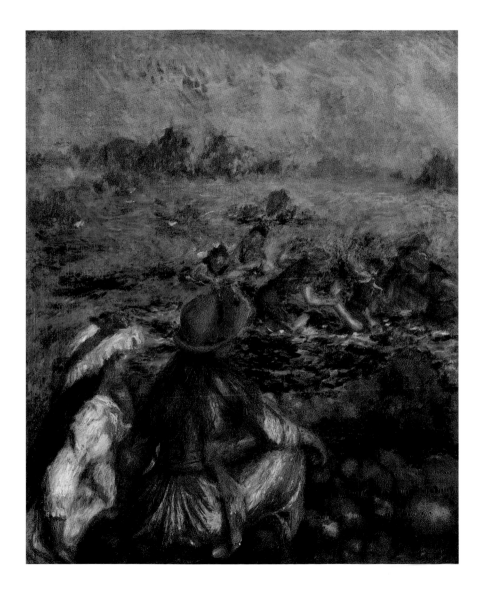

Sisley, Alfred

Le Barrage de Saint Mammes, 1885

Courtesy of Private Collection/Christie's Images

Born in Paris of English parents, Alfred Sisley had a conventional art education in Paris and at first was strongly influenced by Corot. In 1862 he entered the studio of Charles Gleyre, where he was a fellow pupil with Monet and Renoir, whom he joined on sketching and painting expeditions to Fontainebleau. The range of colours employed by Sisley lightened significantly under the influence of his companions. From 1874 onwards he exhibited regularly with the Impressionists and is regarded as the painter who remained most steadfast to the aims and ideals of that movement. The vast majority of his works are landscapes, drawing on the valleys of the Loire, Seine and Thames for most of his subjects. Sisley revelled in the subtleties of cloud formations and the effects of light, especially in the darting reflection of water. Hopeless at the business aspects of his art and largely dependent on his father for money, Sisley spent his last years in great poverty. Like Van Gogh, interest in his paintings only developed after his death.

MOVEMENT

Impressionism

OTHER WORKS

Wooden Bridge at Argenteuil; Snow at Veneux-Nadon

INFLUENCES

Corot, Paul Renoir, Monet, Charles Gleyre

Alfred Sisley *Born* 1839 Paris, France

Painted in France and England

Died 1899 Moret-sur-Loing, France

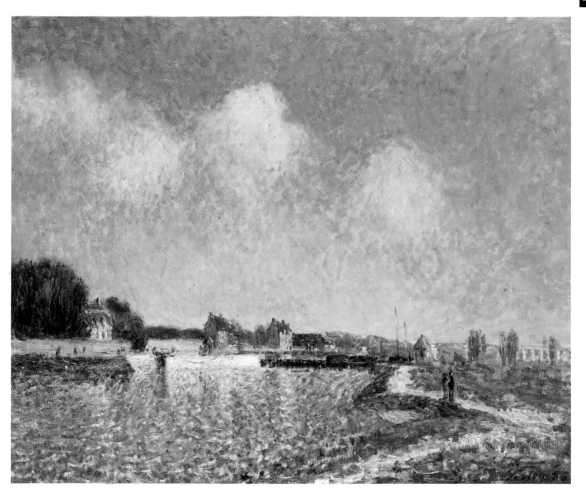

Alma-Tadema, Sir Lawrence

Roses of Heliogabalus, 1888

Courtesy of Private Collection/Christie's Images

Lawrence Alma-Tadema trained at the Antwerp Academy of Art and later studied under Baron Hendryk Leys, an artist noted for his large historical paintings. In 1863 Alma-Tadema went to Italy, whose classical remains, notably at Pompeii, exerted a great influence on him. He moved to England in 1870, where he built up a reputation for narrative paintings in the Classical style. He was knighted in 1899. Three years later he visited Egypt and the impact of Pharaonic civilization had a major impact on the works of his last years. His large paintings brought everyday scenes of long-dead civilizations vividly to life through his extraordinary mastery of detail. He amassed a vast collection of ancient artefacts, photographs and sketches from his travels; the visual aids that enabled him to recreate the ancient world.

MOVEMENT

Neoclassical

OTHER WORKS

The Finding of Moses; The Conversion of Paula

INFLUENCES

Baron Hendryk Leys

Sir Lawrence Alma-Tadema *Born* 1836 Dronrijp, Holland

Painted in Holland, England

Died 1912 Wiesbaden, Germany

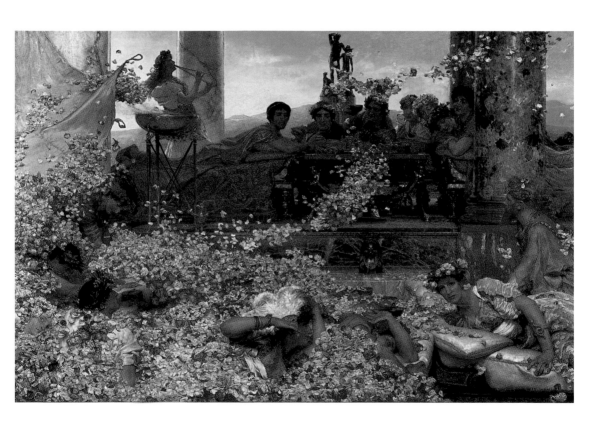

Pissarro, Camille
Jeune Paysanne à sa Toilette, 1888

Courtesy of Private Collection/Christie's Images

French painter, one of the founding fathers of Impressionism. Born at St Thomas in the West Indies, Pissarro was schooled in Paris and enjoyed a brief interlude in Venezuela, before eventually settling in France in 1855. There, he was initially influenced by Corot, whose landscapes he admired at the Universal Exhibition. He also studied at the Académie Suisse, where he met Monet, who introduced him to the future Impressionist circle at the Café Guerbois. Pissarro remained in close contact with Monet in 1870–71, when both men took refuge in London during the Franco-Prussian War.

Pissarro was slightly older than the other Impressionists and this, together with his ability as a teacher, enabled him to assume a guru-like authority within the group. In the mid-1880s, Pissarro flirted briefly with Seurat's Neo-Impressionist techniques, before reverting to his traditional style. In later years, he had increasing trouble with his eyesight and could no longer paint out of doors. Instead, he took to painting lively street scenes from rented hotel rooms. His son Lucien also became a successful artist.

MOVEMENT

Impressionism

OTHER WORKS

View of Pontoise; A Road in Louveciennes; Red Roofs

INFLUENCES

Corot, Monet, Seurat

Camille Pissarro *Born* 1830

Painted in France, England and Venezuela

Died 1903

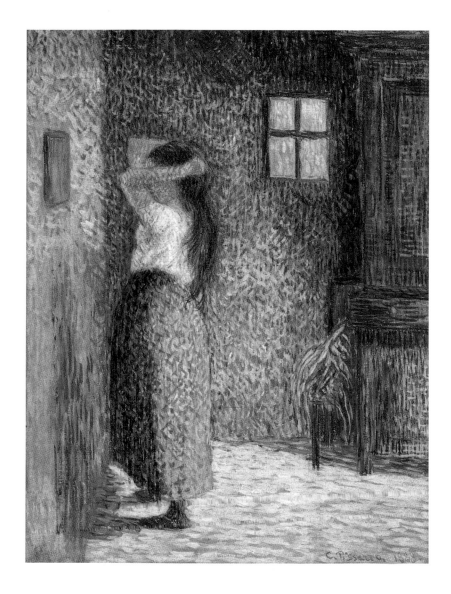

Sargent, John Singer

Women at Work

Born of American parents in Florence, Italy, John Singer Sargent was brought up in Nice, Rome and Dresden – giving him a rather sporadic education but a very cosmopolitan outlook. He studied painting and drawing in each of these cities, but his only formal schooling came at the Accademia in Florence, where he won a prize in 1873, and in the studio of Carolus-Duran in Paris (1874). In 1876 he paid the first of many trips to the USA, re-affirming his American citizenship in that Centennial year. He painted landscapes, but it was his early portraits that earned him acclaim. However, the scurrilous treatment of him by the French press over a décolleté portrait of Madame Gautreau induced him to leave France in 1885 and settle in London, where he spent most of his life. As well as portraits he produced large decorative works for public buildings from 1910 onwards. Some of his most evocative paintings were produced as a war artist in 1914–18.

MOVEMENT

Anglo-American School

OTHER WORKS

The Lady of the Rose; Carmencita; Gassed

INFLUENCES

Carolus-Duran, Frans Hals, Velázquez

John Singer Sargent *Born* 1856 Florence, Italy

Painted in France, England and USA

Died 1925 London, England

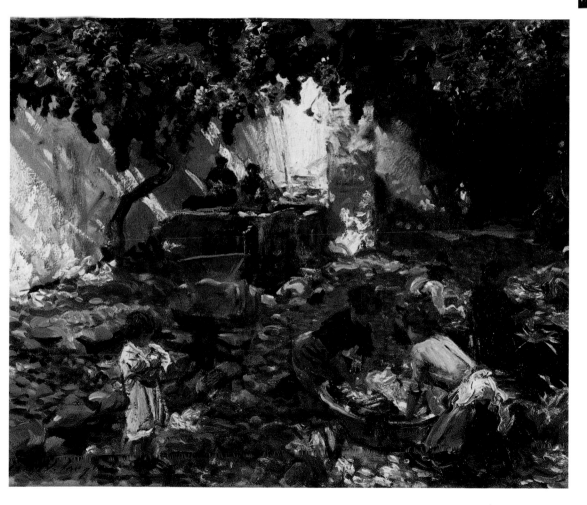

Millais, Sir John Everett
Sweet Emma Morland, 1892

English painter and illustrator, a founding member of the Pre-Raphaelite Brotherhood. Born in Southampton, Millais was a child prodigy and, at the age of 11 became the youngest-ever pupil at the Royal Academy Schools. With Rossetti and Hunt, he formed the nucleus of the Pre-Raphaelite Brotherhood. His *Christ in the Carpenter's Shop* was pilloried by the critics, although his work was vigorously defended by John Ruskin. Millais' relations with this influential critic were initially very cordial, until he fell in love with Ruskin's wife, Effie.

Millais' rift with the art establishment did not last long. He continued painting dreamy Pre-Raphaelite themes until around 1860, but found that they did not sell well and took too long to complete. So gradually he adopted a more commercial style and subject matter, specializing in imposing portraits, sentimental narrative pictures and mawkish studies of children. He also became a prolific book illustrator. This approach won Millais many honours – he was raised to the peerage and became President of the Royal Academy – but damaged his long-term artistic reputation.

MOVEMENT
Pre-Raphaelite Brotherhood

OTHER WORKS
Ophelia; Sir Isumbras at the Ford; Bubbles

INFLUENCES
William Holman Hunt, Dante Gabriel Rossetti

Sir John Everett Millais *Born* 1829 England
Painted in England and Scotland
Died 1896 London, England

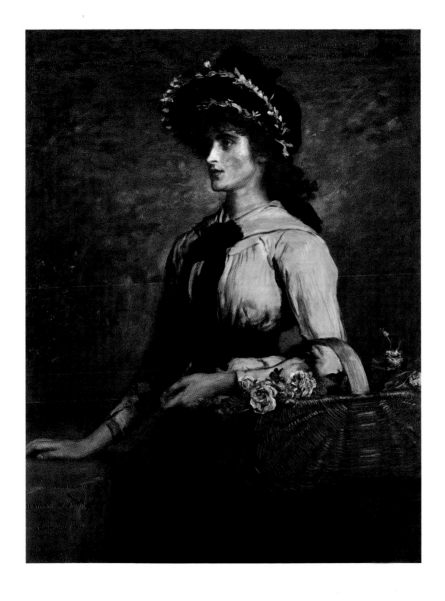

Waterhouse, John William

Ophelia, c. 1894

Courtesy of Private Collection/Christie's Images

An English painter, John Waterhouse's dreamy mythological paintings represent one of the last flowerings of Romanticism in Britain. Born in Rome, the son of a minor artist, Waterhouse moved to England with his family in 1854. He trained at the Royal Academy Schools and began exhibiting there in 1874. Initially, he painted in a traditional, academic vein, specializing in decorative, classical themes, which recall the work of Alma-Tadema and Leighton. By the late 1880s, however, elements of Symbolism and *plein-air* painting began to enter his work.

The pivotal work in Waterhouse's career was *The Lady of Shalott*. Painted in 1888, this was a typically Pre-Raphaelite subject – the kind of theme which he favoured increasingly, in his later years. The style, however, was more modern. The landscape background, in particular, displays a freshness and a robust handling, which underlines Waterhouse's links with the Newlyn School and his debt to continental, *plein-air* painting. During the same period, he also began to paint sirens, mermaids and other *femmes fatales*, drawing his inspiration from the French Symbolists.

MOVEMENTS

Late Romantic, Symbolism

OTHER WORKS

Hylas and the Nymphs; St Eulalia; Echo and Narcissus

INFLUENCES

Frederic Leighton, Alma-Tadema, Sir Edward Burne-Jones

John William Waterhouse *Born* 1849

Painted in England and Italy

Died 1917

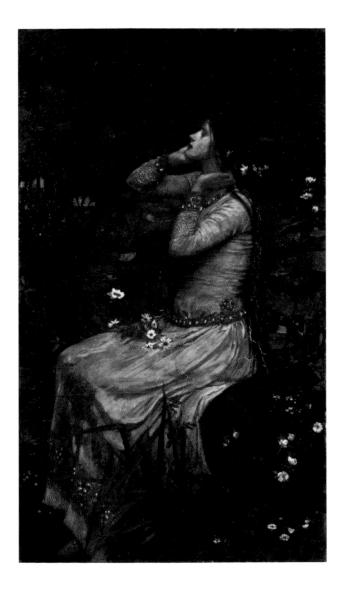

Liebermann, Max

Bathers on the Beach at Scheveningen, *c.* 1897–98

After his early training in Weimar, Germany, Max Liebermann continued his studies in Amsterdam and Paris, one of the first German artists of his generation to go abroad and come under the influence of foreign painters – in his case Courbet, Millet and the Barbizon School. Returning to Germany in 1878 Liebermann quickly established himself as the leading Impressionist, noted for his canvasses of mundane subjects in which elderly people and peasants predominate, although he also produced some noteworthy paintings of more sophisticated subjects, especially the outdoor cafés.

Liebermann played a major role in the establishment of the Berlin Secession in 1899. A major innovator in his heyday, he failed to move with the times and was later eclipsed by the younger avant-garde artists, led by Emil Nolde. Nevertheless, he remained a highly influential figure in German art, where the fashion for the heroic and romantic assured his works a substantial following.

MOVEMENT

German Impressionism

OTHER WORKS

The Parrot Keeper; Haarlem Pig Market

INFLUENCES

Courbet, Millet

Max Liebermann *Born* 1847 Berlin, Germany

Painted in France, Holland and Germany

Died 1935 Berlin

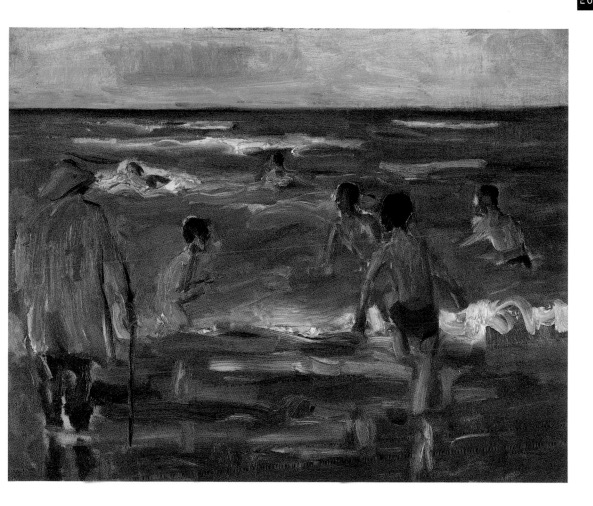

Lavery, Sir John
The French Consulate, The Grand Canal, Venice

Courtesy of Private Collection/Christie's Images/By Courtesy of Felix Rosentiel's Widow & Son Ltd, London on behalf of the Estate of Sir John Lavery

Orphaned at the age of three, John Lavery, born in Belfast, was raised by relatives in Scotland and began his artistic career retouching photographs. When his studio burned down he used the insurance money to acquire an artistic education in London and Paris. Returning to Glasgow in 1885 he founded the group known as the Glasgow School, which promoted the techniques of French Impressionism in Britain. He excelled in landscapes and genre subjects but it was his skill as a portraitist that earned him his biggest commission, to paint the visit of Queen Victoria in 1888, a task that involved over 250 sitters and took two years to complete. The most cosmopolitan British artist of his generation, he spent much of his time in Brittany. He was knighted in 1918 but later devoted much of his energies to promoting better relations between Ireland and Britain. His portrait of his wife Hazel adorned Irish banknotes for many years.

MOVEMENT

Modern British School

OTHER WORKS

The Unfinished Harmony; George Bernard Shaw

INFLUENCES

Pre-Raphaelites, French Impressionists

Sir John Lavery *Born* 1856 Belfast, Ireland

Painted in Britain, France, Ireland and USA

Died 1941 Kilkenny, Ireland

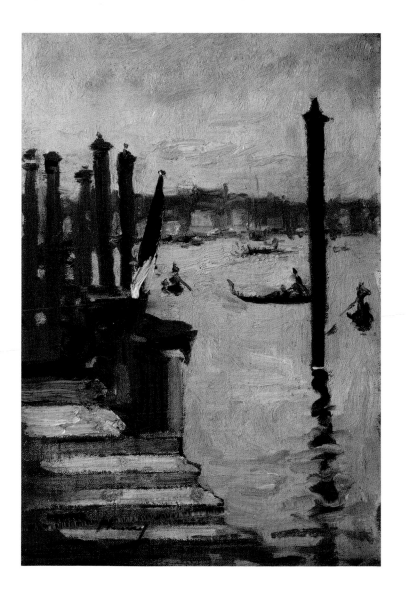

Cassatt, Mary
The Young Mother, 1900

Courtesy of Private Collection/Christie's Images

Mary Cassatt studied art at the Pennsylvania Academy of Art in Philadelphia from 1861 to 1865, but after the American Civil War she travelled to Europe, continuing her studies in Spain, Italy and the Netherlands before settling in Paris, where she became a pupil of Edgar Degas. Her main work consisted of lithographs, etchings and drypoint studies of genre and domestic subjects which often reflect her interest in Japanese prints; but her reputation now rests on her larger works, executed in pastels or oils, which explore the tender relationship between mother and child, although her mastery of technique (which owed much to her original teacher, Thomas Eakins) prevented her from descending into the banal or mawkish. After her death in Paris in 1926 her work was neglected for some time, but in more recent years it has been the subject of re-appraisal and her realistic but sensitive portraiture of women, girls and young children is now more fully appreciated.

MOVEMENT

Impressionism

OTHER WORKS

Mother and Child; Woman Sewing

INFLUENCES

Thomas Eakins, Degas

Mary Cassatt *Born* 1844 Pennsylvania, USA

Painted in USA and France

Died 1926 Paris, France

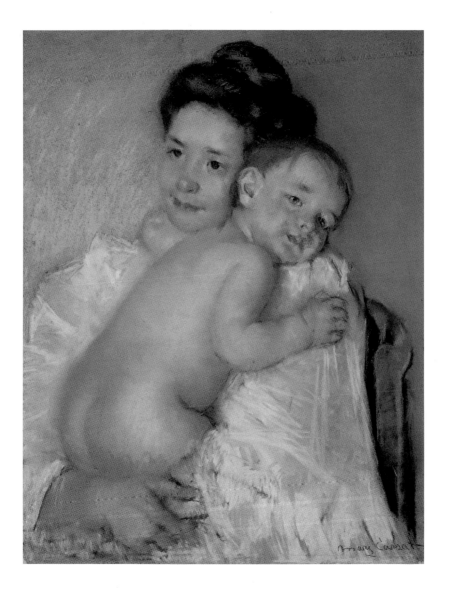

Hunt, William Holman
Master Hilary – The Tracer, 1900

Courtesy of Private Collection/Christie's Images

English painter; one of the founders of the Pre-Raphaelite movement. Born in London, the son of a warehouse manager, Hunt worked as a clerk before entering the Royal Academy School in 1844. There, he met Millais and, together with Rossetti, they formed the core of the Pre-Raphaelite Brotherhood. Hunt's meticulous attention to detail and his fondness for symbolism accorded well with the aims of the group, but his deeply felt religious convictions led him away from the British art scene. In January 1854, he embarked on a two-year expedition to Egypt and the Holy Land, believing that this was the only way to produce realistic images of biblical themes.

The critical response to this enterprise was mixed. *The Scapegoat* was greeted with puzzlement, but *The Finding of the Saviour in the Temple* was received far more enthusiastically, securing Hunt's reputation as a religious painter. Further trips to the East followed, although these were not always happy affairs. In 1866, his wife died in Florence, shortly after giving birth to their son. Hunt later married her sister. In 1905, he wrote his memoirs, which have become a primary source document for the Pre-Raphaelite movement.

MOVEMENT

Pre-Raphaelite Brotherhood

OTHER WORKS

The Hireling Shepherd; The Light of the World

INFLUENCES

Dante Gabriel Rossetti, Augustus Egg, John Everett Millais

William Holman Hunt *Born* 1827

Painted in England, Egypt and the Holy Land

Died 1910

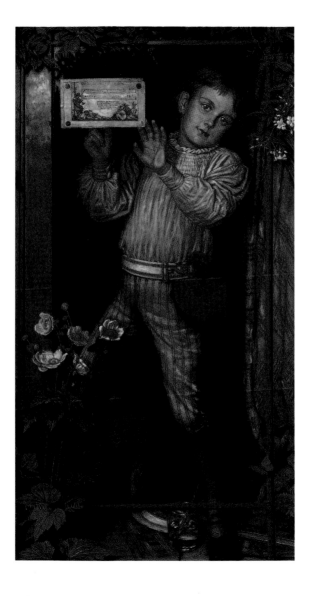

Monet, Claude
Nymphéas, 1907

Courtesy of Private Collection/Christie's Images

French painter; a founding member of the Impressionist circle. Monet was born in Paris, but grew up on the Normandy coast, where he developed an early interest in landscape painting. His early mentors were Jongkind and Boudin, and the latter encouraged Claude to paint outdoors rather than in the studio. This was to be one of the key principles of Impressionism.

While a student in Paris he met Pissarro, Renoir and Sisley, and together they formulated the basic ideas of the movement. One of Monet's paintings, *Impression: Sunrise* gave the group its name.

The Impressionists staged their own shows, holding eight exhibitions between 1874 and 1886. Initially, these attracted savage criticism, causing genuine financial hardship to Monet and his friends. His most distinctive innovation was the 'series' painting. Here, Monet depicted the same subject again and again, at different times of the day or in different seasons. In these pictures, his real aim was not to portray a physical object – whether a row of poplars or the façade of Rouen cathedral – but to capture the changing light and atmospheric conditions.

MOVEMENT

Impressionism

OTHER WORKS

Waterlilies; Wild Poppies; Rouen Cathedral

INFLUENCES

Eugène Boudin, Johan Barthold Jongkind, Pierre-Auguste Renoir

Claude Monet *Born* 1840 Paris, France

Painted in France, England and Italy

Died 1926 Givernay, France

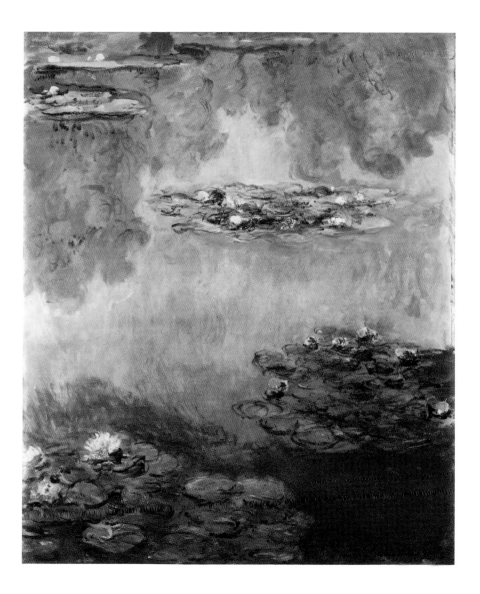

Late 19th Century

The Era of Post-Impressionism

Seurat, Georges
Les Poseuses, 1887–88

Courtesy of Private Collection/Christie's Images

Georges Pierre Seurat studied at the École des Beaux-Arts and was influenced by the precise draughtsmanship of Ingres, as well as with Chevreul's theories on colour. He combined the Classicist tradition with the newer ideas of the Impressionists. In particular, he painted in a very distinctive style using a multitude of different coloured dots to build up the impression of the subject, much as the half-tone process or multicolour photogravure use a screen of dots of varying intensity and depth to achieve the overall image. This extremely precise method he termed divisionism, and it was instrumental in the subsequent development of pointillism. There is not much evidence of this technique, however, in his first major work depicting bathers at Asnières (1884), but it became almost a trade mark in his later paintings. Always meticulous in the execution of his work, Seurat was also painstaking in the preparation, often spending months on preliminary sketches for each canvas.

MOVEMENT

French Impressionism

OTHER WORKS

The Can-Can; Sunday Afternoon on the Island of the Grande Jatte

INFLUENCES

Ingres, Eugène Chevreul

Georges Seurat *Born* 1859 Paris, France

Painted in France

Died 1891 Paris

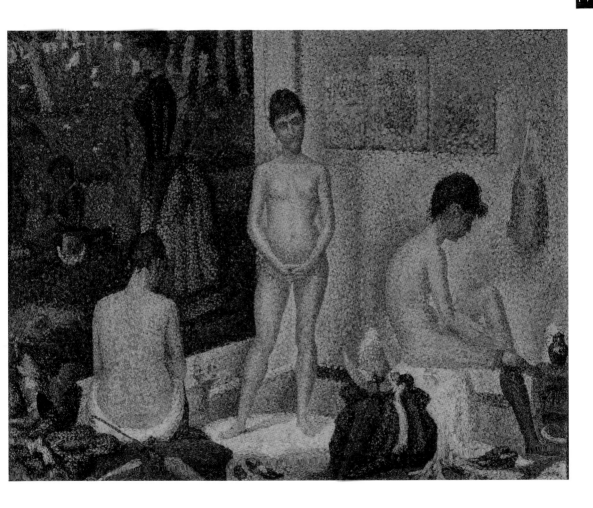

Gogh, Vincent van
Portrait de L'artiste sans Barbe, 1889

Courtesy of Private Collection/Christie's Images

A leading Post-Impressionist and forerunner of Expressionism. Vincent's first job was for a firm of art dealers, but he was sacked after a failed affair affected his ability to work. After a brief stint as a teacher, he became a lay preacher in a Belgian mining district. Here again he was fired when the Church became concerned at his over-zealous attempts to help the poor. Vincent had at least found his true vocation: illustrating the plight of the local peasantry.

Previously influenced by Millet, in 1886 Van Gogh went to Paris where his style changed dramatically. Under the combined impact of Impressionism and Japanese prints, his palette lightened and he began to employ bold simplifications of form. Like Gauguin, he also used colours symbolically, rather than naturalistically. With financial help from his brother, Theo, Vincent moved to the south of France. Gauguin joined him but the pair soon clashed, hastening Van Gogh's mental collapse. Despite his illness he continued working at a frenzied pace until his suicide in July 1890. Van Gogh sold only one painting in his lifetime, but his work has since become the most popular and sought-after of any modern artist.

MOVEMENT

Post-Impressionism

OTHER WORKS

A Starry Night; Sunflowers; The Potato Eaters

INFLUENCES

Jean-François Millet, Louis Anquetin, Gauguin

Vincent van Gogh *Born* 1853

Painted in France, Holland and Belgium

Died 1890

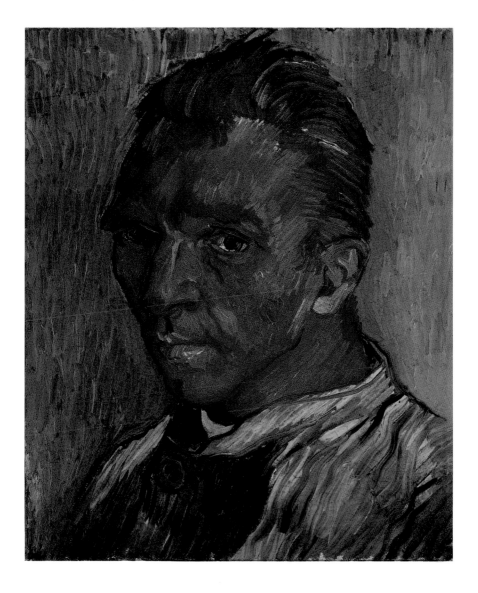

Toulouse-Lautrec, Henri de
Moulin Rouge — La Goulue, 1891

Courtesy of Christie's Images

Henri Marie Raymond de Toulouse-Lautrec-Monfa was the scion of one of France's oldest noble families who had been rulers of Navarre in the Middle Ages. Henri was a chronically sick child whose legs, broken at the age of 14, stopped growing and left him physically deformed. In 1882 he went to Paris to study art and settled in Montmartre, where he sketched and painted the cabaret performers, can-can dancers, clowns, barmaids and prostitutes, although occasionally he painted more conventional subjects as well. He played a prominent part in raising the lithographic poster to a recognized art form. He worked rapidly and feverishly from life, seldom using posed models. He belonged to the artistic milieu in which Impressionists and Post-Impressionists mingled and both schools left their mark on his work. Alcoholism led to a complete breakdown and confinement in a sanatorium (1899) but he recovered sufficiently for a last frenzied bout of hard work.

MOVEMENT
Post-Impressionism
OTHER WORKS
At the Moulin Rouge; The Bar; At the Races; Jane Avril
INFLUENCES
Degas

Henri de Toulouse-Lautrec *Born* 1864 France
Painted in Paris
Died 1901 Paris

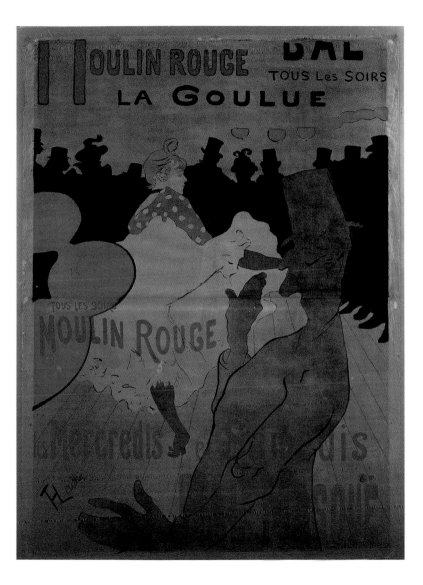

Cézanne, Paul
Still Life with Apples, 1893–94

Courtesy of Private Collection/Bridgeman Art Gallery/Christie's Images

French painter, a leading member of the Post-Impressionists. Born in Aix-en-Provence, the son of a banker, Cézanne's prosperous background enabled him to endure the long struggle for recognition. He studied in Paris, where he met the future members of the Impressionist circle, although his own work at this time was full of violent, Romantic imagery. Cézanne did not mix easily with the group; he was withdrawn, suspicious and prey to sudden rages. Gradually, with Pissarro's encouragement, he tried *plein-air* painting and participated at two of the Impressionist exhibitions. But, in art as in life, Cézanne was a solitary figure and he soon found the principles of the movement too restricting.

After his father's death in 1886, Cézanne returned to Aix, where he brought his style to maturity. His aim was to produce 'constructions after nature'. He followed the Impressionist practice of painting outdoors but, instead of the transient effects which they sought, he tried to capture the underlying geometry of the natural world. This was to make him a fertile source of inspiration for the Cubists.

MOVEMENT

Post-Impressionism

OTHER WORKS

Mont Sainte-Victoire; Apples and Oranges; The Card Players

INFLUENCES

Delacroix, Courbet, Pissarro

Paul Cézanne *Born* 1839 France

Painted in France

Died 1906

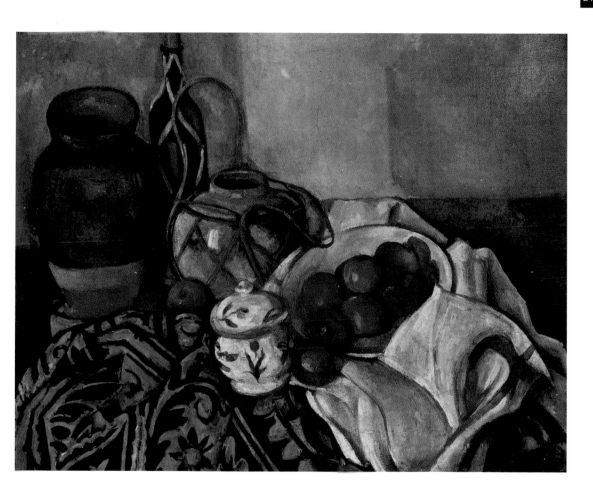

Munch, Edvard
The Scream, 1893

Edvard Munch studied in Christiania (now Oslo) and travelled in Germany, Italy and France before settling in Oslo. During his time in Paris (1908) he came under the influence of Gauguin and had immense sympathy for Van Gogh due to the bouts of mental illness from which both suffered. In fact, this would have a profound effect on the development of Munch as an artist and explains the extraordinary passion that pervades his work. Life, love and death are the themes that he endlessly explored in his paintings, rendered in an Expressionist symbolic style. His use of swirling lines and strident colours emphasize the angst that lies behind his paintings. He also produced etchings, lithographs and woodcut engravings which influenced the German artists of the movement known as Die Brücke.

MOVEMENT

Expressionism

OTHER WORKS

Puberty, The Dance of Life; The Madonna; Ashes

INFLUENCES

Gauguin, Van Gogh

Edvard Munch *Born* 1863 Loten, Norway

Painted in Oslo, Norway

Died 1944 Oslo

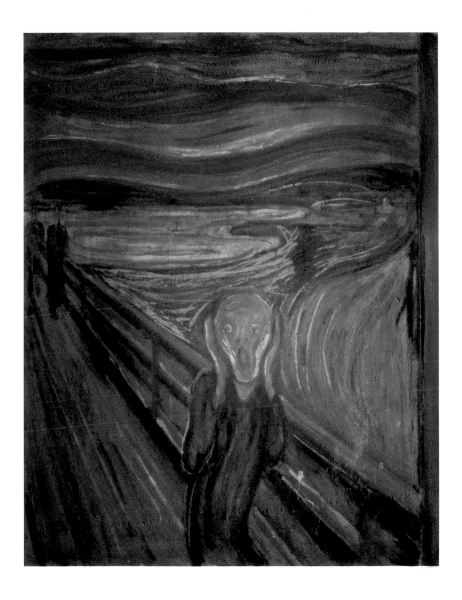

Beardsley, Aubrey

The Peacock Skirt, illustration for Oscar Wilde's play, 'Salome', 1894

Courtesy of Fogg Art Museum, Harvard University Art Museums, USA/Bridgeman Art Library

English graphic artist, the epitome of *fin-de-siècle* decadence. Born in Brighton, Beardsley was a frail child and suffered his first attack of tuberculosis in 1879. He left for London at the age of 16, working initially in an insurance office, while attending art classes in the evening. In 1891 Edward Burne-Jones persuaded him to become a professional artist and, two years later, Beardsley received his first major commission, when J. M. Dent engaged him to illustrate Malory's *Morte d'Arthur*. The success of this venture gave him the opportunity to work on an even more prestigious project, the illustration of Wilde's *Salome*, while also producing images for a new journal, *The Yellow Book*.

Soon Beardsley developed a unique style, combining the bold compositional devices used in Japanese prints; the erotic, sometimes perverse imagery of the Symbolists; and an effortless mastery of sinuous, linear design, which prefigured Art Nouveau. A glittering career seemed to beckon, but in 1895 the scandal surrounding the Wilde trial led to his sacking from *The Yellow Book*. His tubercular condition flared up again and within three years he was dead.

MOVEMENTS

Symbolism, Decadence, Art Nouveau

OTHER WORKS

The Toilet of Salome; How King Arthur saw the Questing Beast

INFLUENCES

Sir Edward Burne-Jones, Kitagawa Utamaro, Toulouse-Lautrec

Aubrey Beardsley *Born* 1872 Brighton, England

Worked in England and France

Died 1898

Mucha, Alphonse

La Danse

Alphonse Mucha's (1860–1939) patron for a number of years was the brilliant French actress, Sarah Bernhardt (1874–1934). She was also an astute businesswoman who recognized Mucha's unique talent. His posters were instantly eye-catching, captivating and beautiful; all qualities that could be attributed to Bernhardt. It is interesting to note that while many Art Nouveau images of women were almost ethereal and at least stylized, there were very occasionally real women, the *femmes nouvelles* of the era, behind the fakes.

Sarah Bernhardt was one of two entertainers who came to embody the Art Nouveau woman for many people: Loïe Fuller (1862–1928) was the other. Fuller was an American dancer who came to Paris's Folies Bergère in 1892 and became the darling of the Parisian avant-garde. She had choreographed a divine dance using layers of Chinese silk that billowed and undulated as she moved. Fuller danced on a glass floor that was lit from below, causing the veils of fabric to change colour as they flowed evocatively. Fuller was adored by Symbolist artists and writers and they tried to capture the effect that her visual display had had on them.

MOVEMENT

Art Nouveau

OTHER WORKS

Poster of Les Saisons

INFLUENCES

Aubrey Beardsley, Japanese Prints

Alphonse Mucha *Born* 1860

Worked in Czechoslovakia, Austria and France

Gauguin, Paul

Nave Nave Moe, 1894

Courtesy of Hermitage, St Petersburg/Bridgeman/Christie's Images

Although he was born in Paris, Gauguin spent his early childhood in Peru, returning to France in 1855. He worked for a time as a stockbroker, painting only as a hobby, until the stock market crash of 1882 prompted a dramatic change of career. His first pictures were in the Impressionist style, influenced in particular by his friend, Camille Pissarro. Increasingly, though, Gauguin became dissatisfied with the purely visual emphasis of the movement, and tried to introduce a greater degree of symbolism and spirituality into his work. Inspired by Japanese prints, he also developed a new style, coupling bold splashes of bright, unmixed colour with simplified, linear designs. At the same time, haunted by memories of his Peruvian childhood, Gauguin developed a growing fascination for exotic and primitive cultures. Initially, he was able to satisfy this need in Brittany where, inspired by the region's distinctive Celtic traditions, he produced *The Vision after the Sermon*, his first great masterpiece. Then in 1891, he moved to the French colony of Tahiti. Dogged by poverty and ill health, he spent most of his later life in this area producing the paintings for which he is best known today.

MOVEMENTS

Post-Impressionism, Impressionism, Symbolism

OTHER WORKS

Where Do We Come From? What Are We? Where Are We Going To?

INFLUENCES

Camille Pissarro, Emile Bernard, Vincent Van Gogh

Paul Gauguin *Born* 1848 Paris, France

Painted in France, Denmark, Martinique Tahiti

Died 1903

Sickert, Walter
L'Hotel Royal Dieppe, *c.* 1894

Born in Munich, Bavaria, Walter Richard Sickert was the son of the painter Oswald Adalbert Sickert and grandson of the painter and lithographer Johannes Sickert. With such an artistic pedigree it was almost inevitable that he should follow the family tradition. In 1868 his parents moved to London, where he later studied at the Slade School of Art and took lessons from Whistler, whose limited tonal range is reflected in much of Sickert's work. On the advice of Degas – whom he met while studying in Paris – he made detailed preliminary drawings for his paintings rather than paint from life. As a youth, Sickert had been an actor and he had a lifelong interest in the theater, reflected in many of his paintings. He was a competent all-rounder, painting portraits, rather seedy genre subjects and murky landscapes, and as a teacher he wielded enormous influence on the British artists of the early twentieth century.

MOVEMENT

British Impressionism

OTHER WORKS

Mornington Crescent Nude; La Hollandaise Nude

INFLUENCES

James McNeill Whistler, Degas

Sickert, Walter *Born* 1860 Munich, Germany

Painted in London, Dieppe, and Venice

Died 1942 Bathampton, Avon, England

Vuillard, Edouard
Causerie chez les Fontaines

Jean Edouard Vuillard studied at the Académie Julien in Paris and shared a studio with Pierre Bonnard. Both artists were inspired by Sérusier's theories derived from the works of Gauguin and became founder members of Les Nabis in 1889. Vuillard was also influenced by the fashion for Japanese prints and this was reflected in his paintings of flowers and domestic interiors, executed with a keen sense of tone, colour and light. He was also a prolific designer of textiles, wallpaper and decorative features for public buildings. His paintings of cozy domestic subjects show a tremendous feeling for texture and patterning, a skill he picked up from his mother who was a dressmaker. The bolts of brightly coloured cloth that surrounded him as a child found an echo in his own textile designs. His later paintings were more naturalistic, aided by photography, which he employed to capture the fleeting moment.

MOVEMENT

Les Nabis

OTHER WORKS

Femme Lisant; Le Soir; Two Schoolboys; Mother and Child

INFLUENCES

Paul Sérusier, Gauguin

Edouard Vuillard *Born* 1868 Cuiseaux, France

Painted in France

Died 1940 La Baule, France

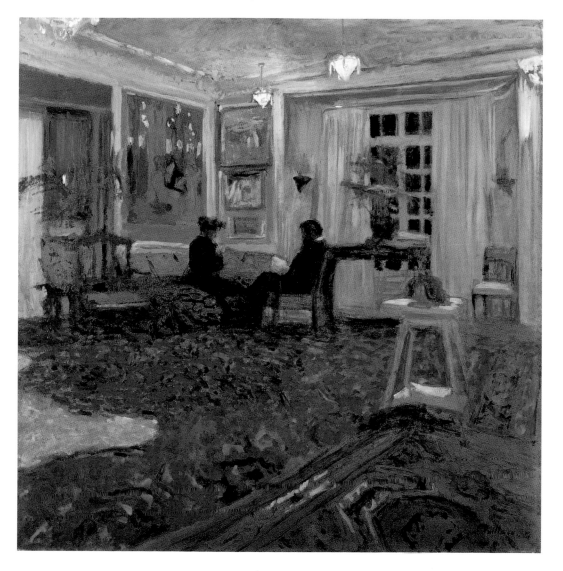

Klimt, Gustav
The Kiss, 1907–08

Courtesy of Osterreichische Galerie, Vienna, Austria/Bridgeman Art Library

Klimt was born in Vienna and became one of the leading lights in the city's most dazzling, artistic period. The son of a goldsmith, he trained at the School of Applied Arts and started work as a decorative painter. He achieved early success with the schemes at the Burgtheater and the Kunsthistorisches Museum, but future commissions were threatened by his growing fascination with avant-garde art. Faced with official opposition, Klimt resigned from the Viennese Artists' Association in 1897 and founded the Vienna Sezession, becoming its first president. This coincided with protracted disputes about his decorations for the university, a project that he abandoned in 1905.

Klimt's style was a compelling blend of Art Nouveau and Symbolist elements. From the former, he derived his taste for sinuous, decorative lines, while from the latter he borrowed his erotic subject matter and, in particular, his interest in the theme of the *femme fatale*. It was this blatant eroticism which troubled the authorities, though it did not seriously damage Klimt's career. He was always in great demand as a portraitist, and he continued to receive private commissions for decorative schemes.

MOVEMENT

Vienna Sezession

OTHER WORKS

Judith I; The Beethoven Frieze

INFLUENCES

Hans Makart, Edvard Munch, Franz von Stuck

Gustav Klimt *Born* 1862 Vienna, Austria

Painted in Austria-Hungary, Belgium

Died 1918

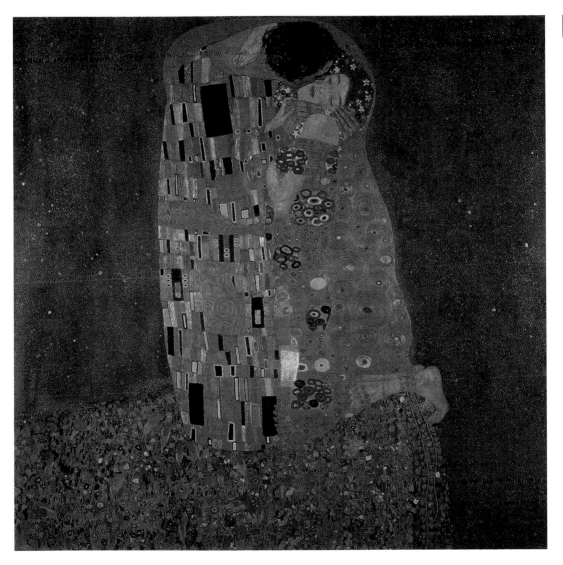

20th–21st Centuries

The Modern Era

Henri, Robert

Grace — Chinese Girl

Courtesy of Private Collection/Christie's Images

Born in Cincinnati, Ohio in 1865, Robert Henri enrolled at the Pennsylvania Academy of Fine Arts, Philadelphia, in 1886 and two years later went to Paris where he studied at the École des Beaux Arts. His formal training was rounded off by extensive travels in Italy and Spain. On his return to the USA in 1891 he became a teacher at the Women's School of Design, Philadelphia. He worked in Paris again from 1896 to 1901, but later settled in New York where he taught at the Art Students' League. He was a fervent believer in realism, which led critics to deride his 'Ashcan School', but he wielded enormous influence on the next generation of American artists. Despite his teaching commitments he was a prolific artist. In 1908 he founded his own art school in New York and formed the group known as 'The Eight'.

MOVEMENT

American Realism

OTHER WORKS

La Neige; The Equestrian; Young Woman in Black

INFLUENCES

Manet, Renoir

Robert Henri *Born* 1865 Cincinnati, Ohio, USA

Painted in Paris, Philadelphia and New York, USA

Died 1929 New York

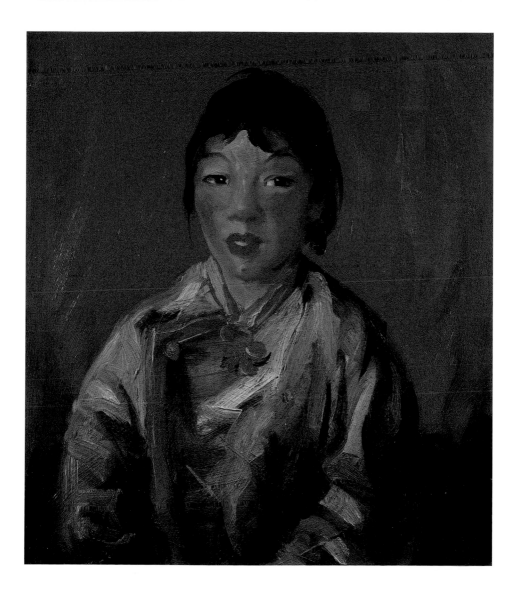

Kandinsky, Wassily

Composition No7, 1913

Born in Moscow, Kandinsky trained as a lawyer, but turned to art after visiting an exhibition of Monet's work. He moved to Munich, where he studied under Franz von Stuck. Here, he demonstrated his talent for organizing groups of artists, when he founded influential Der Blaue Reiter ('The Blue Rider'), an association of Expressionist artists, which included Franz Marc, August Macke and Paul Klee.

Kandinsky's personal style went through many phases, ranging from Jugenstil (the German equivalent of Art Nouveau) to Fauvism and Expressionism. He is most celebrated, however, for his advances towards abstraction. This came about after he returned to his studio one evening, and was enchanted by a picture he did not recognize. It turned out to be one of his own paintings lying on its side. Kandinsky immediately realized that subject matter lessened the impact of his pictures and he strove to remove this from future compositions.

In later life, Kandinsky taught at the Bauhaus, until it was closed down by the Nazis in 1933. He spent his final years in France, becoming a French citizen in 1939.

MOVEMENTS

Expressionism, Abstract Art

OTHER WORKS

Swinging; Composition IV (Battle); Cossacks

INFLUENCES

Claude Monet, Paul Klee, Franz Marc

Wassily Kandinsky *Born* 1866 Moscow, Russia

Painted in Russia, Germany, France and Holland

Died 1944 Neuilly-sur-Seine, France

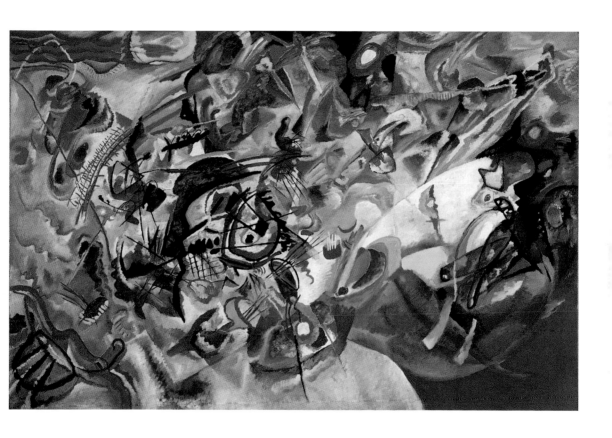

Derain, André
La Tamise et Tower Bridge, 1906

Courtesy of Private Collection/Christie's Images © ADAGP, Paris and DACS, London 2002

While studying art in Paris, André Derain teamed up with fellow student Maurice de Vlaminck with whom he shared a studio. Although very different in temperament they sparked radical ideas off each other regarding the use of colour and, encouraged by Matisse whom they met in 1899, they gradually evolved the style known as Fauvism, distinguished by its often violent and savage use of contrasting colours. In 1905 Ambroise Vollard, a prominent art dealer, encouraged Derain to travel to England and try to capture the strange lighting effects in the Pool of London. The results were startling but considered to be some of his greatest masterpieces. Later he toned down the adventurous use of colour and, under the influence of Cézanne, painted landscapes in a more Impressionist style. He also designed theatre sets, notably for Diaghilev, as well as working as a book illustrator.

MOVEMENT

Fauvism

OTHER WORKS

Houses of Parliament; Barges on the Thames; The Pool of London

INFLUENCES

Maurice de Vlaminck, Henri Matisse, Paul Cézanne

André Derain *Born* 1880 Chatou, France

Painted in France and England

Died 1954

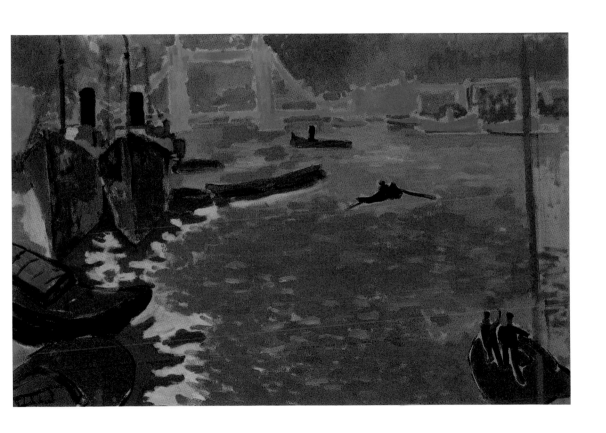

John, Gwen

A Corner of the Artist's Room in Paris, *c.* 1907

A Welsh painter and the greatest female artist of her age, John trained at the Slade School in London together with her brother Augustus, who also went on to become a famous artist. She then moved to Paris to study under Whistler, from whom she derived her delicate sense of tonality. In 1903, John planned to walk to Rome with a friend, but they only got as far as France, where she decided to settle. For a time she worked as a model in Paris and, through this, met the sculptor Rodin, who became her lover. He urged her to paint more, but John's output was small and it was only through the generosity of her chief patron, an American lawyer named John Quinn, that she was able to give up modelling and devote herself to her art.

Quiet and retiring, John lived alone and rarely exhibited her work. In her solitude, she developed a unique style, painting intimate, small-scale subjects – usually female portraits or corners of her studio – in thin layers of exquisitely muted colours. At first glance, these often appear frail and insubstantial but, like the artist herself, they also exude an inner calm and strength.

MOVEMENT

Intimism

OTHER WORKS

The Convalescent; Girl Reading at the Window; Nude Girl

INFLUENCES

James Whistler, Henry Tonks

Gwen John *Born* 1876 Wales

Painted in England and France

Died 1939 Dieppe, France

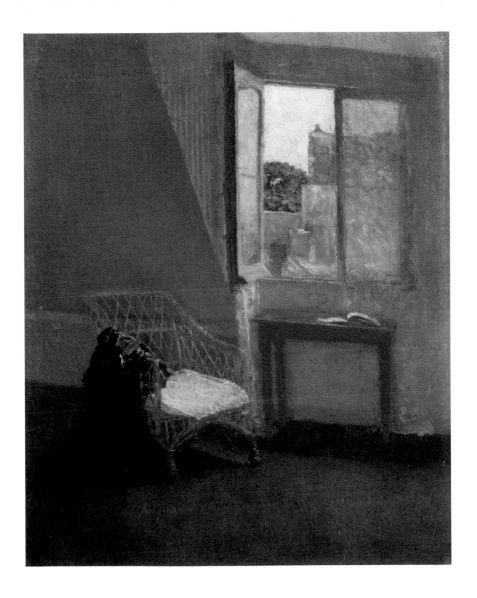

Heckel, Erich
Windmill, Dangast, 1909

Erich Heckel studied architecture in Dresden from 1904 to 1906 and it was during this period that he met Ernst Ludwig Kirchner and Karl Schmidt-Rottluf, with whom he formed the avant-garde group known as Die Brücke (The Bridge). They were strongly influenced by Edvard Munch, Cézanne and Van Gogh, and this was reflected in the vigorous quasi-primitive approach which they adopted in their paintings and prints – well suited to works which invariably had a strongly radical character. The group was dissolved in 1913 and the following year Heckel was drafted into the German army, serving as a medical orderly throughout the war. Like many of his contemporaries, his wartime experiences influenced his paintings in the postwar period. Vilified by the Nazis when they came to power, he continued to live in Berlin but from 1949 to 1956 he was professor at the Karlsruhe Academy of Art. He was noted for his nudes, his style mellowing and becoming more decorative in his later years.

MOVEMENT
German Expressionism

OTHER WORKS
Bathers; Sleeping Negress; Landscape in Thunderstorm

INFLUENCES
Ernst Ludwig Kirchner, Edvard Munch

Erich Heckel *Born* 1883 Döbeln, Germany

Painted in Dresden, Berlin and Karlsruhe

Died 1970 Hemmenhofen, Switzerland

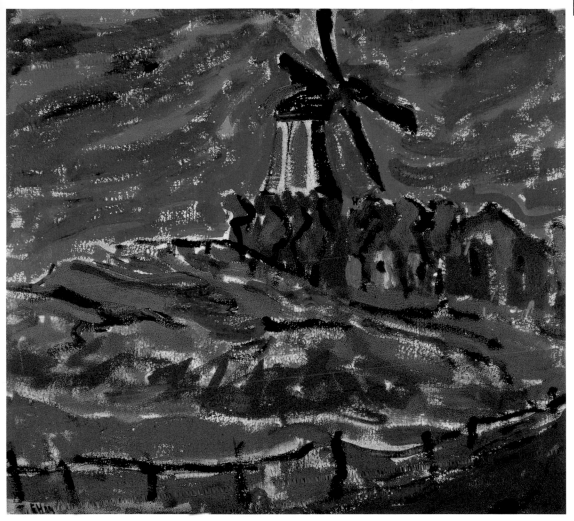

MacDonald, J. E. H.

Clearing after Rain, Maganatawan River, Ontario, 1910

Courtesy of Christie's Images, London, UK/Bridgeman Art Library

James Edward Hervey MacDonald was born in England of Scottish-Canadian parents, and at the age of 14 he settled with them in Hamilton, Ontario. He studied art there and later in Toronto, and in 1894 joined the leading Toronto graphic art company Grip, where he remained until 1912. He was the doyen of the extremely talented group of artists working for this firm, including Tom Thomson, Arthur Lismer, Frederick Varley and Franklin Carmichael. MacDonald was a founder member of the Arts and Letters Club (1908) which, under his leadership, rapidly became the forum for Canadian avant-garde artists. Notoriety came his way in 1916 when he exhibited seven paintings at the Toronto annual show; his painting *The Tangled Garden* was ferociously attacked by the newspaper critics. After Thomson's untimely death in 1917, MacDonald continued to be the guiding light and the prime mover in establishing the 'Group of Seven' in 1920. Significantly, the Group broke up after his death.

MOVEMENT

Modern Canadian School

OTHER WORKS

Mist Fantasy; Autumn, Algoma

INFLUENCES

Henry Thoreau, Walt Whitman

J. E. H. MacDonald *Born* 1873 London, England

Painted in Canada

Died 1932 Toronto, Ontario, Canada

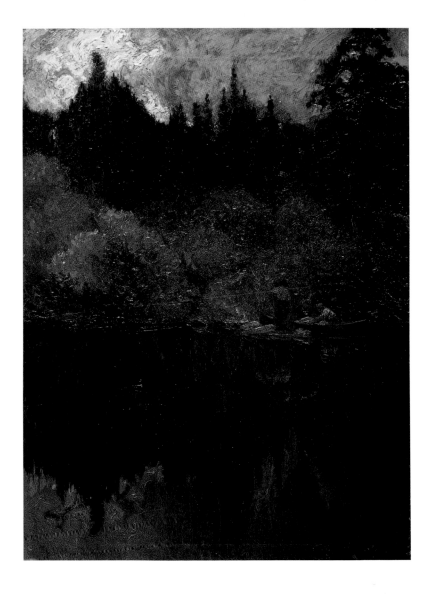

Malevich, Kasimir

The Carpenter III, 1910

Courtesy of State Russian Museum, St Petersburg, Russia/Bridgeman Art Library

Kasimir Severinovich Malevich studied in Moscow from 1902 to 1905 and came under the influence of the French Impressionists. In 1912 Mikhail Larionov invited him to take part in the inaugural Knave of Diamonds exhibition. Later the same year he visited Paris and immediately converted to Cubism, attacking this new style with zeal and improving and refining it in a style which he called Suprematism. His exhibition of Suprematist art in 1915 gained a mixed reception and he subsequently modified his style, rejecting the stark minimalism of such works as *Black Square* and injecting a great deal of colour. But he reverted to his ideals in 1918 with a series of paintings entitled *White on White*, the ultimate example of minimalism. Thereafter he abandoned painting and concentrated on sculpture, becoming one of the leading Constructivists of the early Soviet era.

MOVEMENTS

Cubism, Suprematism

OTHER WORKS

Dynamic Suprematism; Woman with Buckets

INFLUENCES

Mikhail Larionov, Pablo Picasso

Kasimir Malevich *Born* 1878 Kiev, Ukraine

Painted in Moscow, Russia

Died 1935 Leningrad (now St Petersburg), Russia

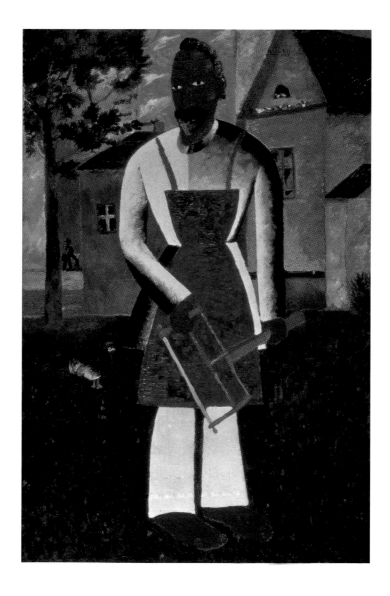

Schiele, Egon
Liegender Halbakt Mit Rolem, 1910

Courtesy of Private Collection/Christie's Images

Egon Schiele studied at the Vienna Academy of Fine Arts in 1906 and the following year he met Gustave Klimt, whose Vienna Sezession movement he joined in 1908. A disciple of Sigmund Freud, Schiele sought to explore the deeper recesses of the human psyche, especially the sexual aspects. He developed a particularly stark style of Expressionism – distinguished by figures, often naked and usually emaciated – with harsh outlines, filling the canvas with contorted limbs and anguished features. Long before the Nazis were denouncing his paintings as degenerate art, the Austrian authorities were confiscating and destroying his works. In 1912 he was actually arrested, convicted of offences against public morals and briefly imprisoned. After his marriage in 1915 his art mellowed, taking on a brighter and more sensuous form, and it is interesting to conjecture how this trend might have developed had he not died in the influenza pandemic of 1918.

MOVEMENT

Austrian Expressionism

OTHER WORKS

The Embrace; Recumbent Female Nude with Legs Apart

INFLUENCES

Gustav Klimt

Egon Schiele *Born* 1890 Tulln, Austria

Painted in Vienna, Austria

Died 1918 Vienna

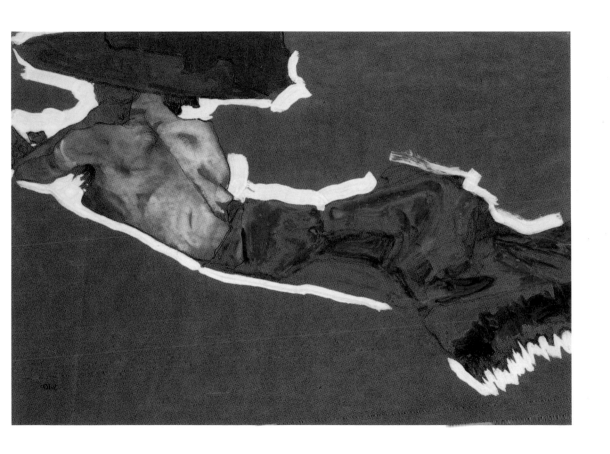

Pechstein, Max

Rote Kirche, 1911

Courtesy of Private Collection/Christie's Images/© DACS 2002

Max Hermann Pechstein studied art in Dresden, where he joined Die Brücke (The Bridge) in 1906. The only member of this avant-garde group to have received a formal art education, he had a formulative influence on his contemporaries. Later he co-founded the Neue Sezession in Berlin and was the first of that group to achieve widespread popularity, mainly because his paintings were more decorative than those of his fellow artists. He was profoundly influenced by Van Gogh, Matisse and the Fauves, reflected in his vibrant colours and dramatic composition. Later he was also attracted to primitive art, evident in the greater angularity of his figures in the 1920s and 1930s. Bright, contrasting colours are emphasized by thick black lines creating an almost stained-glass effect. Pechstein taught at the Berlin Academy from 1923 until 1933, when he was dismissed by the Nazis, but he survived the Third Reich and was reinstated in 1945.

MOVEMENT

German Expressionism

OTHER WORKS

Meadow at Moritzburg; Tale of the Sea; Seated Female Nude

INFLUENCES

Vincent Van Gogh, Henri Matisse

Max Pechstein *Born* 1881 Zwickau, Germany

Painted in Dresden and Berlin

Died 1955 Berlin, Germany

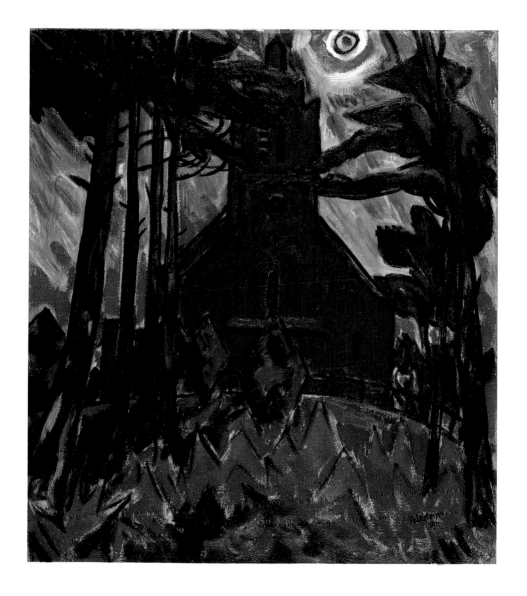

Duchamp, Marcel

Nude Descending a Staircase, No 2, 1912

Courtesy of Philadelphia Museum of Art, Pennsylvania, PA, USA/Bridgeman Art Library/© Succession Marcel Duchamp/ADAGP, Paris and DACS, London 2002

Although he produced relatively few artworks, Duchamp was a key figure in twentieth century art, playing a seminal role in the development of several different movements. Duchamp trained in Paris, and was briefly influenced by Cézanne and the Fauves. His first real masterpiece – *Nude Descending a Staircase* – was a potent blend of Cubism and Futurism, In 1913 he invented the 'ready-made' – an everyday object, divorced from its normal context and presented as a work of art in its own right. Two years later, Duchamp moved to the US, where he became a leading light of the New York Dada movement. His work from this period displayed a mischievous sense of humour, whilst also challenging existing preconceptions about the nature of art. In *L.H.O.O.Q.*, for example, he added a moustache and a smutty inscription to the *Mona Lisa*. His most notorious ready-made was a urinal, which he exhibited under the title of *Fountain*. After receiving a legacy, Duchamp's output slowed dramatically but his later work has been seen as a foretaste of Kinetic art and Conceptual art.

MOVEMENTS

Cubism, Dada, Conceptual Art

OTHER WORKS

Fountain; The Bride Stripped Bare by her Bachelors Even

INFLUENCES

Francis Picabia, Paul Cézanne, Man Ray

Marcel Duchamp *Born 1887* Normandy, France

Worked in France and the USA

Died 1968 Paris, France

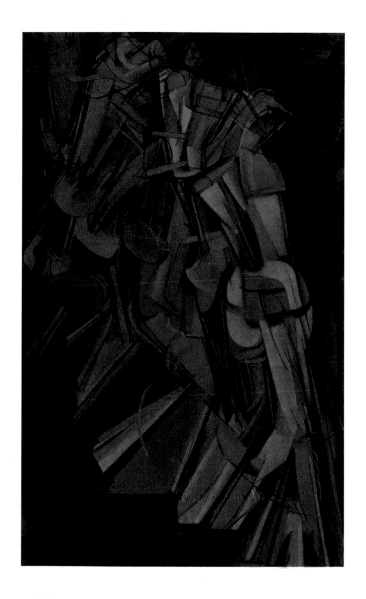

Bonnard, Pierre

Intérieur, 1913

Pierre Bonnard settled in Paris in 1888, where he studied at the Académie Julien and the École des Beaux-Arts. With Maurice Denis and Edouard Vuillard, with whom he shared a studio, he was influenced by Paul Gauguin's expressive use of colour and formed the group known as Les Nabis (from the Hebrew word for prophet) and later the Intimists. While other artists at the end of the nineteenth century were tending towards abstraction, Bonnard was influenced by Japanese prints and concentrated on landscapes and interiors which strove after subtle effects in light and colour at the expense of perspective. At the turn of the century he was moved by the intensity and passion in the paintings of Van Gogh and this led him to become a founder member of the Salon d'Automne in 1903. Thereafter he was influenced by Les Fauves (literally 'the wild beasts'), whose strident colours and distorted images he tamed and harnessed to his own style.

MOVEMENTS

Les Nabis, Intimism, Fauvism

OTHER WORKS

Mirror on the Washstand; The Open Window; The Table

INFLUENCES

Paul Gauguin, Vincent Van Gogh

Pierre Bonnard *Born* 1867 Fontena-aux-Roses, France

Painted in Paris, France

Died 1947 Le Cannet, France

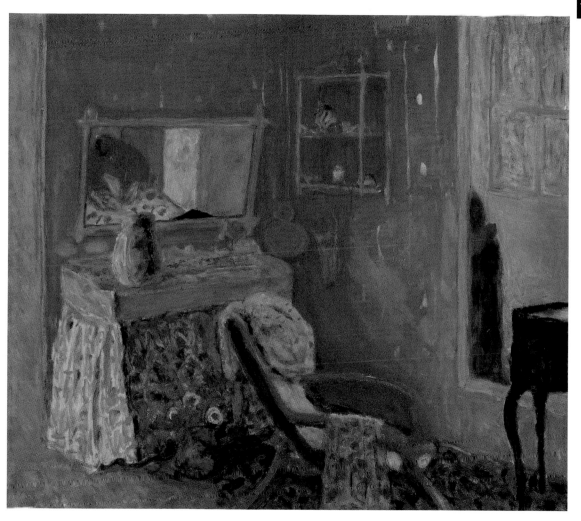

Marc, Franz

Spingendes Pferd, 1913

Courtesy of Private Collection/Christie's Images

Franz Marc studied theology in Munich intending to enter the Church, but switched to art, which he regarded as an intensely spiritual activity. He studied painting in Italy and France before returning to Munich where, with Kandinsky, he founded the Blaue Reiter group in 1911. An intensely religious man, he believed that animals were more in harmony with nature than human beings and therefore he concentrated on paintings in which animals, notably horses and foxes, featured prominently. In his earlier works the animals form the dominant subject but later they merged into the landscape as though an integral part of it. He speculated on how animals perceived the world and this influenced his later Expressionist work, which was almost devoid of figurative motifs and explored the emotional potential of colour. He returned to Germany on the outbreak of World War I; his death in action brought to an abrupt end one of the most promising artists of the early twentieth century.

MOVEMENTS

Impressionism, Expressionism

OTHER WORKS

Tiger; Deer in Wood; Foxes; Tower of the Blue Horses

INFLUENCES

August Macke, Kandinsky

Franz Marc *Born* 1880 Munich, Germany

Painted in Munich and Paris

Died 1916 Verdun, France

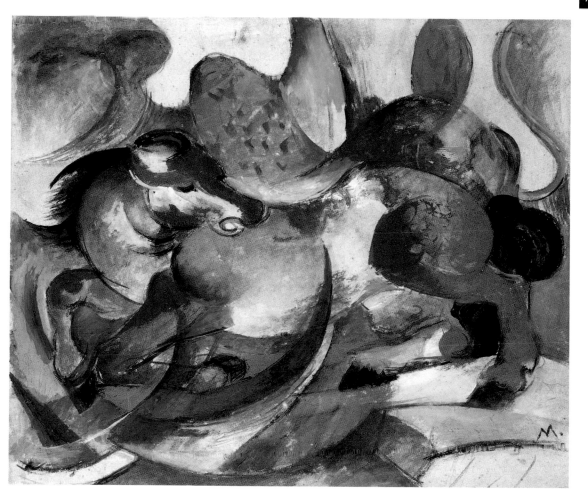

Balla, Giacomo

Grand Fiore Futurista

After a conventional art training in his native Turin, Giacomo Balla went to Paris in 1901 where he was strongly influenced by Impressionism and Divisionism. In 1910 he signed the Futurist Manifesto, publicizing his commitment to a form of art that would express the vibrant dynamism of the twentieth century. In his paintings Balla tried to convey the impression of speed through the use of overlapping images like time-lapse photographs. Futurism lost its freshness and idealism during World War I and in the 1920s it became increasingly stereotyped and associated with Fascism. As a result, Balla turned to more abstract forms and from 1930 onwards tended to return to the more mainstream styles of figurative painting. Nevertheless, echoes of Balla's technique may be found in many works of the late twentieth century which use blurred or overlapping images to suggest rapid movement.

MOVEMENT

Futurism

OTHER WORKS

Girl Running on the Balcony; Dog on a Leash; Flight of Swallows

INFLUENCES

Umberto Boccioni, Carlo Carrà

Giacomo Balla *Born* 1871 Turin, Italy

Painted in Italy

Died 1958 Rome, Italy

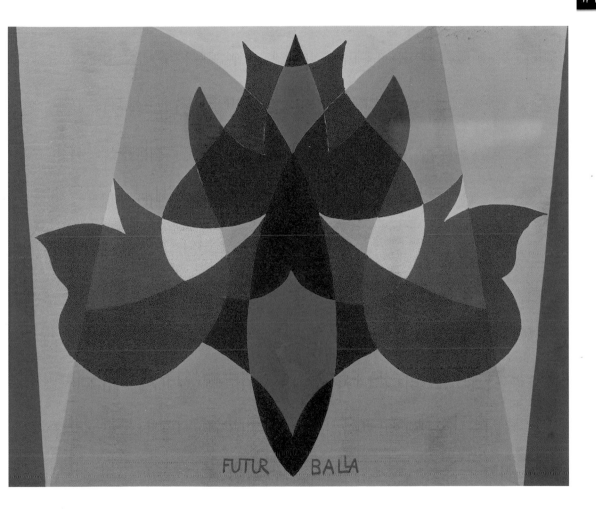

Chirico, Giorgio de

Piazza d'Italia, c. 1915

Born in north-western Greece of Venetian descent, Giorgio de Chirico studied in Athens and Munich, then worked in Paris and finally collaborated with Carrà in Italy, founding Pittura Metaphisica. About 1910 he began painting a series of pictures of deserted town squares, imbued with a dreamlike quality, characterized by incongruous figures and strange shadows which anticipated the style of the Surrealists, on whom he exerted tremendous influence. After suffering a breakdown during World War I he developed his metaphysical style of painting, which conveyed an intensely claustrophobic impression. In the 1920s, however, his paintings often verged on the abstract before he returned to a more traditional style shortly before World War II – the complete antithesis of all he had done up to that time. He continued to embrace academic naturalism in the postwar period.

MOVEMENT

Metaphysical painting, Surrealism

OTHER WORKS

The Uncertainty of the Poet; The Archaeologists

INFLUENCES

Carlo Carrà

Giorgio de Chirico *Born* 1888 Volo, Greece

Painted in France and Italy

Died 1978 Rome

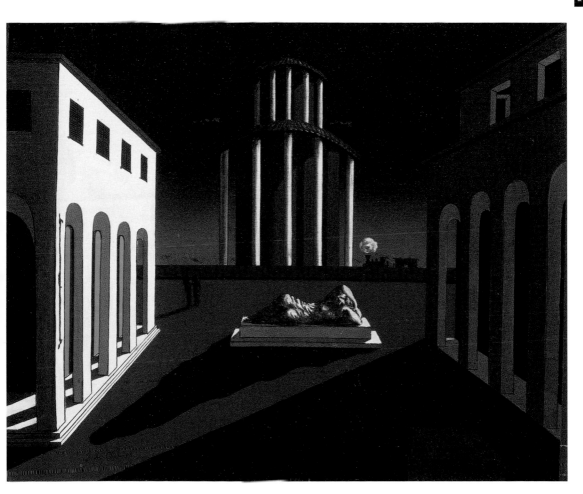

Modigliani, Amedeo

Beatrice Hastings Assise, 1915

Courtesy of Private Collection/Christie's Images

Modigliani was born into a Jewish family in Livorno, Italy. Although educated in Florence and Venice he spent most of his career in France. His highly individual style combined the linear elegance of Botticelli, whose work he had studied in Italy, with the avant-garde ideas that were circulating in pre-war Paris. His key influence was the Romanian sculptor Brancusi, whom he met in 1909. Under his guidance, Modigliani produced an impressive series of African-influenced stone figures.

After the outbreak of war, the raw materials for sculpture became scarce, so Modigliani turned to painting. Most of his subjects were sensual nudes or portraits, featuring slender, elongated figures. These received little attention from the critics; he was better known for his self-destructive, bohemian lifestyle, a lifestyle which caused the breakdown of his health – he died of tuberculosis at the age of 35. Tragically, Jeanne Hébuterne, his mistress and favourite model, committed suicide on the following day while pregnant with the artist's child. Modigliani's reputation was only secured posthumously, through a retrospective exhibition in Paris in 1922.

MOVEMENT

School of Paris

OTHER WORKS

Seated Nude; The Little Peasant; Portrait of Jeanne Hébuterne

INFLUENCES

Sandro Botticelli, Paul Cézanne, Constantin Brancusi

Amedeo Modigliani *Born* 1884, Livorno, Italy

Painted in Italy and France

Died 1920 Paris, France

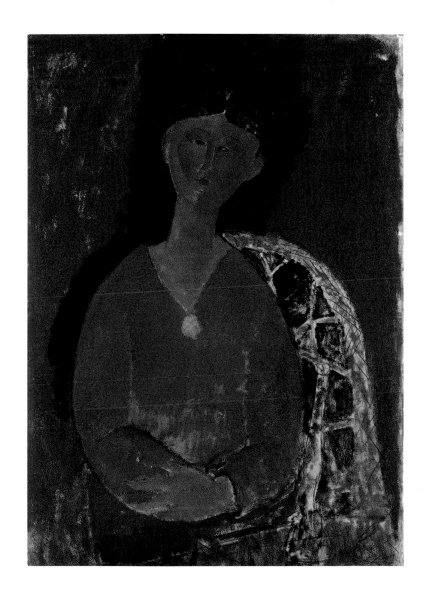

Kirchner, Ernst Ludwig
Königstein Mit Roter Kirche, 1916

Born in Aschaffenburg, Germany in 1880, Kirchner studied architecture in Dresden before turning to painting as a result of encouragement from fellow students Erich Heckel and Karl Schmidt-Ruttluf. In 1905 these three artists formed the movement known as Die Brücke (The Bridge), which continued until 1913. The name signified the fact that they spanned the art of the past and present and derived inspiration from a variety of disparate sources, from primitive tribal art to Van Gogh. Kirchner was the dominant personality in this group, which sought to give direct expression to human feelings. Kirchner evolved a distinctly angular style highlighted by bold, contrasting colours. Like so many other artists drafted into the infantry, Kirchner suffered a severe nervous breakdown and while convalescing in Switzerland he concentrated on Alpine landscapes as an antidote to the horrors of trench warfare. His postwar paintings grew more abstract in the time leading up to his suicide in 1938.

MOVEMENTS

Die Brücke, Expressionism

OTHER WORKS

Striding Into the Sea; Berlin Street Scene; The Red Tower in Halle

INFLUENCES

Vincent Van Gogh, Edvard Munch, Paul Gauguin

Ernst Ludwig Kirchner *Born* 1880 Aschaftenburg, Germany

Painted in Germany and Switzerland

Died 1938 Davos, Switzerland

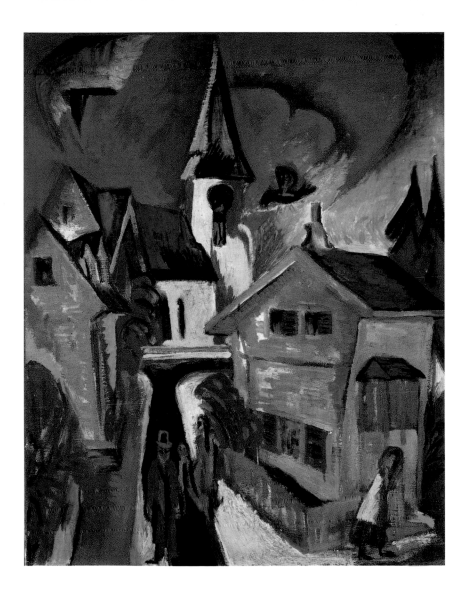

Orozco, José Clemente

Caballo Salvajes

José Clemente Orozco studied engineering and architecture in Mexico City and later art at the Academia San Carlos. Although schooled in the Spanish classical tradition, Orozco was strongly influenced by his studies of the art and architecture of the Toltecs and Mayas and this was reflected in his paintings, which also imbibed much from the European Expressionists. At the same time, he was an ardent revolutionary and a lifelong political activist - as a result his canvasses often have an emphatic social message. Many of his paintings deal with dramatic events in Mexico's turbulent history – the revolution of 1911 and the subsequent civil war providing a fertile source of material. Orozco's passion for the sweeping social and economic changes wrought in the 1920s and 1930s also comes across very vividly in his work. He worked at various times between 1917 and 1934 in the United States and painted murals and other decorations for several public buildings.

MOVEMENTS

Expressionism, Social Realism

OTHER WORKS

Table of Universal Brotherhood; Modern Migration of the Spirit

INFLUENCES

Diego Rivera

José Clemente Orozco *Born* 1883 Qudad Guzman, Mexico

Painted in Mexico and USA

Died 1949 Mexico City

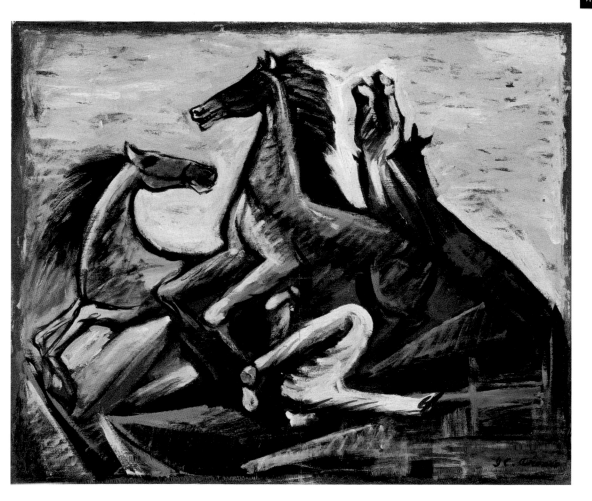

Thomson, Tom
The Jack Pine, 1916–17

Thomas John Thomson originally worked as an engraver and draughtsman at Grip Limited in Toronto, illustrating books and periodicals, and it was not until 1906 that he took up painting seriously. While working at Grip he was encouraged by co-workers J. E. H. MacDonald and Arthur Lismer to develop his painting. Other artists who were subsequently employed as graphic designers at Grip included Frederick Varley, Frank Johnston and Franklin Carmichael, who all made their name as painters; never before or since has any commercial firm employed such a talented group. While many of his younger colleagues became official war artists, Thomson remained behind, but it was his tragic death in mysterious circumstances – drowned near Wapomeo Island on Canoe Lake in 1917 – which had a major impact on the post-war development of Canadian art. His death shocked his friends but increased their determination to paint Canada their way. A. Y. Jackson summed this up when he wrote, 'he was the guide, the interpreter, and we the guests partaking of his hospitality so generously given'.

MOVEMENT
Modern Canadian School

OTHER WORKS
Pine Island; Snow in the Woods; Sunrise

INFLUENCES
A. Y. Jackson, J. E. H. MacDonald, Arthur Lismer

Tom Thomson *Born* 1877 Ontario, Canada
Painted in Canada

Died 1917 Wapomeo Island on Canoe Lake, Ontario

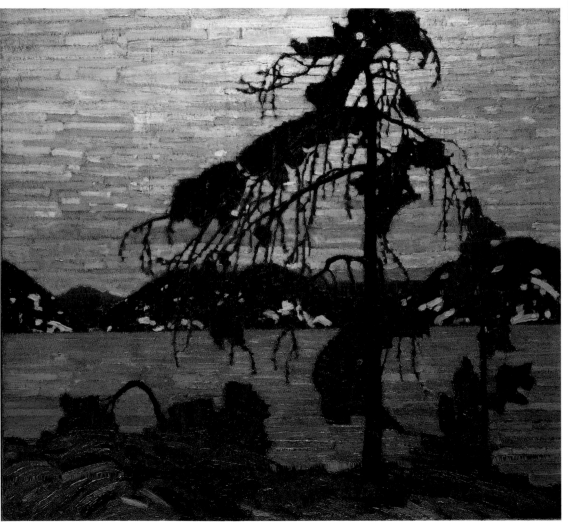

Braque, Georges
Verre et as de Trefle, 1917

Born in Argenteuil, the son of a house-painter, Braque was initially trained to carry on the family business. In 1902 he switched to art, but retained a profound respect for craftsmanship and always ground his own pigments. Initially, he joined the Fauvist group, but his style altered radically after two key events in 1907. Firstly he was overwhelmed by an exhibition of Cézanne's work, then, later in the year, he saw *Les Demoiselles d'Avignon* in Picasso's studio and embarked on a unique collaboration with the Spaniard. Working, in Braque's words, 'like two mountaineers roped together', they created Cubism. This artistic partnership was halted by the war, when Braque was called to the Front. He was decorated for bravery before being discharged with serious wounds in 1916. Unlike Picasso, who changed direction completely, Braque spent the remainder of his career refining his experiments with Cubism. These culminated in a magnificent cycle of paintings on *The Studio*, which he began in 1947. Braque also diversified into design work, producing ballet décors, stained-glass windows, book illustrations and, most notable of all, a ceiling for the Etruscan Gallery in the Louvre.

MOVEMENT

Cubism

OTHER WORKS

The Round Table; Guitar and Fruit Dish; Still Life with Violin

INFLUENCES

Pablo Picasso, Paul Cézanne, Juan Gris

Georges Braque *Born* 1882, Argeuteille-sur-Seine, France

Painted in France

Died 1963 Paris, France

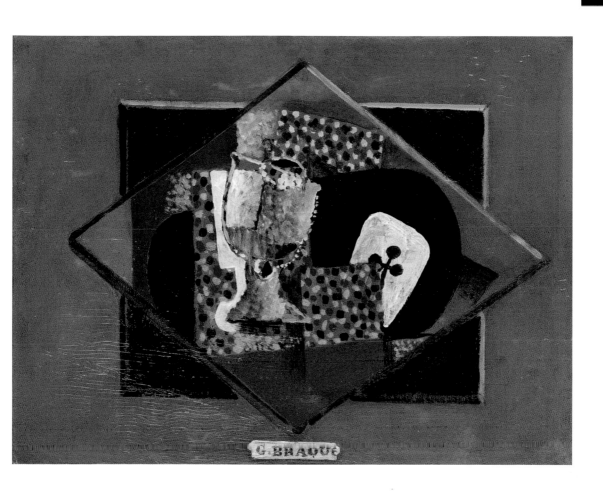

Klee, Paul
Moonshine, 1919

Courtesy of Private Collection/Christie's Images © DACS 2002

Paul Klee studied in Munich and worked there as an etcher. In 1911 he joined with Feininger, Kandinsky and Jawlensky in the Blaue Reiter group founded by August Macke; up to that time he had worked mainly in watercolours, painting in an Expressionist manner with overtones of Blake and Beardsley, but subsequently he veered towards Cubism under the influence of Robert Delaunay and from 1919 onwards painted mostly in oils. In 1920 he became a teacher at the Bauhaus and in the ensuing period his paintings mingled the figural with the abstract as he explored subtle combinations of colours and shapes, often deriving elements from folk art and even children's drawings. He severed his connections with the Bauhaus and returned to Switzerland when the Nazis came to power in 1933 and condemned his works as degenerate art.

MOVEMENTS

Expressionism, Cubism

OTHER WORKS

The Castle in a Garden; At the Sign of the Hunter's Tree

INFLUENCES

August Macke, Robert Delaunay

Paul Klee *Born* 1879 Münchenbuschsee, Switzerland

Painted in Berne and Munich

Died 1940 Muralto-Locarno, Switzerland

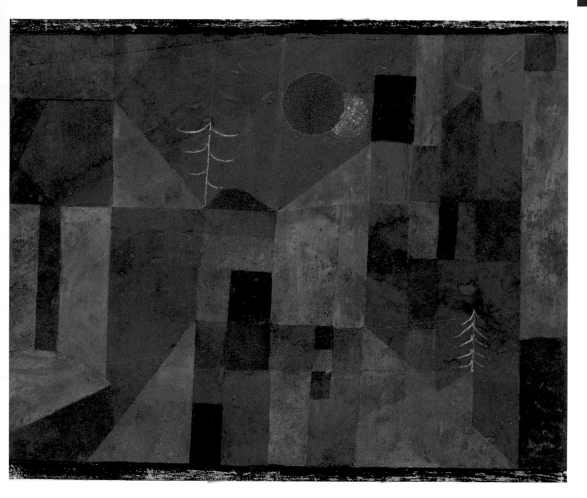

John, Augustus

Meditation at Ischia, Portrait of Thomas Earp

Courtesy of The Artists' Estate/Bridgeman Art Library/Christie's Images

Augustus Edwin John studied at the Slade School of Art and the University of London under Fred Brown and Henry Tonks, winning a scholarship with his *Moses and the Brazen Serpent* (1896). He went to Paris in 1900 and later travelled in the Netherlands, Belgium and Provence. His early work was influenced by Rembrandt, El Greco and the Post-Impressionists. A colourful, larger-than-life character, John hit the headlines when he roamed around England in a horse and cart, painting gypsy scenes. His later style was marked by the use of bold, bright colours, his first major oil being *The Smiling Woman* (1908) the first of many paintings in which his wife Dorelia was the model. During World War I he served as a war artist with the Canadians. From the 1920s onwards he painted numerous portraits. He became a member of the Royal Academy in 1928, resigned in protest in 1938, was re-elected in 1940 and in 1942 was awarded the Order of Merit. His genre scenes are full of wry humour.

MOVEMENT

English School

OTHER WORKS

Canadians Opposite Lens; The Smiling Woman

INFLUENCES

Rembrandt, El Greco

Augustus John *Born* 1878 Tenby, Wales

Painted in England

Died 1961 Hampshire, England

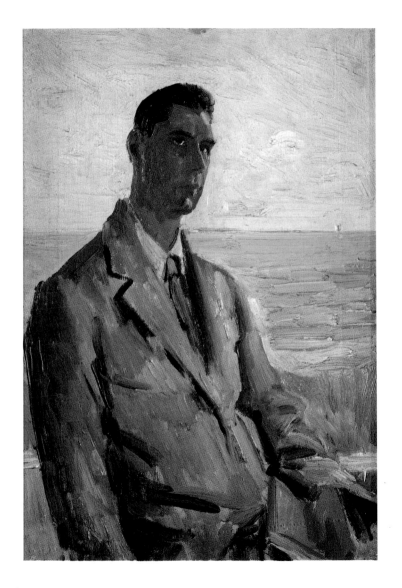

Léger, Fernand
Le Petit Déjeuner, 1921–22

Fernand Léger studied architecture in Caen and painting at the Académie Julien in Paris from 1903. Through Braque and Picasso he was introduced to Cubism in around 1910, but he soon developed his own distinctive brand of art described as the 'aesthetic of the machine', already evident in his work by 1913 but more fully developed after World War I. In this period he designed costumes and sets for the Swedish Ballet and collaborated with Man Ray on the first abstract film, *Le Ballet Mécanique* (1924). During World War II he lived in the USA where he taught at Yale and painted mainly acrobats and cyclists as well as working on the murals for the UN headquarters building in New York. After returning to France he concentrated on large paintings of men and machinery, earning the epithet of the 'Primitive of the Machine Age'.

MOVEMENT

Cubism

OTHER WORKS

The Construction Workers; The Builders; Still Life with a Beer Mug

INFLUENCES

Georges Braque, Pablo Picasso

Fernand Léger *Born* 1881 Argentan, France

Painted in France and USA

Died 1955 Gif-sur-Yvette, France

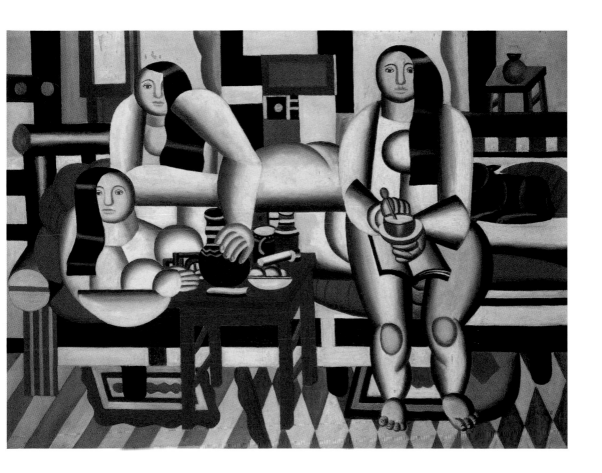

Gris, Juan

La Grappe de Raisins, 1925

Courtesy of Private Collection/Christie's Images

Born José Victoriano Gonzalez, Gris began his art studies in Madrid before going to Paris in 1906 to work as a magazine illustrator. An early associate of Picasso and Matisse, he became one of the leading exponents of Synthetic Cubism from 1912 onwards, the majority of his paintings involving the deliberate distortion and rearrangement of the elements. He also made extensive use of collage, such as strips of newspaper cut up and rearranged. He moved to Boulogne after World War I and in the 1920s designed costumes and sets for several of Diaghilev's Ballets Russes as well as working as a book illustrator. In his later years he experimented with brighter, contrasting colours and also produced a number of multicoloured sculptures.

MOVEMENT

Synthetic Cubism

OTHER WORKS

Glasses; Newspaper and a Bottle of Wine; The Bay

INFLUENCES

Henri Matisse, Pablo Picasso

Juan Gris *Born* 1887 Madrid, Spain

Painted in Paris and Boulogne

Died 1927 Paris, France

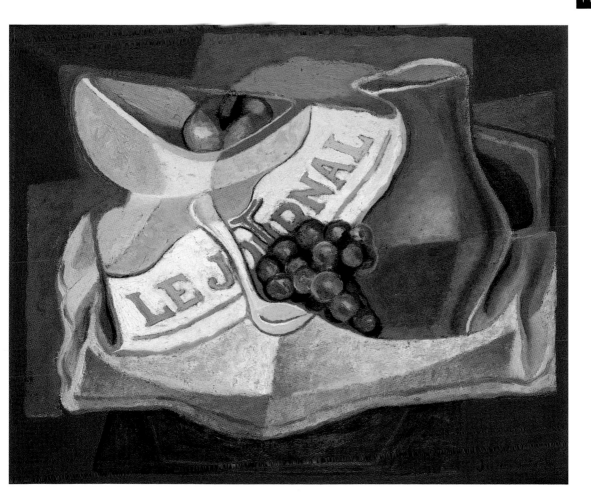

Moholy-Nagy, László
CH Beata 2

László Moholy-Nagy studied law in Budapest, but never practiced. Instead, he dabbled in photography and turned to painting after World War I, associating with Dadaists and Constructivists in Vienna and Berlin and constructing what he termed 'photograms': non-representational photographic images made directly from the subject without a camera. In 1925 he joined the Bauhaus under Gropius and established his reputation in the ensuing decade as the foremost exponent of the New Photographers' movement. In 1935 he moved to London, where he designed the futuristic sets for fellow-Hungarian Alexander Korda's film, *Things to Come*. In 1937 he went to the USA where he was appointed head of the Bauhaus School in Chicago, later renamed the Institute of Design. He became an American citizen at the end of World War II. Although primarily associated with photography, he also worked as a sculptor, designer and painter, often using collage and photo-montage.

MOVEMENT

Constructivism

OTHER WORKS

CHX; Composition A II; Jealousy

INFLUENCES

Naum Gabo, Kasimir Malevich

László Moholy-Nagy *Born* 1895 Hungary

Painted in Vienna, Berlin, Weimar, London and Chicago

Died 1946 Chicago, USA

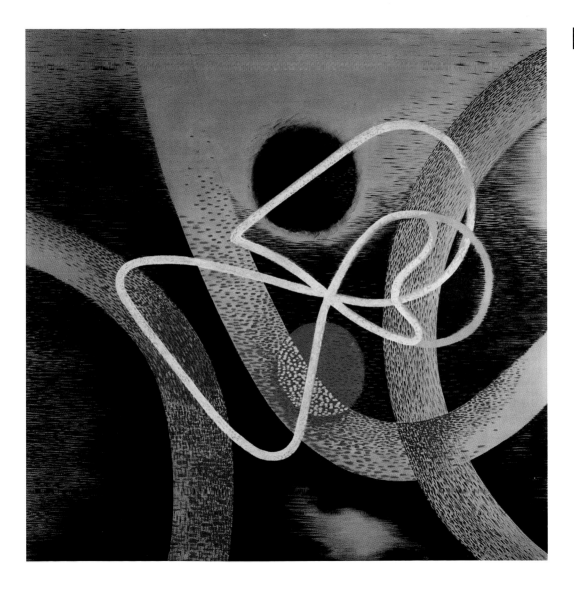

Delaunay, Robert
Triomphe de Paris, 1928–29

After a conventional art training in Paris, Robert Delaunay worked as a designer of sets for the theatre and did not take up painting seriously until 1905–06, when he came under the influence of the Neo-Impressionists. Over the ensuing decade he was also closely associated in turn with the Fauves, the Cubists and especially Der Blaue Reiter in 1911–12. In the latter years, however, his experimentation with contrasting colour patterns resulted in the development of a distinctive style which his friend, the poet Guillaume Apollinaire, dubbed Orphism because of its lyrical, almost musical, harmony. In his initial period, Delaunay painted numerous landscapes in and around Paris – the Eiffel Tower being a favourite subject – but gradually he moved towards a more non-figurative style. In his organization of contrasting colours he had a profound influence on the development of Abstract art in the 1920s. He collaborated with his wife Sonia, especially from 1918 onwards when he returned mainly to stage design.

MOVEMENT

Orphism

OTHER WORKS

Eiffel Tower; Sainte Severin; Political Drama

INFLUENCES

Pablo Picasso, Otto Freundlich, Franz Marc, Wassily Kandinsky

Robert Delaunay *Born* 1885 Paris, France

Painted in Paris

Died 1941 Montpellier, France

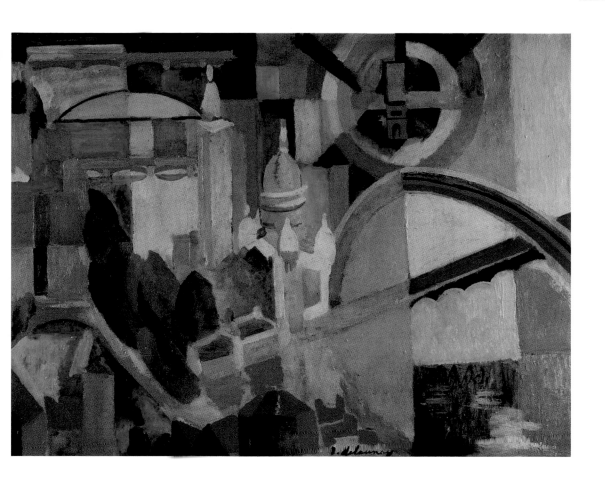

Lempicka, Tamara de

Les Deux Amies, *c.* 1928

Courtesy of Private Collection/Christie's Images/© ADAGP, Paris and DACS, London 2002

Tamara de Lempicka came from a Polish upper-class family, which gave her an excellent all-round international education. In 1918 she and her Russian husband fled the Russian Revolution to Paris. Here Lempicka came under the influence of the avant-garde artists, notably Fernand Léger. However, the painter whose work most impressed her and whose style is reflected in her own female nudes was Paul Cézanne, then near the end of his long career. Lempicka became one of the most fashionable portrait painters in Paris in the interwar period, her work emphasizing the glamour and ostentatious wealth of her patrons, idealizing their beauty and elegance. The other side of Lempicka, however, was her homosexuality – which was reflected in her extraordinary studies of female nudes, always fully representational (and often devastatingly so) yet with overtones of Cubism in the use of simplified anatomy and the geometric patterns of the background. The result was electrifying and highly distinctive.

MOVEMENT

Cubism

INFLUENCES

Paul Cézanne, Fernand Léger

Tamara de Lempicka *Born* 1898 Warsaw, Poland

Painted in Paris and Mexico

Died 1980 Cuernavaca, Mexico

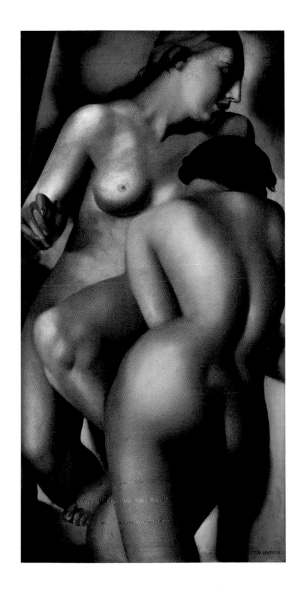

O'Keeffe, Georgia

Red Gladiola in White Vase, 1928

Georgia O'Keeffe studied at the Art Institute of Chicago in 1905–06 and then the Art Students' League in New York City (1907–08), where she met her future husband Alfred Stieglitz, the founder of the avant-garde circle that bears his name. She was an early convert to Abstract Art and, with Stieglitz, did much to spread the gospel among American artists from 1915 onwards. In the 1920s, however, she developed a more figurative style, concentrating on architectural or floral motifs but injecting a note of Surrealism into her paintings. Her work was characterized by sharply defined images that explored geometric patterns and earned for her work the epithet of Precisionism. She travelled all over the world, drawing on her experiences in many of her later works. In her last years she resided in New Mexico, whose monumental scenery found expression in a number of her landscapes.

MOVEMENT

Modern American School

OTHER WORKS

Radiator Building; Cow's Skull with Calico Roses

INFLUENCES

Alfred Stieglitz

Georgia O'Keeffe *Born* 1887 Wisconsin, USA

Painted in USA

Died 1986 Santa Fé, New Mexico, USA

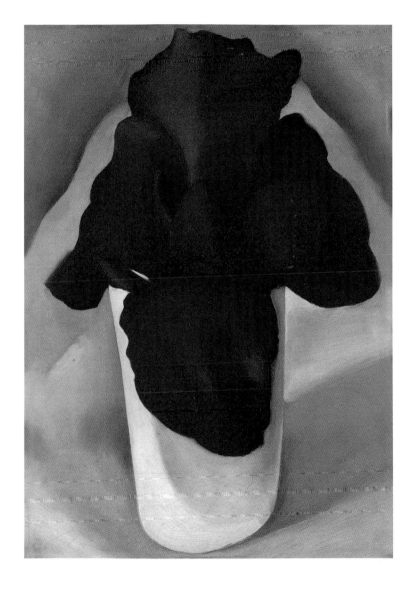

Hopper, Edward
Chop Suey, 1929

Courtesy of Whitney Museum of American Art, New York, USA/Bridgeman Art Library

Edward Hopper studied in New York City under Robert Henri between 1900 and 1906 and then travelled in Europe over the ensuing four years. The artistic atmosphere in Paris (1909–10) had a major impact on him and his paintings up to the mid-1920s reflect the influence of the French Impressionists. In this period he worked mainly as an illustrator, but from 1924 he concentrated on large-scale works which drew upon contemporary American life for their inspiration, from diners and gas stations to hotel lobbies and late-night bars. This emphasis on scenes which were instantly recognizable, coupled with the strong interplay of light and shadow, left an indelible impression – so much so that Hopper's art has come to represent urban America of the interwar years and had a major impact on the Pop Art of more recent years.

MOVEMENT

American School

OTHER WORKS

Room in New York; People in the Sun

INFLUENCES

Robert Henri

Edward Hopper *Born* 1882 New York, USA

Painted in New York

Died 1967 New York

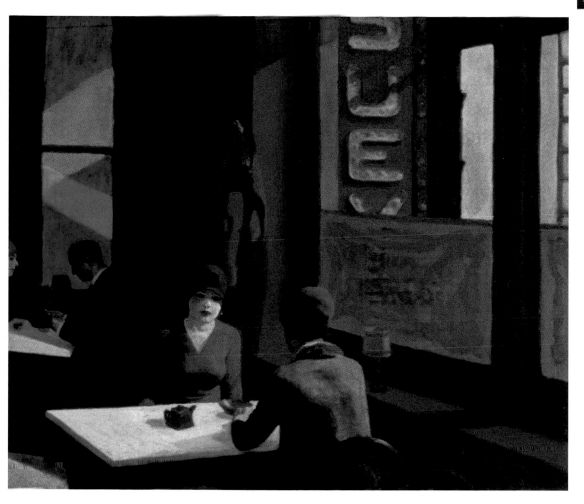

Dufy, Raoul
Large Blue Nude, 1930

Although he had a conventional training at the École des Beaux Arts in Paris, Raoul Dufy was attracted to the radical ideas of Matisse and Derain and for some time flirted with Impressionism, Cubism and Fauvism. In 1907 he turned away from painting to concentrate on textile patterns, graphic design and book illustrations, but in 1919 he took up painting again and settled on the French Riviera. There he was encouraged by his friend, the couturier Paul Poiret, to embark on a prolific series of paintings executed swiftly, characterized by large areas of flat colour and sharply incised black lines after the manner of the Chinese calligraphic artists. He created a kind of *ukiyo-e*, pictures of transient scenes, on promenades and beaches, at regattas and race meetings. His greatest masterpiece was the vast mural for the Exposition Universelle in Paris, 1938, one of the largest works ever painted.

MOVEMENT

Modern French School

OTHER WORKS

The Paddock; The Pier and Promenade at Nice

INFLUENCES

Henri Matisse, André Derain, Maurice de Vlaminck

Raoul Dufy Born 1877 Le Havre, France

Painted in Paris and the French Riviera

Died 1953 Forcalquier, France

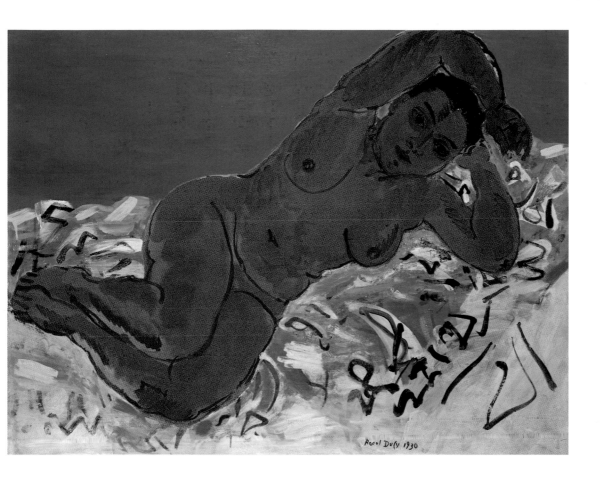

Raoul Dufy 1930

Mondrian, Piet

Composition with Red, Blue and Yellow, 1930

Born Pieter Cornelis Mondriaan, he simplified his name in 1909 when he moved to Paris, where he came under the influence of the Cubists, notably Henri Matisse. From still life, his work became progressively more abstract, his paintings distinguished by tightly regimented geometric shape and contrasting bright colours. In 1917 he became a founder member of De Stijl, the movement which derived its name from the journal which provided a forum for the Dutch avant-garde artists. Through this medium he propounded the theories which had a profound effect on a later generation as well as his contemporaries, and led to the development of the movement known as Neoplasticism. Mondrian was the arch-apostle of the abstract in its purest, simplest form. He moved to London in 1938, but after his studio was destroyed in the Blitz he settled in New York.

MOVEMENTS

De Stijl, Neoplasticism

OTHER WORKS

Composition with Red, Yellow and Blue; Broadway Boogie Woogie

INFLUENCES

Henri Matisse

Piet Mondrian *Born* 1872 Amersfoot, Holland

Painted in Holland, London, England and New York

Died 1944 New York

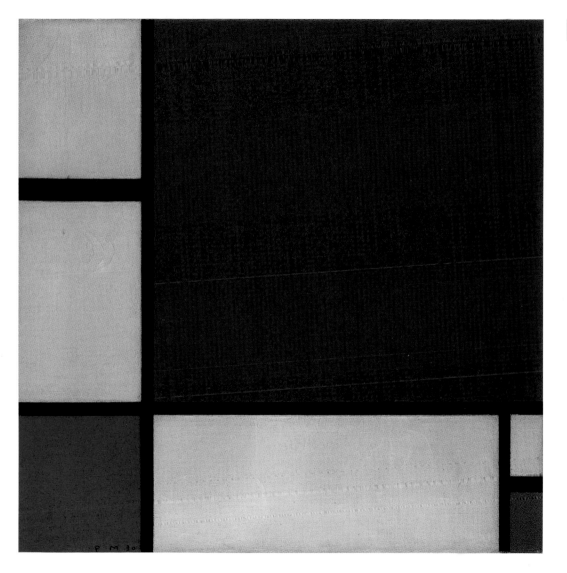

Kahlo, Frida

Autoretrato en la Frontera entre Mexico y los Estados, 1932

Born at Coyoicoan near Mexico City, Frida Kahlo had the misfortune to be in a streetcar crash at the age of 15. During the long convalescence from her terrible injuries she took up painting and submitted samples of her work to Diego Rivera, whom she married in 1928. Artistic temperament resulted in a stormy relationship that ended in divorce in 1939; many of Kahlo's self-portraits in this period are wracked with the pain she suffered all her adult life, as well as reflecting anger at her husband's numerous infidelities. Indeed, pain and the suffering of women in general were dominant features of her paintings, endlessly explored and revisited in canvasses that verge on the surreal and often shock with their savage intensity. André Breton, the arch-apostle of Surrealism, neatly described her art as "like a ribbon tied around a bomb".

MOVEMENT

Surrealism

OTHER WORKS

Self Portrait with Cropped Hair; Self Portrait with Monkey

INFLUENCES

Diego Rivera

Frida Kahlo *Born* 1907 Coyoicoan, Mexico

Painted in Mexico City

Died 1954 Mexico City

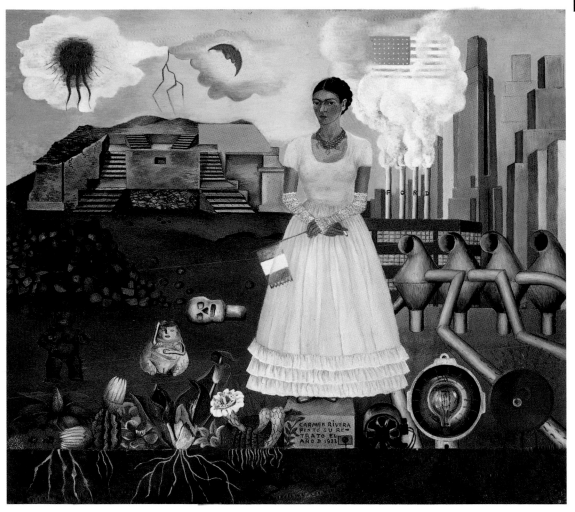

Picasso, Pablo
Le Repos, 1932

Spanish painter, sculptor, draughtsman and ceramicist; the most versatile and influential artist of the twentieth century. Having studied in Barcelona, Picasso finally settled in Paris in 1904. His Blue (1901–04) and Rose (1904–06) periods produced his popular scenes of vagrants and circus performers, which were loosely inspired by Puvis and the Symbolists. Then, in 1907, he produced *Les Demoiselles d'Avignon*, the most influential painting of the twentieth century. Named after the red-light district in Barcelona and drawing inspiration from African sculpture, it opened the way for the Cubist movement, which Picasso spearheaded with Braque.

In the 1920s he ushered in a Classical revival, while also being hailed as an inspiration by the Surrealists. Increasingly, though, his paintings displayed a pessimistic strain, brought on by the collapse of his marriage and the deteriorating political situation. This culminated in his most celebrated picture, *Guernica*, which commemorated an atrocity in the Spanish Civil War. Picasso's ongoing hostility to the Franco regime led him to make France, rather than Spain, the base for his later artistic activities.

MOVEMENTS

Cubism, Surrealism, Classical Revival

OTHER WORKS

Three Musicians

INFLUENCES

Paul Cézanne, Georges Braque, Toulouse-Lautrec

Pablo Picasso *Born* 1881 Malaga, Spain

Painted in Spain, France and Italy

Died 1973 Aix-en-Provence, France

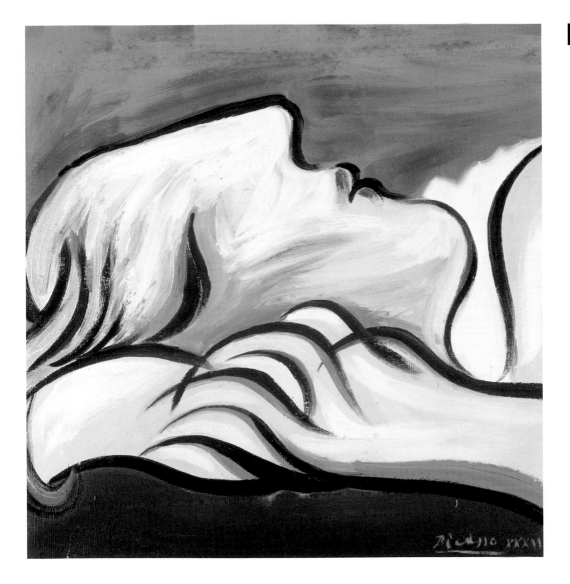

Jackson, A. Y.

Winter, Charlevoix County, 1933

Courtesy of Art Gallery of Ontario, Toronto, Canada/Bridgeman Art Library

One of the most influential Canadian artists of the twentieth century, Alexander Young Jackson originally worked as a commercial artist in Montreal (1895–1906), before moving to Chicago. While continuing in the same profession, he attended classes at the Art Institute of Chicago and then went to Paris in 1907, where he studied under Jean-Paul Laurens at the Académie Julian. He returned to Canada in 1909 and settled in Toronto in 1913, where he became one of the leaders of the Group of Seven, founded in 1920. In World War I he was wounded in action but later became a war artist. He resumed his work as a landscape painter in 1919, becoming the leading advocate for a distinctive Canadian style of painting, his words as eloquent as his paintings were striking. He travelled to every part of Canada, including the Arctic, to record the rich variety of landscape.

MOVEMENT

Modern Canadian School

OTHER WORKS

Terre Sauvage; Springtime in Picardy; First Snow

INFLUENCES

Jean-Paul Lauren, Lawren Harris, Tom Thomson

A. Y. Jackson *Born* 1882 Montreal, Canada

Painted in Canada and France

Died 1974 Kleinburg, Ontario, Canada

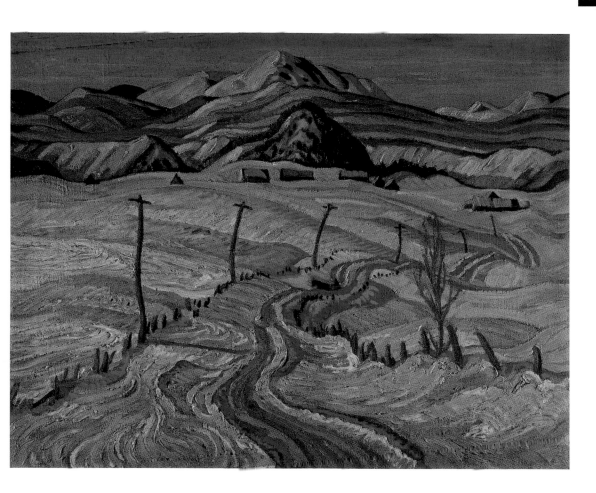

Magritte, René

Le Chef d'Oeuvre ou Les Mystères de l'Horizon

The great Surrealist master René François Ghislain Magritte studied at the Académie Royale des Beaux-Arts in Brussels (1916–18) and became a commercial artist for fashion magazines and a designer of wallpaper. His paintings were initially influenced by Futurism and Cubism, but later he was attracted to the work of Giorgio de Chirico. In 1924 he became a founder member of the Belgian Surrealist group, which provided an escape from the dull routine of his everyday work. From 1927 to 1930 he lived in Paris to better continue his study of the Surrealists, then returned to Brussels where he built his reputation for paintings of dreamlike incongruity, in which themes and objects are jumbled in bizarre, nonsensical situations, often showing paintings within paintings. He is regarded in the United States as a forerunner of Pop Art.

MOVEMENT

Surrealism

OTHER WORKS

Rape; The Reckless Sleeper; The Treachery of Images

INFLUENCES

Giorgio de Chirico

René Magritte *Born* 1898 Lessines, Belgium

Painted in Belgium

Died 1967 Brussels, Belgium

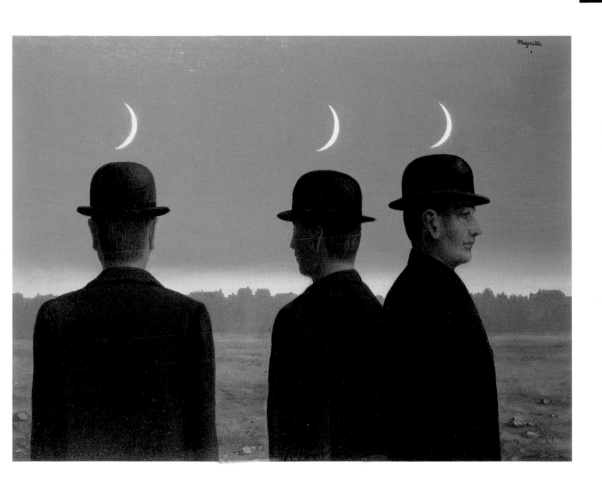

Wood, Grant

Adolescence, 1933

Born at Anamosa, Iowa, Grant Wood spent his entire life in this small town in the American Midwest, and his paintings are a chronicle of the people and the scenery of the district. In the 1920s, however, he travelled to France and the Netherlands where he studied the works of the old masters, especially the Gothic, Romanesque, Renaissance and Flemish School, all of which had a strong influence on his own paintings. His best-known painting, *American Gothic*, is aptly named, for in it Wood depicts a cottage in his home town whose Gothic window appealed to him. In the foreground stands a typical Midwestern farmer and his wife, actually Wood's sister and his dentist, who served as his models. He was severely criticized at the time for lampooning the values of Middle America but he defended himself, insisting that the painting was intended as a sincere tribute to the simple dignity of rural communities. Wood was the foremost of the Regionalists, a group of American artists who rejected the abstract in favour of the realism of ordinary people and their locale.

MOVEMENT

Regionalism

OTHER WORKS

Haying

INFLUENCES

Jan Van Eyck, Rogier van der Weyden

Grant Wood *Born* 1892 Anamosa, Iowa, USA

Painted in Iowa

Died 1942 Anamosa

Douglas, Aaron

Aspects of Negro Life: Song of the Towers, 1934

© Schomberg Center, The New York Public Library/Art Resource, New York

The leading exponent of the Harlem Renaissance, Aaron Douglas studied at the University of Kansas and from 1925 to 1927 studied art in New York under Winold Reiss, who encouraged him to accept and celebrate his African American heritage. Throughout the 1920s he illustrated a number of books by emerging African American authors, while drawings contributed to a number of magazines of the period show the influence of African art forms, putting Douglas in the forefront of the Harlem Renaissance. In 1931 he went to Paris and studied at the Académie Scandinave under Despiau, and in 1938 he travelled all over the American South and Haiti. He later taught at Fisk University in Nashville, Tennessee. In the 1930s he executed a number of large murals for public buildings in Nashville and New York which drew on the African American cultural tradition and history. He played a prominent role in the development of modern African American consciousness.

MOVEMENT

Modern American School

OTHER WORKS

Aspects of Negro Life, From Slavery through Reconstruction

INFLUENCES

Winold Reiss, Charles Despiau

Aaron Douglas *Born* 1899 Topeka, Kansas, USA

Painted in New York, Nashville and Paris

Died 1979 Nashville, Tennessee

Kokoschka, Oskar
Zwei Madchen, 1934

Oskar Kokoschka studied at the Vienna School of Arts and Crafts (1905–09) and joined the Wiener Werkstätte, where he produced lithographs distinguished by their strong graphic sense. His drawings contributed to the German avant-garde magazine *Der Sturm* reveal a highly original approach to Expressionism. After military service in World War I, in which he was seriously wounded, he taught at the Dresden Academy of Art from 1919 until 1924 but subsequently he travelled extensively in Europe and North America before settling in Prague. When the Nazis dismembered Czechoslovakia in 1938 he moved to England, becoming naturalized in 1947, but six years later he settled in Switzerland, where he died in 1980. A versatile artist, he painted landscapes and urban scenes but it is for his very expressive portraits, in which disparate colours bring out the psychological profile of the sitter, that he will be remembered.

MOVEMENT

Expressionism

OTHER WORKS

Portrait of a 'Degenerate Artist'; Children Playing

INFLUENCES

Gustav Klimt, Max Beckmann

Oskar Kokoschka *Born* 1886 Pöchlarn, Austria

Painted in Vienna, Dresden, Prague and London

Died 1980 Montreux, Switzerland

Dalí, Salvador

Le Sommeil, 1937

Spanish painter, graphic artist and film-maker – the most controversial member of the Surrealists. Dalí was born in Catalonia and studied at the Academy of Fine Arts in Madrid, until his outrageous behaviour caused his expulsion. Before this, he had already made contact with the poet Lorca and the film-director Buñuel. In the early 1920s, he dabbled in a variety of styles, including Futurism and Cubism, although it was the metaphysical paintings of de Chirico which made the deepest impact on him.

The key stage in Dalí's career came in 1929, when he made *Un Chien Andalou* with Buñuel, met his future wife Gala and allied himself with the Surrealists. His relationship with the latter was rarely smooth and, after several clashes with Breton, he was forced out of the group in 1939. In the interim, he produced some of the most memorable and hallucinatory images associated with the movement, describing them as 'hand-painted dream photographs'. Dalí remained very much in the public eye in later years, gaining great celebrity and wealth in the US, but for many critics his showmanship overshadowed his art.

MOVEMENT

Surrealism

OTHER WORKS

The Metamorphosis of Narcissus; The Persistence of Memory

INFLUENCES

Pablo Picasso, Giorgio de Chirico, Yves Tanguy

Salvador Dalí *Born* 1904 Catalonia, Spain

Painted in Spain, France, USA and Italy

Died 1989

Tanguy, Yves

Paysage Surréaliste, 1937

Going to sea as a teenager and later serving in the French army, Yves Tanguy did not take up painting until his return to Paris in 1922. Without any formal training, he was influenced by the work of Giorgio de Chirico and joined the Surrealists in 1925, subsequently concentrating on that style known as Biomorphism because its images were derived from living organisms. Inevitably, Tanguy's paintings in the ensuing period drew heavily on memories of naval and military service. In 1939 he immigrated to the United States, where he married fellow-artist Kay Sage and settled in Woodbury, Connecticut. In his last years his work took on a darker character, suggestive of dream sequences which reflected his fascination with the Freudian theories of psychoanalysis. His paintings were non-figurative, inhabited by small objects, often boney-like but defying description and suggestive of some other world.

MOVEMENTS

Biomorphism, Surrealism

OTHER WORKS

Dehors; The Invisible; The Rapidity of Sleep

INFLUENCES

Giorgio de Chirico, Salvador Dali

Yves Tanguy *Born* 1900, Paris, France

Painted in Paris, France and Woodbury, Connecticut, USA

Died 1955, Woodbury

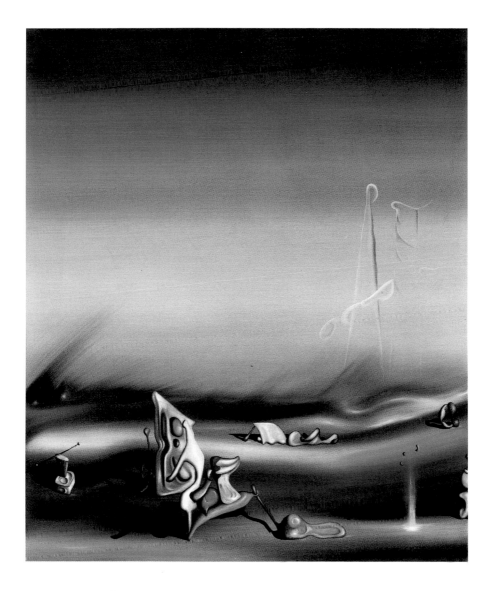

Ernst, Max
Forêt et Soleil, 1938

German painter and a leading Surrealist. Born near Cologne, Ernst studied psychology at Bonn University, taking a particular interest in the art of the insane. Before the war he befriended Arp and Macke and mixed with the Blaue Reiter (Blue Rider) group. Then, in 1919, he staged the first Dada exhibition in Cologne. Typically for this movement, visitors had to enter the show through a public urinal and were handed axes, in case they wished to destroy any of the exhibits. In 1922, Ernst moved to Paris and joined the Surrealist circle. His work in this style was incredibly varied. He made considerable use of the chance images, which were suggested by automatic techniques, such as *frottage* (rubbings of textured surfaces). At the same time, he exploited the 'poetic sparks', which were created by the juxtaposition of totally unrelated objects. These sometimes took the form of paintings, but were also produced as collages, drawn from popular magazines.

Ernst was interned during World War II and spent much of his later career in America.

MOVEMENTS

Surrealism, Dada

OTHER WORKS

The Robing of the Bride; Europe after the Rain

INFLUENCES

August Macke, Hans Arp, Giorgio de Chirico

Max Ernst *Born* 1891, Cologne, Germany

Painted in Germany, France and the USA

Died 1976

Johnson, William H.
Going to Church, *c.* 1940–01

Courtesy of Smithsonian American Art Museum, Washington, DC/Art Resource, NY

Born in South Carolina in 1901, William Henry Johnson migrated to New York in 1918 and settled in Harlem. For five years he studied art at the National Academy of Design and later moved to Denmark, after marrying the Danish weaver and potter Holche Krake in 1930. He later spent some time in Norway before returning to the USA shortly before World War II. In 1943 they lost everything as a result of a house fire, and soon afterwards his wife died. Johnson had a mental breakdown and by 1947 had to be committed to an institution. In 1967 he gave his collected works, amounting to some 800 oils and watercolours and about 400 sketches and drawings, to the National Museum of American Art. He died three years later, and it is only since the 1970s that his achievement has been fully recognized and his importance in the development of contemporary American art fully appreciated. His paintings are characterized by their passion and exuberance, with echoes of Van Gogh and the Constructivists as well as the influence of African tribal sculpture and textile patterns.

MOVEMENT

African American School

OTHER WORKS

Lamentation; Cagnes-sur-Mer; Minnie; Jacobia Hotel; Jitterbugs

INFLUENCES

Van Gogh, Kasimir Malevich

William H. Johnson *Born* 1901 South Carolina, USA

Painted in Denmark, Norway and USA

Died 1970 Long Island, New York

Rivera, Diego

Vendedora de Flores, 1942

Courtesy of Private Collection/Christie's Images/2002 Banco de Mexico Diego Rivera & Frida Kahlo Museums Trust, Av. Cinco de Mayo No. 2, Col. Centro,

Del. Cuauhtemoc 06059, Mexico, D.F.

The outstanding muralist of Latin America, Diego Rivera studied art in Mexico City and Madrid; he went to Paris in 1911, where he met Picasso and began painting Cubist works, which were strongly influenced by Gris and Braque. By contrast, a sojourn in Italy studying the frescoes of the Renaissance masters made such an impact on him that, on his return to Mexico in 1921, he concentrated on large murals decorating the walls of public buildings. These depicted every aspect of life in Mexico and drew on the turbulent history of its people. Rivera's best work was carried out during a period when Mexico was dominated by left-wing, anti-clerical governments, which regarded Rivera as the leading revolutionary artist. He also worked in the USA where he painted murals extolling the industrial proletariat and preaching social messages. He evolved his own brand of folk art with overtones of such disparate elements as Aztec symbolism and Byzantine icons.

MOVEMENT

Mexican Modernism

OTHER WORKS

Court of the Inquisition; Workers of the Revolution

INFLUENCES

Juan Gris, Georges Braque

Diego Rivera *Born* 1886 Guanajuato, Mexico

Painted in Mexico and USA

Died 1957 Mexico City

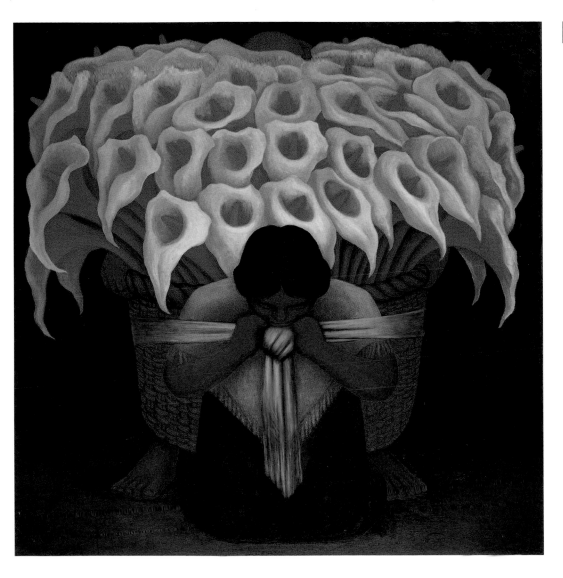

Schwitters, Kurt

Roter Kreis, 1942

Courtesy of Private Collection/Christie's Images/© DACS 2002

Kurt Schwitters studied at the Dresden Academy and worked as a painter, designer, architect, typographer, writer and publisher, disparate occupations and disciplines which he combined with remarkable flair. He was intrigued by Cubism very early on and produced a number of abstract paintings in this style, but was then attracted to Dadaism and strongly influenced by Hausmann, Arp and other leading exponents. During this phase he produced montages of totally unrelated objects and incongruous fragments of junk and ephemera, such as discarded leaflets, bus tickets and used stamps torn off envelopes. After 1920 he took this notion a step further, incorporating street rubbish in enormous three-dimensional collages which he termed Merzbau ('cast-off construction'). This led to the Dadaist magazine *Merz*, which he ran from 1923 until 1932. When the Nazis came to power he fled to Norway and from there moved in 1940 to England, where he died in 1948.

MOVEMENT

Dada

OTHER WORKS

Chocolate; Spring Picture; Circle

INFLUENCES

Jean Arp, Marcel Duchamp, Raoul Hausmann

Kurt Schwitters *Born* 1887 Hanover, Germany

Painted in Germany, Norway and England

Died 1948 Ambleside, Cumbria, England

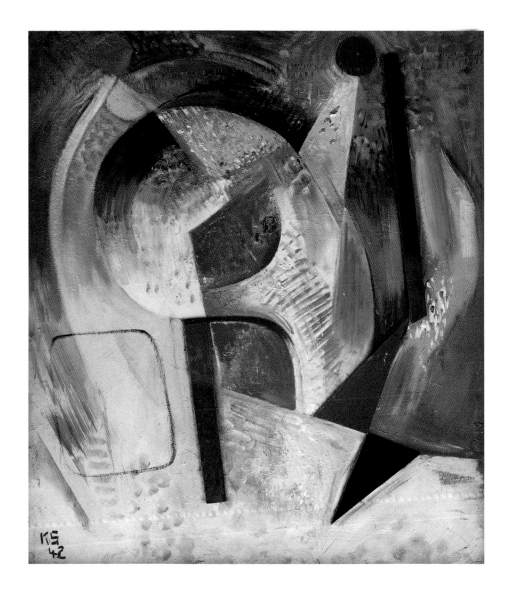

Lowry, L. S. (Laurence Stephen)
Industrial Landscape, 1944

Distinctive British painter, famous for his pictures of 'matchstick men'. Lowry was born in Old Trafford, Manchester, and lived in or near the city throughout his life. He failed to gain entry to the local art school and, instead, took on office work and painted in the evenings. Initially, he was employed by an insurance company and, after 1910, as a rent collector for a property firm. In later years, much of his time was also devoted to the care of his invalid mother. They were very close and Lowry was devastated when she died in 1939.

The childlike qualities of Lowry art have often been classified as naïve, but technically this is untrue, since he had a succession of teachers at evening school. The most significant of these was Adolphe Valette, who also painted urban townscapes. From an early stage, Lowry began producing unglamorous views of the local, industrial scene, focusing in particular on details of everyday life. These ranged from the grotesque to the humorous. Lowry's style baffled the art establishment – he was conspicuously omitted from the Royal Academy's survey of twentieth century British art – but his paintings sold well and he has remained unfailingly popular with the public.

MOVEMENT

Naïve Art

OTHER WORKS

Our Town; Man Lying on a Wall; Sudden Illness; The Pond

INFLUENCES

Adolphe Valette, Camden Town School

L. S. Lowry *Born* 1887 Manchester, England

Painted in England

Died 1976 Glossop, England

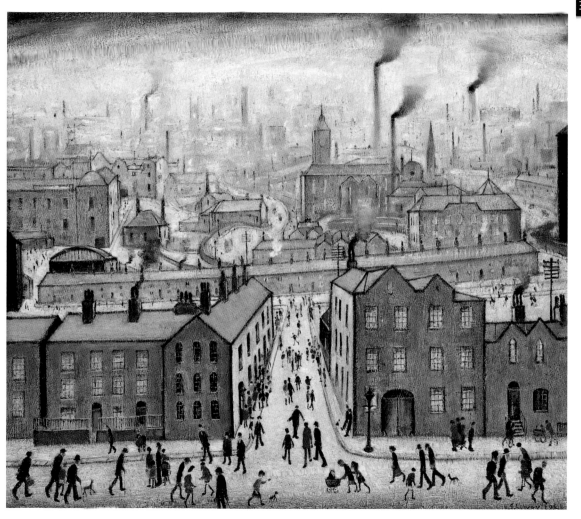

Still, Clyfford
Jamais, 1944

Courtesy of Peggy Guggenheim Foundation, Venice, Italy/Bridgeman Art Library

Raised in the American Midwest, Clyfford Still studied art at Spokane University, Washington, graduating in 1933 when the United States was still recovering from the Depression. Eschewing the social realism of his contemporaries, he strove to evolve his own distinctive style, embracing elements of Biomorphism in which organic forms predominated. In 1941 he settled in San Francisco and subsequently taught at the California School of Fine Arts (1946–50). During this period he emerged as one of the leading exponents of Abstract Expressionism. Heavily influenced by Barnett Newman and Mark Rothko, he favoured large canvasses in which a single colour predominated; the variations in colour, form and content being largely confined to the periphery. Interest and variety in the principal colour was imparted by its rich texture and brushwork. Many of his works were either completely untitled or only given the most cryptic of titles. Thus it was mainly left to the viewer to divine the significance of the detail at the edges of his canvas, although Still himself was a past-master in the art of making pretentious statements that allegedly explained the metaphor of his work.

MOVEMENT

Abstract Expressionism

OTHER WORKS

Untitled, No1 ; Untitled 1953

INFLUENCES

Barnett Newman, Mark Rothko

Clyfford Still *Born* 1904

Painted in Spokane, Washington, San Francisco, California, USA

Died 1980 New Windsor, Maryland, USA

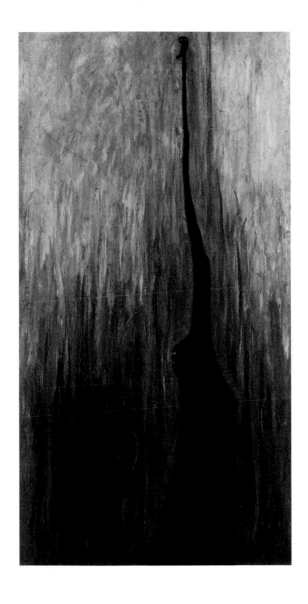

Tanning, Dorothea

The Truth about Comets and Little Girls

Dorothea Tanning worked as a librarian in her home town of Galesburg, Illinois. In 1930 she went to work in Chicago and attended a two-week course of evening classes in art at the Academy of Fine Art, before going to New York in 1936, where she found employment as a commercial artist. Her earliest paintings drew on childhood nostalgia interpreted in a surreal manner, and this brought her to the attention of the American Surrealists. In 1946 she married Max Ernst, the German Dadaist then living in exile in the USA, and together they settled in France, where she worked as a painter, graphic artist and designer of theatrical sets and costumes. Tanning's later work has a more fully rounded character but still essentially explores the female psyche and sexuality through the medium of dreams. Her paintings often combine a superficial childhood innocence with rather disturbing sexual undertones and morbid symbolism.

MOVEMENT

Surrealism

OTHER WORKS

Born; Eine Kleine Nachtmusik; A Very Happy Picture; A Family Portrait

INFLUENCES

Max Ernst

Dorothea Tanning *Born* 1910 Galesburg, Illinois, USA

Painted in Chicago, New York and Paris

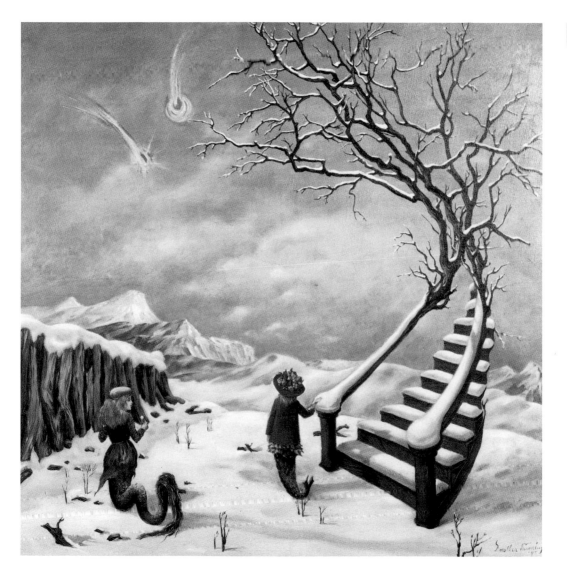

Matta, Roberto

Abstracto

Born Roberto Sebastian Matta Echaurren, he trained as an architect in his native city of Santiago and continued his studies under Le Corbusier in Paris. He took up painting in 1937 and was immediately attracted to Surrealism, of which he became one of the outstanding figures over the ensuing decade. He moved to the United States in 1939 and made his debut at the Julien Levy Gallery the following year. His work had an enormous impact on the younger generation of American artists, his approach to Surrealism being markedly different from that of Dali and the other main European exponents. His technique of apparently random brushstrokes without rational control influenced such painters as Arshile Gorky and Jackson Pollock. From Abstract Expressionism he gradually moved towards what he termed as 'transparent Cubism' in the late 1940s, bringing back figural elements.

MOVEMENTS

Surrealism, Abstract Expressionism

OTHER WORKS

Invasion of the Night; Disasters of Mysticism; Abstraction; Untitled

INFLUENCES

Hans Bellmer

Roberto Matta *Born* 1911 Santiago, Chile

Painted in Chile and US

Died 2002 Civitavecchia, Italy

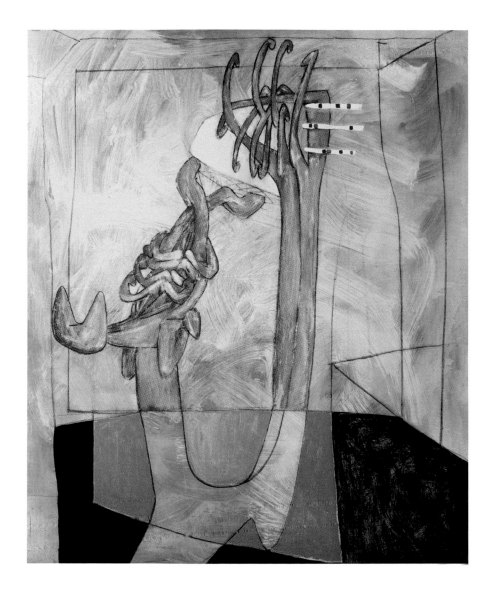

Pollock, Jackson

Something of the Past, 1946

Courtesy of Private Collection/Christie's Images/© ARS, New York and DACS, London 2002

Pollock grew up in the American West, becoming familiar with Native American art at an early age. He was briefly influenced by Benton and the Regionalists, but learned more from Siqueiros and the Mexican muralists. He was impressed by their expressive, almost violent use of paint. Pollock also began to explore the possibilities of Jungian psychology. This started as an aspect of his private life – psychotherapy was one of the many treatments he tried for his long-term alcoholism – but it also fuelled his art. For, like the Surrealists, he adopted the idea of automatic painting, as a mirror of the subconscious.

After years of isolation and critical neglect, Pollock's experiments bore fruit in the late 1940s. By 1947, he had perfected the 'drip' technique which made him famous. He placed his canvas on the floor and covered it in trails of paint, poured directly from the can. This process was carried out in an artistic frenzy, comparable with the Indian ritual dances which he had witnessed as a boy. Pollock's output slowed in the 1950s and he was killed in a car crash in 1956.

MOVEMENT

Abstract Expressionism

OTHER WORKS

Convergence; Autumn Rhythm; Lavender Mist

INFLUENCES

André Masson, Thomas Hart Benton, David Siqueiros

Jackson Pollock *Born* 1912 USA

Painted in USA

Died 1956

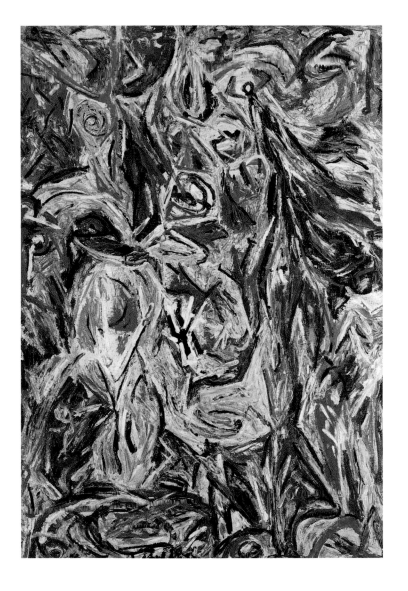

Gorky, Arshile
Year after Year, 1947

Originally named Vosdanig Manoog Adoian, Gorky was born at Khorkom Vari in Turkish Armenia. He survived the genocide perpetrated on the Armenians by the Turks during World War I and escaped to the West, settling in the USA in 1920. The death of his mother during one of the Turkish atrocities had a profound influence on his art. It was at this time that he adopted his new name, taking the surname from the celebrated Russian writer Maxim Gorky. In America he trained at the Rhode Island School of Design and continued his studies in Boston. For several years his style was a heady but eclectic mixture of elements drawn from Miró, Cezanne, Picasso, Motta and André Breton, and it was from the latter that he was attracted to Surrealism, concentrating on biomorphism (the creation of organic abstracts), but later he developed his own distinctive style which promoted Abstract Expressionism.

MOVEMENT

Abstract Expressionism

OTHER WORKS

Agony; Waterfall

INFLUENCES

Joan Miró, Pablo Picasso, Paul Cézanne

Arshile Gorky *Born* 1904 Khorkom Vari, Turkey

Painted in USA

Died 1948 Sherman, Connecticut, USA

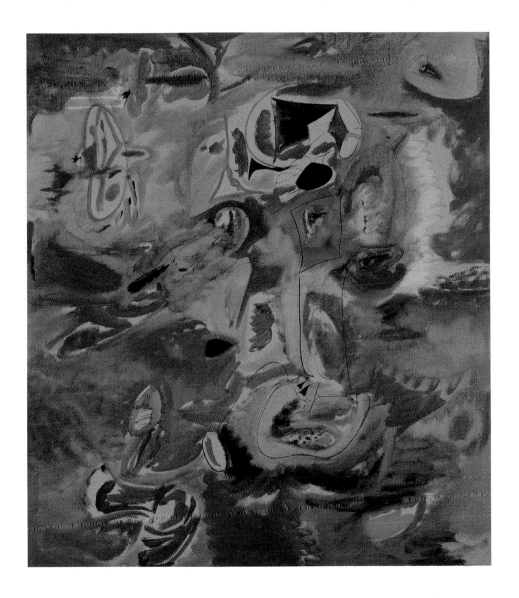

Nolde, Emil
Lichtzauber, 1947

Courtesy of Private Collection/Christie's Images/© The Nolde-Foundation 2002/© Nolde-Stiftung Seebüll

Born Emil Hansen in Nolde, Germany, he later adopted the name of his birthplace. He trained as a wood-carver but later studied painting in Munich, where he was briefly a member of the Expressionist group known as Die Brücke (The Bridge) in 1906–07 as well as Die Blaue Reiter (The Blue Rider). He was, however far too rugged an individualist ever to conform too closely to any particular movement, and developed his own distinctive Blut und Boden (blood and soil) style of painting, originally confined largely to religious themes expressed with distorted images and violent brushstrokes, but later extended to landscapes, seascapes, still life and flowers. Most of his work was done in a remote area of the German North Sea coast where he lived increasingly as a recluse. His last work, a series entitled Unpainted Pictures, was completed in secrecy as he suffered the delusion of still being harassed by the Nazis. He was also a prolific producer of etchings, lithographs and woodcuts.

MOVEMENT

Expressionism

OTHER WORKS

The Life of Christ; Meeting on the Beach; Red Poppies

INFLUENCES

James Ensor, Maurice de Vlaminck

Emil Nolde *Born* 1867 Nolde, Germany

Painted in Germany

Died 1956 Seebüll, Germany

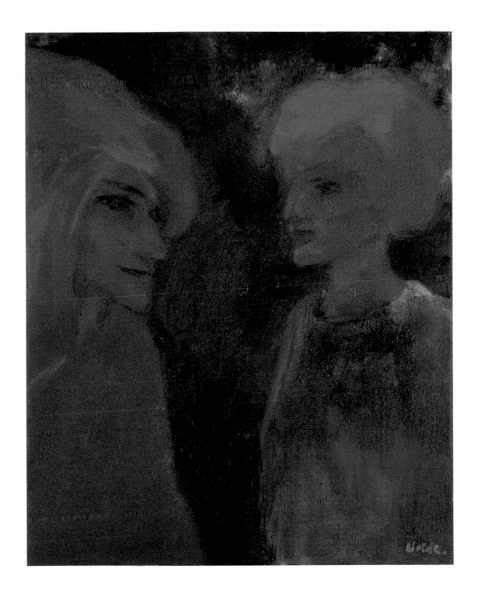

Beckmann, Max

Artisten, 1948

Max Beckmann is regarded as one of the greatest figurative artists of the twentieth century. He studied in Weimar and worked as a draughtsman and printmaker before moving to Berlin in 1904, where he embarked on large-scale paintings. During World War I he worked as a hospital orderly – a terrifying experience that shaped his subsequent art. There are Gothic overtones in his canvasses which starkly depict the hopeless struggle of the individual against evil. Not surprisingly, his work was dismissed by the Nazis as degenerate. In 1937 he fled to Holland and spent the last years of his life in the USA, a period in which his paintings expressed a new hope for the world. He was both prolific and versatile, his work ranging from still life and formal portraits to landscapes, abstracts and symbolic compositions, often bizarre and monstrous but always thought-provoking.

MOVEMENT

Expressionism

OTHER WORKS

Departure; Quappi with Parrot; The Night

INFLUENCES

George Grosz

Max Beckmann *Born* 1884 Leipzig, Germany

Painted in Germany, Holland and USA

Died 1950 New York, USA

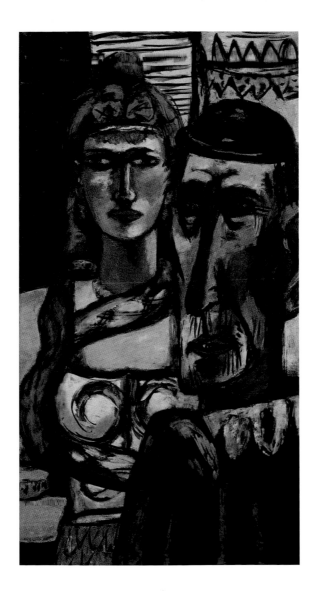

Newman, Barnett

Untitled, 1948

Barnett Newman trained at the Art Students' League in New York City while also studying at the City College in the early 1920s. Many years later, in the last decade of his life, he taught at the universities of Saskatchewan and Pennsylvania. In between he began his professional career as an Abstract Expressionist about 1930, but gradually developed his own highly distinctive style which eschewed the loose techniques of Expressionism for a more disciplined, rigorous approach. At the same time, the range of his palette gradually decreased as he moved towards a more monochrome treatment, relieved only by one or two vertical bands of contrasting colour which Newman styled as 'zips' from their resemblance to zip-fasteners on clothing. Ultimately, between 1952 and 1962, Newman painted in black and white, the minimalism of his pictures relieved only by the subtleties of shade and density, but in his last years he utilized colours of extraordinary depth and tone. From about 1965 he also produced a number of steel sculptures.

MOVEMENT

Abstract Expressionism

OTHER WORKS

Moment; Adam; Covenant; Onement III

INFLUENCES

Piet Mondrian, Mark Rothko

Barnett Newman *Born* 1905 New York, USA

Painted in New York

Died 1970 New York

Spencer, Sir Stanley

Angels of the Apocalypse, 1949

Stanley Spencer spent most of his life in the Berkshire village of Cookham, which provided him with most of his inspiration. He studied at the Slade School of Art in London from 1909 to 1912 but does not appear to have been affected by any of the avant-garde developments in that period. Apart from military service in World War I, and a period during World War II spent on Clydeside recording the toil of shipyards, he remained very close to his roots – a familiar sight in Cookham, painting or sketching. Often dismissed as an eccentric, he worked outside the artistic mainstream, but inevitably some trends in art found a reflection in his paintings, notably his use of distorted anatomy and space. A profoundly religious man, his paintings often have biblical connotations, although events such as the Resurrection are placed in the context of Cookham or Clydeside. He covered his enormous canvasses with drawings of the subjects, which were then painted over. He was knighted shortly before he died.

MOVEMENT

Modern English School

OTHER WORKS

The Resurrection; The Crucifixion; Self-Portrait with Patricia

INFLUENCES

Pre-Raphaelites

Sir Stanley Spencer *Born* 1891 Cookham, Berkshire, England

Painted in Cookham and Port Glasgow, Scotland

Died 1959 Cookham

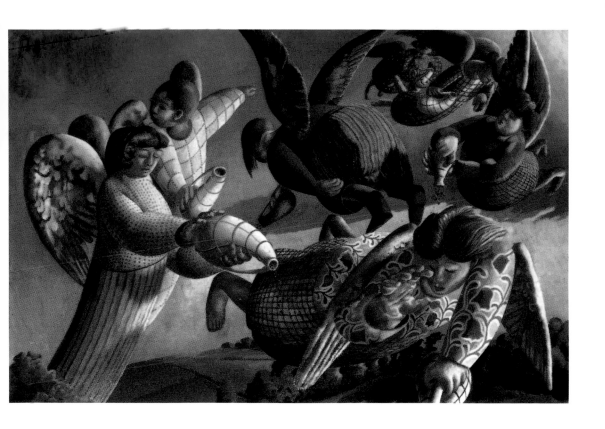

Kooning, Willem De

Woman, 1950

Born in the Netherlands, Willem de Kooning was apprenticed to a firm of commercial artists at the tender age of 12 but shortly after receiving his diploma from the Rotterdam Academy of Fine Arts in 1925 he emigrated to the United States and settled in New York, where he worked as a house painter and commercial artist. From the early 1930s he shared a studio with Arshile Gorky and made painting a full-time career from about 1936. Through Gorky he was introduced to Surrealism, reflected in the predominantly black and white paintings of his early period. In the immediate postwar period, under the influence of Adolph Gottlieb, he turned to colour and painted female figures, tending towards Abstract Expressionism. He became one of the foremost exponents of this movement, especially as expressed in his action paintings. In the last years of his long life, however, he turned to modelling figures in clay.

MOVEMENT

Abstract Expressionism

OTHER WORKS

The Visit; Marilyn Monroe

INFLUENCES

Arshile Gorky, Adolph Gottlieb

Willem de Kooning *Born* 1904 Holland

Painted in New York, USA

Died 1997 New York

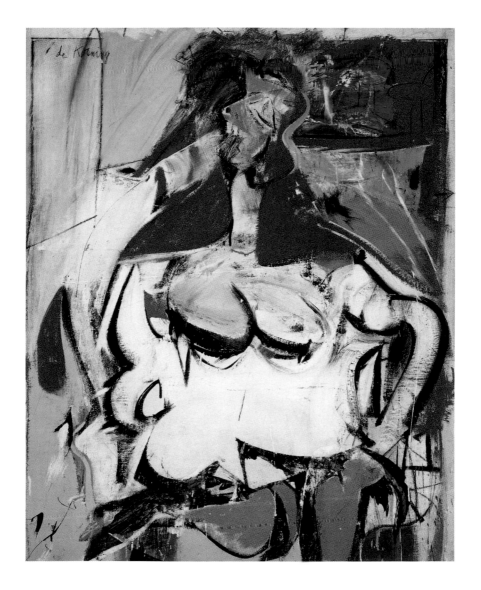

Woodruff, Hale
Afro Emblems, 1950

Although born in Illinois, Hale Woodruff was raised in Tennessee and witnessed the persecution of African Americans at close quarters. He studied at the John Herron Art Institute in Indianapolis and won a Harmon scholarship that enabled him to continue his studies at the Académie de la Grande Chaumière in Paris (1927–31). His later Expressionist paintings reflect the influence of this period. On his return to America he taught at Atlanta and New York Universities. He was one of the foremost creators of large murals on an epic scale, illustrating episodes in the history of African Americans, notably the Amistad Mutiny panels for the Savery Library of Talladega College, Alabama. The Amistad mutiny was a defining moment in the history of African Americans and it was the turning point in Woodruff's career. Subsequent murals were commissioned for Atlanta University but in the latter part of his working life Woodruff turned from representational painting to Abstract Expressionism.

MOVEMENT

African American School

OTHER WORKS

The Mutiny Aboard the Amistad; Leda; Landscape with Green Sun

INFLUENCES

Diego Rivera, José Clemente Orozco

Hale Woodruff *Born* 1900 Cairo, Illinois, USA

Painted in Alabama, Georgia and Tennessee

Died 1980 USA

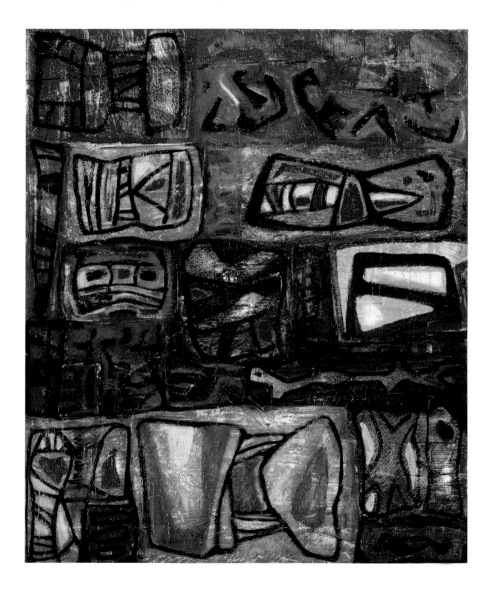

Hofmann, Hans

The Veil in the Mirror, 1952

Hans Hofmann studied art in Munich before settling in Paris at the beginning of the twentieth century. Here he came under the influence of the Impressionists, Fauves and Cubists in turn, imbibing their ideas and selecting the aspects of their art which suited him best. On the outbreak of World War I he returned to Munich, where he established his own art school in 1915. In 1930 he immigrated to the United States where, the following year, he opened the Hofmann School of Fine Art in New York City. He introduced to America the techniques of improvisation, which he had pioneered in Germany. He strove to translate the feelings of the artist into light, colour and form; texture was of major importance and he revelled in exploring this aspect of painting. These experiments conducted over many years finally evolved in the distinctive style which he practiced in America and was to have a profound influence on the development of Abstract Expressionism in his adopted country.

MOVEMENT

Abstract Expressionism

OTHER WORKS

Apparition; Nulli Secundus; The Prey; Exuberance

INFLUENCES

Henri Matisse, Pablo Picasso

Hans Hoffman *Born* 1880, Weissenburg, Germany

Painted in Munich, Paris and New York, USA

Died 1966, New York

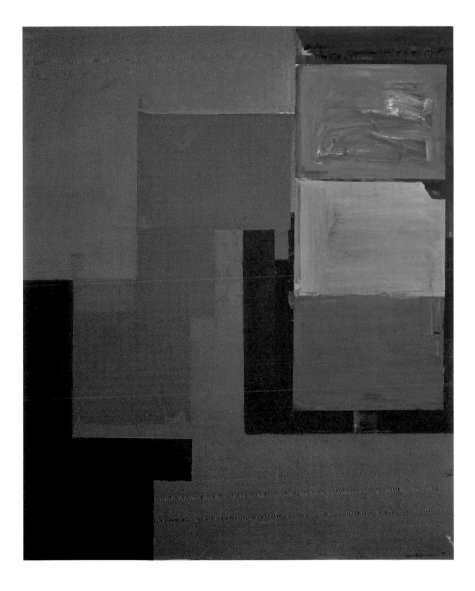

Matisse, Henri
The Snail, 1953

French painter, printmaker and designer; the dominant figure in the Fauvist movement. Initially a lawyer's clerk, Matisse turned to art in 1890. His first teacher, Bouguereau, was a disappointment, but he learned a great deal from his second master, Gustave Moreau, a Symbolist painter with a taste for exotic colouring. Matisse's early works were mainly Impressionist or Neo-Impressionist in character but, after painting trips to the Mediterranean, he began to employ more vivid colours; using them to create an emotional impact, rather than simply to transcribe nature.

After years of failure, Matisse and his friends made their breakthrough at the Salon d'Automne of 1905. Critics were overwhelmed by the dazzling canvasses on display and dubbed the group *Les Fauves* ('The wild beasts').

Matisse continued to find his greatest inspiration from painting on the Riviera, but he also travelled widely, visiting Morocco, America and Spain. He decorated a chapel in Vence in southern France, in gratitude for a nun who had nursed him, and experimented with 'cut-outs' (pictures formed from coloured paper shapes, rather than paint).

MOVEMENT

Fauvism

OTHER WORKS

The Dance; Luxe; Calme et Volupte; The Blue Window

INFLUENCES

Paul Signac, Henri-Edmond Cross, Gustave Moreau, Paul Cézanne

Henri Matisse *Born* 1869 France

Painted in France and Morocco

Died 1954

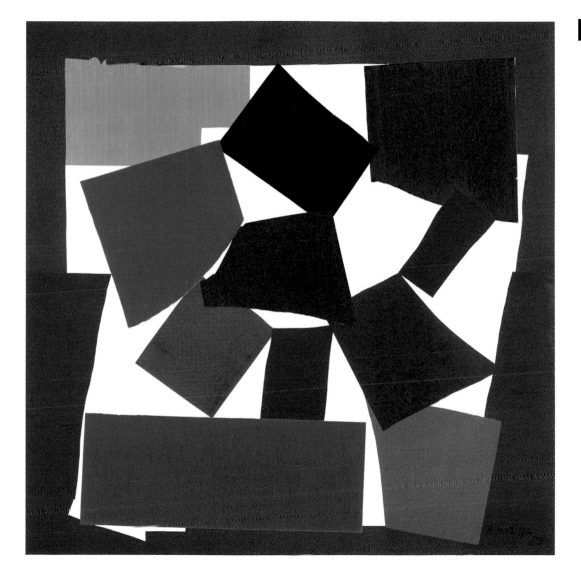

Albers, Josef

Homage, 1954

Courtesy of Private Collection/Christie's Images © DACS 2002

Albers trained in the prevailing German academic tradition, at the art schools of Berlin, Essen and Munich. He combined their discipline in draughtsmanship with his own imaginative flair and innovative approach when he continued his studies at the Bauhaus in Weimar, subsequently working as an abstract painter and furniture designer. The advent of the Nazi regime forced him to leave Germany and settle in the United States, where he developed a style that gave free rein to the exploration of colours and their relationship to each other. He held a series of important academic appointments, at the avant-garde Black Mountain College, North Carolina (1933–49) and at Yale University (1950–60). His work became increasingly non-figurative and in the 1950s culminated in purely geometric canvasses, notably in his series entitled *Homage to the Square*. He was also one of the foremost colour theorists of the immediate post-war period, publishing a seminal work on the subject in 1963 which was influential in the subsequent rise of geometric abstract painting.

MOVEMENT

Abstract Expressionism

OTHER WORKS

Skyscrapers; Homage to the Square: Blue Climate; Apparition

INFLUENCES

Walter Gropius, Wassily Kandinsky

Josef Albers *Born* 1888 Bottrup, Germany

Painted in Germany, USA

Died 1976 New Haven, Connecticut, USA

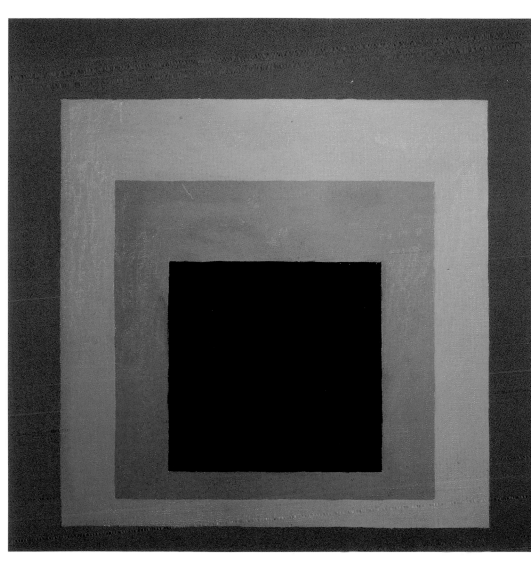

Giacometti, Alberto

Annette Assise, 1954

Alberto Giacometti studied in Geneva but worked mostly in Paris, where he settled in 1922, working for some time primarily as a sculptor with Antoine Bourdelle. He moved in the intellectual circle dominated by Jean-Paul Sartre and was an enthusiastic disciple of Existentialism. In his painting he was originally drawn to the Cubists but in 1930 he embraced Surrealism as preached by André Breton, although he was expelled from the movement five years later. This was a defining moment, which resulted in a radical departure from previous styles and the evolution of strange, wraith-like figures. Although he is best remembered as a sculptor for his semi-abstract bronzes such as the *Thin Man* series and even more skeletal, spidery figures of the immediate postwar period, the same qualities are evident in his paintings – mostly portraits of real people executed in an abstract fashion.

MOVEMENT

Surrealism

OTHER WORKS

Jean Genet; Portrait of Yanaihara

INFLUENCES

Antoine Bourdelle; Andre Breton

Alberto Giacometti *Born* 1901 Switzerland

Painted in Paris

Died 1966 Chur, Switzerland

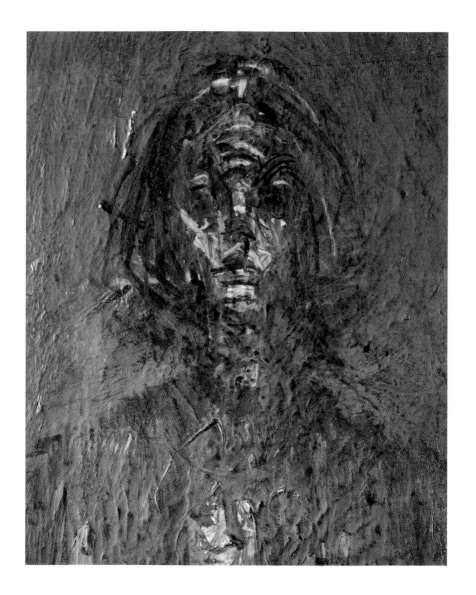

Bacon, Francis

Seated Figure (Red Cardinal), 1960

Born in Dublin of English parents, Bacon left home at the age of 15, travelling to London, Berlin and Paris. In Paris he visited a Picasso exhibition, which inspired him to paint. In 1929, Bacon settled in London, where he designed Bauhaus-style furnishings and later, during wartime, joined the Civil Defence. His breakthrough as an artist came in 1945, when his *Three Studies for Figures at the Base of a Crucifixion* caused a sensation at the Lefevre Gallery. In this, as in many of his future works, elements of mutilation, pain and claustrophobia combined to create a highly disturbing effect.

From 1946 to 1950, Bacon resided in Monte Carlo, partly to satisfy his passion for gambling. His international reputation growing, he returned to London. His source material was very diverse, ranging from the work of other artists (Velázquez, Van Gogh) to films and photographs (Muybridge, Eisenstein) and autobiographical details. His studies of caged, screaming figures, for example, are often viewed as a reference to his asthma. Bacon's prevailing theme, however, is the vulnerability and solitude of the human condition.

MOVEMENT

School of London

OTHER WORKS

Sleeping Figure; Man with Dog

INFLUENCES

Pablo Picasso, Diego Velázquez, Mathis Grünewald, Eadweard Muybridge

Francis Bacon *Born* 1909 Dublin

Painted in Britain, France and South Africa

Died 1992

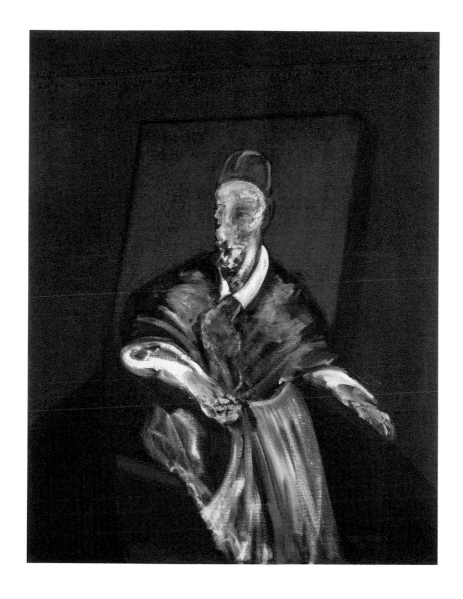

Escher, M. C.
Ascending and Descending, 1960

Although M. C. Escher did not belong to any Surrealist group, his work shares its aesthetic language if not an idealist or motivational one. His work before about 1937 is based on observations of reality, depicted as a kind of super-reality in the exaggerated use of line to emphasize a key aspect of the motif. For example in *St Peter's Rome* (1935) the view is from inside the dome of the church. By exaggerating the angle of the view towards the ground, one that could not possibly have been taken from reality, the viewer is presented with a vertiginous headlong plummet to the marble floor.

His work post 1937 is from a period when he was forced to flee to Switzerland, avoiding the imminent build-up of Fascist troops in Italy, where he had been living until then and which had been such an inspiration for his 'architectural' drawings. After this time Escher had to rely more on memory and imagination and so began to create more playful forms of spatial exploration. These were based on his observations of the regular divisions of the plane at the Alhambra, which prompted an investigation of the mathematical principles behind it.

MOVEMENT

Superrealism

OTHER WORKS

Sky and Water; Drawing Hands; Relativity

INFLUENCES

Mathamatics, Moorish Mosaics

Maurits Cornelis Escher *Born* 1898 Leeuwarden, Netherlands

Worked in Holland, Italy, Belgium

Died 1972

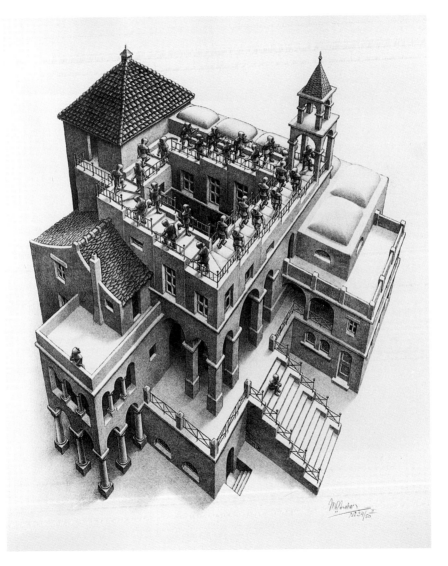

Lichtenstein, Roy

Kiss II

Roy Lichtenstein enrolled at the Art Students' League (1939) and later studied at Ohio State College. After military service (1943–46) he returned to Ohio State as a teacher, and later taught at New York State and Rutgers Universities. He began exhibiting in 1949, his early works inspired by aspects of American history, strongly influenced by Cubism, though later he tended towards Abstract Expressionism. While teaching at Rutgers he met Allan Kaprow, who opened his eyes to the artistic possibilities inherent in consumerism and from about 1960 he developed what later came to be known as Pop Art, in which images are painted in the style of the comic strip. Even the dots of the screening process used in the production of comic books is meticulously reproduced in Lichtenstein's highly stylized paintings.

MOVEMENT

Pop Art

OTHER WORKS

In the Car; M-Maybe; Whaam!

INFLUENCES

Allan Kaprow

Roy Lichtenstein *Born* 1923 New York, USA

Painted in USA

Died 1997 New York

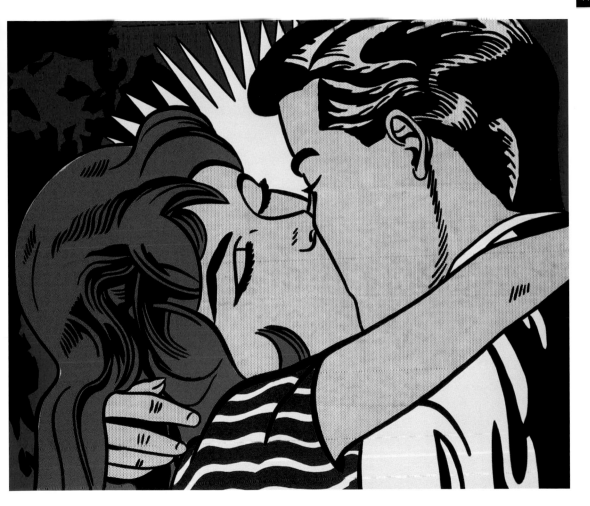

Tàpies, Antoni

Black with Four Grey Corners, 1960

Antoni Tàpies studied law in Barcelona in 1943–46 but then gave up his studies to concentrate on painting, in which he was almost entirely self-taught. He became a founder member of the Catalan group of avant-garde writers and artists known as Dau al Set (Seven on the Die). His paintings reflect a diversity of influences, from the abstract radicalism of Catalonia in the Civil War period to the philosophy of the Surrealists and the lyrical qualities of Robert Motherwell and Joan Miró. He had his first one-man show in America in 1953 and thereafter made an impact on the international scene, winning many prizes. Since 1955 he has concentrated on 'matter' painting, influenced by such French artists as Fautrier. At first this consisted of mixing paints and varnish with unusual substances such as marble dust, pieces of cloth, straw and strips of metal. Taking this to its logical conclusion he eventually replaced canvas with solid objects, as in his *Desk with Straw*.

MOVEMENT

Modern Spanish School

OTHER WORKS

Violet Grey with Wrinkles; Perforated Body; Peintre Grise et Verte

INFLUENCES

Alberto Burri, Robert Motherwell, Joan Miró, Jean Fautrier

Antoni Tàpies *Born* 1923 Barcelona, Spain

Painted in Barcelona

Delaunay, Sonia

Rythme Couleur, 1961

Born Sonia Terk Stern at Gradizhsk in the Ukraine, she was raised in St Petersburg and studied art in Karlsruhe, Germany and then, in 1905, attended the Académie de la Palette in Paris. In order to remain in France, in 1909 she contracted a marriage of convenience with the art critic Wilhelm Uhde but it was dissolved after a few months. In 1910 she married the French painter Robert Delaunay (1885–1941) with whom she founded the movement known as Orphism. Together they designed and painted sets and costumes for Diaghilev's Ballets Russes. Robert is chiefly remembered for his endless experiments in colour orchestration, which had a profound effect on abstract art, while Sonia concentrated on Art Deco textile designs. In the interwar period she also evolved a purity of expression using brightly contrasting colours in her paintings, mainly in watercolours, that influenced her textile designs and vice versa.

MOVEMENTS

Orphism, Cubism

OTHER WORKS

Girls in Swimming Costumes

INFLUENCES

Robert Delaunay, Wassily Kandinsky

Sonia Delaunay *Born* 1885 Gradizhsk, Ukraine

Painted in France

Died 1979 Paris, France

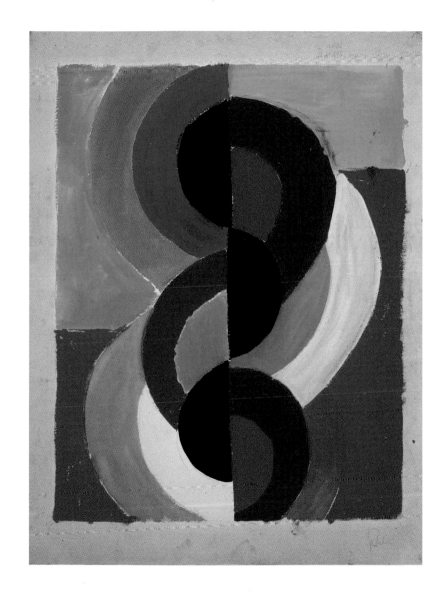

Lewis, Norman

Evening Rendezvous, 1962

Born in New York Norman Lewis was one of the few natives of that city to gain early prominence as the artistic chronicler of African American life in Harlem. Under the WPA (Works Project Administration) scheme of the 1930s, he was able to study at Columbia University and was later a pupil of Augusta Savage. His WPA assignment consisted of the decorations of the Harlem Art Centre, which put him in touch with other black American artists. In the late 1930s he began painting in a semi-abstract manner, reducing the human figure to geometric lines. Later he veered towards Abstract Expressionism. In the 1960s he belonged to the Spiral Group, which gave artistic interpretation to the civil rights movement. In 1971, while working at the Art Students' League, he formed the Cinque Gallery with Ernie Crichlow and Romare Bearden, with the aim of exhibiting the art of young people from ethnic minorities.

MOVEMENT

Abstract Expressionism

OTHER WORK

Yellow Hat; Ovum; Processional; Every Atom Glows

INFLUENCES

Augusta Savage

Norman Lewis *Born* 1909 New York, USA

Painted in New York

Died 1979 New York

Warhol, Andy
Shot Red Marilyn, 1964

Courtesy of Christie's Images/© The Andy Warhol Foundation for the Visual Arts, Inc./ARS, New York and DACS, London 2002

American artist specializing in printmaking and films. Warhol was born in Pittsburgh, the son of Czech immigrants. In 1949 he moved to New York, where he became a successful commercial artist. This gave him a solid grounding in silkscreen printing techniques and taught him the value of self-promotion – both of which were to feature heavily in his art. Warhol's breakthrough came when he began to make paintings of familiar, everyday objects, such as soup cans, dollar bills and Brillo pads. Early examples were hand-painted, but Warhol soon decided to use mechanical processes as far as possible. His aim, in this respect, was to free the image from any connotations of craftsmanship, aesthetics or individuality. He further emphasized this by describing his studio as 'The Factory'.

Warhol rapidly extended his references to popular culture by portraying celebrities (Marilyn Monroe, Marlon Brando), as well as more sinister items, such as news clippings with car crashes or the electric chair. He also associated himself with other branches of the mass media, notably through his links with the rock band The Velvet Underground, and through his controversial films.

MOVEMENT

Pop Art

OTHER WORKS

Campbell's Soup Can; Marilyn Monroe; Brillo

INFLUENCES

Roy Lichtenstein, Jasper Johns

Andy Warhol *Born* 1928 Pittsburgh, USA

Painted in USA

Died 1987 New York, USA

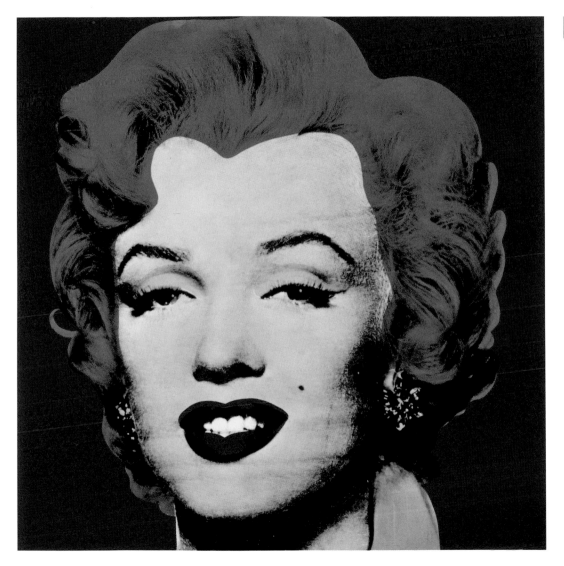

Dubuffet, Jean
Cortège, 1965

Jean Dubuffet studied at the Académie Julien in Paris but, dissatisfied with the styles in 'new art' then being taught, branched out on his own and began exploring unusual materials and the deliberate use of coarse canvas and paint applied roughly. He believed that there was more truth in the art produced by the untrained, the childish or the psychotic and strove to recreate such effects. The synthesis of rough materials with discarded rubbish such as pieces of old newspapers and broken glass resulted in what he termed Art Brut (raw art), which was the antithesis of painterly perfection and aesthetic sensitivity. By this means Dubuffet confronted the spectator with the seamier side of life and nature in the raw. Though often derided, he exerted a tremendous influence on the next generation of artists and anticipated the Pop Art and neo-Dadaism of the 1960s.

MOVEMENT

Abstract Expressionism

OTHER WORKS

Man with a Hod; Villa sur la Route; Jazz Band

INFLUENCES

Antoni Tapiès, Alberto Giacometti

Jean Dubuffet *Born* 1901 Le Havre, France

Painted in France

Died 1985 Paris, France

Chagall, Marc
Le Repos, 1967–8

Courtesy of Private Collection/Christie's Images/© ADAGP, Paris and DACS, London 2002

Born into an Orthodox Jewish family in what was then known as Russian Poland, Marc Chagall studied in St Petersburg and Paris and returned to his native city on the eve of World War I. Initially he worked as a sign-writer but on his return to Russia he joined the Knave of Diamonds group and participated in their 1917 exhibition, which was intended as an attack on the stuffy classicism of the Moscow School of Art. The Revolution broke out shortly afterwards and Chagall was appointed Director of the Vitebsk Art School before being summoned to Moscow to design sets for the Jewish Theatre. He left Russia in 1922 and settled near Paris. On the outbreak of World War II he moved to the USA where he designed sets and costumes for the ballet, as well as illustrating books and producing stained-glass windows, notably for the UN Building in New York and the Hadassah Hospital in Jerusalem. He also painted the murals for the Knesset (Israeli parliament). His paintings combine fantasy, folklore and biblical themes with an intensely surreal quality. Indeed, it is claimed that Guillaume Apollinaire originally coined the term 'Surrealist' to describe Chagall's paintings.

MOVEMENT

Surrealism

OTHER WORKS

Above the Town; I and the Village

INFLUENCES

Gauguin, The Fauves

Marc Chagall *Born* 1887 Vitebsk, Russia

Painted in Russia, France and USA

Died 1985 Saint Paul-de-Vence, France

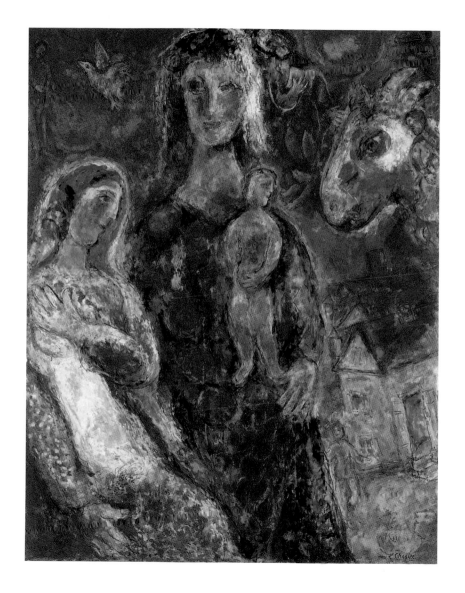

Hassan, Faik

Two Women, 1967

Faik Hassan studied at the Institute of Fine Arts in Baghdad, Iraq, then won a scholarship to the École des Beaux-Arts in Paris, from which he graduated in 1938. On his return to Iraq he established and directed the department of painting and sculpture at the Institute of Fine Arts. During his time in France he came under the influence of the Cubists and Impressionists, which are reflected in many of his own paintings, although he also explored abstract art and painted landscapes and genre scenes in a relatively conventional style. He established the Pioneers Group in 1950 but withdrew from it in 1962 and five years later formed the Corners Group (Al Zawiya), whose aim was to serve the nation through their art, hence his many pictures with a strong social or political theme. After Iraq became a republic in 1958 he created the colossal mosaic mural entitled *Celebration of Victory* located in Tiran Square. In the last decade of his life he resumed painting in the Impressionist style.

MOVEMENT

Modern Iraqi School

OTHER WORKS

Celebration of Victory

INFLUENCES

Pablo Picasso, Pierre Bonnard

Faik Hassan *Born* 1914 Baghdad, Iraq

Painted in Baghdad and Paris

Died 1992 Baghdad

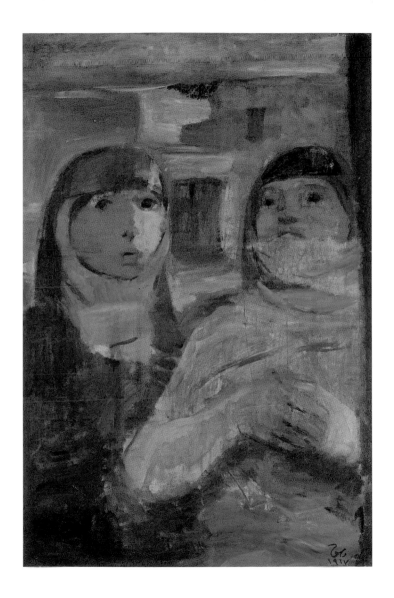

Botero, Fernando
La Visita, 1968

Courtesy of Private Collection/Christie's Images

The outstanding Colombian artist of the twentieth century is Fernando Botero, who has attained a universal reputation in recent years. He studied the great masters of European art and the influence of such disparate artists as Uccello, Piero della Francesca, Mantegna, Velázquez and Rubens is discernible in his work, which exalts form while exploring new realities. His work is by no means rigidly classicist, but he has combined his studies of the old masters with a detailed examination of the popular indigenous art of Colombia. The extraordinary range of his work, encompassing figures, portraits, landscapes and genre subjects, is characterized by ironic humour and warm humanity, coupled with wry, shrewd observation of the scenes and people around him. Figures are often depicted in a curious pneumatic fashion with fixed expressions on their grossly inflated faces, deliberately producing a naïve style. Botero has also produced a number of monumental sculptures, chiefly of female nudes.

MOVEMENT

Modern Latin American School

OTHER WORKS

Sunday Afternoon; Colombian Woman

INFLUENCES

Paolo Uccello, Piero della Francesca, Diego Velázquez, Paul Rubens, Francisco Goya

Fernando Botero *Born* 1932 Medellin, Colombia

Paints in Colombia

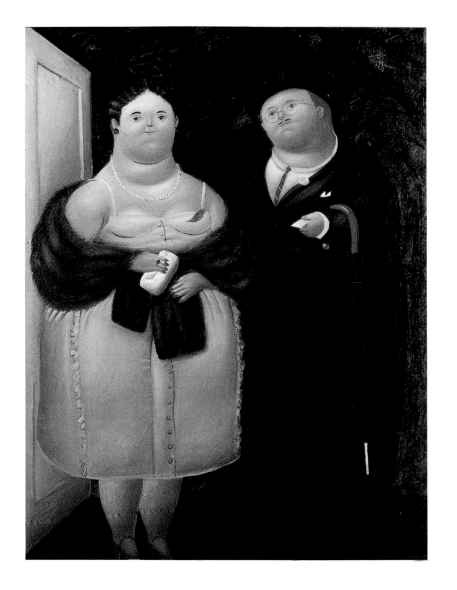

Rothko, Mark
Untitled, 1968

Born Marcus Rothkovitch in Dvinsk, Russia, Rothko emigrated to the US in 1913. He studied briefly at Yale and in New York, although he considered this to have had little influence on his painting. Rothko's style took many years to evolve. His early figurative works included portraits and psychologically-infused urban scenes, which he exhibited with the American expressionist group, The Ten. Rothko embraced ancient myth as he moved into a surrealist phase in the late 1930s, drawing on them as subjects for his increasingly abstract works. By 1946, he moved into pure abstraction, painting amorphous shapes, or 'Multiforms', that would coalesce into his familiar rectangles on fields of colour by 1949. Although the works were formally quite simple, Rothko executed them with a meticulous eye for colour, balance and brushwork that give them a dramatic presence beyond their initial appearance. He was pleased that viewers often found looking at his paintings a deeply emotional experience. While he maintained the essential elements of his signature style, Rothko's paintings became generally larger, darker and more meditative in the last dozen years of his life.

MOVEMENTS

Abstract Expressionism, Colour Field Painting

OTHER WORKS

Central Green; Blue; Orange; Red; Number 118

INFLUENCES

Henri Matisse, Arshile Gorky, Clyfford Still

Mark Rothko *Born* 1903 Drinsk, Russia

Painted in New York, USA

Died 1970 New York

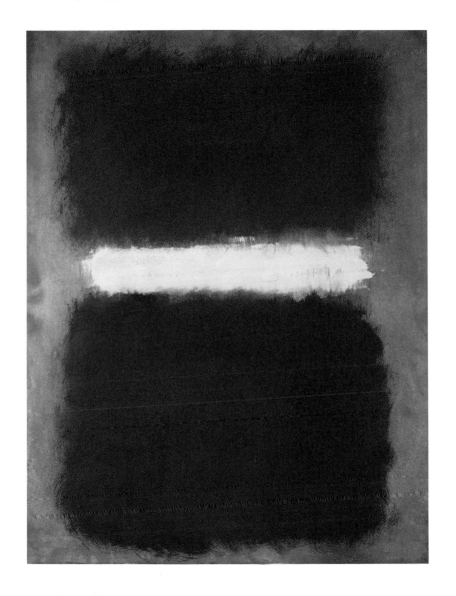

Stella, Frank

Agbatana II, 1968

Courtesy of Musée d'Art et d'Industrie, St Etienne, France/Bridgeman Giraudon/© ARS, New York and DACS, London 2002

Frank Philip Stella studied at Phillips Academy in Andover, Maine (1950–54) and Princeton University (1954–58). After university he went to New York City, where he worked as a house painter, an experience which influenced his art. He began painting in the Minimalist style in 1959, using a broad brush in order to eliminate the brushstrokes typical of art, and created works which were often virtually solid blocks of black, relieved only by a few contrasting stripes. Later he evolved polychrome patterns of straight lines or concentric rings and curves using the same technique of eliminating brushstrokes, which would have detracted from the overall effect. These paintings have a decidedly Art Deco character, reflecting Stella's admiration of the Bauhaus designs of the 1920s. His method is to cut templates and assemble them in reliefs painted in day-glo and metallic paints. His more recent work, in fact, verges on the sculptural, with its multicoloured, three-dimensional effects.

MOVEMENTS

Minimalism, Abstract Expressionism

OTHER WORKS

Tuxedo Park Junction; Harewa; Jarama II

INFLUENCES

Josef Albers, Gwen John

Frank Stella *Born* 1936 Malden, Massachusetts, USA

Paints in New York

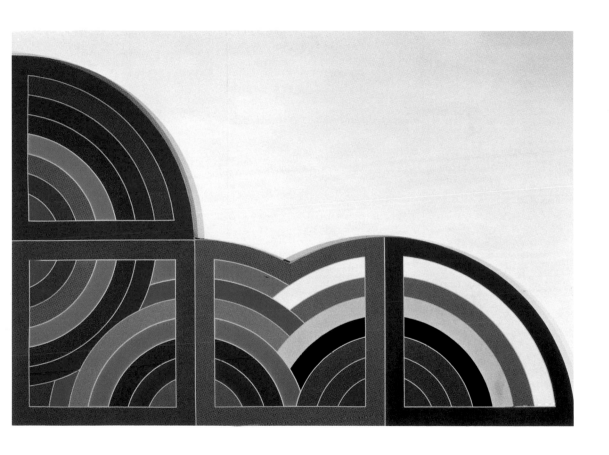

Bearden, Romare H.

Sunday after the Sermon, 1969

Courtesy of Art Resource, New York/© Romare Bearden Foundation/VAGA, New York/DACS, London 2002

Born in Charlotte, North Carolina, in 1914, Romare Howard Bearden moved with his family to New York when he was three and eventually settled in Harlem. He began drawing cartoons at New York University, where he was also art editor of the student magazine *Medley*. Although originally intending a career in medicine, he switched to art and enrolled for evening classes at the Art Students' League where he studied under George Grosz. After military service in World War II the GI Bill enabled him to pursue his art studies at the Sorbonne, being particularly drawn to such masters as Duccio, De Hooch, Rembrandt and Manet. When he returned to the United States in 1952 he did not immediately take up creative painting, but from 1964 onwards he began producing collages. He is a versatile painter of landscapes and urban scenes, figures and abstracts, bringing to bear a highly intellectual approach in his work and drawing upon his southern roots for inspiration.

MOVEMENT

Modern American School

OTHER WORKS

Sunday After Sermon; Before the Dark; The Visitation

INFLUENCES

George Grosz

Romare Bearden *Born* 1914 Charlotte, North Carolina, USA

Paints in New York and Paris

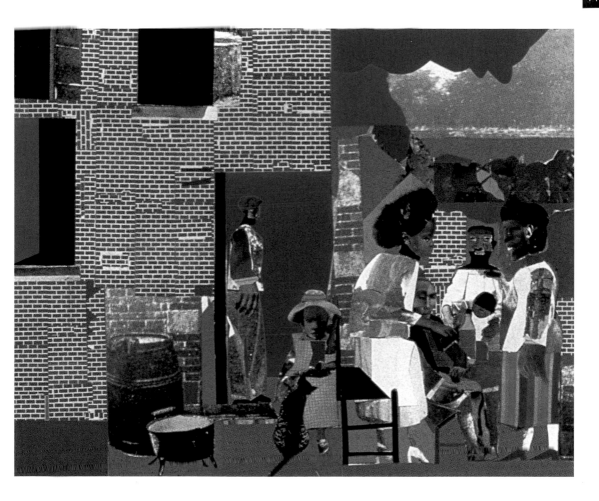

Oppenheim, Meret

Blaues Auge, 1969

Courtesy of AKG, London © DACS 2002

Meret Oppenheim was raised by her grandparents in Switzerland during World War I. At the age of 18 she went to Paris, where she enrolled at the Académie de la Grande Chaumière. She met Giacometti and Arp, who introduced her to Surrealism and she even modelled for Man Ray. Oppenheim began contributing her own three-dimensional objects to the Surrealist exhibitions in 1933 and achieved critical acclaim three years later with *Object, Fur Breakfast*: a cup, saucer and teaspoon covered with gazelle fur. This typified much of her later work, in which ordinary, everyday objects were transformed into articles with fetishistic or sado-masochistic undertones. In her paintings and sculptures she explored female sexuality and woman's role as a male sex object. One of the few female Surrealists, she was certainly the most highly original of them. On one occasion she even staged a banquet in which a nude female formed the centrepiece of the table decoration.

MOVEMENT

Surrealism

OTHER WORKS

The Governess (My Nurse); Red Head; Blue Body; Influences

INFLUENCES

Marcel Duchamp, Louise Bourgeois

Meret Oppenheim *Born* 1913 Berlin, Germany

Painted in Switzerland

Died 1985 Basle, Switzerland

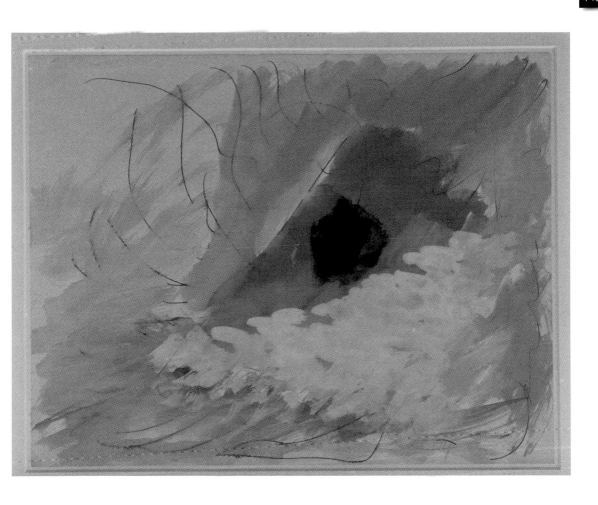

Rauschenberg, Robert

Untitled, 1964

Robert Rauschenberg studied at the Kansas City Art Institute and at Black Mountain College, North Carolina, where he was strongly influenced by Joseph Albers. In 1948 he crossed the Atlantic and enrolled at the Académie Julien in Paris (1948). His friendship with the avant-garde composer John Cage led to their collaboration in *Happenings*, in which Cage supplied the music and Rauschenberg the visual entertainment, later extended from collages to painting entirely in one colour – black, white or red. From such minimalism in the early 1950s he moved on to highly controversial pictures, which were not only unusual in colour and surface treatment, but also incorporated scraps of ephemera and even three-dimensional objects such as stuffed birds, rusty metal, rubber tyres, pieces of discarded clothing and any old junk, often dripping with paint. The results are unsettling and unnerving, but always thought-provoking.

MOVEMENTS

American Abstract, Pop Art

OTHER WORKS

The Red Painting; Canyon; Bed; Reservoir

INFLUENCES

Joseph Albers, Marcel Duchamp

Robert Rauschenberg *Born* 1925 Port Arthur, Texas, USA

Paints in France and USA

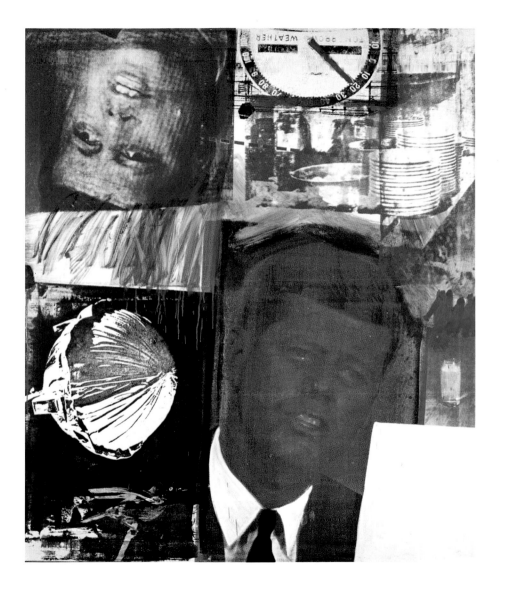

Richter, Gerhard

Wolken (Fenster), 1970

Gerhard Richter studied in his native city of Dresden and Düsseldorf before engaging in a career as a designer of sets for the stage and then working as a commercial artist in advertising. His early paintings were mostly figurative, but from 1962 onwards he produced paintings that were derived from blurred photographic images. Many of his paintings have been produced in series, exploring particular themes that continually flit back and forward between the camera and the canvas, hovering between figuration and the abstract. In particular, he painted a series of oils derived from aerial photographs of cities. His most recent work has consisted of enormous canvasses, more purely abstract in character, with emphasis on the artist rather than the subject. Noted for his range and versatility, coupled with absolute mastery of his technique, he has an infinite capacity to rediscover or reinvent the medium. A great innovator, he has had a tremendous influence on postwar German art.

MOVEMENT

Modern German

OTHER WORKS

Abstraktes Bild; Stag; Betty; Colour Streaks; Townscape series

INFLUENCES

Otto Dix

Gerhard Richter *Born* 1932 Dresden, Germany

Paints in Germany

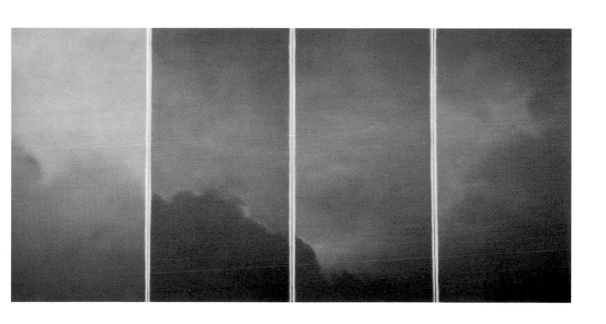

Thomas, Alma

Snoopy - Early Sun Display on Earth, 1970

Alma Thomas moved with her family to Washington, DC in 1906 following race riots in the South. She came from a African American professional, middle class family and trained as a kindergarten teacher. After a spell in Wilmington, Delaware she returned to Washington in 1921 and became the first art graduate of Howard University. She taught art at Shaw Junior High School until her retirement in 1959. A spell in New York City, taking a teacher's postgraduate course at Columbia, brought her into contact with avant-garde art, but it was not until 1949 that she took a painting course at American University, and only when she retired in her sixties did she take up painting seriously. In the last decade of her life she painted prolifically in watercolours and acrylic, emerging as one of the greatest colourists of her generation. Always independent, she did not conform to any particular style but used colour in her own distinctive manner.

MOVEMENT

Abstract Art

OTHER WORKS

Pinks of Cherry Blossom; Light Blue Nursery

INFLUENCES

Wassily Kandinsky

Alma Thomas *Born* 1891 Columbia, Georgia, USA

Painted in Washington, DC, USA

Died 1978 Washington, DC

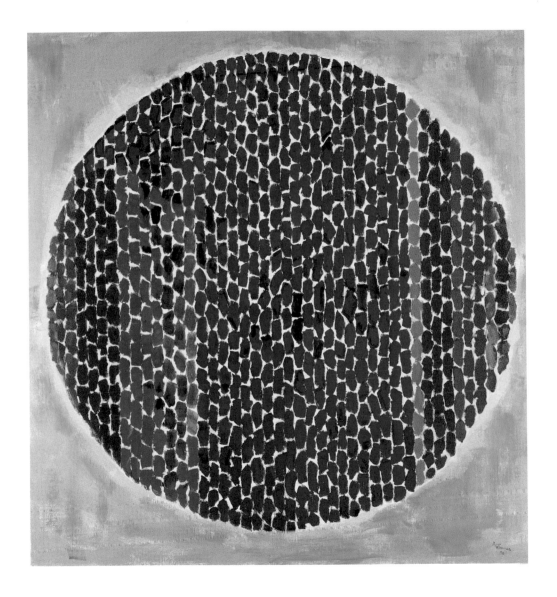

Arakawa, Shusaku
War of the Worlds

Courtesy of Private Collection/Christie's Images

Shusaku Arakawa studied medicine and mathematics at Tokyo University but later switched to painting at the Musashino College of Art, and staged his first one-man show in the National Museum of Modern Art in 1958. Strongly influenced by the Dadaists of the early 1920s, he revived this movement in Japan and staged a number of 'happenings' from 1960 onwards to satirize the sickness and corruption in contemporary Japanese society. These activities caused a furore and Arakawa moved to the USA in 1961, settling in New York where he has lived ever since, working as a performance artist and film-maker as well as continuing to paint. Sending up those artists who produced works entitled *Untitled*, he produced a series under the name *Untitledness*, where blank spaces had pin marks where the object should be. A series entitled *Diagrams* consisted of spray-painted silhouettes of everyday objects. Later works explored the relationship between different forms of representation.

MOVEMENT

Dadaism

OTHER WORKS

Diagrams; Webster's Dictionary; The Mechanism of Meaning

INFLUENCES

Jean Arp, Kurt Schwitters, Man Ray

Shusaku Arakawa *Born* 1936 Nagoya, Japan

Painted in Tokyo and New York

These are all the same size

These are all the same size

ROOM FOR CORRECTION

These are all the same size

DO NOT ALLOW FOR CORRECTION

WAR OF THE WORLDS

Scully, Sean

Untitled, 1971

Courtesy of Christie's Images

Although born in Dublin, Ireland, Sean Scully was raised in London, where he studied at the Croydon College of Art (1965–68) and Newcastle University (1968–72). He continued his art education at Harvard University before settling permanently in the United States in 1975. Such a rich and varied training is reflected in his paintings, which provide an interesting blend of elements derived from Minimalism and Conceptual Art on the one hand and the Abstract Expressionism of his adopted country. This is manifest in his most characteristic works, in which the dominant features are vertical or horizontal bands of contrasting colours, generally muted shades of brown, beige and deep reds alternating with black. At first glance they may appear Minimal, but closer examination reveals the rich textures and layers of colour. Scully styles these works triptychs, and this is true in so far as they comprise three pieces of canvas whose juxtaposition is deliberately uneven. The use of a term more commonly associated with medieval religious works is a reflection of Scully's regard for the spiritual qualities of abstract painting.

MOVEMENT

Abstract Expressionism

OTHER WORKS

Paul; The Fall; White Window; Why and What

INFLUENCES

Noel Foster, Mark Rothko, Barnett Newman

Sean Scully *Born* 1945 Dublin, Ireland

Paints in London and New York

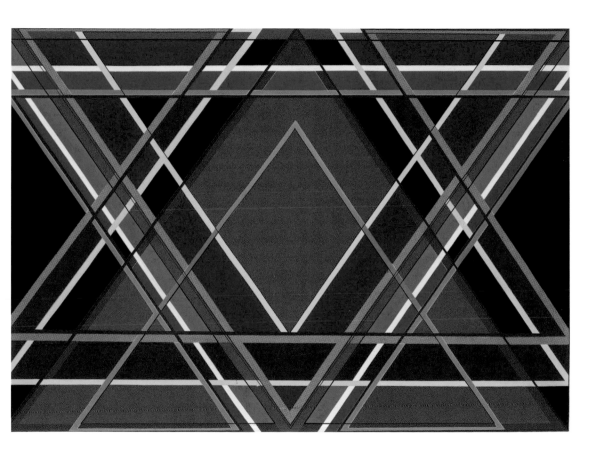

Sutherland, Graham
Landscape Orange and Blue, 1971

Courtesy of Private Collection/Christie's Images

Graham Vivian Sutherland originally intended to become a railway engineer, but switched courses and studied art at Goldsmiths College in London. Influenced by the visionary artist Samuel Palmer, he worked mainly as an etcher, but the market for prints collapsed in the aftermath of the stock-market crash of 1929, and as a result Sutherland took up painting instead. A visit to south-west Wales in 1934 introduced him to the astonishing diversity of the Pembrokeshire scenery which would provide endless subject matter for his later paintings. Sutherland's great landscapes combined elements of the romantic with the abstract. From 1941 until 1945 he was employed as an official war artist, and in the postwar period he produced a number of memorable (if occasionally controversial) portraits, including that of Sir Winston Churchill (1955). True to his original training, Sutherland also produced posters, ceramic designs and textiles, the best known being the extraordinary tapestry *Christ in Majesty*, which he executed for the new Coventry Cathedral in 1962.

MOVEMENT

Modern English Landscape School

OTHER WORKS

Red Landscape; Entrance to a Lane; Devastation: House in Wales

INFLUENCES

Samuel Palmer, Pablo Picasso, Odilon Redon

Graham Sutherland *Born* 1903 London, England

Painted in England and Wales

Died 1980 London

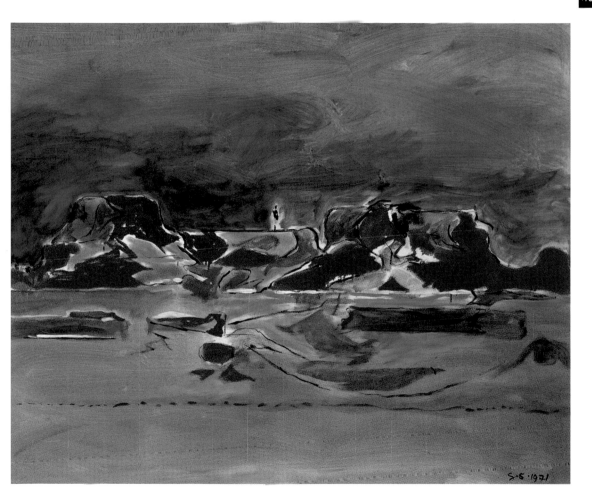

S·S·1971

Hockney, David

Sun from The Weather Series, 1973

Courtesy of Christie's Images © David Hockney/Gemini G. E. L

British painter, photographer and designer Hockney was born in Bradford, Yorkshire and trained at the Royal College of Art. There, his fellow students included Allen Jones, Derek Boshier and R. B. Kitaj, and together they all exhibited at the Young Contemporaries exhibition of 1961, a landmark show which marked the arrival of British Pop Art. Hockney himself denies belonging to this movement, even though his early work contained many references to popular culture. Instead, his style may be better defined as New Figuration – a blanket term, relating to the revival of figurative art in the 1960s.

Hockney has travelled widely in Europe, but his main passion has been for the United States, especially Los Angeles where he settled in 1976. Throughout his career, autobiographical subjects have featured heavily in his paintings, ranging from friends, such as the Clarks and lovers sunbathing by swimming pools, to an entire book of pictures devoted to his dogs. Hockney has also been a prolific stage designer, creating sets and costumes for *The Rake's Progress*, *The Magic Flute* and *Parade*. In recent years, he has also experimented with photo-work, producing elaborate 'photocollages' from hundreds of photographic prints.

MOVEMENT

Pop Art, New Figuration

OTHER WORKS

A Bigger Splash; Mr and Mrs Clark and Percy; Influences

INFLUENCES

Pablo Picasso, Henri Matisse, Jean Dubuffet

David Hockney *Born* 1937 Bradford, Yorkshire, England

Painted in Britain, USA and France

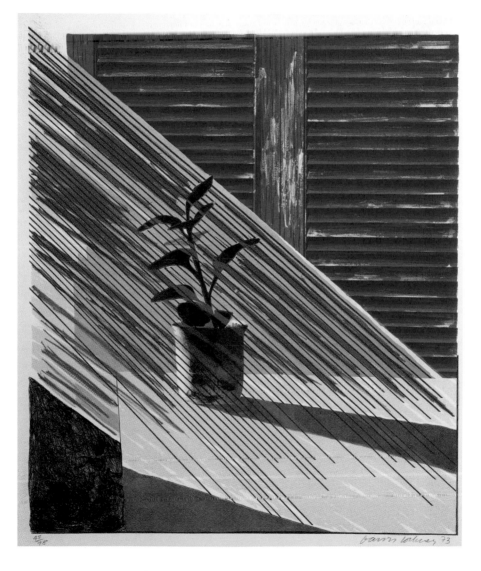

45/75 David Hockney 73

Johns, Jasper
Flags, 1973

Courtesy of Private Collection/Christie's Images © Jasper Johns/VAGA, New York/DACS, London 2002

Jasper Johns studied at the University of South Carolina, Columbia. In 1952 he settled in New York City and there he met Robert Rauschenberg, who shared his views on the brash banality of contemporary culture, which they exploited in the development of Pop Art. By taking the familiar, the mundane and everyday icons such as the Stars and Stripes and the numerals on football jerseys he created works of art that put them in an entirely new light. The influence of Dada is evident as he deliberately set himself against the tenets of conventional art. Thus, originality is eschewed by taking previously existing and immediately recognizable objects and emphasizing their very ordinariness. Johns is a versatile artist, working in oils, encaustic, plaster and other materials in various media.

MOVEMENT

Pop Art

OTHER WORKS

Device; Zero Through Nine; Zone

INFLUENCES

Marcel Duchamp

Jasper Johns *Born* 1930 Augusta, Georgia, USA

Paints in New York

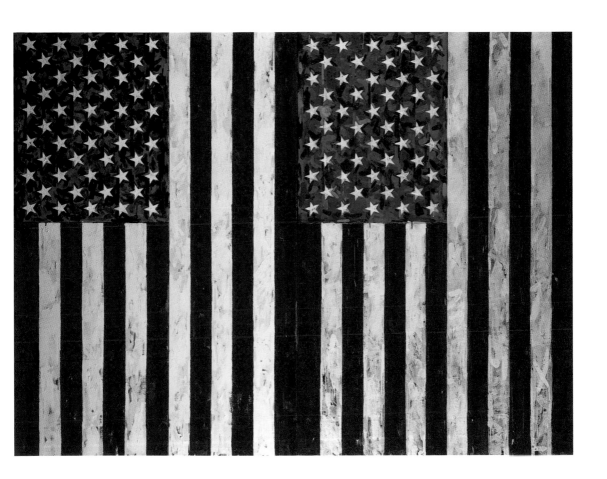

Al Attar, Suad

Paradise in Blue

Courtesy of Sotheby's Picture Library

Suad Al Attar studied at the University of Baghdad, the California Polytechnic State University in San Luis Obispo, the Wimbledon School of Art and the Central School of Art and Design, London where she took a degree in printmaking. In 1965 she became the first female Iraqi artist to have a solo exhibition in Baghdad and has since received numerous awards at international exhibitions in Cairo, Brazil, London, Madrid and Poland. She paints in oils on canvas or card laid down on board and her work ranges from figures and still life to landscapes and decorative works which combine the classical Islamic art forms of the Middle East with modern Western influences. In the past decade she has painted a number of semi-abstract works inspired by images in the love poems of Mahmoud Darwish. She also creates tapestries with traditional Arab motifs.

MOVEMENT

Modern Iraqi School

OTHER WORKS

Abacus; Birds of Paradise; Blue Sunset Birds; Bustan Guardian

INFLUENCES

Classical Islamic art forms of the Middle East

Suad Al Attar *Born* 1942 Baghdad, Iraq

Paints in Iraq

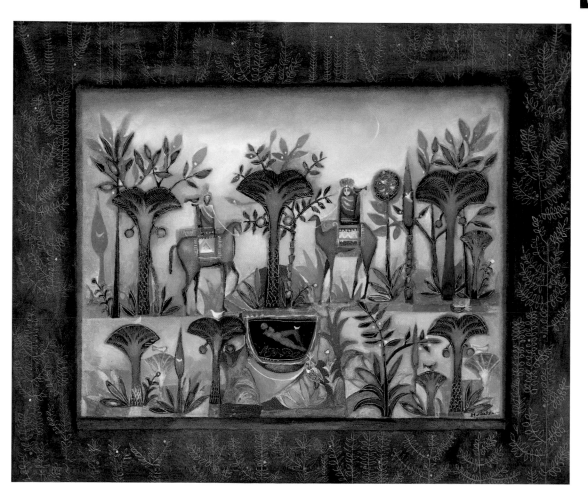

Frankenthaler, Helen

Sundowner, 1974

Courtesy of Private Collection/Christie's Images

After a college education at Bennington in Vermont, Helen Frankenthaler studied art under the abstract printmaker Hans Hoffman and the Mexican painter Rufino Tamayo. While still at Bennington, however, she evolved her own highly distinctive technique of applying very thin, diluted paint to the unprimed canvas so that it soaked right through. These 'stain-soak' paintings were created with a series of applications in different colours and consistencies, the canvasses being laid flat on the studio floor. This technique created an unusual, atmospheric effect and the subtle blending of forms (not unlike that of certain watercolours, a medium in which she also worked) which form the basis for her large abstracts are vaguely suggestive of landscapes or the natural world. From 1958 to 1971 she was married to Robert Motherwell, whose influence can be discerned in her own brand of Abstract Expressionism. In her more recent paintings, acrylics have been applied to give greater depth to the principal details.

MOVEMENT

Abstract Expressionism

OTHER WORKS

Black Frame; Door; The Other Side of the Moon

INFLUENCES

Rufino Tamayo, Jackson Pollock, Robert Motherwell

Helen Frankenthaler *Born* 1928, New York, USA

Paints in New York

Miró, Joan

Personnages, Oiseaux, Étoiles, 1974–6

Spanish painter, ceramist and graphic artist; a key member of the Surrealists. Miró trained under Francisco Gali. His early work showed traces of Fauvism and Cubism, but his first one-man show was a disaster. Undeterred, Miró decided to travel to Paris, the acknowledged home of the avant-garde. There, he contacted Picasso, who introduced him to the most radical artists and poets of the day. These included the blossoming Surrealist group, which Miró joined in 1924.

Miró was fascinated by the challenge of using art as a channel to the subconscious and, from the mid-1920s, he began to fill his canvasses with biomorphic, semi-abstract forms. Nevertheless, he felt suspicious of some of the more outlandish, Surrealist doctrines and remained at the fringes of the group. He moved to France during the Spanish Civil War, producing patriotic material for the struggle against Franco, but was obliged to return south in 1940 after the Nazi invasion. By this stage, Miró's work was much in demand, particularly in the US, where he received commissions for large-scale murals. Increasingly, these featured ceramic elements, which played a growing part in the artist's later style.

MOVEMENT

Surrealism

OTHER WORKS

Dog Barking at the Moon; Aidez l'Espagne

INFLUENCES

Pablo Picasso, Hans Arp, Paul Klee

Joan Miró *Born* 1893 Barcelona, Spain

Painted in Spain, France, USA and Holland

Died 1983 Palma de Mallorca, Spain

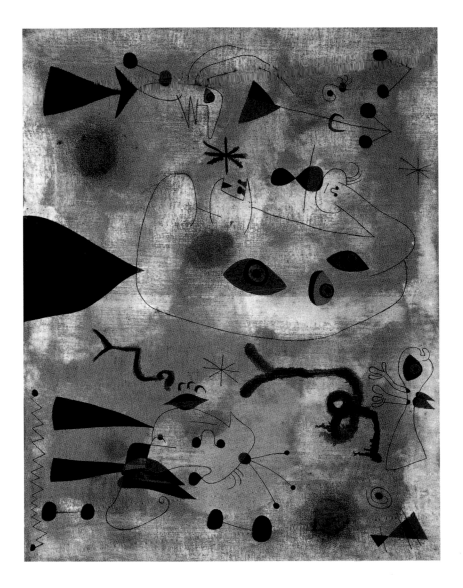

White, Charles
Mother Courage II, 1974

Courtesy of National Academy of Design, New York, USA/Bridgeman Art Library

Charles White was largely self-taught but from an early age he was imbued with the desire to depict the African American heroes whose exploits formed a large part of the folklore of the 1920s when he was growing up. His reputation was assured by one of his most ambitious early works, the mural entitled *Five Great American Negroes*, which was commissioned for the Chicago Public Library. In this great work can be seen the tension and emotion, the realistic depiction of persecution, injustice and struggle, that characterized much of his later work. The passion is more restrained in the tempera mural completed in 1943 for Hampton University illustrating the contribution of the Negro to American democracy — a mural whose vast expanse is crammed with portraits large and small. Features and forms are sharply outlined with a geometric, angular style that adds to their rugged character, and this intensely graphic quality came to fruition in White's later works, from murals to individual portraits.

MOVEMENT

African American School

OTHER WORKS

Frederick Douglass; Booker T. Washington; In Memoriam

INFLUENCES

Charles Alston, Hale Woodruff

Charles White *Born* 1918 Chicago, Illinois, USA

Painted in Chicago and Los Angeles

Died 1979

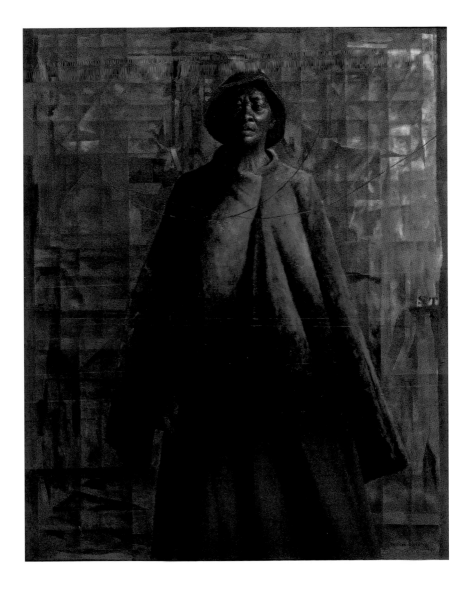

Hodgkin, Sir Howard
Dinner at the Grand Palais, 1975

Courtesy of Private Collection/Christie's Images

Howard Hodgkin studied at the Camberwell School of Art in London and then Bath Academy of Art, where he later taught (1956–66). Although his painting does not fit neatly into any particular movement he was influenced by William Scott, his teacher at Bath, to regard painting as a physical object. An early but lifelong attraction to the Mughal art of India is also evident in the range of brilliant, contrasting colour. His paintings have a superficial impression of being abstract, but a closer examination reveals that they are truly representational, mostly of interiors or encounters, with figures caught in a split second. These qualities are evoked strongly in his masterpiece *Dinner at Smith Square*, painted in oil on wood between 1975 and 1979, now in the Tate Gallery. He was awarded the Turner Prize for contemporary British art in 1985 and was knighted in 1992.

MOVEMENT

Modern English

OTHER WORKS

Lovers; Menswear; Interior at Oakwood Court

INFLUENCES

William Scott, Mughal art

Sir Howard Hodgkin *Born* 1932 London, England

Paints in London

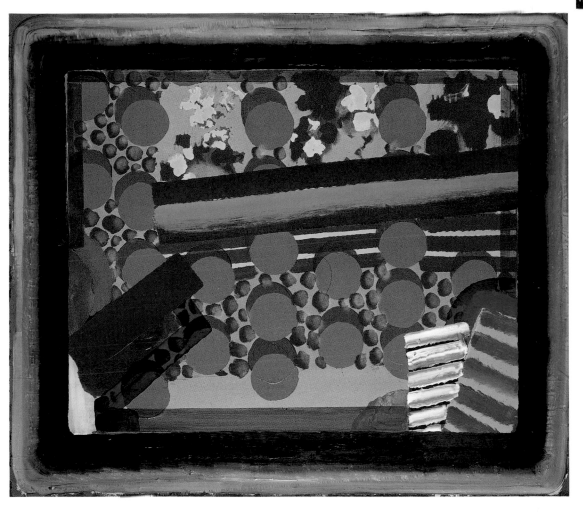

Morrisseau, Norval

Ojibway Headdress, 1975

Courtesy of Collection of the Dennos Museum Center, Northwestern Michigan College, Traverse City, Michigan

Native North American painter and graphic artist. Born in Fort William, Canada, Morrisseau hails from the Ojibwa tribe and has made this the focus of his art. Awareness of Native American traditions blossomed during the 1960s, as a by-product of the civil rights movement, and Morrisseau belonged to the generation that spearheaded this revival. He held his first one-man exhibition at the Pollock Gallery, Toronto, in 1962, and the success of this show established him as the leader of a new school. This has been variously described as the Woodlands or Algonquian school of legend painting.

Morrisseau took his basic subject matter from Ojibwa folk traditions. Many of these had been preserved as pictographs on birchbark scrolls. Traditionally, non-Native Americans were not permitted to see these images, but Morrisseau broke this taboo. He also combined the legends with more universal, Native American symbolism and European forms. Much of his work has a strong, spiritual basis, dealing with such themes as soul travel and self-transformation. It reached its widest audience in Montreal, when Morrisseau and Carl Ray designed the Indian Pavilion for Expo 67.

MOVEMENT

Algonquian Legend Painters

OTHER WORKS

Thunderbird; Loon Totem and Evil Fish; The Creation of the Earth

INFLUENCES

Midewiwin birchbark scrolls, aboriginal rock art, Ojibwa folklore

Norval Morrisseau *Born* 1931

Paints in Canada, USA

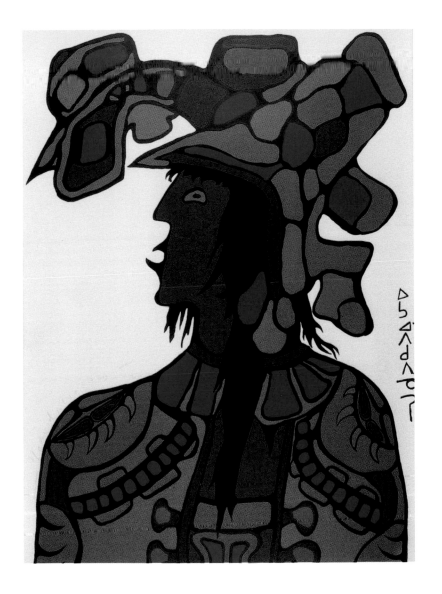

Freundlich, Otto

Composition

Courtesy of Private Collection/Christie's Images

After art training in Munich and Berlin, Otto Freundlich settled in Paris in 1909, where he joined the avant-garde circle dominated by Picasso. In 1911 he exhibited at the Neue Sezession in Berlin, revealing the latest trends from France. He returned to Germany for military service in World War I, during which (1917) he joined the Aktion group of artists and between 1919–23 was associated with the Bauhaus. He returned to Paris in 1924 and latterly worked in Pontoise as a painter, graphic artist and sculptor. In 1929 he commenced the magazine *A bis Z*; a prolific writer, he was the intellectual voice of the avant-garde. In 1939 he was interned as an enemy alien, released on the intervention of Picasso and moved to the Pyrenees, where he spent the next two years repainting from memory all those works which had been destroyed by the Nazis as degenerate art. Betrayed to the Gestapo in 1943, he was transported to Majdanek concentration camp where he died soon afterwards. Work on the restoration of the stained glass in Chartres Cathedral (1914) inspired his kaleidoscopic paintings which anticipated the Op Art of the 1960s.

MOVEMENTS

Abstract Art, Orphism

OTHER WORKS

Diptych; La Rosace; Composition avec Trois Personnages

INFLUENCES

Pablo Picasso, Wassily Kandinsky, Paul Klee, Robert Delaunay, Max Ernst

Otto Freundlich *Born* 1878 Pomerania (now Poland)

Painted in Munich, Berlin, Paris, Pontoise and the Pyrenees

Died 1943 Majdanek, Lublin, Poland

Kiefer, Anselm

Noch Ist Poten Nicht Verloren IV, 1978

Courtesy of Private Collection/Christie's Images

One of the leading artists to emerge in Germany in recent years, Anselm Kiefer originally studied law, but switched to art around 1965 and had his first one-man show five years later. Between 1970 and 1972 he studied under Joseph Beuys, but did not embrace either Minimalism or Conceptual Art as did so many of his contemporaries. In subsequent years he developed large-scale paintings, executed on paper or burlap, mounted on canvas and using charcoal or black paint to create a starkly etched effect with muted tones of yellow and brown, which drew upon the myths and legends of Germany. Although controversial (and sometimes accused of fascist overtones) Kiefer's monumental paintings are inspired by the works of Caspar David Friedrich and the operas of Wagner. In addition to his paintings, Kiefer has produced numerous drawings and etchings and well as massive 'books' in wood or lead, engraved and worked over.

MOVEMENT

Neo-Expressionism

OTHER WORKS

Spiritual Heroes of Germany; Parsifal series; Lilith

INFLUENCES

Joseph Beuys, Caspar David Friedrich

Anselm Kiefer *Born* 1945, Donaueschingen, Germany

Paints in Germany

Oonark, Jessie

Angagok Conjuring Birds, 1979

Courtesy of Collection of the Dennos Museum Center, Northwestern Michigan College, Traverse City, Michigan/The Artist

Jessie Oonark spent her entire life in the Baker Lake community of Inuit in northern Canada, learning her skills in needlework from her mother. She excelled in the art of sewing duffel parkas intricately embroidered with figures, but it was not until 1963 that she was encouraged to apply these skills to wall-hangings. These are noted for the brilliant colours of the images and their striking resemblance to the frescoes of Pharaonic Egypt, although executed without any knowledge of Egyptian art. Jessie Oonark also produced a vast number of drawings, many of which began as preliminary sketches for her embroideries but were later regarded as works of art in their own right. Her large wall-hangings were worked in mixed media, involving duffel, felt and embroidery floss with strips of caribou hide to create an almost three-dimensional effect. She combined traditional Inuit images dating back many centuries with the changes wrought by exposure to twentieth century civilization, but always in a truly unique and individual manner.

MOVEMENT

Modern Canadian School

OTHER WORKS

What the Shaman Can Do; Angagok Conjuring; Day Spirit

INFLUENCES

Inuit Tribal Art

Jessie Oonark *Born* 1906 Canada

Painted in Baker Lake, Canada

Died 1985 Churchill, Manitoba, Canada

Fischl, Eric

Love

Courtesy of Private Collection/Christie's Images

Educated at the California Institute of the Arts (1969–72), Eric Fischl led the reaction against Op Art and Minimalism in the late 1970s and 1980s, calling for a return to a more purely figurative and representational style of painting which had strong echoes of the Social Realism of the New Deal era. What has marked out his work from his predecessors of the 1930s, however, is the psycho-sexual undertones of his compositions, in which the spectator becomes a voyeur, looking at scenes which may appear relatively simple and straightforward on one level, but which reveal disturbing elements of anxieties, phobias, insecurities and a wide range of sexual hang-ups, invariably unexplained and thus open to individual interpretation. Although far less accomplished technically than the paintings of Tamara de Lempicka, for example, Fischl's sly exploration of repressed or ambivalent sexuality invites obvious comparison.

MOVEMENT

Neo-Figurative School

OTHER WORKS

Bad Boy; Sleepwalker; Pizza Eater

INFLUENCES

Tamara de Lempicka, Norman Rockwell, Walter Sickert

Eric Fischl *Born* 1948 New York, USA

Paints in New York

Gilbert and George

Helping Hands, 1982

Courtesy of Private Collection/Christie's Images

Italian-born Gilbert Proesch first met George Pasmore when they were both students at St Martin's School of Art in London and have worked together since graduating in 1969. George had previously studied at Dartington Hall and the Oxford School of Art, while Gilbert had attended the Academy of Art in Munich. Since the late 1960s they have worked as performance artists, principally as living sculptures, their faces and hands covered with gold paint and holding the same pose for hours on end. Subsequently they developed two-dimensional art, often comprising a series of framed photographs which are integrated to form a single entity. Their very conservative images in these collaborative works often clash with the subject matter, in which bodily functions and overt references to homosexuality feature prominently. Controversy surrounds their work, which is often seen as promoting rather than condemning fascist or racist attitudes, although they claim to be attempting to define the 'new morality'.

MOVEMENT

Modern British School

OTHER WORKS

Fear; Flying Shit; England; The Nature of Our Looking

INFLUENCES

Op Art, Performance Art

Gilbert Proesch *Born* 1942 Dolomites, Italy

Worked in Italy, Germany and England

George Pasmore *Born* 1943 Devon, England

Paints in England

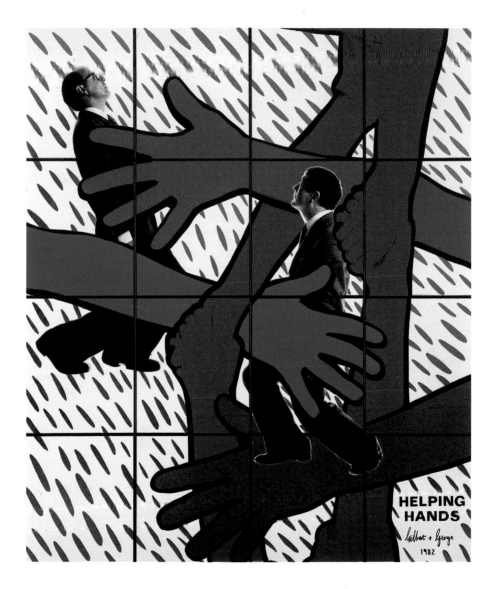

Kitaj, R. B.
Golem, 1982–3

Courtesy of Private Collection/Christie's Images/The Artist courtesy of Marlborough Fine Art

Born in Cleveland, Ohio, in 1932, Ronald Brooks Kitaj travelled the world as a merchant seaman (1951–55) but after service in the US Army he went to Oxford to study art. In 1960 he enrolled at the Royal College of Art in London. Older and infinitely more worldly wise that his fellow students, he was an outstanding figure with a charismatic personality who played a leading role in introducing Pop Art to Britain in the 1960s. An abiding friendship with David Hockney was forged in this period. The strident colours and brashness of Pop Art belie the intellectual depth of Kitaj's work, which draws on many disparate sources, from his Hungarian Jewish ancestry to the ethnic art of the countries he visited as a seaman. The result is often a riotously eclectic mixture of patterns and images. Most of his work up to 1975 was executed in oils but in more recent years he has concentrated on pastels, a trend encouraged by his second wife, Sandra Fisher. This is cleverly demonstrated in his masterpiece *The Wedding* which celebrates their marriage.

MOVEMENT

Pop Art

OTHER WORKS

If Not, Not

INFLUENCES

Arthur Boyd, Edward Burra

R. B. Kitaj *Born* 1932 Cleveland, Ohio

Paints in London, England

Schnabel, Julian

Hamid in a Suit of Light, 1982

Courtesy of Private Collection/Christie's Images

Although a native of New York City, Schnabel studied art at the University of Texas from 1969 to 1972. After moving back to New York, he began exhibiting in 1976, creating enormous canvasses in which layers of paint are applied in different ways in order to create interesting and unusual textures. A later development on these lines includes the use of shards of pottery to break up the surfaces and heighten dramatic effect. Unfortunately this combination of paint and crockery is friable and inherently unstable, creating numerous problems for curators and conservators of art galleries housing these monumental works. More recently he has also created paintings on velvet. Apart from re-inventing Action Painting, Schnabel has experimented with imagery on the grand scale, creating extraordinary works which incorporate numerous images and portraits mingled with allusions to history and emotions. Since the early 1980s he has enjoyed phenomenal commercial success.

MOVEMENT

Action Painting

OTHER WORKS

Blue Nude with Sword; Humanity Asleep; St Francis in Ecstasy

INFLUENCES

Robert Motherwell, Robert Rauschenberg

Julian Schnabel *Born* 1951 New York, USA

Paints in New York

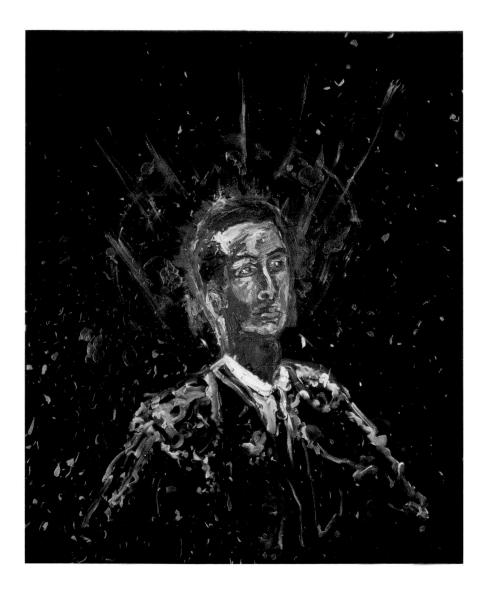

Tjapaltjarri, Clifford Possum
Water Dreaming, 1982

Clifford Possum Tjapaltjarri had no formal art training in the conventional Western sense, but he inherited an Aboriginal artistic and spiritual tradition stretching back thousands of years. He belongs to the group of Aboriginal artists known as the Western Desert Painters, who have adapted their tribal art forms to the Western world only in so far as they use westernized materials and techniques, instead of wood, bark, sand or indigenous dyes. Tjapaltjarri works in acrylic paints on canvas, but otherwise much of his work clings steadfastly to the imagery and expression practiced by his ancestors. A large part of his oeuvre centres on the Dreamtime, the sacred world of the tribe's ancestral spirits, whom the Aborigines regard as the creators of all living things. Superficially, his paintings may seem abstract, but they are actually a carefully constructed and systematized map or chart of a particular tribal or community site.

MOVEMENT

Australian Aboriginal

OTHER WORKS

Kangaroo Dreaming

INFLUENCES

Tribal art

Clifford Possum Tjapaltjarri *Born 1932* Nabberby Creek, Central Australia

Painted in Central Australia

Died 2002 Australia

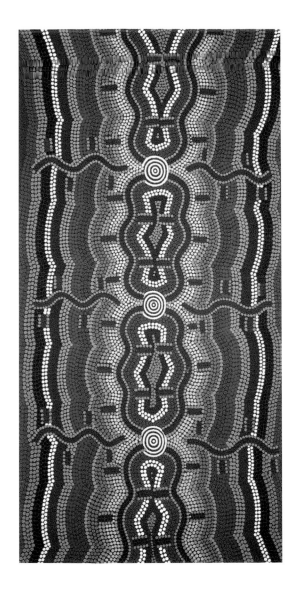

Dine, Jim

Townsend Monotype 1 (Heart), 1983

Trained at the University of Cincinnati, the Boston Museum of Fine Arts School and the University of Ohio, Jim Dine was one of the foremost exponents of Pop Art. He held his first exhibition of objects as images in 1959, alongside Claes Oldenburg, with whom he subsequently collaborated on a number of projects. Like the Dadaists, he believed in the combination of many different media and the use of ready-made objects or fragments of them in creating his compositions. Taking this process to its logical conclusion in the late 1950s he began organizing a series of 'happenings', live performances which combined his art with his experience of life. These, in effect, were the forerunners of the Performance Art that came to fruition a few years later. In more recent years, however Dine has returned to a more representational and figurative style of painting. He has combined oils with collage, or etching and printing on hand-coloured paper.

MOVEMENT

Performance Art, Pop Art

OTHER WORKS

The Toaster; Wiring the Unfinished Bathroom

INFLUENCES

Dadaism, Surrealism, Abstract Expressionism

Jim Dine *Born* 1935 Cincinnati, Ohio, USA

Paints in Cincinnati, Boston and New York

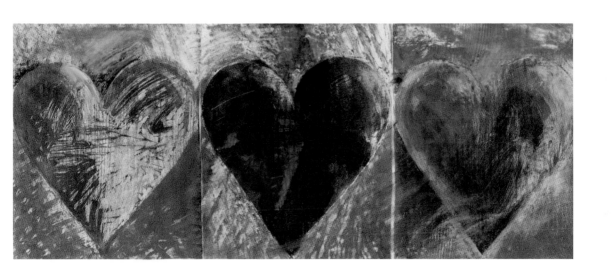

Thiebaud, Wayne
Free Way Traffic, 1983

Wayne Thiebaud originally worked as a sign-painter and later a freelance cartoonist in New York before turning to fine art in 1949. His expertise in his earlier vocations stood him in good stead, for his paintings are both witty and executed with a clarity and deftness that make them instantly recognizable. His reputation has been built largely on the series of paintings of American junk food, pies, cakes, sweets, ice-cream and other delicacies, which often strike a nostalgic note but are invariably presented in a humorously deadpan manner. He injects realism by laying on the paint in thick slabs so that the icing or frosting on cakes looks good enough to eat. More recently he has painted figures of women, harshly lit in artificial light or the bright sunlight of California where he now lives, but here again he incorporates a wide range of minor objects, all painted against severely plain backgrounds.

MOVEMENT

Pop Art

OTHER WORKS

Refrigerator Pies; Woman and Cosmetics; Various Cakes

INFLUENCES

Pierre Bonnard, Man Ray, Edward Ruscha

Wayne Thiebaud *Born* 1920 Mesa, Arizona, USA

Paints in New York, Sacramento and San Francisco

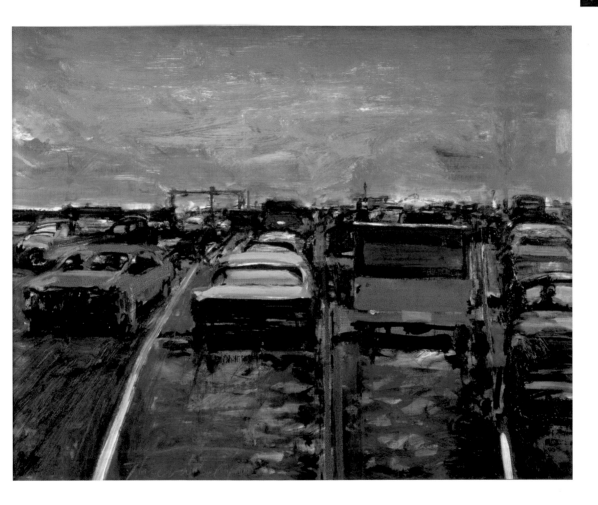

Motherwell, Robert

Chrome Yellow Elegy, 1984

Robert Burns Motherwell briefly attended the California School of Fine Arts in San Francisco before studying philosophy at Stanford, Harvard, Grenoble and Columbia universities. This unusual combination of academic training enabled him to write authoritatively on various aspects and theories of modern art, more especially the American brand of Abstract Expressionism which he helped to formulate in the 1940s. He only took up painting professionally in 1941, due to the influence of Roberto Matta. Motherwell's large paintings were often characterized by unconscious doodles, a concept which arose from his interest in Freudian psychoanalysis and the interpretation of dreams. With Mark Rothko and others he founded the Subjects of the Artist movement to encourage the development of the next generation, and was also preoccupied with aspects of Symbolism.

MOVEMENT

Abstract Expressionism

OTHER WORKS

Elegies to the Spanish Republic; Bolton Landing Elegy Influences

INFLUENCES

Roberto Matta

Robert Motherwell *Born* 1915 Aberdeen, Washington, USA

Painted in New York, USA

Died 1991 Cape Cod, Massachusetts, USA

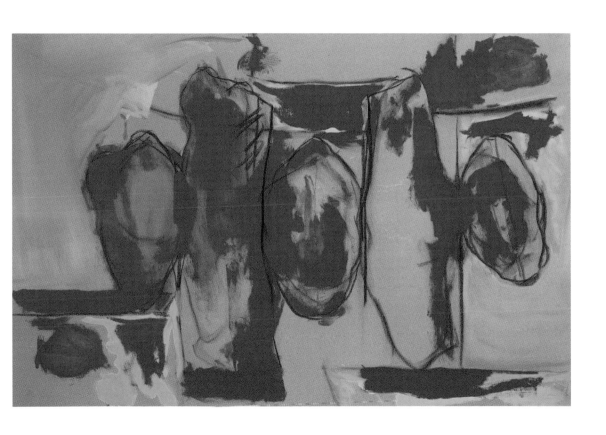

Hawkins, William

Niagara Falls, 1986

One of the foremost practitioners of American Vernacular and Outsider Art to emerge in the late twentieth century, William Hawkins was barely able to read or write and had no art training at all. Despite this he produced an extraordinary range of paintings. He migrated to Columbus, Ohio in 1916, where he held a wide variety of jobs, from truck-driver to brothel-keeper. Although he began drawing in the 1930s, he did not begin painting in the style that made him famous until the late 1970s. His technique evolved naturally – dripping paint on to cardboard or plywood tilted to "watch the painting make itself". Vivid imagery combined motifs seen in newspapers with memories of his native Kentucky countryside. From his early years he had a deep knowledge of animals, an awareness that informs even his most fantastic dinosaur paintings. Latterly he combined paint with pieces of wood, gravel or found objects. His pictures often have elaborate borders including his full name with date and place of birth.

MOVEMENT

American Vernacular, Outsider School

OTHER WORKS

Abstract; The Last Supper; Prancing Horse; Country House

INFLUENCES

None

William Hawkins *Born* 1895 Kentucky, USA

Painted in Columbus, Ohio

Died 1990 Columbus, Ohio

Haring, Keith
Untitled

Courtesy of Private Collection/Christie's Images

Keith Haring received his formal training at the Ivy School of Art in Pittsburgh, followed in 1978 by a year at the New York School of Visual Arts. In this period he was influenced by Keith Sonnler and Joseph Kossuth, who encouraged him to experiment with form and colour, and to develop as a Conceptualist. His informal, though, in the long run the most influential, art education came through the medium of comic strips and television cartoons as well as the graffiti of the New York streets. He himself spent some time covering the commercial advertisements on the New York subway with flamboyant graffiti executed with coloured chalks and marker pens. Prolific and far-ranging, his work reflected the age in which he grew up. In the 1980s he graduated from the sidewalk to commercial art, producing motifs reproduced on T-shirts and badges, and then posters and murals, drawing on the fertile mix of cultures in his adopted city.

MOVEMENT

Conceptualism

OTHER WORKS

Ignorance-Fear; Silence-Death; Untitled

INFLUENCES

Keith Sonnler, Joseph Kossuth

Keith Haring *Born* 1958 Pennsylvania, USA

Painted in New York, USA

Died 1990 New York

Arikha, Avigdor

Alexander Frederick Douglas-Home, Lord Home of the Hirsel, 1988

© The Artist, Courtesy of Scottish National Portrait Gallery, Edinburgh

Avigdor Arikha was born in 1929 in Bukovina (Romania) and survived the Holocaust thanks to the boyhood drawings he had created in deportation. He arrived in Palestine in 1944 where he received a Bauhaus art-education at Bezalel, Jerusalem from 1946-1949, and where he was also severely wounded in Israel's war of Independence in 1948. He continued his art studies at the École des Beaux-Arts in Paris (1949-1951) where he still mainly resides. His style, which was at first figurative, had evolved into abstraction in the late 1950s. He renounced abstraction in 1965 in favour of drawing and painting from observation, treating all subjects, whether they be still lifes, landscapes, nudes or portraits (such as Lord Home and Queen Elizabeth the Queen Mother) in a single sitting. As an art historian, Arikha has curated exhibitions at the Louvre (Poussin, 1979) and the Frick Collection in New York (Ingres, 1986), among others. His writings include: Peinture et Regard, Paris, 1991 and On Depiction, London, 1995. Books about him include Arikha by Samuel Beckett, Robert Hughes et al., London, 1985 and Avigdor Arikha by Monica Ferrando and Arturo Schwarz, Bergamo, 2001.

MOVEMENT

International School

OTHER WORKS

Anne from the Back; The Square in June

INFLUENCES

Mondrian

Avigdor Arikha *Born* 1929 Bukovina, Romania

Paints in Israel, France, England and USA

Close, Chuck
Cindy II, 1988

Courtesy of Private Collection/Christie's Images/© Chuck Close

Chuck Close studied art at Yale from 1962 to 1964 and settled in New York City in 1967. In that year, influenced by the photographic self-portraits produced by Claude Cahun in the 1920s, he began painting photographs of portraits, meticulously reproducing the tiniest detail. Every line and wrinkle, every pore and individual strands of hair are carefully delineated. In fact, appearances can be deceptive; closer examination often reveals slight distortion or blurring around the ears or shoulders in order to convey the impression that the face is looming towards the viewer. In this way the artist remedies the shortcomings of the camera lens. In more recent years he has taken this a stage further, combining this photo-realism with such techniques as finger-painting, a microscopic stippled effect and collages.

MOVEMENT

Hyper-realism

OTHER WORKS

John

INFLUENCES

Claude Cahun

Chuck Close *Born* 1940 Monroe, Washington State, USA

Paints in New York

Onus, Lin

Jimmy's Billabong, 1988

Lin Onus was completely self-taught and began painting full-time in 1974. He had his first one-man exhibition the following year at the Aborigines Advancement League in Melbourne and has since had regular shows in Melbourne, Canberra and Sydney. His work is represented in all the major Australian national and state art galleries and he has had many commissions from institutions and corporate collections. He is currently Chairman of the Aboriginal Arts Committee of the Australian Council, although he is at pains to stress that he should not be regarded purely as an Aboriginal artist and finds the labelling of his painting in this manner rather irksome. He is best known for his extraordinary blend of traditional Aboriginal imagery and photorealist landscapes, which he describes as 'a natural convergence of Aboriginal and non-Aboriginal techniques'. In more recent years he has also produced a series of fiberglass sculptures of dingoes.

MOVEMENT

Modern Australian School

OTHER WORKS

Arafura Swamp

INFLUENCES

Traditional Aboriginal art forms

Lin Onus *Born* 1948 Melbourne, Australia

Painted in Melbourne

Died 1996

Rego, Paula

The Cadet and his Sister, 1988

Rego was born in Lisbon, but her father worked for Marconi in Essex and she was educated at an English school. In 1952, she entered the Slade School of Art, where she trained under Coldstream. There she met Victor Willing, a fellow painter, who became her husband in 1959. They lived in Portugal until 1963, after which they resided principally in England.

Rego's early work was strongly influenced by Dubuffet. She also produced semi-abstract collages, sometimes with political overtones. Increasingly, though, she turned to figurative painting, drawing much of her inspiration from children's illustration, nursery rhymes and her own memories of childhood. In mature works, such as *The Maids*, these playful elements are transposed into unsettling contexts, hinting at games of a very sinister kind. Rego's paintings have brought her success, both in Portugal and the UK. She has twice represented her native land at the Bienal in São Paolo, and on one occasion for Britain. In 1990, she became the first Associate Artist of the National Gallery in London.

MOVEMENT

Symbolist Figuration

OTHER WORKS

Crivelli's Garden; The Policeman's Daughter

INFLUENCES

Jean Dubuffet, Pablo Picasso, Walt Disney, James Gillray

Paula Rego *Born* 1935 Lisbon, Portugal

Paints in Britain and Portugal

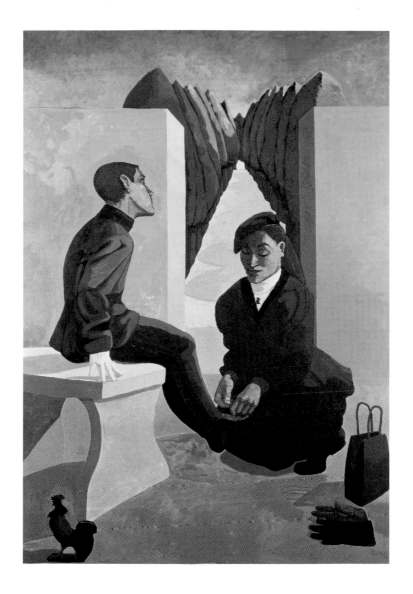

Samba, Chéri

Mobali Ya Monyato, 1989

Courtesy of Galerie Peter Herrmann, Berlin/© Chéri Samba

In colonial times it was axiomatic that aspiring African artists had to receive a good grounding in European styles and techniques, but gradually it dawned that such an influence was often negative or counterproductive. Fortunately for Chéri Samba, he was entirely self-taught and if he had been influenced in any way by European art it was through the medium of the cartoons and graphic art in contemporary newspapers. In 1975 he graduated from drawing cartoons to painting them on canvas, but without compromising his direct, crystal-clear approach. Every painting tells a story, the images generally enhanced by words, an unconscious borrowing from the art of China and Japan. Detail is painstaking, brushwork is crisp and outlines are hard-edged, enhancing the impact of his work. One of the most prominent of the naive painters to emerge in post-colonial Africa, his paintings with their undertones of social realism are now in many international collections.

MOVEMENT

Modern African School

OTHER WORKS

Mr Poor's Family

INFLUENCES

Henri Rousseau, Gino Severini

Chéri Samba *Born* 1956 Kinto M'Vulia, Zaire (now Congo)

Paints in Congo

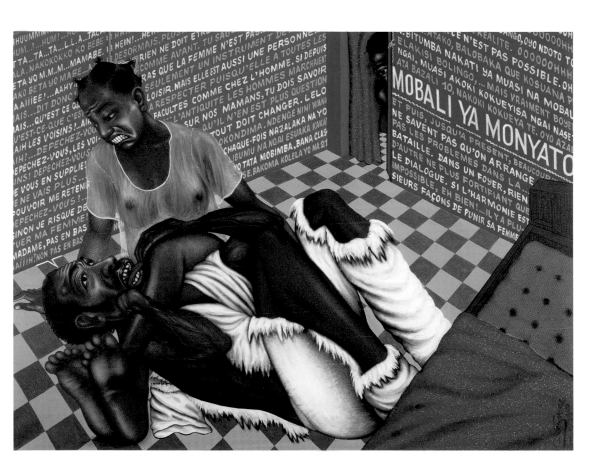

Freud, Lucian

Annabel, 1990

Courtesy of Private Collection/Christie's Images/© Lucian Freud

Naturalized British painter; a leading member of the School of London. Freud was born in Berlin, the grandson of the famous psychoanalyst Sigmund Freud. As a Jewish family living in the shadow of Nazism, the Freuds left Germany in the 1930s, settling in London. Lucian joined the Merchant Navy, becoming an artist after he was invalided out of the service in 1942. He trained under Cedric Morris, and the hallucinatory realism of his early style hints at an admiration for Surrealism and Neue Sachlichkeit. His greatest influence, however, was Ingres. Freud emulated the meticulous draughtsmanship of the Frenchman, apparently attempting to depict every strand of hair on his sitters. His virtuoso skill was recognized when in 1951, his remarkable *Interior at Paddington* won a prize at the Festival of Britain.

Freud's style changed in the late 1950s, when he replaced his fine sable brushes with stiffer, hog-hair ones which led to a more painterly approach, in which the artist conveyed his flesh-tones through thicker slabs of colour. Freud's favourite subject matter has been the 'naked portrait': starkly realistic nudes, devoid of any picturesque or idealizing elements.

MOVEMENT

Realism, School of London

OTHER WORKS

Hotel Bedroom; Francis Bacon

INFLUENCES

Cedric Morris, Jean-Auguste-Dominique Ingres, George Grosz

Lucian Freud *Born* 1922 Berlin, Germany

Paints in Britain

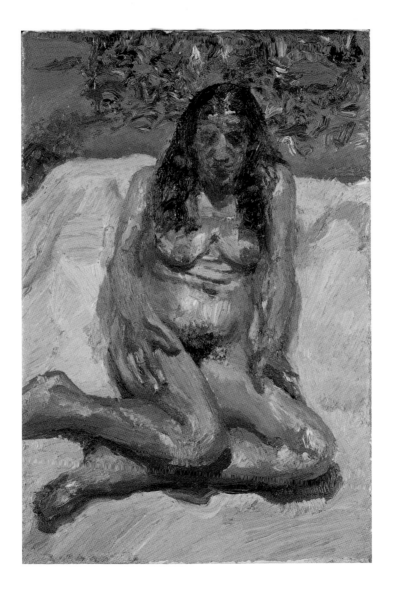

Riley, Bridget
Close by, 1992

Bridget Riley studied at Goldsmiths College of Art (1949–52) and the Royal College of Art (1952–55) in London. She had her first one-woman exhibition at Gallery One, London, in 1962 and has had many other shows all over the world in subsequent years. Influenced by the Futurists Giacomo Balla and Umberto Boccioni, she began to develop an optical style in the 1960s – now known as Op Art – in which hallucinatory images were created in black and white, in geometric or curvilinear patterns endlessly repeated to produce the illusion of rippling or undulating movement. By 1966 she had moved into colour, which enabled her to widen the scope of these images considerably; her colours vary in depth and tone and add subtlety to the overall pattern. Widely acclaimed in England, she made an impact on the international scene in 1968 when she became the first British artist to win the top award for painting at the Venice Biennale.

MOVEMENT

Op Art

OTHER WORKS

Cataract I; In Attendance; Fission; Fall

INFLUENCES

Giacomo Balla, Umberto Boccioni, Joseph Albers

Bridget Riley *Born* 1931 London, England

Paints in London

Howson, Peter

Study for the Bestiary, Fieldmouse

Courtesy of The Fleming-Wyfold Art Foundation/Bridgeman Art Library/Courtesy of Angela Flowers Gallery

Although born in London, Peter Howson trained at the Glasgow School of Art from 1975 to 1981 and has since lived in Scotland, apart from forays abroad as an official war artist. His style is essentially figurative, but he took the lead in creating the New Image, which has had a tremendous impact on British art since the late 1980s. Living and working in Glasgow – a city which was then in the process of re-inventing itself in the aftermath of post-industrial decay – he was strongly influenced by the prevailing socio-economic conditions and his paintings have echoes of the Social Realism of the 1930s. His figures, though recognizable, are often monstrous in appearance, reflecting the harshness of living and working conditions. This stark realism came to fruition in his paintings from the Balkan conflicts of the 1990s when, as a war artist, he did not pull his punches on the atrocities and appalling hardships he witnessed. An uncompromising, often fearful, reality pervades his work.

MOVEMENT

Modern British School

OTHER WORKS

A Night That Never Ends; Plum Grove; Patriots

INFLUENCES

Stanley Spencer

Peter Howson *Born* 1958, London, England

Paints in England, Scotland and the Balkans

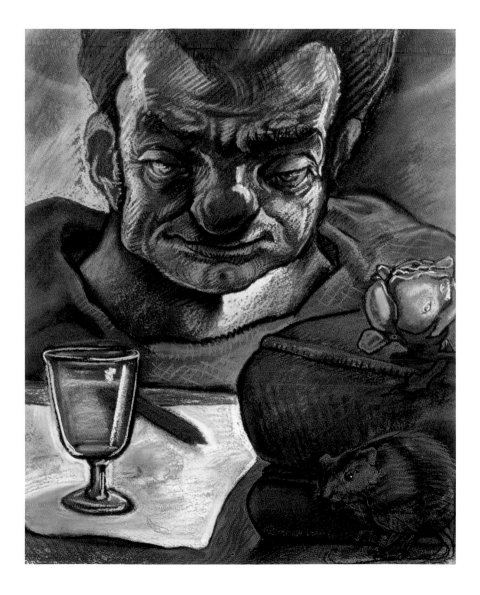

Hirst, Damien

Painting for Marco Pierre-White, 1996

Courtesy of Jay Jopling/White Cube (London)/© the artist

Marcus Harvey's.(b. 1963) *Myra* was *the* sensation of the Royal Academy's 'Sensation' exhibition of 1997. Gazing balefully out from beneath a great bob of peroxide hair in the infamous photograph, 'Moors Murderer' Myra Hindley was one of the great anti-icons of post-war Britain. Just to add insult to injury as far as many were concerned, Harvey's eleven-foot blow-up was composed entirely of children's hand prints.

Was this a calculated outrage? Ever since Damien Hirst launched the exhibition 'Freeze' in a warehouse in London's Docklands in 1988, there had been accusations that 'Britart' began and ended in cheap sensation. London's young artists made no attempt to reject the charge, making play with it instead. While works such as *Myra* and Tracey Emin's *Bed* became the lightning conductors for media-orchestrated outrage, others were getting on with only slightly less controversial work. Hirst himself, the founder of Britart, aroused press opprobrium for a series of animal carcasses bisected and preserved in formaldehyde, and this little still life is, in its way, just as challenging. Simultaneously charming and morbid, a memento mori and a record of cruelty, it sums up the aesthetic and moral ambiguity of great art.

MOVEMENT

Britart/Young British Artists

OTHER WORKS

The physical Impossibilty of Death on the Mind of Someone Living

INFLUENCES

Frances Bacon, English Punk, 60's Op-Art

Damien Hirst *Born* 1965 Bristol, England

Works in London

Menon, Anjolie Ela
Still Life with Head, 1998

Courtesy of Private Collection/Christie's Images

Anjolie Ela Menon studied at the Sir J J School of Art in Mumbai (Bombay) before going on to Delhi University, where she majored in English Literature. As a result of highly successful exhibitions in Mumbai and Delhi in the late 1950s, she was awarded a French government scholarship and continued her studies at the École Nationale des Beaux-Arts in Paris. Before returning to India she travelled all over Europe and the Middle East, studying the classical art of Rome, Greece and Byzantium. One of the most cosmopolitan of modern Indian artists, she has since lived and worked in Britain, Germany, Russia and the USA, although she now resides in New Delhi, where she served on advisory committees of the National Gallery of Modern Art. She is regarded as India's foremost female painter of the present day; although renowned for her large murals she has also produced numerous easel paintings, landscapes, portraits and genre subjects – often reflecting traditional Indian motifs.

MOVEMENT
Modern Indian School

OTHER WORKS
Portrait; Malabar; The Fisherman's Tale

INFLUENCES
Amrita Sher-Gil, Rabindranath Tagore

Anjolie Ela Menon *Born* 1940, India
Paints in India, France, Britain, Russia and USA

Matar, Joseph
Glow of Morning, 2001

Joseph Matar was educated at the Marist Brothers' School in Jounieh and began working as an artist in Beirut. He received his art training under Omar Onsi, Rachid Webbe and George Corm between 1951 and 1957, while studying at the Italian Cultural Centre in Beirut (1955–57) and anatomy at the Beirut Faculty of Medicine (1958). Travelling scholarships enabled him to continue his studies at the San Fernando School of Fine Arts in Madrid (1961–63), Rome (1973) and the University of Paris (1963 and 1985). He began teaching art in 1954 at both high-school and university levels and has held a number of professorships since 1980. He has had more than 60 one-man shows around the world and his paintings are in major collections in many countries. Matar paints in oils and watercolours, both abstracts and landscapes. In addition to being the Lebanon's foremost contemporary painter he is a poet of considerable merit, recognized by an award for outstanding achievement from the International Library of Poetry, 2001.

MOVEMENT

Modern Lebanese School

OTHER WORKS

Corner of the Galaxy; Marriage Feast at Cana; Harvest; Temple

INFLUENCES

Omar Onsi, Rachid Wehbe, George Corm

Joseph Matar *Born* 1935 Ghadir, Lebanon

Paints in Lebanon, Spain, France and Italy

Author Biographies

Dr Robert Belton (General Editor)
Author of *The Beribboned Bomb:The Image of Women in Male Surrealist Art*, *Sights of Resistance* and *The Theatre of the Self: The Life and Art of William Ronald*, Dr Robert Belton is the Associate Dean of Arts at Okanagan University College in Kelowna, British Columbia. He has received the Alma Mater Society Frank Knox Award for Teaching Excellence and the Arts and Science Undergraduate Award for Teaching Excellence.

Christopher Rothko
Christopher Rothko is Mark Rothko's second child. He holds a BA in Literature from Yale University and a PhD in Psychology from The University of Michigan. He has worked to organize and present most of his father's recent exhibitions around the globe. He has written extensively as a classical music critic and, when work and children allow, likes to write fiction.

Tom Middlemost
Tom Middlemost is an art curator who specialises in Australian art. In June 2001 he began a three month internship with the former director Lars Nittve, one of the world's leading art curators, at Tate Modern, London, to develop the Charles Sturt University's art collection. Tom is passionate about making art accessible to people in country regions of Australia.

Dr James Mackay
Dr James Mackay is a journalist and broadcaster, biographer and historian. A former salesroom correspondent for the *Financial Times*, he has also written numerous books on art, sculpture, antiques and collectables, including *Dictionary of Sculptures in Bronze* and *Animaliers*. A graduate of Glasgow University, he is regarded as the world's leading authority on Robert Burns.

Iain Zaczek
Born in Dundee and educated at Wadham College, Oxford and the Courtauld Institute of Art in England, Ian Zaczek, has written numerous art books, some of which include *Lovers in Art*, *Impressionists* and *Celtic Art and Design*. His most recent book, published in 2002, is entitled *Women in Art*.

Dr Julia Kelly
Dr Julia Kelly is currently a lecturer at Manchester University. Educated at Oxford and the Courtauld Institute of Art in England, she specialises in twentieth-century art, with a particular interest in Surrealism and the inter-war period. Her PhD thesis was on the art writings of Michel Leiris and she has published works on Picasso and Francis Bacon.

William Matar
The son of the famous Lebanese artist, Joseph Matar, William is the site owner and director of LebanonArt.net He and his other experienced editorial staff have provided invaluable help in choosing the Middle Eastern Art represented in this book.

Bibliography

Adams, S., *The Barbizon School and the Origins of Impressionism*, Phaidon Press, 1994

Akurgal, E., *The Art of the Hittites*, Thames and Hudson, 1962

Aldred, C., *The Development of Ancient Egyptian Art from 3200 to 1315 BC*, 3 vols, Tiranti, 1973

Ames-Lewis, F. and Rogers, M. eds., *Concepts of Beauty in Renaissance Art*, Ashgate Publishing Limited, 1998

Amiet, P., *Art of the Ancient Near East*, New York, 1980

Archer, M., *Art since 1960*, Thames and Hudson, 1997

Arribas, A., *The Iberians*, Thames & Hudson, 1964

Atil, Ed., *Turkish Art*, Smithsonian Institute Press, Washington DC/New York, 1980

Barnhart, R.M. et al., *Three Thousand Years of Chinese Painting*, Yale University Press, 1997

Berenson, B., *The Italian Painters of the Renaissance 1894–1907*, Cornell University Press, 1980

Berger, J., *Ways of Seeing*, Penguin Books, 1990

Berlo, J.C. and Wilson L.A., *Arts of Africa, Oceania and the Americas*, Englewood Cliffs, NJ, 1993

Berrin, K. and Pasztory, E. eds., *Teotihuacán: Art from the City of the Gods*, San Francisco/London, 1993

Blurton, T.R., *Hindu Art*, British Museum Press, 1992

Boardman, J., *The Oxford History of Classical Art*, Oxford University Press, 1993

Boardman, J., *Greek Art*, Thames and Hudson, 1996

Boardman, J., *Pre-classical: From Crete to Archaic Greece*, Penguin Books, 1967

Boime, A., *Art in the Age of Revolution 1750–1800*, University of Chicago Press, 1987

Bomford, D. et al., *Impressionism*, National Gallery Company Ltd. 1990

Brilliant, R., *Roman Art from the Republic to Constantine*, Praeger Pub. Text, 1974

Brown, J., *The Golden Age of Painting in Spain*, Yale University Press, 1991

Buckton, D. ed., *Byzantium*, London, 1994

Camille, M., *Gothic Art*, US Imports & PHIPEs, 1996

Campbell, L., *Renaissance Portraits*, Yale University Press, 1990

Canby, S.R., *Persian Painting*, British Museum Press, 1993

Carpenter, R., *Greek Art*, Philadelphia, 1962

Caruana, W., *Aboriginal Art*, Thames and Hudson, 1993

Charbonneaux, J., *Hellenistic Art*, George Braziller, 1973

Chastel, A., *French Art: The Renaissance 1430–1620*, Paris, 1995

Clarke, G., *The Photograph*, Oxford University Press, 1997

Clunas, C., *Art in China*, Oxford Paperbacks, 1997

Collon, D., *Ancient Near Eastern Art*, British Museum Press, 1995

Craven, R.C., *Indian Art* (1976) Thames and Hudson, 1997

Crichton, R.A., *The Floating World: Japanese Popular Prints 1700–1900*, London, 1973

Cumming, R., *Annotated Great Artist*, Dorling Kindersley, 1998

D'Alleva, A., *Art of the Pacific*, Weidenfeld Nicolson, London/New York, 1998

Davies, D. ed., *Harrap's Illustrated Dictionary of Art and Artists*, Harrap Books Ltd. 1990

Deepwell, K. ed. *Women Artists and Modernism*, Manchester/New York, 1998

Duro, P. and Greenhalgh, M., *Essential Art History*, Bloomsbury, 1992

Eisenman, S.E., *Nineteenth Century Art: A Critical History*, Thames and Hudson, 1994

Evans, H.C. and Wixom, W.D. eds., *The Glory of Byzantium*, Harry N. Abrams, Inc., 1997

Eyo, E. and Willett, F., *Treasures of Ancient Nigeria*, Collins, 1982

Fer, B., *On Abstract Art*, Yale University Press, 2000

Fong, Wen C., *Beyond Representation*, Yale University Press, 1992

Frankfort, H., *The Art and Architecture of the Ancient Orient*, Yale University Press, 1996

Fry, E.F., *Cubism*, Thames and Hudson, 1966

Gale, M., *Dada and Surrealism*, Phaidon Press, 1997

Gaze, D. ed., *Dictionary of Women Artists*, Fitzroy Dearborn, 1997

Geidion, S., *The Eternal Present: The Beginning of Art*, Oxford University Press, 1962

Gilbert, C., *History of Renaissance Art throughout Europe*, Abrams, 1973

Gillon, W., *A Short History of African Art*, Penguin Books, 1991

Godfrey, T., *Conceptual Art*, Phaidon Press, 1998

Gombrich, E.H., *Art and Illusion*, Phaidon Press, 2002

Goodman, C., *Digital Visions, Computers and Art*, Harry N. Abrams, 1987

Gordon, E.D., *Expressionism, Art and Idea* (1987) New Haven/London, 1991

Grabar, A., *Early Christian Art*, London, 1968

Hanfmann, G., *Roman Art*, W.W. Norton, 1975

Haskell, F., *History and its Images*, Yale University Press, 1993

Hauser, A., *The Social History of Art*, Routledge, 1985

Held, J. and Posner, D., *17th and 18th Century Art*, Harry N. Abrams Inc. 1972

Henderson, G., *Early Medieval*, University of Toronto Press Inc. 1993

Hessel, I., *Inuit Art: An Introduction*, British Museum Press, 1998

Honour, H., *Neoclassicism*, Penguin, 1968

Honour, H., *Romanticism*, Viking, 1979

Howard, J., *Art Nouveau: International and National Styles in Europe*, Manchester University Press, 1996

Irwin, R., *Islamic Art*, Laurence King Publishing, 1997

James, T.G.H., *An Introduction to Ancient Egypt*, British Museum Publications, 1979

Jantzen, H., *High Gothic*, Princeton University Press, 1984

Kaplan, P. and Manso, S. eds., *Major European Art Movements 1900–1945*, E. P. Dutton, 1977

Kemp, M., *The Science of Art*, Yale University Press, 1990

Klindt-Jensen, O., *Viking Art*, University of Minnesota Press, 1980

Kramrisch, S., *The Art of India through the Ages*, Motilal Banarsidass, 2002

Kubler, G., *The Art and Architecture of Ancient America*, Yale University Press, 1992

Laing, L. and Laing, J., *Art of the Celts*, Thames and Hudson, 1992

Lee, S.E. and Richard, N., *A History of Far Eastern Art*, Thames and Hudson, 1997

Leroi-Gourhan, A., *The Art of Prehistoric Man in Western Europe*, Thames and Hudson, 1967

Leroi-Gourhan, A., *The Dawn of European Art*, Cambridge University Press, 1982

Levey, M., *High Renaissance*, Penguin, 1975

Levey, M., *The Early Renaissance*, Harmondsworth, 1967

Livingstone, M. ed., *Pop Art: A Continuing History*, Harry N. Abrams, 1990

Lodder, C., *Russian Constructivism*, Yale University Press, 1998

Loevren, S., *The Genesis of Modernism*, Hacker Art Books Inc. 1983

Lowden, J., *Early Christian and Byzantine Art*, Phaidon Press, 1997

Lynton, N., *The Story of Modern Art*, Phaidon Press, 1992

Martin, J.R., *Baroque*, Westview Press, 1977

Mason, P., *History of Japanese Art*, Harry N. Abrams, Inc., 1993

Miller, M.E., *The Art of Mesoamerica*, Thames and Hudson, 2001

Morphy, H., *Aboriginal Art*, Phaidon Press, 1998

Nochlin, L., *Realism*, Penguin Books, 1991

Noma, S., *The Arts of Japan*, Kodansha America, 1978

Osborne, R., *Archaic and Classical Greek Art*, Oxford University Press, 1998

Pächt, O. et al., *Book Illumination in the Middle Ages*, Harvey Miller Publishers, 1994

Panofsky, E., *Meaning in the Visual Arts*, Peter Smith Pub. 1988

Panofsky, E., *Renaissance and Renascences in Western Art*, Paladin, 1970

Partridge, L., *The Art of Renaissance Rome*, US Imports & PHIPEs, 1996

Phillips, P., *The Prehistory of Europe*, Viking, 1980

Phillips, T. ed., *Africa: The Art of a Continent*, Prestel Publishing Ltd, 1999

Piotrovsky, B. et al., *Scythian Art*, Phaidon Press, 1993

Pollitt, J.J., *Art and Experience in Classical Greece*, Cambridge University Press, 1972

Powell, R.J., *Black Art and Culture in the Twentieth Century*, Thames and Hudson, 1997

Rampage, N.H. and A., *The Cambridge Illustrated History of Roman Art*, Cambridge, 1991

Rawson, J., *The British Museum Book of Chinese Art*, British Museum Press, 1992

Rewald, J., *The History of Impressionism*, Secker & Warburg, 1980

Richter, G., *A Handbook of Greek Art*, Phaidon Press 1987

Rosen, C. and Zerner, H., *Romanticism and Realism*, Faber and Faber, 1984

Rosen, R. et al., *Making Their Mark: Women Artists Move into the Mainstream*, Abbeville Press, 1991

Rosenblum, R. and Janson, H.W., *19th Century Art*, Thames and Hudson, 1984

Rosenblum, R., *Transformations in Late Eighteenth Century Art*, Princeton University Press, 1992

Roskill, M., *What is Art History?* University of Massachusetts Press, 1989

Rowland, B., *The Evolution of the Buddha Image*, Arno P, New York, 1976

Sandler, I., *Art of the Postmodern Era*, Icon Editions, 1996

Schäfer, H., *Principles of Egyptian Art*, Aris & Phillips, 1986

Schapiro, M., *Modern Art, 19th and 20th Centuries*, George Braziller, 1978

Singer, J.C. and Denwood, P. eds., *Tibetan Art: Towards a Definition of Style*, Laurence King Publishing, 1997

Spivey, N., *Etruscan Art*, Thames and Hudson, 1997

Stanley-Baker, J., *Japanese Art*, Thames and Hudson, 2000

Starzecka, D.C. ed., *Maori: Art and Culture*, British Museum Press, 1998

Stone-Miller, R., *Art of the Andes*, Thames and Hudson, 1995

Strong, D.E., *Roman Art*, Yale University Press, 1992

Ucko, P. and Rosenfeld, A., *Palaeolithic Cave Art*, Weidenfeld & Nicolson, 1967

Vermeule, C.V., *Roman Art: Early Republic to Late Empire*, Boston, 1979

Watson, W., *The Arts of China to AD 900*, Yale University Press, 2000

Welch, S.C., *Art of Moghul India*, Arno P, New York, 1976

Whelte, K., *The Materials and Techniques of Painting*, Van Nost, Reinhold, New York, 1975

Willett, F. *African Art: An Introduction*, Harcourt School Pub. 1971

Wölfflin, G. *Principles of Art History*, G Bell. 1950

Wollheim, H. *Painting as an Art*, Thames and Hudson, 1990

Yonemura, A. et al., *Twelve Centuries of Japanese Art from the Imperial Collections*, Smithsonian Institution Press, 1998

Zarnecki, G. *Romanesque*, Herbert Press, 1989

Index By Artist

Index By Painting